The Art of George STUBBS

Venetia Morrison

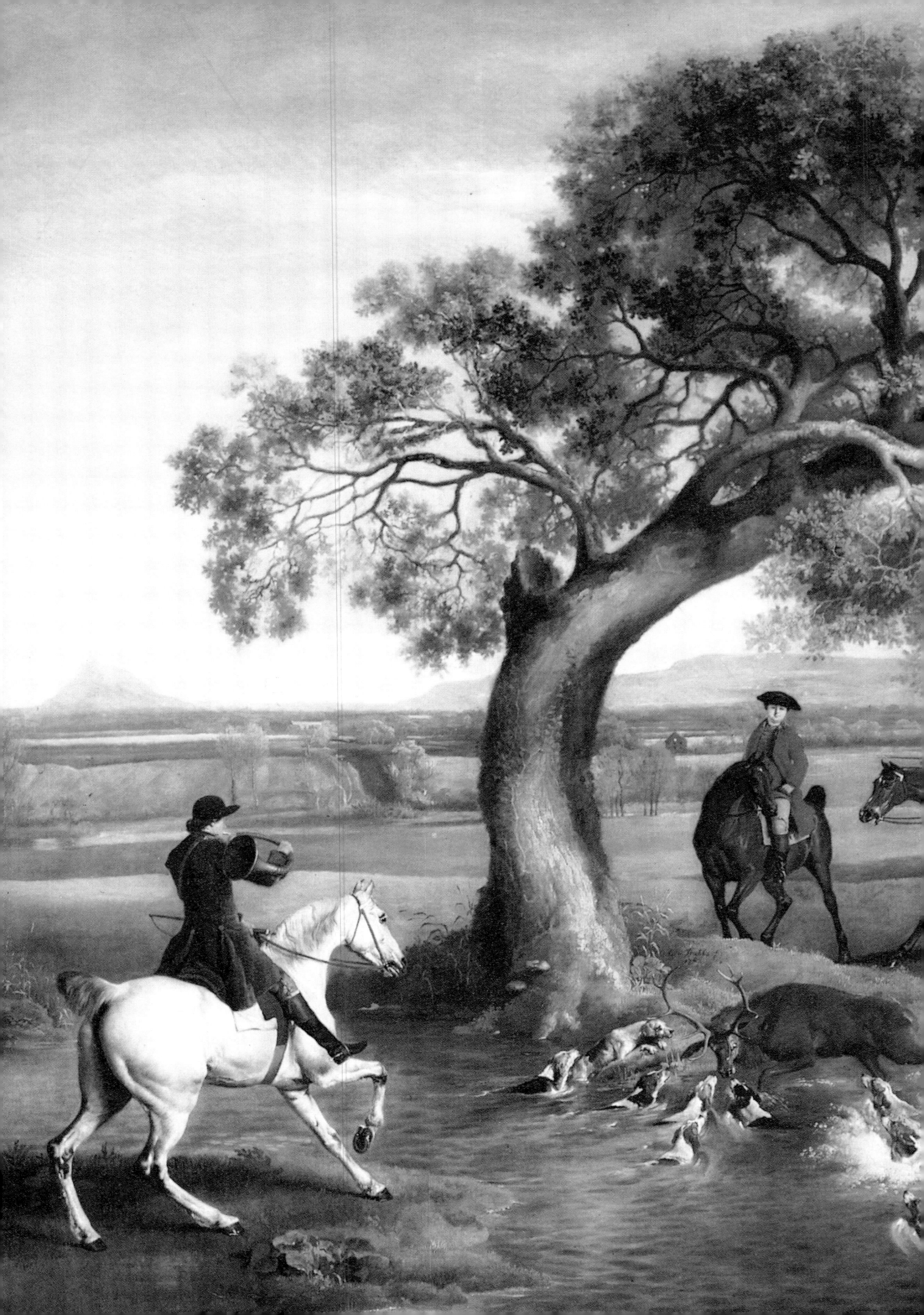

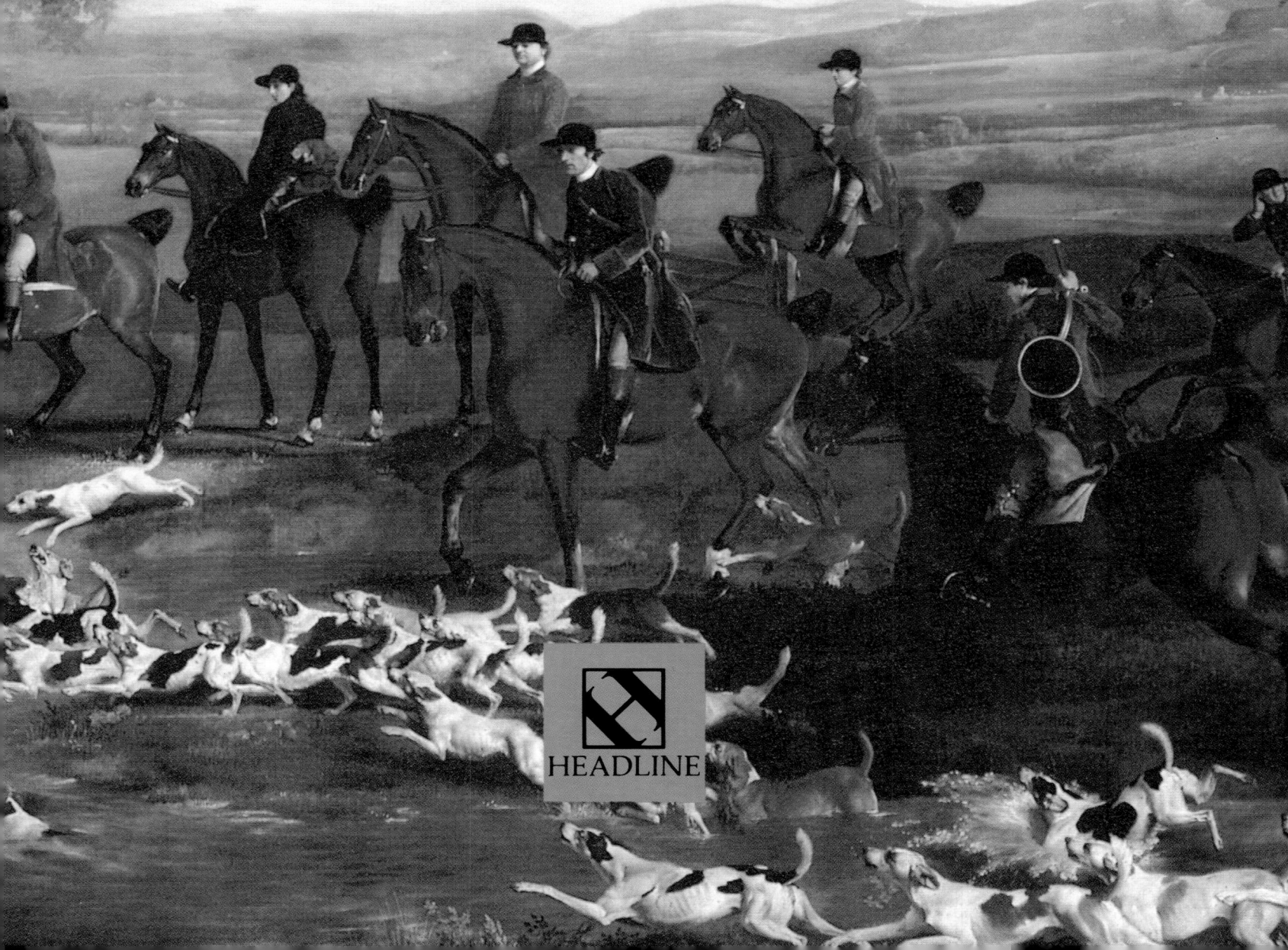

The Art of_
George_
STUBBS

Venetia Morrison

HEADLINE

A QUARTO BOOK

Copyright © 1989 by Quarto Publishing plc

First published in Great Britain in 1989 by
HEADLINE BOOK PUBLISHING PLC

HEADLINE BOOK PUBLISHING PLC
79 Great Titchfield Street,
London W1P 7PN

British Library Cataloguing in Publication Data
Morrison, Venetia
The Art of George Stubbs.
1. English painting. Stubbs, George, 1724-1806
I. Title
759.2

ISBN 0 7472 0161 7

This book was designed and produced by
Quarto Publishing plc
The Old Brewery, 6 Blundell Street
London N7 9BH

Creative Director: Peter Bridgewater
Art Director: Ian Hunt
Editorial Director: Jeremy Harwood
Senior Editor: Sally MacEachern
Editor: Clare Pumfrey
Artwork: Danny McBride
Picture Manager: Joanna Wiese
Picture Researcher: Sophie Charlton

Typeset by
Central Southern Typesetters, Eastbourne
Manufactured in Hong Kong by
Regent Publishing Services Ltd
Printed in Hong Kong by South Sea Int'l Press Ltd

CONTENTS

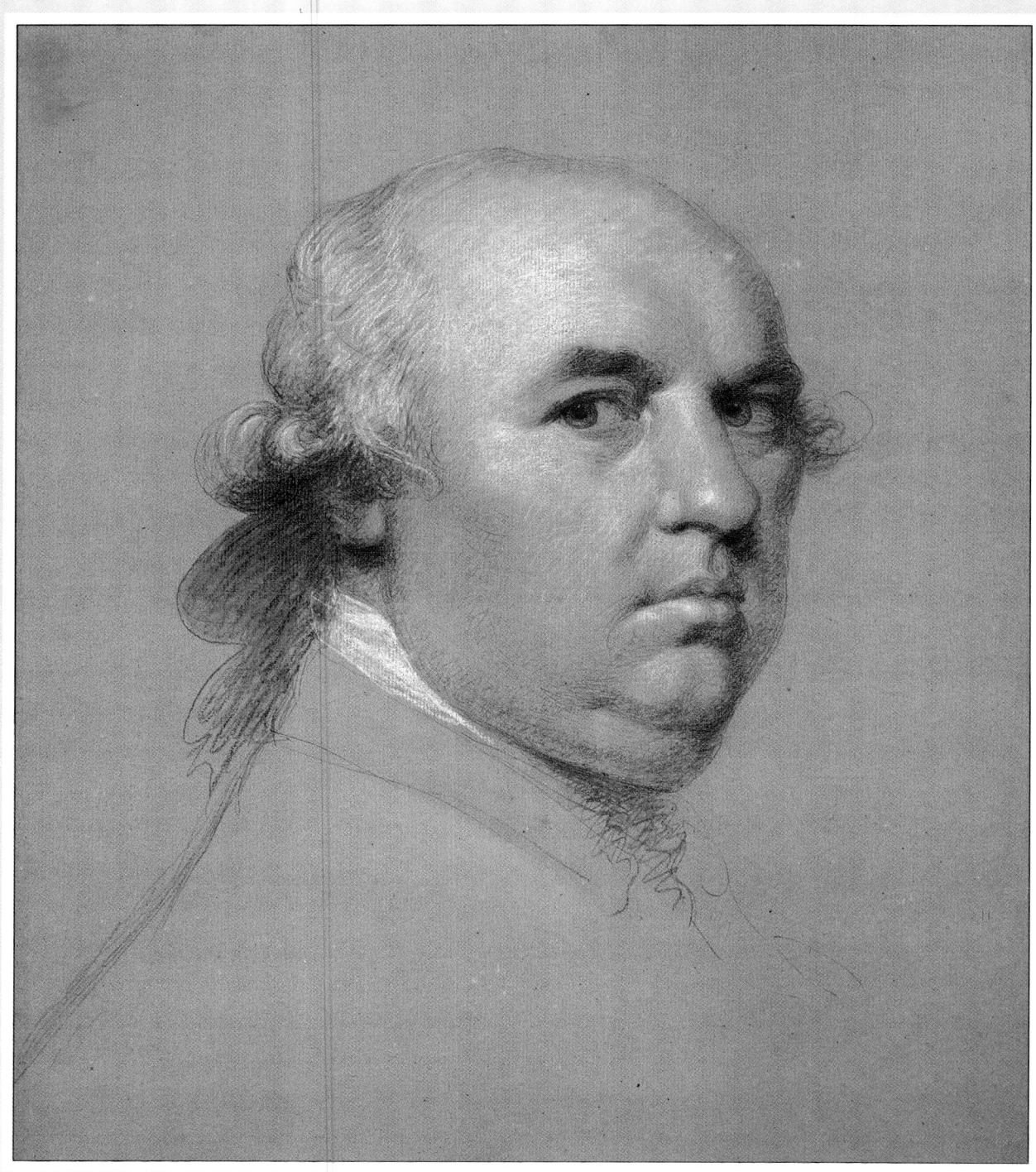

PORTRAIT STUDY OF GEORGE STUBBS
*by Ozias Humphry, 1777. This study in black and
white chalk depicts Stubbs at the age of 53. Evidently a
preparatory drawing for the portrait on p120, it
describes Stubbs' strong personality and independent
outlook.*

A Painter who
Painted Horses

'George Stubbs was a great artist.' 'George Stubbs painted horses.' During Stubbs' lifetime, these two statements were seen as contradictory; indeed, it is only relatively recently that critics have looked beyond his subject-matter and attempted a true assessment of the quality of his work.

Stubbs was known in his own time as 'Mr Stubbs the Horse Painter', a title that has clung to him ever since. It was one that Stubbs himself fought to overcome, for it was not a term of respect. In the 18th century, a strict hierarchy of subject-matter was widely accepted by the artistic establishment. According to this convention, the painting of animals came a very poor last after the painting of historical subjects, portraits, genre scenes and landscapes. An artist who confined himself to the painting of horses was considered to possess only slightly greater status than a craftsman. This prejudice against the various forms of animal painting continued throughout the 19th century, but, during the last 50 years the art world has come to see the real merit of George Stubbs the artist.

─────── RE-EVALUATING STUBBS ───────
The dawning of the re-evaluation of Stubbs' work came in the late 1930s. Geoffrey Grigson's celebrated essay, which first appeared in *Signature* in 1938 (later republished in *The Harp of Aeolus* in 1947), was the first step along the road towards a full appreciation of the artist. Grigson pointed out that Stubbs 'was a painter who painted horses', which was not at all the same thing as a horse-painter. Two exhibitions in the 1950s established Stubbs' right to be in the running for consideration as a British artist of quality. The first was held at the Walker Art Gallery in Liverpool, Stubbs' birthplace, in 1951. A total of 68 paintings together with a number of prints and drawings, were displayed. Six years later the Whitechapel Art Gallery put on an exhibition of similar scale, the first major exhibition of Stubbs' work in London since 1885, when Vokins of Great Portland Street had shown some of his paintings.

The Whitechapel display was organized by Basil Taylor, the art historian who did most towards promoting the revival of interest in Stubbs. The 1984 exhibition of his work at the Tate Gallery compiled by Judy Egerton was a further turning point, marking the end of the argument as to whether Stubbs was an artist of merit or not. The majority of the critics who reviewed it were generous in their praise, though one found the horses very difficult to admire and suggested various 'anti-horse' approaches to the paintings.

─── THE UNANSWERABLE QUESTIONS ───
On his death in 1806 Stubbs' reputation was already in decline. His career had reached the height of its success in the 1760s and 40 years later he was neither in vogue as a horse-painter nor highly regarded as an artist. The horses who had made his reputation were to become the millstone of his later years. Isolated and out of the main stream of the art world, he died with artistic ambitions unfulfilled. Yet he died not altogether embittered, since throughout his life he had always combined his artistic career with other interests of a more or less scientific nature and these occupied much of his energy and enthusiasm in his last years.

Indeed, Stubbs' artistic career had been a varied one, for he did not start out as an animal-painter. For the first decade of his working life he is said to have painted portraits and built up a modestly successful practice. So what made him alter course in his mid-30s from painting people to painting horses? Answers to this question and many others concerning Stubbs cannot be given verifiable answers. Conclusions have to be drawn from the very small amount of written evidence available and from whatever information can be gleaned from the artist's work. Why did he go to Rome? Why did he turn to horses? Why did he embark on the arduous Anatomy project? Why was the lion and horse series planned and executed? Why embark on the adventure with Wedgwood and the ceramic experiments? What led him to his superb print-

making technique? Such intriguing questions cannot be answered with hard facts, but it is interesting to raise them in an attempt to find out more about the artist.

DISCOVERING THE MAN
BEHIND THE ARTIST

Any attempt at a study of the life of George Stubbs presents almost as many problems as it does solutions. The main obstacle is the shortage of source material, the manuscript *Memoir* by the artist Ozias Humphry being the primary document. This short account is detailed in some areas but generally vague about chronology, and tells little about Stubbs' character. Humphry must have known him well – he painted Stubbs' portrait in 1777 and again in 1794; the *Memoir* itself is the result of their conversations in about 1795. Humphry's portrait study in black and white chalk is helpful because it reveals character; the questioning eyes and stubborn, down-turned mouth suggest an independent and determined personality. The tone of the *Memoir* is somewhat earnest, emphasizing how hard Stubbs worked and how frugal he was in his habits. Could John Wesley's Methodism lie behind these rather puritanical undertones? During Stubbs' youth, Wesley was touring the countryside preaching abstinence, hard work and concentration as the road to salvation. Stubbs' application to every aspect of his career was remarkable, particularly in the case of his anatomical studies, and may indicate that he was influenced, if only indirectly, by Wesley's teachings. However, it is difficult to tell whether the tone of voice in the *Memoir* is that of Stubbs or of Humphry.

Most of the information we have about Stubbs' character comes from sources close to him and they do not give a very balanced picture. For example, Mary Spencer, his 'female friend', and probably his niece, tells us in her notes which were added to the Humphry manuscript that he was 'in his private life exemplary for honour, honesty, integrity and temperance (his general beverage water, and his food simple), possessed of a firm and manly spirit yet with a heart over-flowing with the milk of human kindness, beloved by his friends, feared by his enemies and esteemed by all who knew him'. It is likely that Mary was his common-law wife in today's terminology and was not, therefore, in a position to be objective; however, the few contemporary references which do exist do not add much more to the picture.

[1]The basic biographical facts about Stubbs outlined below are given more fully in Constance-Anne Parker's *Mr Stubbs the Horse Painter*. Quotations are taken from Ozias Humphry's *Memoir* and later additions.

THE EVOLVING ARTIST

George Stubbs was born in 1724 in Liverpool where his father John Stubbs was 'a considerable Currier and Leather dresser in that Town'.[1] His memories of his childhood as told to Ozias Humphry reflect a happy family background. But John Stubbs intended his son to follow him into the family business and strongly advised against his choice of painting as a profession with the usual parental worries about the lack of security and prospects. He felt that his son was throwing away the benefit of the good start in life that his father had been able to provide for him, 'having, as he conceived, provided for his Son a good home, with a certain and a considerable income, he thought his Son's wishes rather denoted wantoness and caprice than any prudential scheme for a creditable settlement in the world'.

The younger Stubbs did work for the family business but not for very long as by the time he was about 15 years old he had left. Eventually his father relented, 'finding as his end approached that young George's passion for painting rather increased than abated, in his last illness, he called his son to him and told him that finding nothing was so likely to make him happy as the pursuit of painting, he recommended him to enquire for some eminent Character in the Arts to instruct him, being willing to allow him any expense that it was in his power to afford, as he had always been of opinion that to excel in the profession was difficult and required every aid'. There are no details with regard to the younger Stubbs' general education, but no doubt this kind and conscientious parent would have given his son a good start. Stubbs' anatomy studies are the product of a trained and disciplined mind, and on his death he left a considerable library, both of which point to a sound basic grounding.

Soon after his father's death Stubbs followed his advice and found 'some eminent Character in the Arts' with whom to study painting. He arranged to be taught by Hamlet Winstanley, an artist then practising in Liverpool who, having seen an example of Stubbs' work, agreed to take him on, presumably as a sort of pupil/assistant. Their exact relationship does not appear to have been established at the outset and, very quickly, it broke down.

Before 1729, Winstanley had been commissioned to copy many of the paintings in the collection of Lord Derby at Knowsley Hall just outside Liverpool. These were used to form a book of engravings which were published in that year. Stubbs thought that he had been taken on to copy all the pictures in this collection, which seems strange as Winstanley had already done so many, and the younger artist was very put out when he was not

allowed to paint the first one that he chose. Since, for his initial effort, he elected to copy Van Dyck and Snyders' *Amor Scientarium,* he should not have been too surprised when his teacher refused permission as it was hardly a beginner's piece. It was an allegorical painting which showed Cupid among the symbols of war, music, painting, architecture and sculpture. No doubt the difficulty of the work, and especially the twisted pose of Cupid, attracted Stubbs. However, according to the *Memoir,* Winstanley objected to this choice on the grounds that he wished to study it himself and did not want Stubbs to duplicate his work. His reasoning seems odd in view of the fact that he had already copied the painting. Stubbs was clearly put out by this development, whatever the reason behind it. When his request to copy Giovanni Panini's *Ruins of Rome* was also turned down he completely lost his temper, telling Winstanley that he could 'copy *all* if he would, for as he found he could not depend upon his word, or his Engagement he would have nothing further to do with him'.

The next part of this passage in the *Memoir* gives evidence of an early manifestation of Stubbs' independent approach to his study and practice of painting. He 'would for the future look into Nature for himself and consult and study her only: and to this determination he steadily adhered during the course of his long life, for he never copied one picture whatever for his improvement – either in Italy or elsewhere'. It appears that a remark made in the heat of the row with Winstanley developed into the creed of his artistic career; though, of course, Stubbs' memories of his youth may have been influenced by the course of his subsequent development. He may have argued a case with the benefit of hindsight to give an appearance of logic to his headstrong decision to teach himself and to rely on the study of nature. But if the *Memoir* is taken literally it presents the fledgling artist (he was only 17 years old) as a bold and courageous youth who knew his own mind and was not afraid of striking out on his own. The word 'nature' can be given many different meanings, but it would seem that Stubbs used it to signify that which he was able to observe and experience at first hand.

Stubbs proved himself able to cope with the discipline of teaching himself, and the parting with Winstanley was, in the long run, fortunate as the association did not last long enough for the young artist to be influenced by the style of the older man. It seems certain that from this point Stubbs was entirely self-taught. 'From this period without seeking assistance from anyone, he proceeded alone to make all his studies after nature, intending by everything he did, to qualify himself for painting rural, pastoral and familiar subjects in History as well as Portraits.' He was able to concentrate on his studies without earning his living owing to the financial assistance of his mother (his father had died in 1741). She supported him until he was nearly 20 years old. In 1744 he travelled to Wigan, though it is not clear whether this was to study or to work, and from there he went to Leeds to paint some portraits. From Leeds he went to York to carry out some commissions, which suggests that, in his early 20s, he had already established a reputation, however modest, as a portrait painter in Yorkshire.

———— EARLY YEARS IN YORK ————

It was during his stay in York that Stubbs' childhood preoccupation with anatomy developed into a major interest. A neighbour in Liverpool, Dr Holt, had provided the child with dissected subjects to study, and as the son of a tanner he would have had every opportunity to examine animal remains. Humphry noted, without giving any clue as to date, that 'at Liverpool he dissected horses and some dogs'. It seems likely that this would have been before his visit to York, since it was there that he was given his first opportunity to dissect a human subject by a surgeon called Charles Atkinson. This would suggest that he already had some dissecting experience.

Of course the study of human anatomy was still considered a very suspect occupation. Corpses were very difficult to obtain, since anatomists were supposed to work only on the bodies of criminals who had been hanged. Stubbs must have considered himself fortunate in having this chance provided by Atkinson, especially as he was not a medical student. That he impressed the physicians of York is evident from the fact that 'He was now prevailed upon to give anatomical lectures privately to the pupils of the hospital, having been constantly engaged upon these studies with credit and general approbation'.

Interwoven with the account of what would then have been considered a dark and sinister subject are passing references to more gentle matters. Having mentioned Stubbs' first human dissection, Humphry writes, 'Here also he had the rencontre with Mr Wynne the Dancing Master'. This conjures up a splendid, if unlikely, image of Stubbs taking dancing lessons. However, it is difficult to believe that he was ever interested in acquiring particular social graces. It seems more probable that 'rencontre' refers to a confrontation, since Humphry uses the word 'the' as though it were a well-known episode. After this passage, the writer returns to the subject of anatomy studies, and then breaks off to mention that 'In York he

began to study French & Fencing', once again suggesting that Stubbs was making efforts to polish his manners. The study of French was probably prompted more by a need to read anatomical and veterinary publications than as a social requirement. And fencing? Given all his other occupations, why and how did he find time for fencing lessons?

Stubbs stayed in York from 1745–52/3 and, by this time, he was able to earn a living from painting portraits. His first known painting, the double portrait of Sir Henry and Lady Nelthorpe, dates from this period, probably painted before 1746. The Nelthorpe's lived near Barton-on-Humber, not far from York, and the family became loyal patrons of Stubbs. Painted when he was in his early twenties it is an accomplished portrait executed with remarkable assurance, given the artist's youth and lack of formal training. The two known portraits of the mid 1750s appear rather less successful than this, his earliest surviving work. The stay in York was a productive time because Stubbs became involved in print-making. However, it was not a venture of his own choosing, but rather it was forced upon him when he was asked to illustrate a book on the recent improvements in midwifery methods. 'At York, Doctor Burton, Physician & Man Midwife, applied to him to make designs for his book of Midwifery – Foetus's wombs, infant Children &c &c &c. When these designs were finished, the Doctor applied to our Artist to engrave them himself, which he wished to decline, urging his total ignorance of engraving in every respect. The Doctor, however, would not listen to these excuses, but pressed upon him the undertaking, to execute them himself insisting upon it, from what he had seen, that he could not fail in whatever he undertook'.

Stubbs had never even seen anyone make prints but he went to see a house painter in Leeds who had done a bit of etching but he was no expert, and was little help as 'he had no other instruction to give than to cover a half-penny with an etching varnish and smoked it, and then with a common sewing needle stuck in a Skewer he showed him how etching was to be done but when he began his etching he found the varnish so hard, that when he had the lines to cross, the wax flew off – so finding this experiment to fail, he cover'd the plate with Wax after having warm'd it, holding it by a little hand rest to the fire till the plate was warm enough to melt the wax, wch he kept holding to the fire till the Wax run off & left

upon the plate a smooth surface, wch he smoked by a candle and then proceeded to etch his figures on it – under such disadvantages, it is not surprizing that the execution of the prints fail'd in some degree; especially as some of them were too small to be finish'd without an engraver which was all new to him. – These Gravers he borrowed of a Clock-maker and with the Needles of the Graver under such disadvantages, he executed the plates. – The prints were certainly very imperfect and therefore our artist wish'd not to set his name to them, but with all their Imperfections Doctor Burton was satisfied as they were exact and illustrative', and the book, *An Essay Towards a Complete New System of Midwifery*, was published in 1751.

The illustrations are indeed crudely executed but some have a compelling quality that is difficult to explain. Stubbs had been given access to the body of a woman who had died in childbirth, 'a female subject who had died in childbed was found singularly favorable for the purpose of these studies and brought to York by Stubbs' pupils, where it was concealed in a Garrett, and all the necessary dissections made', so he had firsthand knowledge of his subject. To this, he added a creative element, for the prints depict living unborn babies who inhabit small self-sufficient worlds.

Some of the prints are more successful than others in achieving this quality of vitality; the more sculptural, three-dimensional images are the most convincing. The facial expressions of the babies in some of the illustrations also help to raise them above the level of clinical studies. For example, the twins of Table 16 are grimacing with the discomfort of their tightly-packed world; the expressive quality of the concept of the drawing overcomes the shortcomings of Stubbs' early printmaking efforts. That he was an unwilling student of printing techniques is evident from his attempt to find a commercial engraver for his illustrations to the *Anatomy of the Horse,* but again he was forced to do the work himself, this time with more satisfactory results.

The *Memoir* becomes rather vague about Stubbs' movements following the completion of Dr Burton's illustrations but he probably stayed on in York for a year or two and then moved on to Hull 'always practising portrait painting and dissection'. From here he returned to Liverpool and soon embarked for Italy, in 1754, at the age of 30.

SIR HENRY AND LADY NELTHORPE; BEFORE 1746.
*This is the earliest known painting by Stubbs. It has
never been exhibited as it is enclosed within the
panelling of the Nelthorpe's house in Lincolnshire
(previous page).*

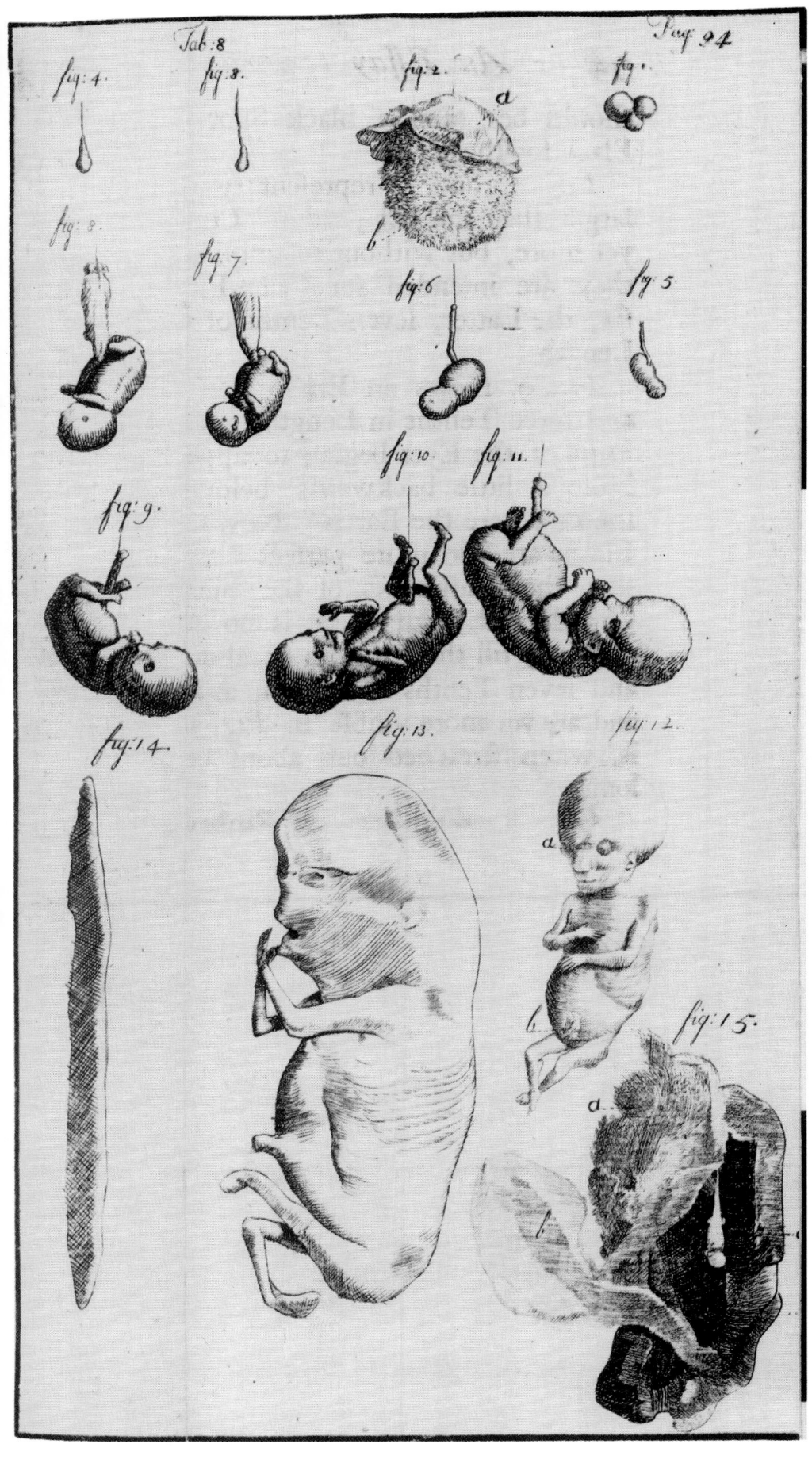

AN ESSAY TOWARDS A
COMPLETE NEW SYSTEM
OF MIDWIFERY, BY DR
JOHN BURTON, TABLE 8.
*Spermatozoa, ova, and
a group of embryos in
different stages of
development.*

AN ESSAY TOWARDS A
COMPLETE NEW SYSTEM
OF MIDWIFERY TABLE 10
*Fig. 1. A cephalic
presentation. Fig. 2. A
breech presentation.*

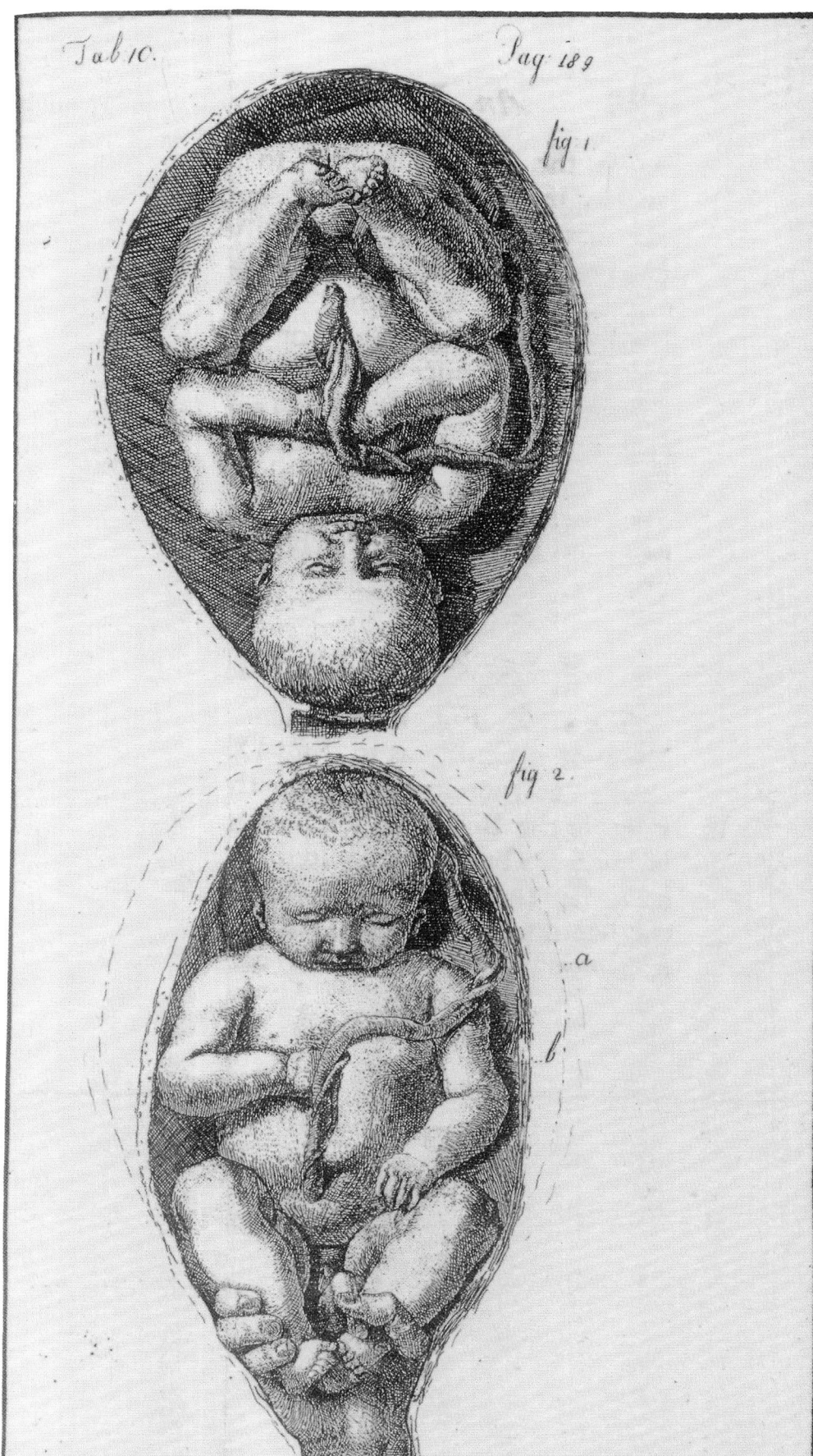

────────── THE VISIT TO ROME ──────────

Why did he go to Rome? Travel was an expensive, arduous and frequently hazardous occupation; in addition, he would have had to neglect his portrait practice for some months. His real reasons must have been more positive than those given in the *Memoir* – his 'motive for going thither was to convince himself that nature was and is always superior to art'. Would Stubbs, who had such an enquiring spirit, have closed his mind to all that he was going to see before he had even left home? It seems out of character. If we consider his position in his 30th year, it would seem possible that he needed a new impetus in his career, something that would lead him out of familiar territory and on towards a new challenge. It appears that he had established a provincial portrait painting practice in the north of England which had supported him for some years, but on entering his third decade he may have found that he was treading water. A visit to Rome was a well-established method of improving artistic status in the 18th century; Joshua Reynolds had recently returned, Robert Adam went in 1754, William Chambers and Richard Wilson were there at the same time as Stubbs. Thomas Jenkins, Matthew Brettingham and Gavin Hamilton acting as dealers in the supply of Roman sculpture to wealthy English patrons for their newly built sculpture galleries, were also in Rome with Stubbs.

It was not essential for English artists to have firsthand experience of the art of Italy, after all, Thomas Gainsborough rose to the top of the profession without ever leaving the country. Nevertheless, it was a useful stepping stone and ensured contact with other artists and new patrons, both important considerations for an artist as yet not in touch with the artistic circles of London. Rome was the focal point of the Grand Tour, that essential final phase of the young grandee's education. As a result, there was a constant supply of enthusiastic young patrons passing through the city with plenty of money to spend.

Along with the prospects of increased status and patronage, one might tentatively add Stubbs' curiosity with regard to Rome's heritage. As recorded in the *Memoir*, Stubbs had a perverse pride in how little he learned from his visit and how he disagreed with everyone else about everything they saw. 'It does not appear that whilst he resided in Rome he ever copied one picture or even designed one subject for an historical composition; nor did he make one drawing or model from the Antique either in Bas-relief or single figure: and so much had he devoted himself to observe and to imitate particular objects in Nature, that whenever he accompanied the students in Rome to view the palaces of the Vatican,

Borghese, Colonna, etc. and to consider the pictures, he differed always in opinion from his companions; and if it was ever put to the vote found himself alone on one side, and all his friendly associates on the other'. But this passage, like some others in the *Memoir*, seems to emphasize Stubbs' early independent stance with the benefit of hindsight; it is hard to believe that he went to Rome with the declared intention of learning nothing. Perhaps it made his lonely position in later life easier if he could feel that at least he had always been true to his principles, true to nature.

Though he may not have made copies, he certainly saw and discussed many examples of classical art, however unwillingly, and this experience was to affect his own work whether consciously or not. The catalogue of the sale of the contents of his studio following his death lists three landscapes and *Portraits of two Mendicants* as having been painted in Italy, bearing out the *Memoir's* claims. However, a number of the entries in this catalogue refer to subjects not usually associated with Stubbs; religious or historical themes such as *A Magdalen, An Infant Saviour treading on a Serpent* and *Hercules' Choice*. The presence of these titles, together with the fact that the same catalogue records a number of works by Italian masters as being in Stubbs' possession on his death (including Giorgione, Titian and Tintoretto), suggests that Stubbs was rather more open to and appreciative of 'Art' than he sometimes claimed to be.

The Rome visit probably lasted about three months and, according to the Humphry *Memoir,* the artist then returned to England. He spent a week or so in London and then he moved on to Liverpool. However, the *Sporting Magazine* of May 1808 gives a much more exciting account of his journey home from Rome, including a visit to the home of an English-speaking African he had met in Rome during which the artist was supposed to have witnessed the following scene. 'The town where his friend resided was surrounded by a lofty wall and a moat. Nearly level with the wall a capacious platform extended, on which the inhabitants occasionally refreshed themselves with the breeze after sunset. One evening, while Stubbs and his friend were viewing the delightful scenery and a thousand beautiful objects from this elevation, which the brilliancy of the moon rendered more interesting, a lion was observed at some distance, directing his way, with a slow pace, towards a white Barbary horse which appeared grazing not more than 200 yards distant from the moat. The orb of the night was perfectly clear, and the horizon serene. The lion did not make towards the horse by a regular approach, but performed many curvatures, still

AN ESSAY TOWARDS A
COMPLETE NEW SYSTEM
OF MIDWIFERY TABLE 12.
Two different views of the
foetus in the womb.

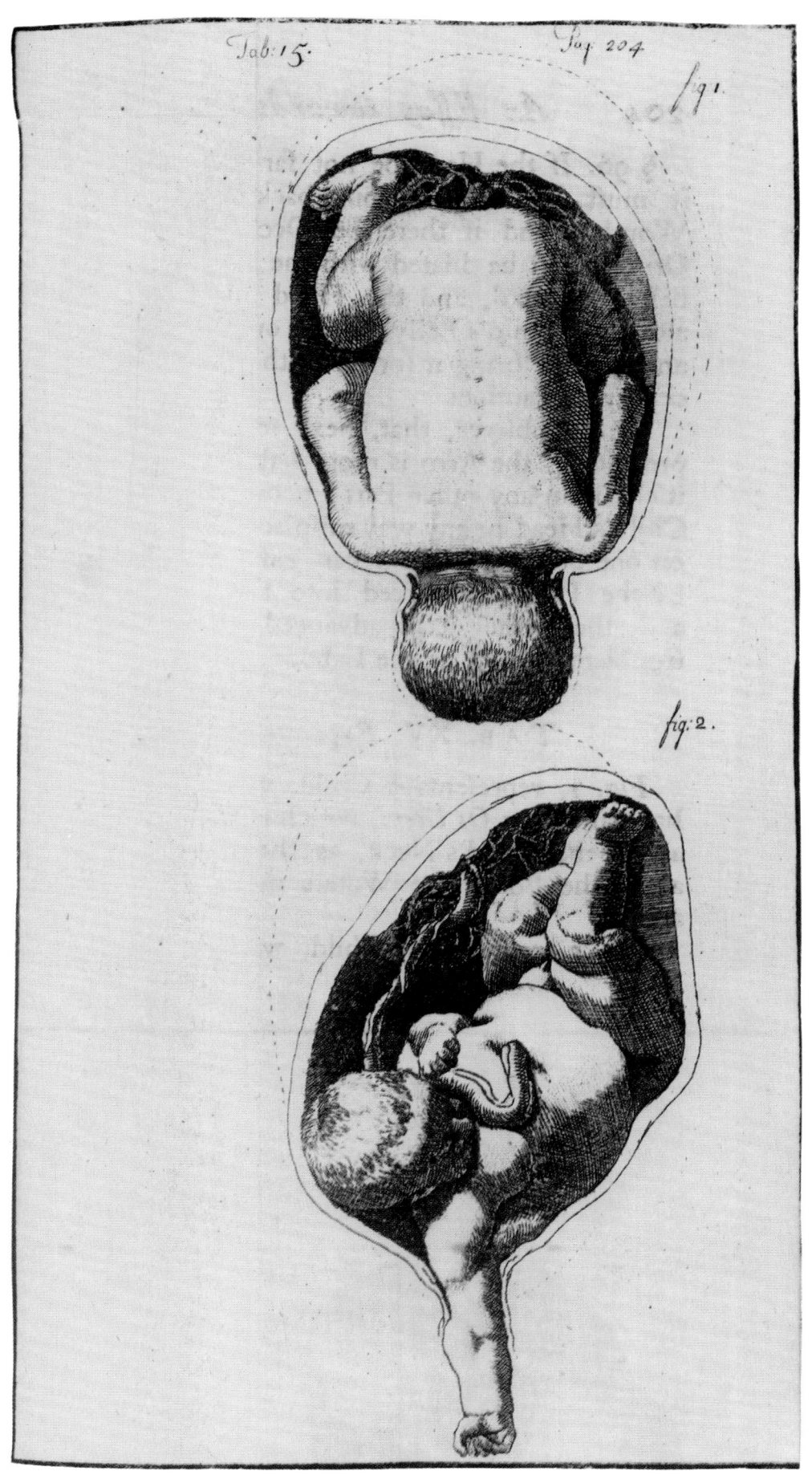

AN ESSAY TOWARDS A COMPLETE NEW SYSTEM OF MIDWIFERY TABLE 15. *Fig. 1. A normal delivery. Fig. 2. An abnormal delivery.*

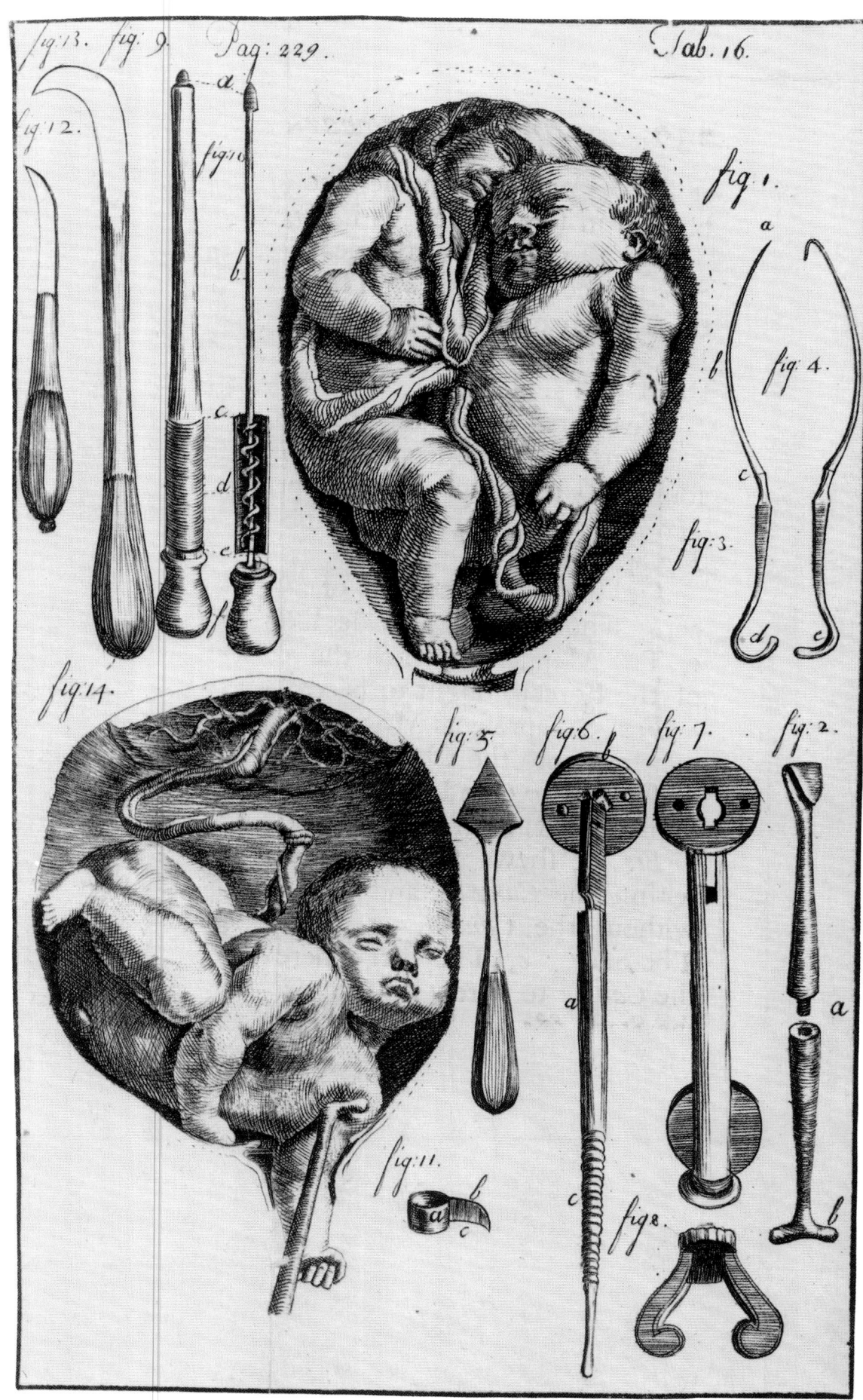

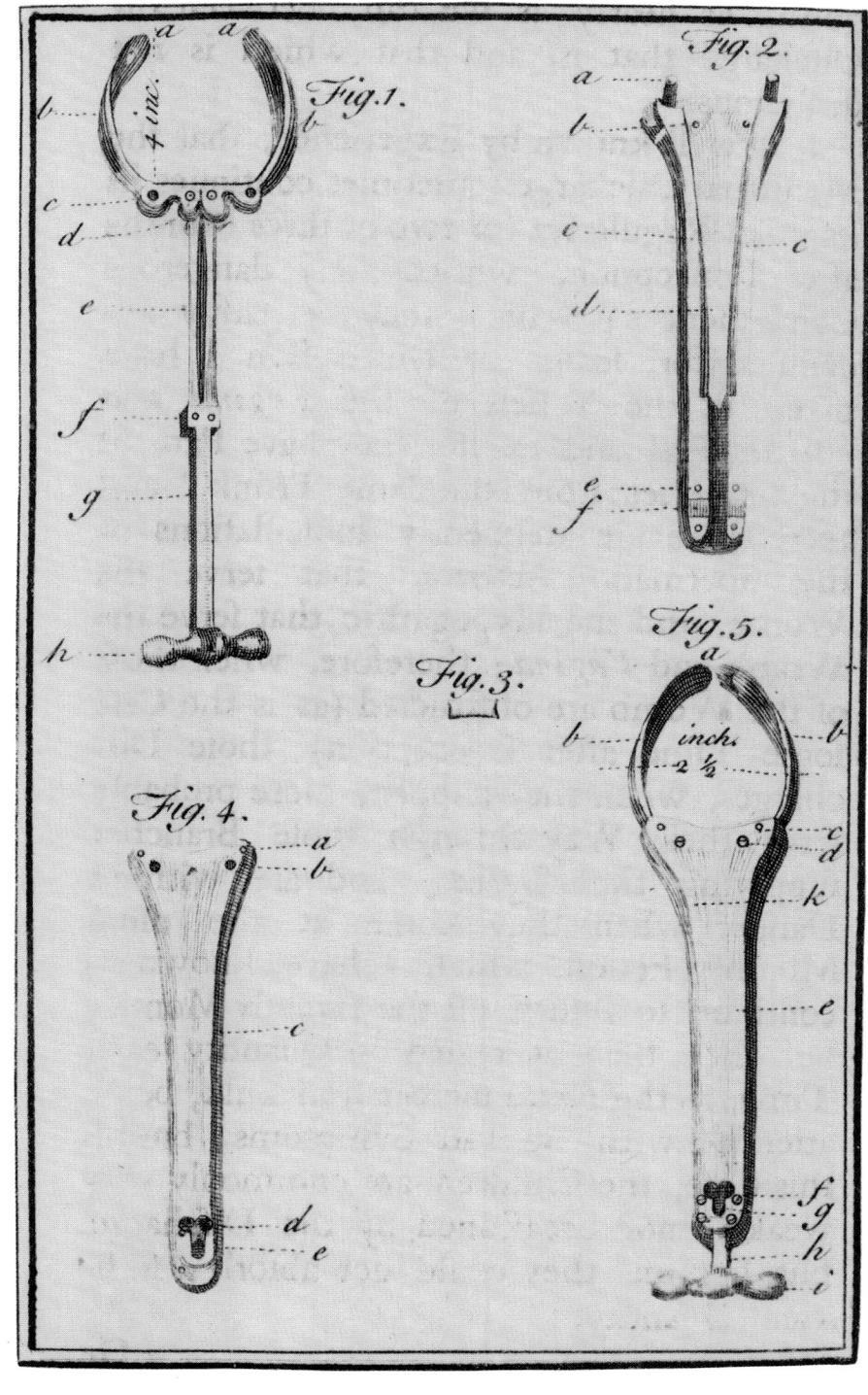

AN ESSAY TOWARDS A
COMPLETE NEW SYSTEM
OF MIDWIFERY TABLE 16.
*An overcrowded
illustration showing
twins, the correction of
an abnormal delivery
position and a number
of obstetric instruments.*

AN ESSAY TOWARDS A
COMPLETE NEW SYSTEM
OF MIDWIFERY TABLE 18.
*A group of delivery
forceps. One of Dr
Burton's most
important contributions
to the science of
obstetrics was his
improvement of these
instruments.*

drawing nearer towards the devoted animal, till the lion, by the shelter of a rocky situation, came suddenly upon his prey. The affrighted barb beheld his enemy, and, as if conscious of his fate, threw himself into an attitude highly interesting to the painter. The noble creature then appeared fascinated, and the lion finding him within his power, sprang in a moment, like a cat, on the back of the defenceless horse, threw him down and instantly tore out his bowels'. The story sounds too good to be true, but why should anyone take the trouble to invent it?

Whichever account is correct, Stubbs returned to Liverpool and remained there for the next two years painting portraits. His mother died about 10 months after his return, and it is possible that he came into some money at this point. A small inheritance together with the income from his portraits may have provided sufficient funds to allow him to proceed with his preparations for his great work, *The Anatomy of the Horse.*

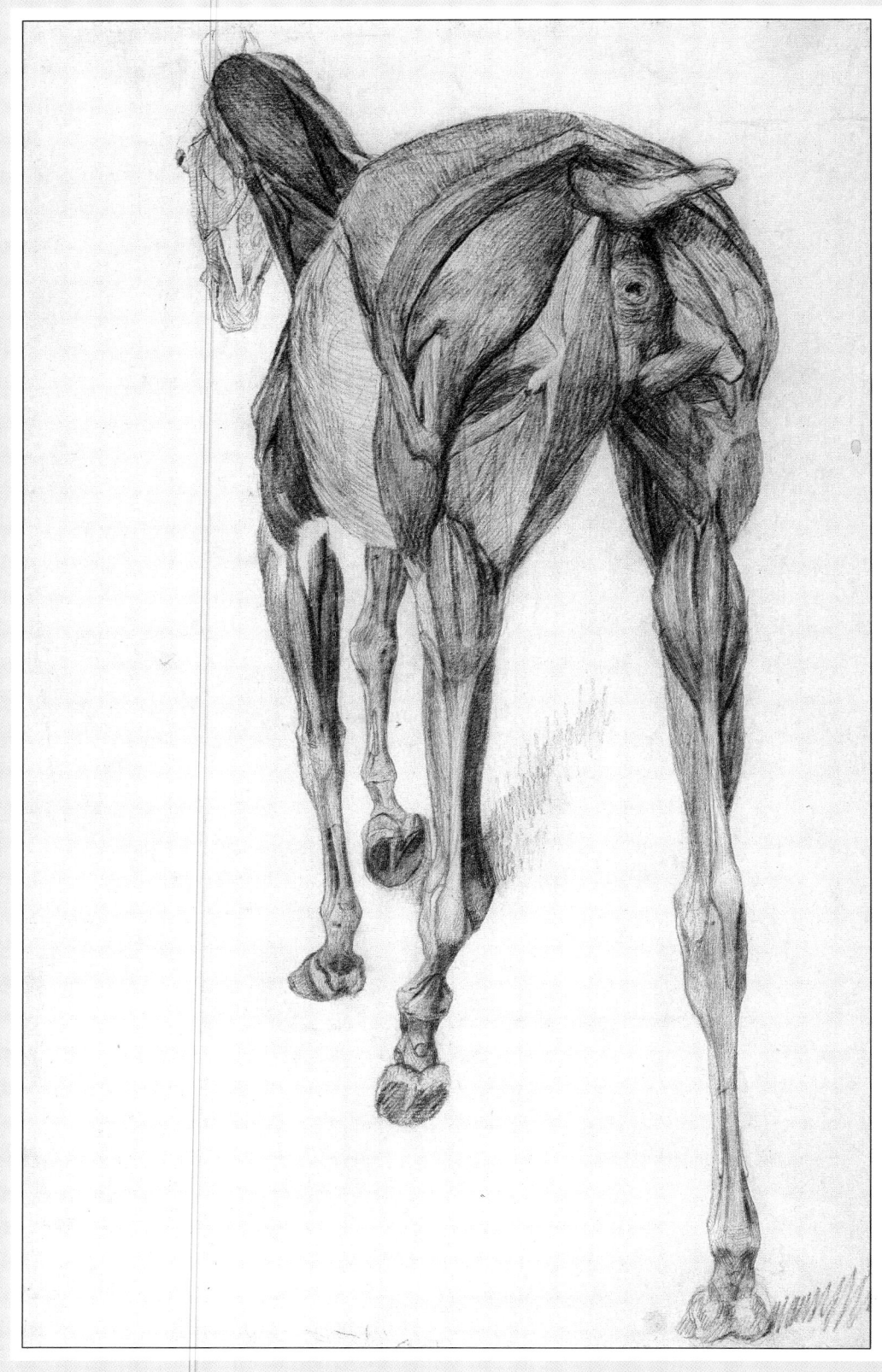

ANATOMY OF THE HORSE:
*working drawing of muscles for the Thirteenth
Anatomical Table.*

THE ANATOMY OF THE HORSE

Stubbs' idea for a full study of the structure of the horse developed during his stay in York. His young medical friends encouraged him to go ahead, promising help, both practical and financial. The surgeon Charles Atkinson may have been important in the early stages of the project, for a reference exists which states that he taught Stubbs the anatomy of the horse. Dr Burton was the owner of a famous library and may have given Stubbs access to all the latest anatomical publications – in the introduction to *The Anatomy of the Horse* there is a reference to the artist having 'consulted most of the treatises of reputation on the general subject of anatomy'. This encouraging environment fed his early interest, providing the impetus for Stubbs to carry out the toughest of all the tasks that he set himself.

The scale of the undertaking would have daunted most men; it demanded 16 months of hard work, much of the time spent at very close quarters to carcasses in a more or less putrified state, with no guarantee of success – financial or otherwise – at the end of it. Stubbs had to find a place in which to study in isolation, partly because the dissection of animals was considered almost as disreputable as that of humans and partly because the smell of the rotting horses would have been formidable. It was probably for these reasons that Stubbs took a farmhouse at Horkstow in Lincolnshire, a few miles from the home of one of his early patrons, Lady Nelthorpe. It was not the ideal place for his purposes, since the room where he made his dissections and studies was not really big enough. As a result, some of the drawings were made at a steep angle.

The room was not on the ground floor either – one account even refers to him working in an attic.

Not surprisingly, Stubbs was renowned for his physical strength, since moving horse carcasses singlehanded is not light work. Owing to his upbringing as a tanner's son he was probably almost immune to the stench that must have surrounded him for the best part of every working day. It would also have instilled in him the need for caution when handling dead animals in order to prevent the spread of infection. Anatomists were always vulnerable to the risk of blood poisoning, and recovery was not guaranteed in the days before the discovery of penicillin.

The help offered by his friends from York was not forthcoming, so his only assistant was Mary Spencer who fortunately shared his interest in anatomical experiments. Humphry gives a full account of the methods Stubbs employed when dissecting a horse. 'The first subject wch was procured was a horse wch was bled to death by the jugular vein – after wch the Arteries and veins were injected [probably with warm wax to preserve their shape]. Then a bar of iron was suspended from the ceiling of the room, by a teagle [tackle or hoist] of Iron to wch Iron Hooks were fix'd – Under this Bar a plank was swung abt 18 Inches wide for the Horses feet to rest upon – & the Horse was suspended to the Bar of Iron by the Hooks above mentioned which were fasten'd into the opposite side of the Horse to that intended to be design'd, by passing the Hooks through the ribs & fastening them under the Back Bone – and by these means the Horse was fix'd in the attitude wch these prints represent and continued hanging in the posture Six or Seven weeks, or as long as they were fit for use – His drawings of a skeleton were previously made – and then the operations upon *this fix'd* subject were thus begun. He first began by dissecting & designing the muscles of the Abdomen – proceeding through five different lays of muscles until he came to the peritoneum and the plura through wch appear'd the lungs & the intestines – after wch the Bowels were taken out & Cast away. – Then he proceeded to dissect the Head, by first Stripping off the skin and after having clear'd and prepared the muscles for the drawing, he made careful designs of them and wrote the explanation wch usually employed him a whole day, then he took off another layer of Muscles wch he prepared, design'd, and described in the same manner as is represented in the Book – and so he proceeded till he came to the Skeleton – It must be noted that by means of the Injection

the Muscles, the Blood vessels, and the Nerves, retain'd their form to the last without undergoing any Change of position. – In this manner he advanced his Work by stripping off Skin and clearing and preparing as much of the subject as he concluded wou'd employ a whole day to prepare, design and describe, as above related till the whole subject was completed.'

——— THE ANATOMIST ALBINUS ———

Stubbs' methods owed much to an earlier text by the greatest human anatomist of the age, Albinus, who was Professor of Anatomy and Surgery at Leyden from 1721–70. His *Tabulae Sceleti et Musculorum Corporis Humani* was published in 1747, and the English edition appeared two years later. The study of anatomy had been revived during the Rennaissance period (it had been practised by both the Greeks and the Romans) with Versalius' *De Humani Corporis Fabrica* of 1543 being the most famous of a number of works on the subject. Albinus' publication marked a new high point in the science 200 years later. However, to 20th-century eyes, it has dated much more than Stubbs' *Anatomy*. The illustrations are beautiful but **more** than a little surreal, with skeletons making grand **dramatic** gestures, as if to show off the latest fashions **against** elaborate backgrounds, two of which include a rhinoceros. In spite of Albinus' extremely scholarly approach, the results look more like satirical cartoons than anatomical illustrations.

The Preface to Albinus' great work explains his methods in some detail, and Stubbs must have found it extremely useful when setting about his own studies. Albinus' account points out the pitfalls which the anatomist is most likely to encounter and gives a clear warning of the awesome difficulties he is likely to have to overcome. For example, he suggests a way of reassembling, with accuracy, a skeleton which has been thoroughly cleaned, for if it is truly clean the means by which it was held together will have been lost. He sought to achieve an end result that illustrated the perfect human specimen, so having procured, dissected and drawn such a skeleton, he used it as the blueprint over which all subsequent studies were drawn, being altered where necessary to fit its near perfect proportions. With limited access to human subjects for dis-

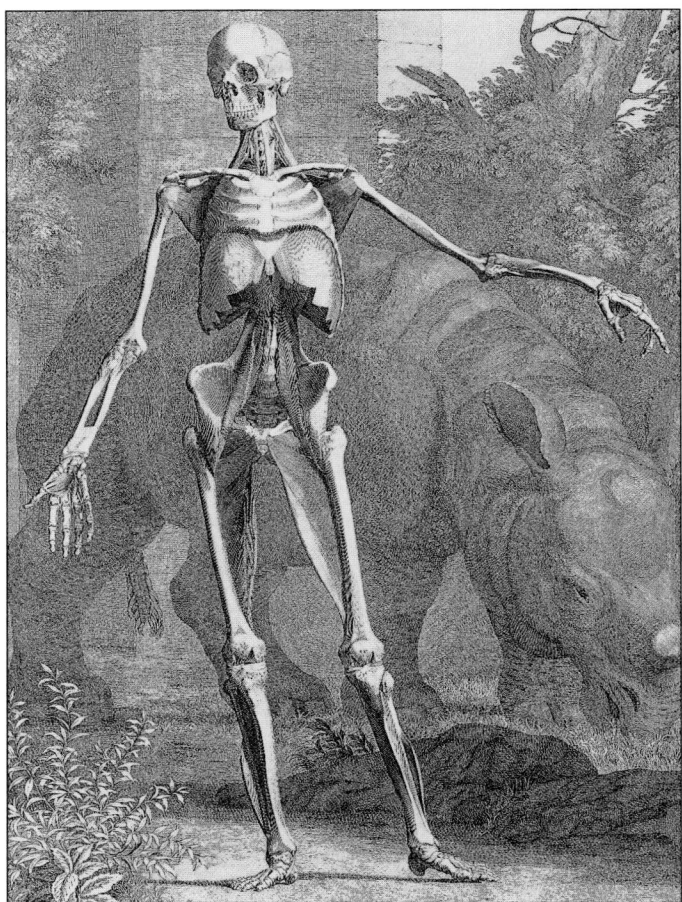

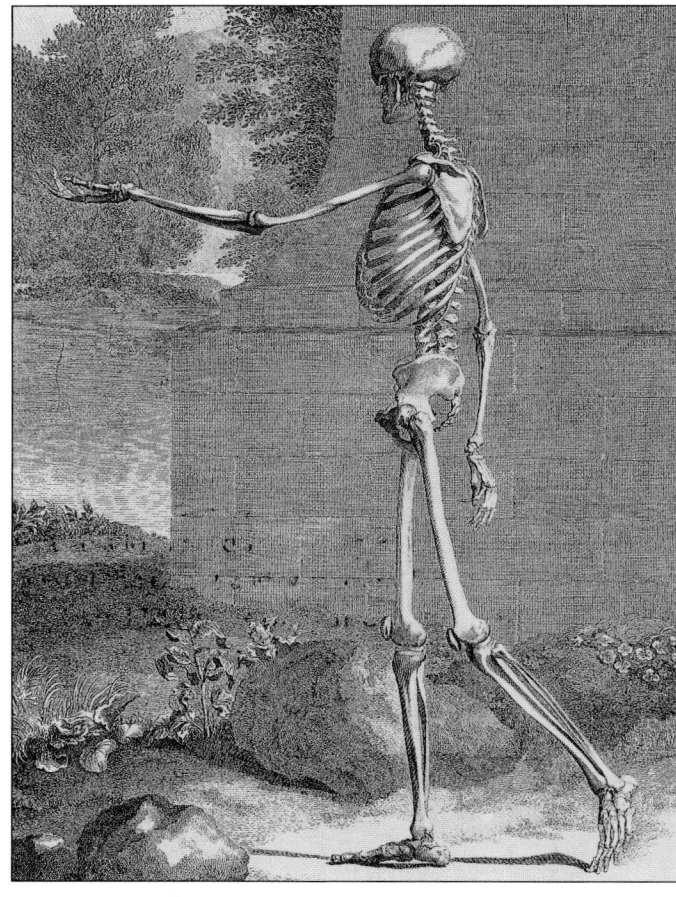

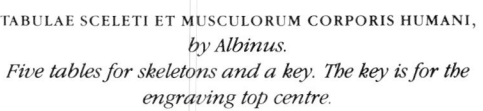

TABULAE SCELETI ET MUSCULORUM CORPORIS HUMANI,
by Albinus.
Five tables for skeletons and a key. The key is for the
engraving top centre.

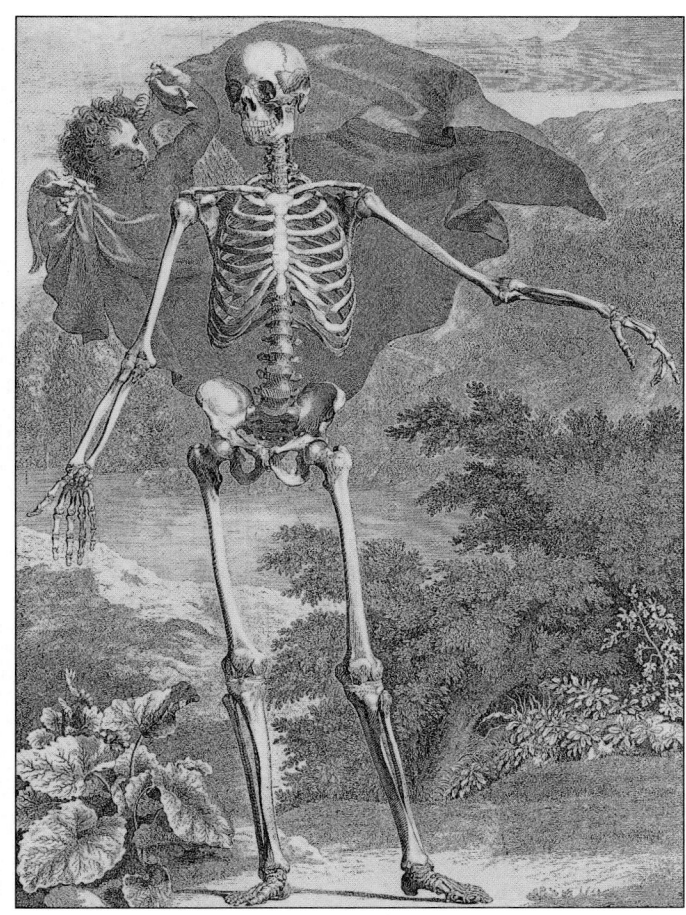

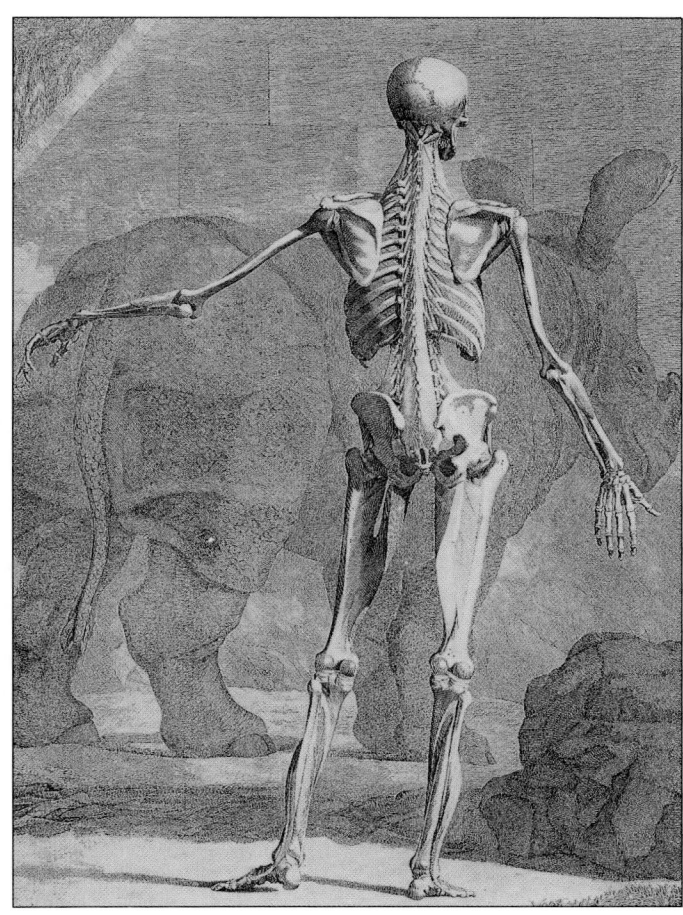

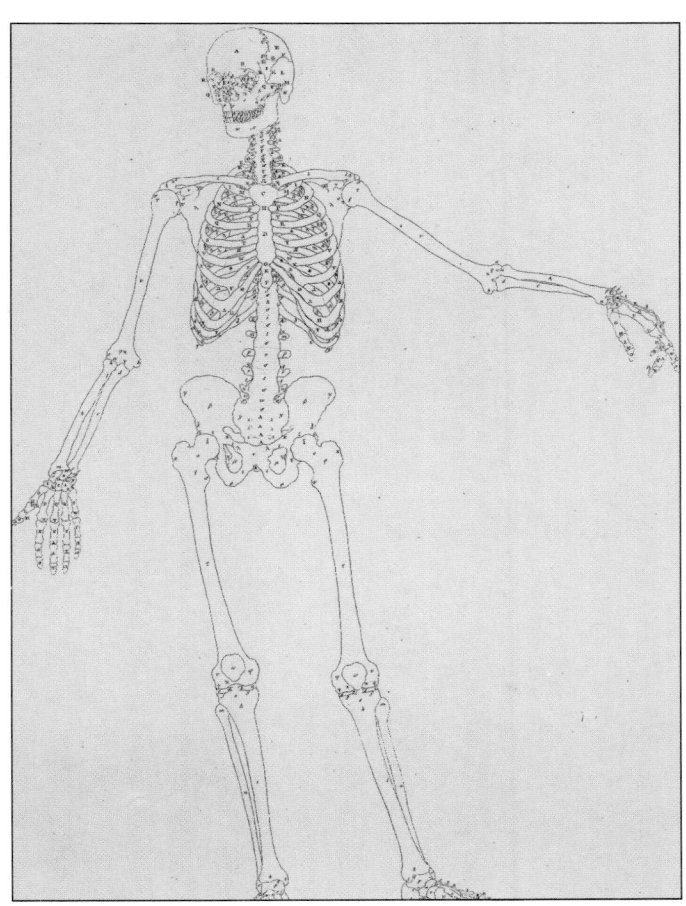

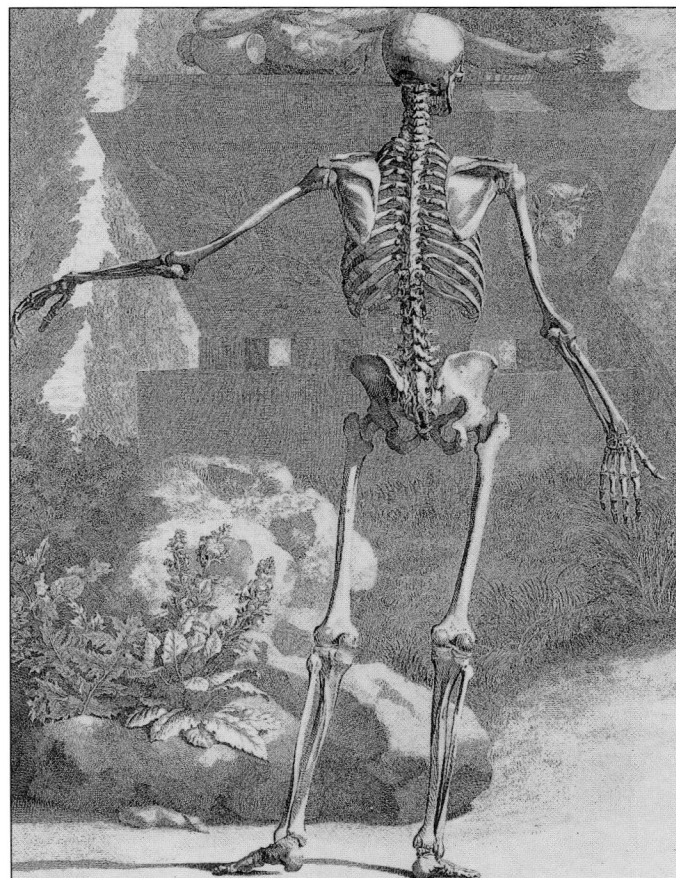

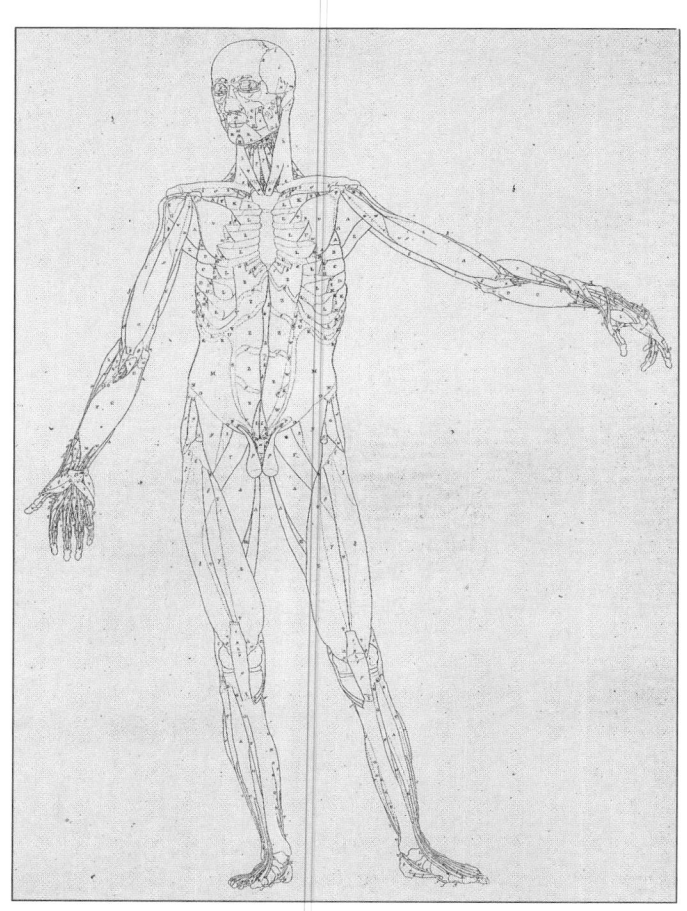
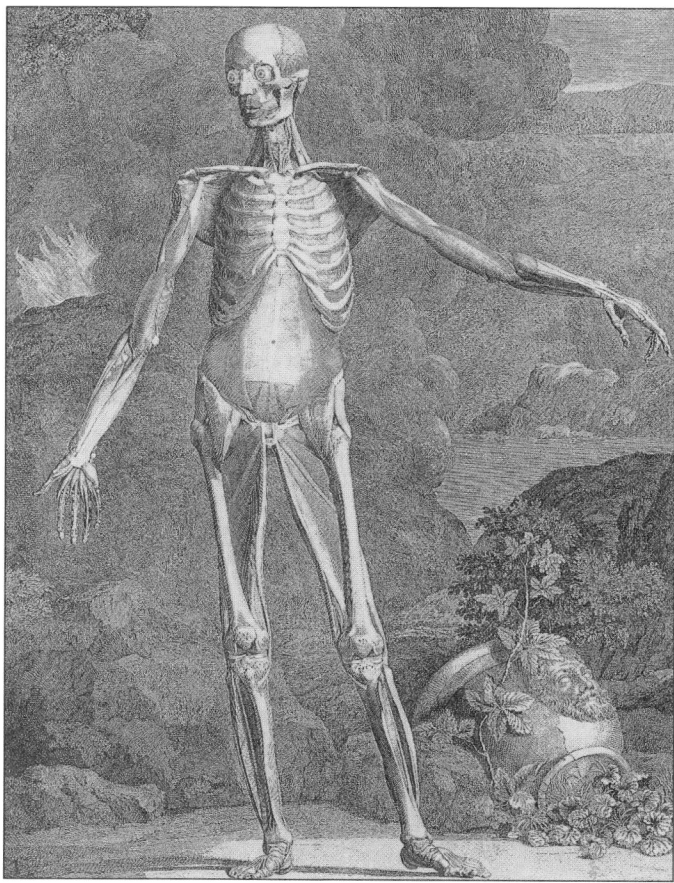

section, Albinus would have had to make his studies from men of varying size and shape. This was the best means of standardizing the results.

Fixing the subject in a lifelike attitude was a very time-consuming operation. A special tripod had to be made to hold the lower half of the body; the spine and head were supported by means of cords passed through a ring in the ceiling; the arms were stretched out and attached to the walls so that the skeleton looked like a giant puppet. Albinus spent several days making the final adjustments to his suspended skeleton, assisted by constant comparison with a thin man the same size as the skeleton, who stood naked beside it. The preservation of anatomical specimens was a constant worry. The usual method employed to delay putrefaction was to wrap the corpse in cloths soaked in vinegar. A severe frost was a welcome event in preventing decay, but was offset by the necessity to provide a fire for the naked man who stood beside the skeleton.

From Albinus, Stubbs took the idea of making his drawings over a skeleton which had been previously drawn. In some cases the inked lines show through his working drawings. The system he used to suspend his horses sounds, from Humphry's description, as if it were more crude than Albinus' puppet strings, but sought the same lifelike posture; a strong emphasis on studying direct from nature is common to both men. However, the most obvious area in which Stubbs did not follow the *Anatomia* was in the matter of the composition of the illustrations. Albinus believed that the 'ornaments' which embellished the background to his plates helped to fill the space and make them look more agreeable, as well as creating a more rounded three-dimensional impression. But Stubbs decided on a plain background, resulting in a less theatrical image of greater clarity. He was later to use the same method in some of his horse-paintings, to great effect.

The very high standards set by Albinus in the human field were an inspiration to Stubbs. However, whereas Stubbs took about 10 years to complete his project, with virtually no outside help, Albinus took about 30 years over his and had assistance from both his students and an artist/engraver, Wandelaar, who worked for him full-time for at least 10 years.

—— THE ANATOMY OF THE HORSE ——

Why did Stubbs decide to devote so much time and energy in studying the anatomy of the horse? One reason may have been that the last, important original work in this field had been carried out in the 16th century. In 1598 Carlo Ruini, of Bologna, had published *Dell' Anotomia ed dell' Infirmata del Cavallo*. It was the first book to concen-

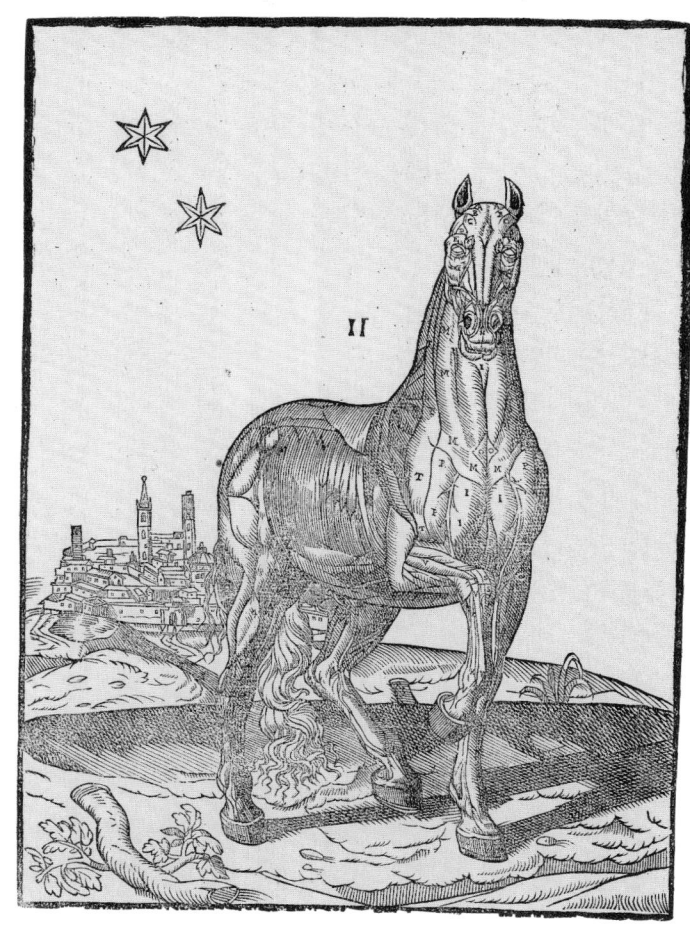

TABULAE SCELETI ET MUSCULORUM CORPORIS HUMANI,
Three tables for muscles and a key. The key is for the engraving

DELL' ANOTOMIA ET DELL' INFIRMATA DEL CAVALLO
by Ruini. Table V (above).

trate on a single animal (other than man) and the first study of the horse. The last of 15 editions was published in 1769, and a number of other books were derived from it. The study of anatomy in general had been greatly advanced since this pioneer work, and Stubbs will have realized that, given the current widespread interest in all aspects of the natural sciences, his contribution was likely to be well received. He may also have believed that he would further his artistic capabilities through a detailed study of nature such as this. Perhaps this was the kind of project he had in mind when he told Winstanley that he would 'look into Nature for himself and consult and study her only'.

Before making any commitment to the *Anatomy,* however, Stubbs must have resolved to focus his future as an artist on the painting of the horse, for these two aspects of his career were dependent on each other. Though he later regretted being so closely identified with painting horses, at this stage it would have been a sound decision.

ANATOMY OF THE HORSE.
*Drawings. Finished
study for the Thirteenth
Anatomical Table.*

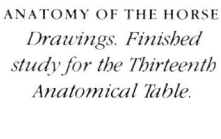

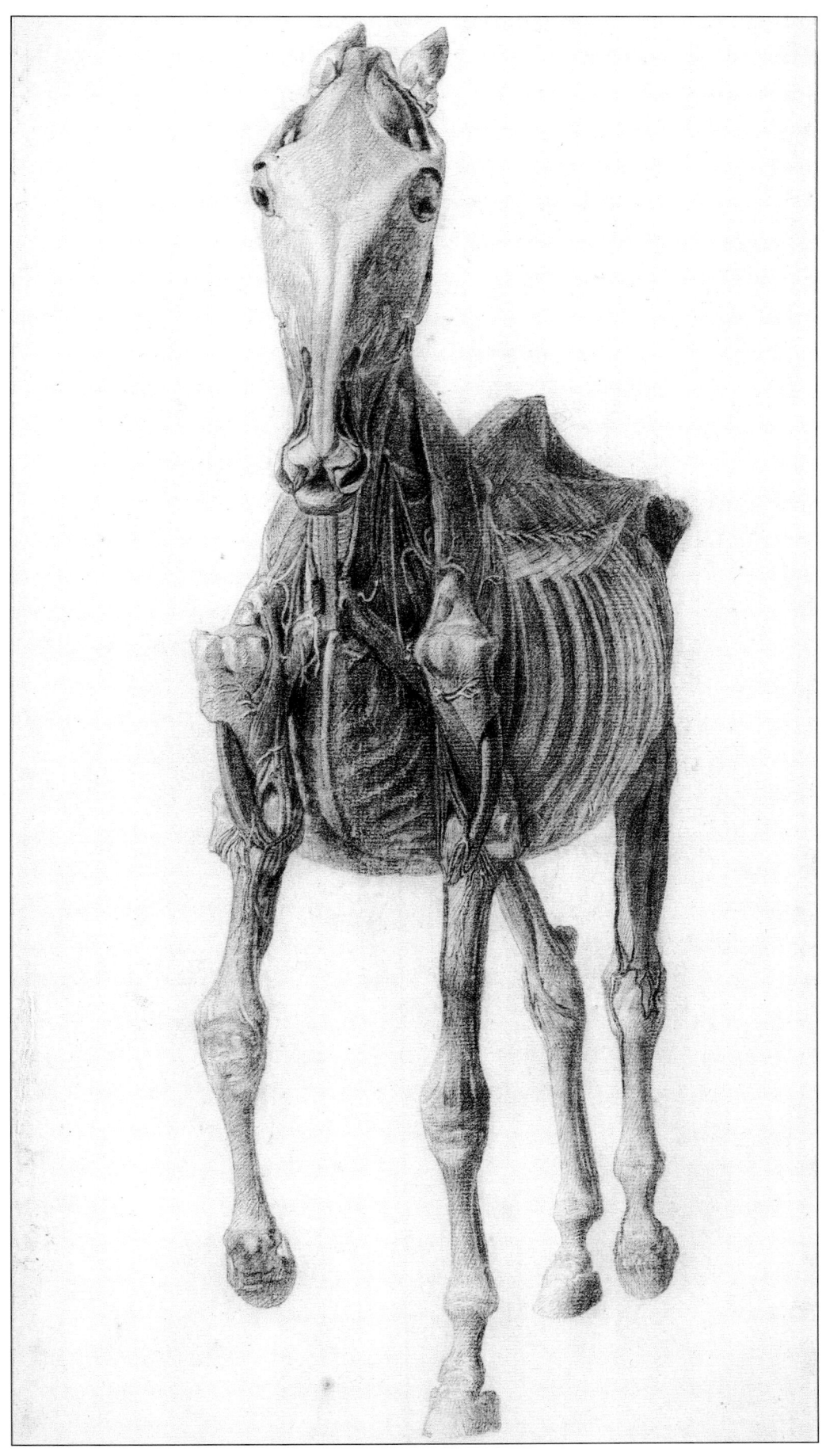

Finished study for the
Ninth Anatomical Table.

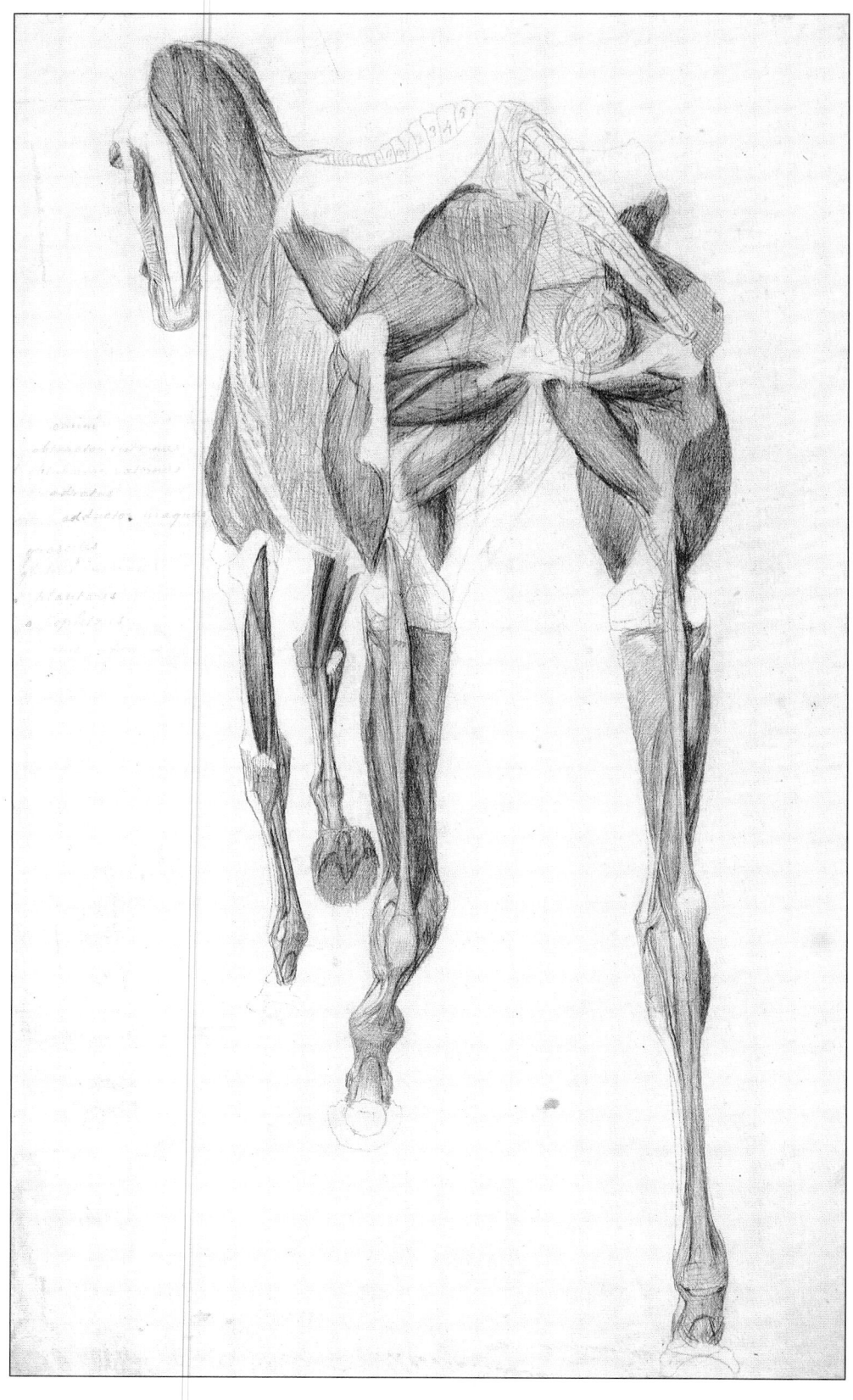

As a provincial painter of portraits with ambitions to climb the ladder of his profession he needed to be able to offer something extra, something different, in order to make his name in a wider context. As an artist who specialized in painting horses, provided with the intellectual credibility of the *Anatomy*, he would be well equipped to take on the London art world. There is no documentary evidence to support this argument, but it is a reasonable explanation for Stubbs' decision to turn from the painting of human portraits to the study of horses. Nevertheless, it was a risky undertaking for an artist in his 30s to turn his back on an established practice in order to start again. Part of the force which impelled him to do it must have been his passionate interest in horses, in both life and death.

Stubbs, of course, would have known horses, would have understood them, would have observed how they worked both physically and mentally during the course of his everyday life. Horses were an integral part of the fabric of the 18th century and not the playthings that, in essence, they are today. Horses in all their guises filled the roles of the modern-day bicycle, tractor, Chieftain tank, runabout family car, Ferrari and Formula One racing car. In contemporary descriptions the usefulness of the horse is often referred to before its beauty. One of the most important advances of the latter half of the 18th century was the development of the canal system, but even this depended on the barge-horse. More familiar than cats or dogs, horses played a part in the lives of a large proportion of the population.

The energy of life suffuses Stubbs' drawings for the *Anatomy of the Horse,* but this is not the result of the artist being true to nature. The horses in these drawings are not the pathetic suspended corpses of reality, they have been reborn, dignified and enobled. The studies which represent the earlier stages of dissection tend to have the ears, eyes and nostrils left intact, and this helps to give a semblance of life, but even the barest skeleton possesses an essential vitality. Perhaps it is created by giving the bones the same relationship one to another as they would have in life; the tensions which maintain the balance of the living animal are present in the drawings; the joints, particularly the hocks, appear to be carrying the weight of the whole horse, not just the bare backbone. But most of all it is the illusion of the figures occupying space which gives the drawings life. Without the help of an elaborate background, Stubbs' partly or fully dissected

Working drawing of a stage in dissection between the Thirteenth and Fourteenth anatomical tables.

horses inhabit a solidly three-dimensional world.

The acute foreshortening of the anterior and posterior views is the result of the cramped dissecting room, but it does not detract from the overall effect. In both these positions the leg nearest the artist tends to look overlong in the early studies, but by the final version the problem of distortion has been solved. One of the most hauntingly beautiful of these drawings is the working study for the 13th Anatomical Table. The original is curiously moving as the horse seems to transcend the horrors of that awful room, part-slaughterhouse and part-studio, and enters another world. Its purposeful forward movement and pricked ears have a poignantly optimistic quality which does not occur in the prints.

The dissections, drawings and text of the *Anatomy* were finished at Horkstow, probably in 1758 when Stubbs was aged 34. He then left for London to seek a printer and publisher for his work. One of the printers he tried was Grignion, who had engraved some of the illustrations to the English edition of Albinus' *Anatomia*. But neither he nor anyone else would take on Stubbs' work. It appears from a confused account given by Humphry that the printers were put off by the fact that amongst Stubbs' drawings were some studies of parts of horses such as ears, noses and sections of limbs. They were worried that since they 'had been unaccustomed to such studies and not understanding them, were fearful of being bewildered, and therefore rather wished to decline undertaking the commission'. No studies of parts of the horse were ever published, nor do the drawings of them survive.

So, once again, Stubbs was compelled to do his own engraving. Since his first print-making efforts of about 10 years before, his technique had greatly improved, as had his draughtsmanship. The engravings for the *Anatomy* are those of a practised hand. The shaping of contour and the rendering of texture is superb. The surface of bone is described by use of clearly defined hatched strokes, and the surface of muscle is represented by a greater density of lines. Ligaments and tendons are given the same treatment as muscles, whereas blood-vessels look like twists of rope. Some of the character, the individuality, of the drawings is inevitably lost in the printing process, but Stubbs' use of the burin (engraving tool) is so splendidly assured that these losses are more than compensated for by the increased monumentality of the images. The tight execution of the plates makes them so convincing, they give the impression that the horses are vital beings, even as skeletons. The Swiss artist Fuseli commented that Stubbs' horses 'depend more on the facsimilist's precision

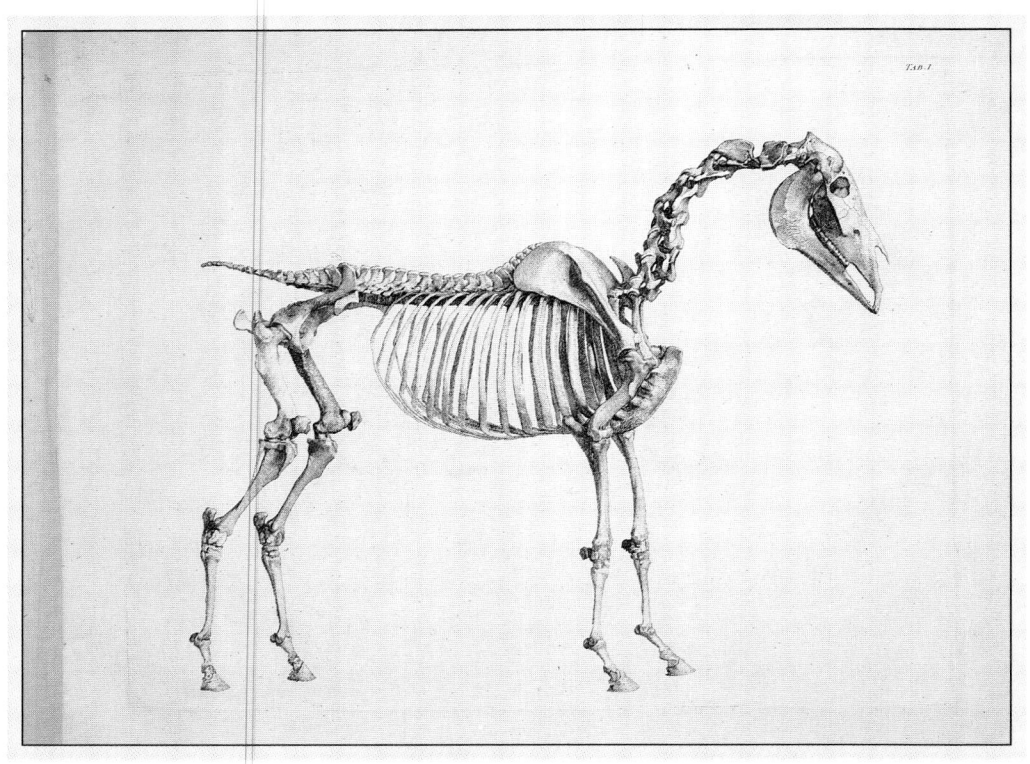

ANATOMY OF THE HORSE.
Engravings. First Skeleton Table: engraving (above).
First Skeleton Table: key (below).

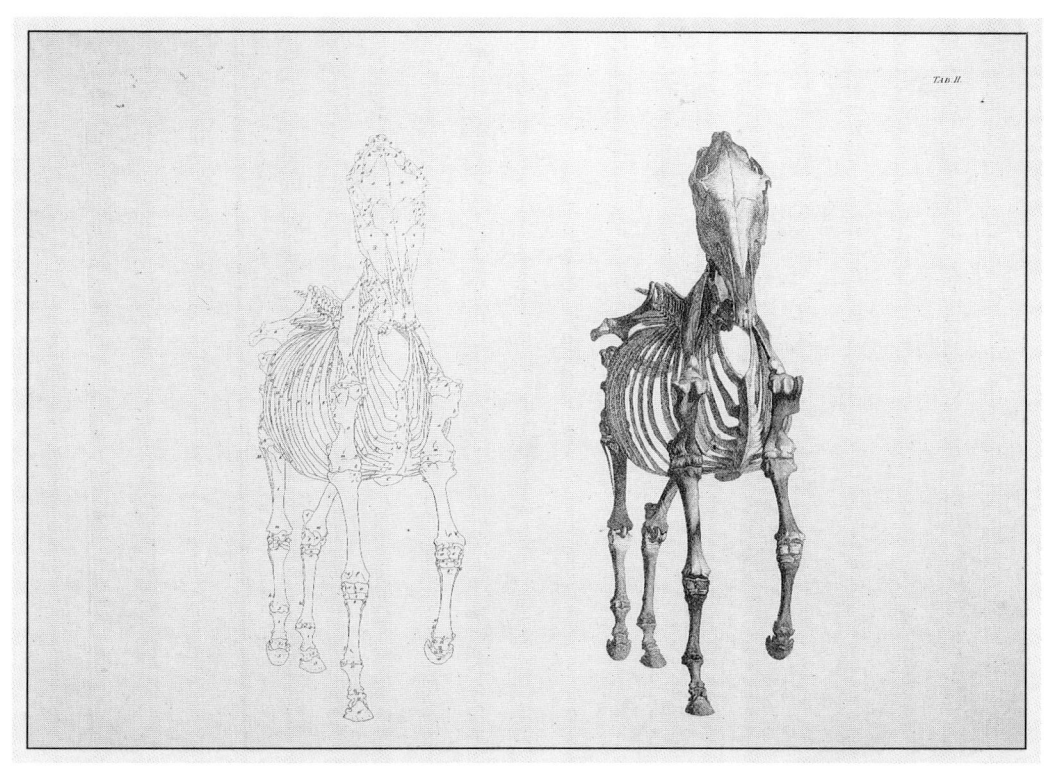

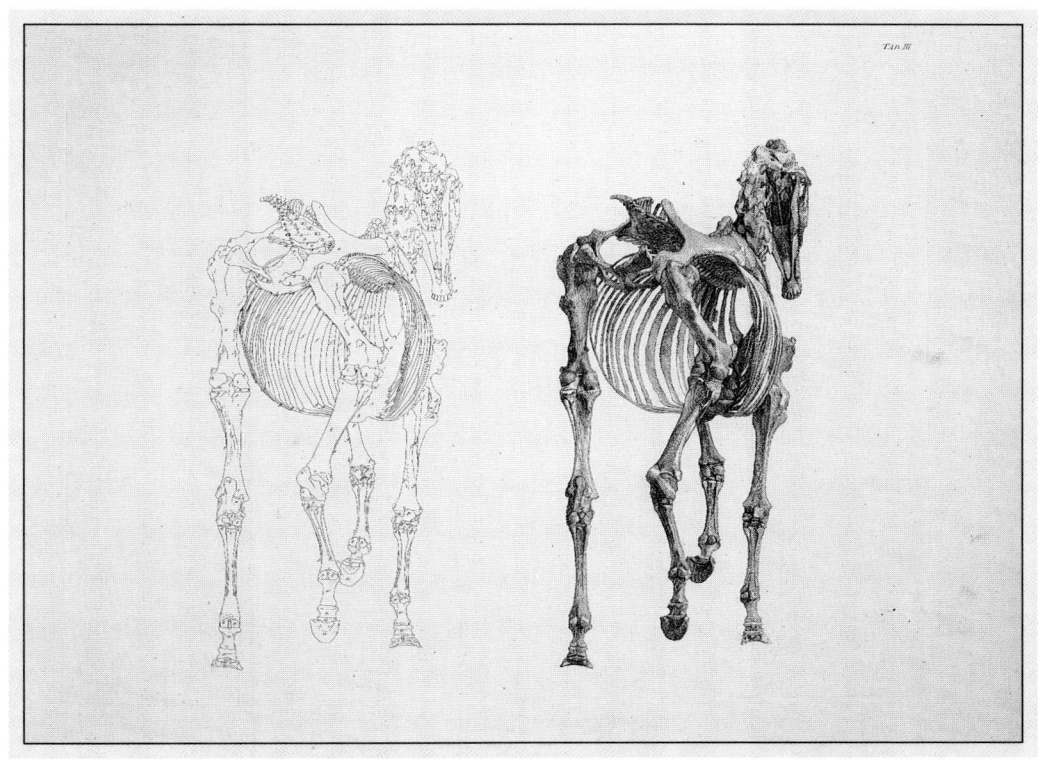

Second Skeleton Table: engraving and key (above).

Third Skeleton Table: engraving and key (below).

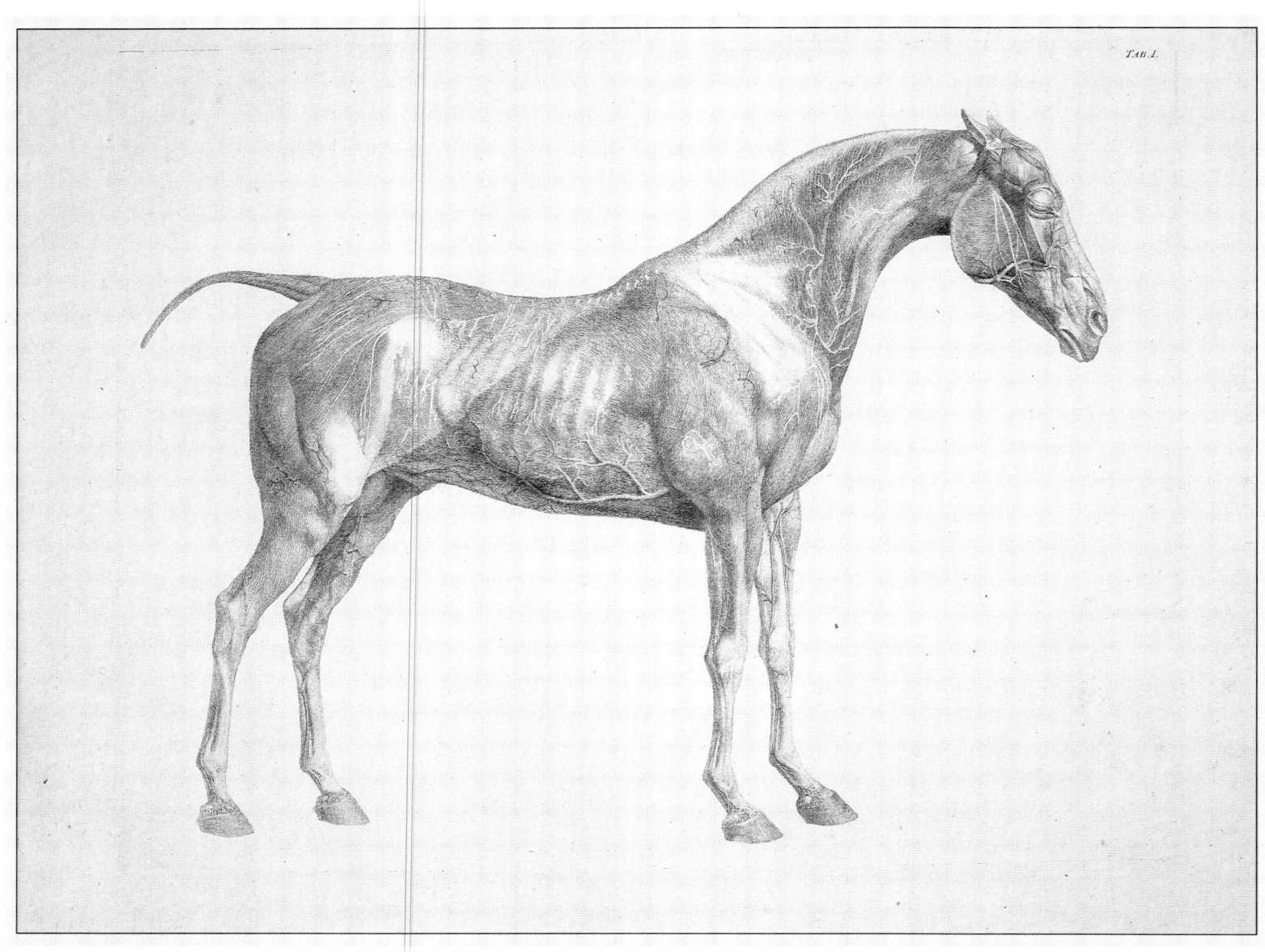

First Anatomical Table: engraving.

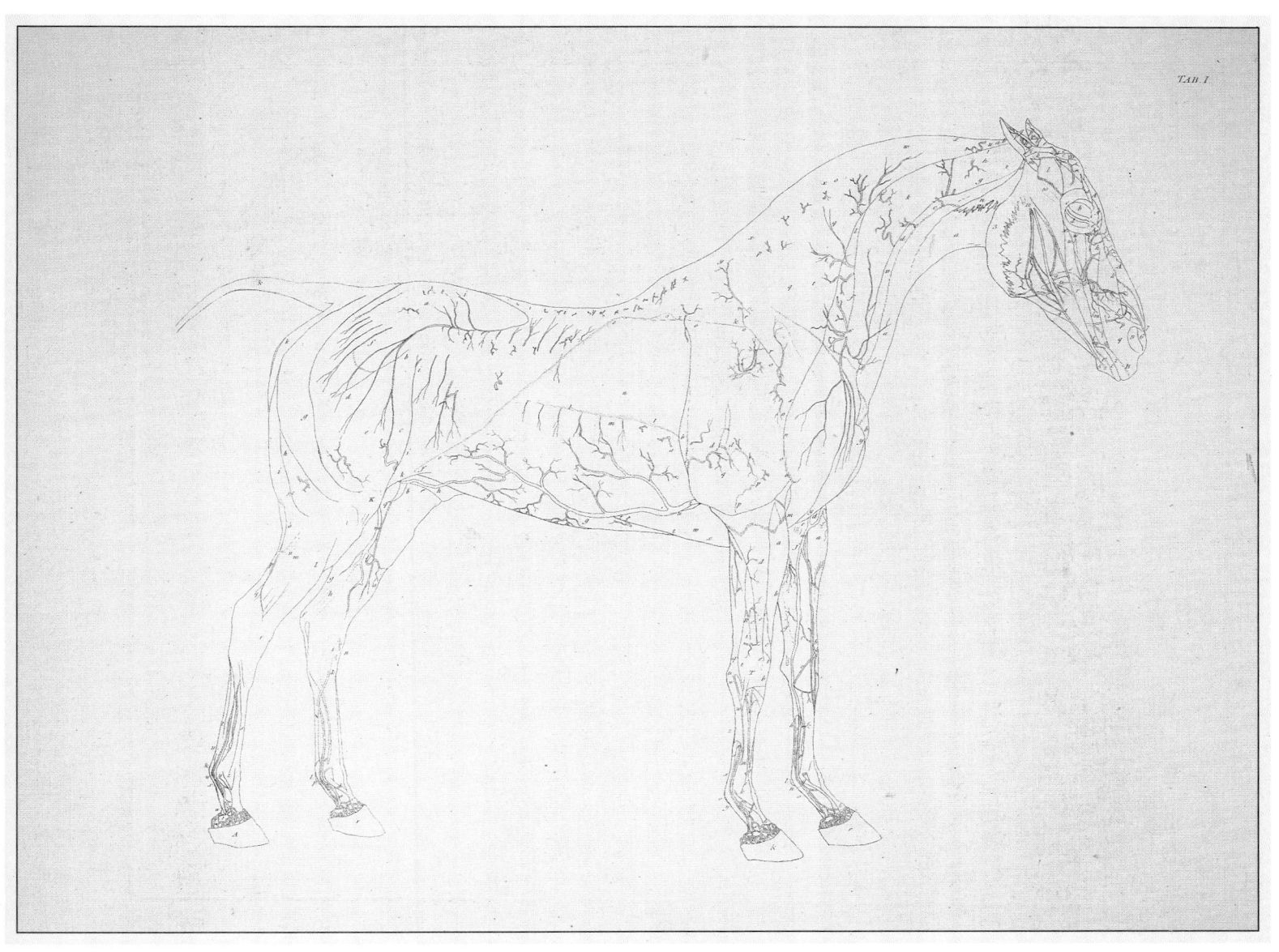

First Anatomical Table: key.

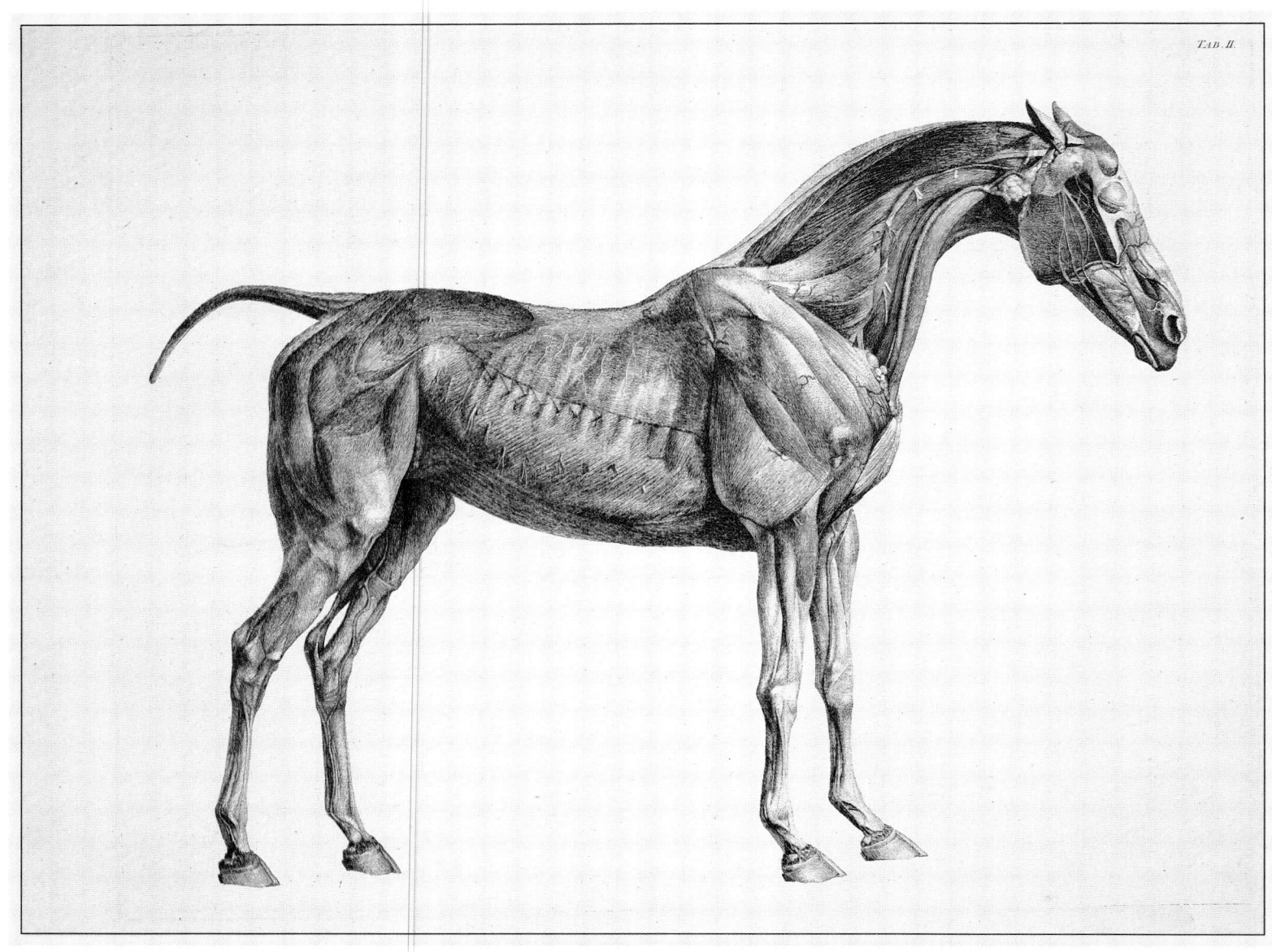

TAB. II.

Second Anatomical Table: engraving.

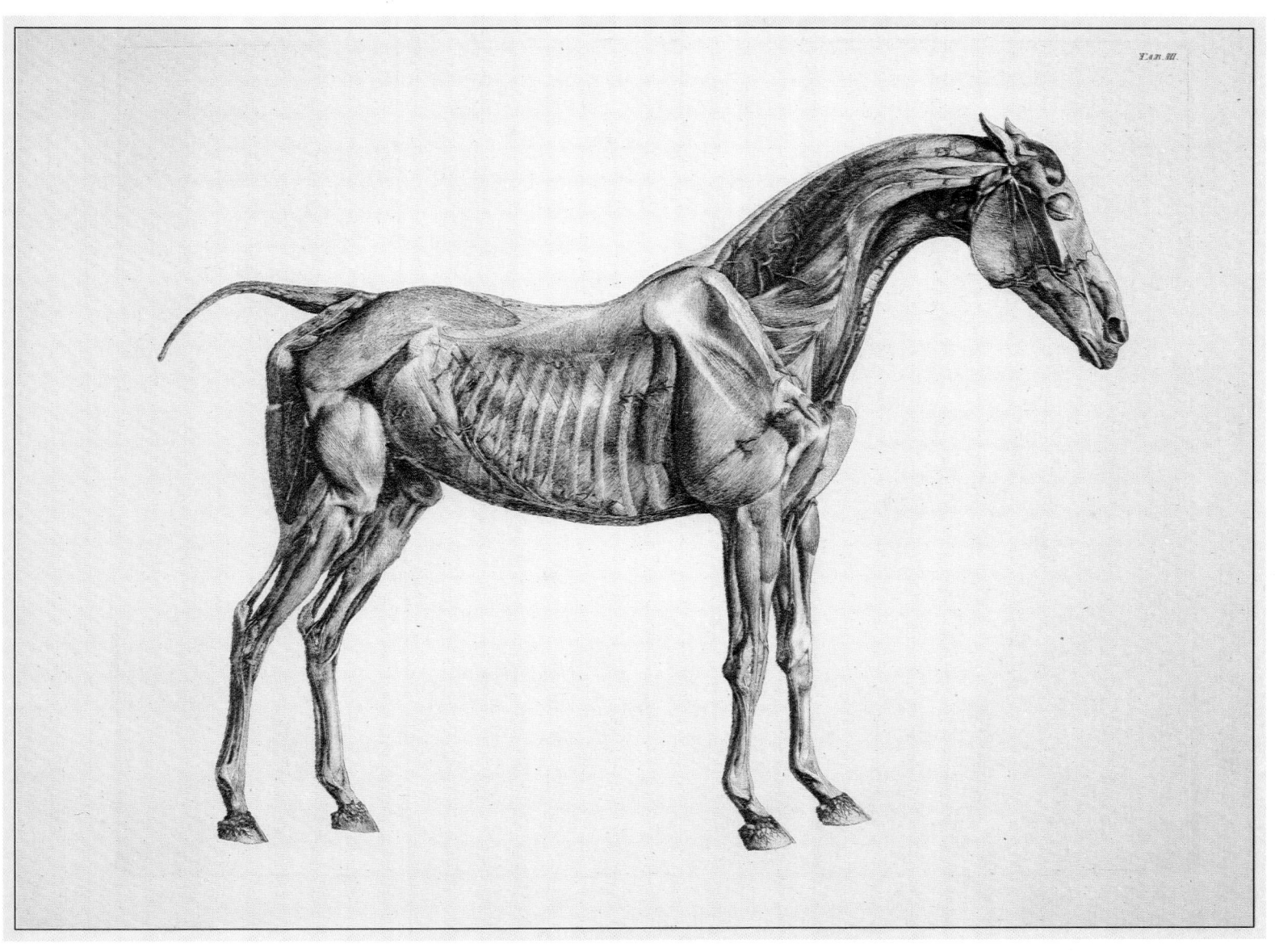

Third Anatomical Table: engraving.

36

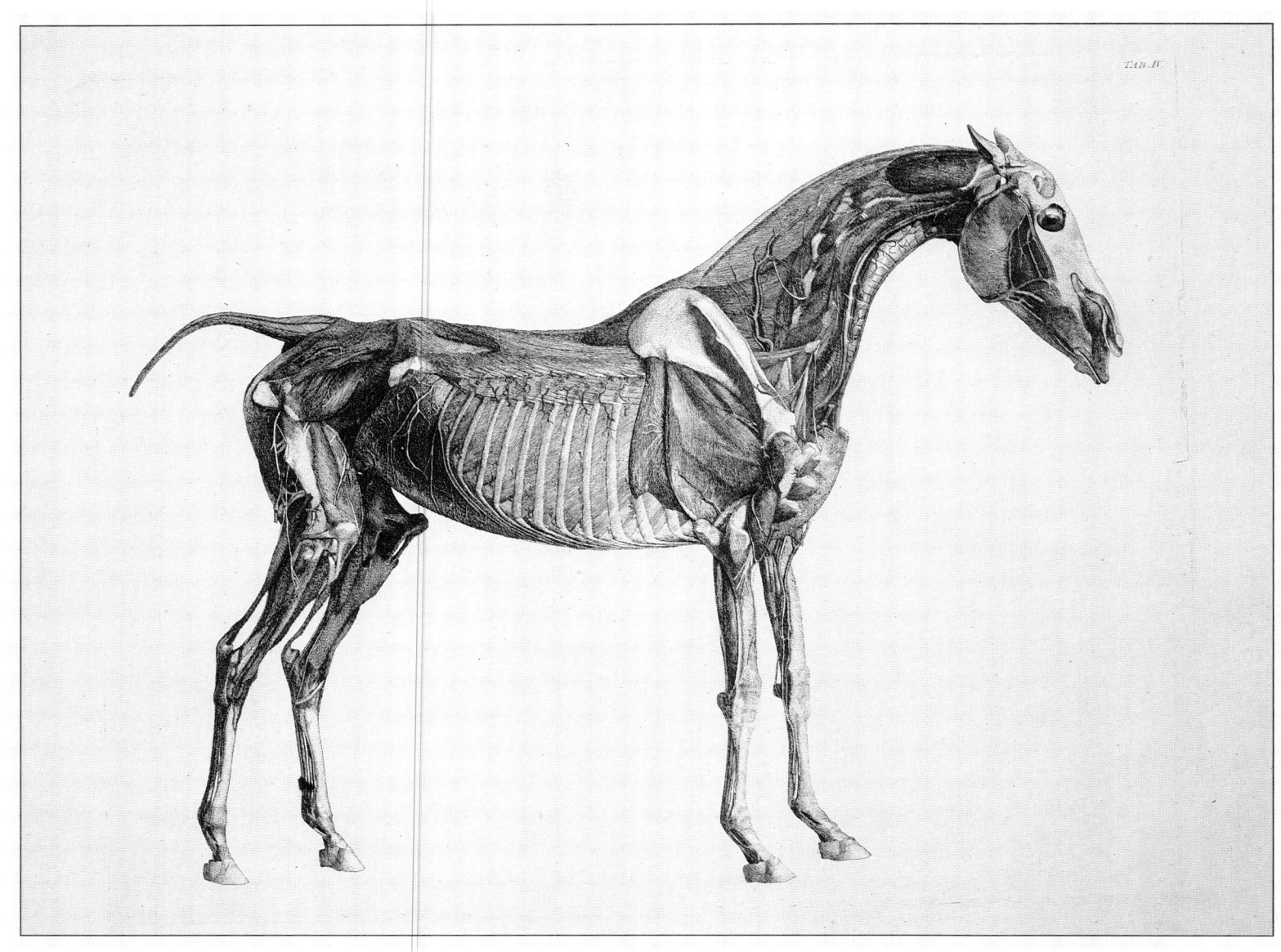

Fourth Anatomical Table: engraving.

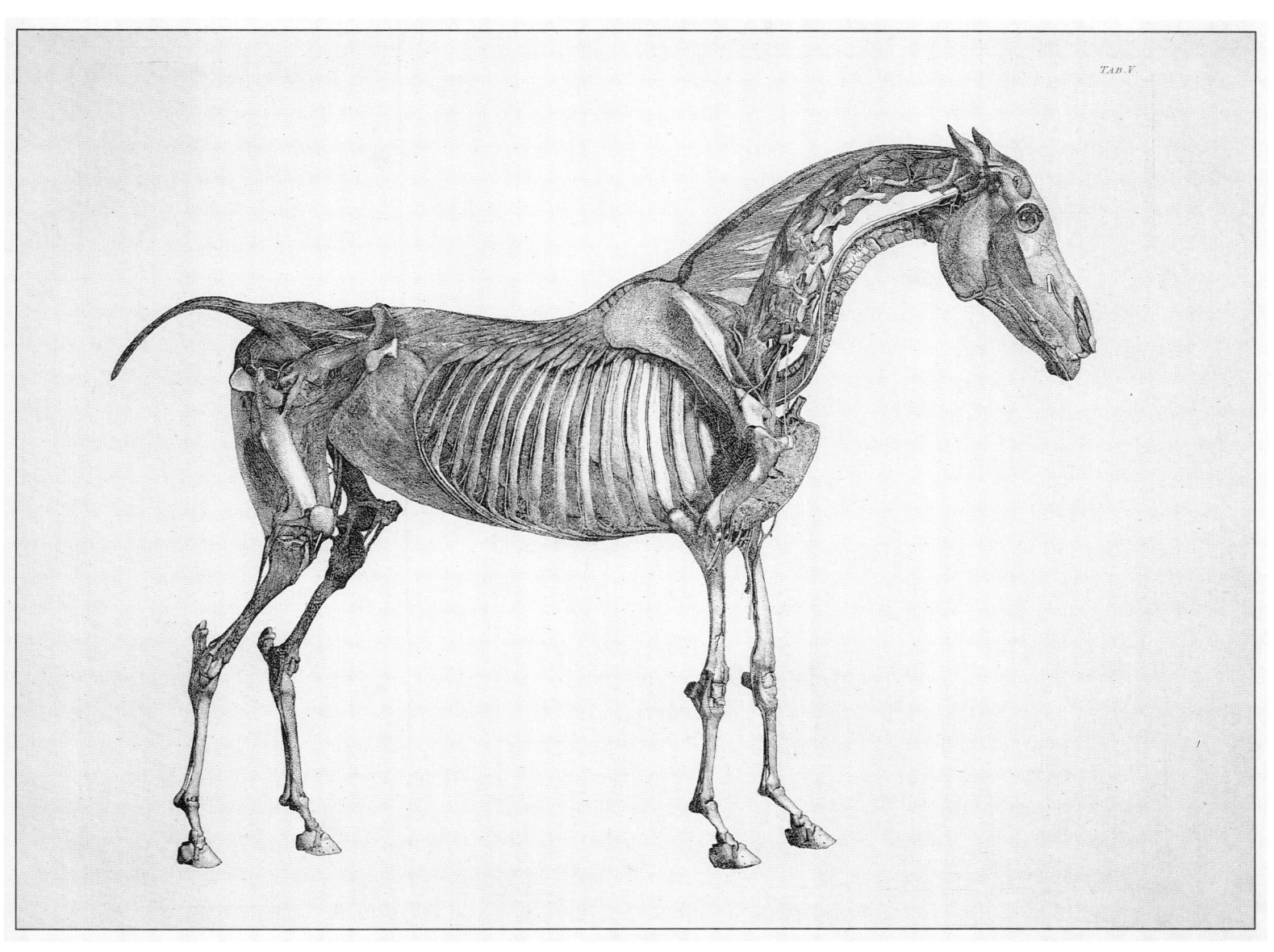

Fifth Anatomical Table: engraving.

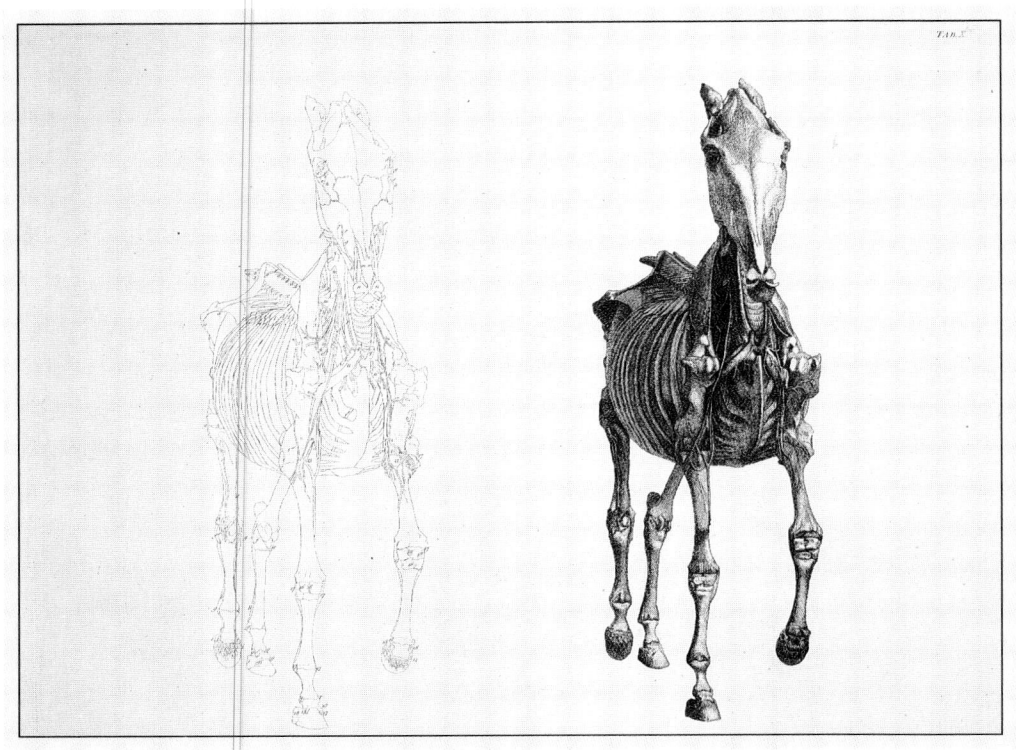

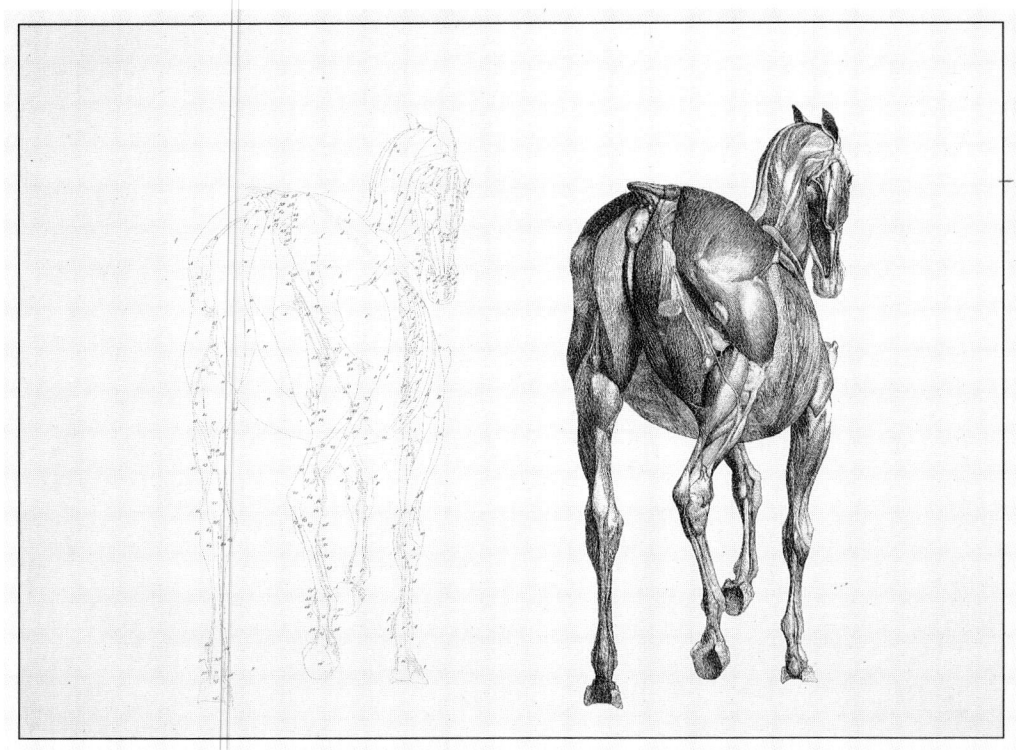

Tenth Anatomical Table: engraving.

Thirteenth Anatomical Table: engraving.

than the painter's spirit', a remark that is unfair to Stubbs' paintings, and simply not true with regard to the *Anatomy* prints. The illustrations that would have resulted from the hand of a facsimilist in this context would have been gruesome and macabre; dead horses would hang limply from hooks attached to the ceiling; it was the 'painter's spirit' that transformed corpses into objects of beauty.

Stubbs fitted the engraving of the plates for the *Anatomy* around his growing painting practice. Consequently, they were not ready for publication until 1766. The years from 1760–70 were some of the busiest in his life, and he had to find time for his print-making while he was involved in some of his most important commissions, amongst them the *Grosvenor Hunt* and *Whistlejacket*. The work was done early in the morning and late at night to avoid interrupting the progress of the oil-paintings. When the prints and text were finished, Stubbs advertised the book in the London press, to be sold at the price of four guineas to subscribers, or five guineas to non-subscribers. Selling by subscription meant that the costs of printing and publication could be met by the money raised in advance, for subscribers paid half the amount before publication and the remainder on delivery. In return, they paid a lower price and were to have a list of their names printed in the book.

The *Anatomy* was finally published in March, 1766, and consisted of 18 'Tables' and 18 corresponding diagrams. The latter provided keys which link the tables to the text. Albinus had devised this system for his *Anotomia*, and much of the layout of Stubbs' work follows that of the earlier publication. The tables are divided into two groups, the first three concern the skeleton alone, each table showing a different position: lateral, anterior and posterior. The remainder deal collectively with the muscles, fascias, ligaments, nerves, arteries, veins, glands and cartilages, with each different stage of dissection shown in the three positions.

The text of Stubbs' book is as clear and logical as his illustrations, and the layman can, with the help of the keyed diagrams, follow his analysis from head to hoof without difficulty. Much of the written description takes the form of a recitation of fact in list form:

'1 2 The depressor of the lower lip.
3 4 Part of the latissimus colli, *which at 4 is inserted into the lower jaw bone.*
5 The elevators of the chin where they are inserted into the skin, the fibres of which are intermixed with the fat of the chin'[2]

But some sections sound less confident, usually where Stubbs was unsure of himself, which is not surprising given the pioneer nature of his work:

'1 A sort of fatty, spongy, glandular substance, lying immediately under the skin, probably a production of the membrana adiposa *lying over the protuberating part of this joint to preserve the bending tendons from bruises when the fetlock touches the ground'[3]*

To anyone interested in horses, the *Anatomy*, notwithstanding the unfamiliar terminology, gives an insight into the mechanics of the horse through the more explanatory sections.

In his introduction, Stubbs listed those to whom he hoped the *Anatomy* might appeal. At the top of the list comes his own profession, and then 'those to whose care and skill the horse is usually entrusted'. This would suggest that he saw it primarily as an aid to artists. He suggests that farriers and horse-doctors would benefit from it, but they would have found the price quite high. Yet the book was never published in a smaller, cheaper format, presumably because any reduction in the size of the illustrations would have made them unintelligible. The widest market for the book was amongst 'those gentlemen who delight in horses and who either breed or keep any considerable number of them', but artists did buy it, and both Gainsborough and Lawrence owned copies.

Perhaps the most gratifying reaction came from scientists: the Medical Review of 1767, for example, was generous in its praise. 'This work not only reflects great honour on the author, but on the country in which it was produced. France may reap great credit from the veterinarian school[4] lately established in that country; but what praise is not due to a private person who, at his own expense, and with the incredible labour and application of years, began, continued and completed the admirable work before us? But it is impossible to give our readers an adequate idea of Mr Stubbs' performance without placing the book itself before their eyes. All we can therefore add concerning it is, that the author himself dissected a great number of horses for the sake of attaining that certainty and accuracy for which his engravings will ever (if we are not greatly mistaken) be highly valued by the curious in comparative anatomy. His original drawings were all his own, and the plates were likewise engraved by his own hand. In short, we are at a loss whether most to admire the artist as a dissector or as a painter of animals.'

Even higher plaudits came from Petrus Camper, a famous Dutch anatomist, Fellow of the Royal Society, member of medical societies or academies in Paris, Edinburgh, Haarlem and Rotterdam. He was clearly im-

[2] [3]Both extracts are taken from the First Anatomical Table of Muscles

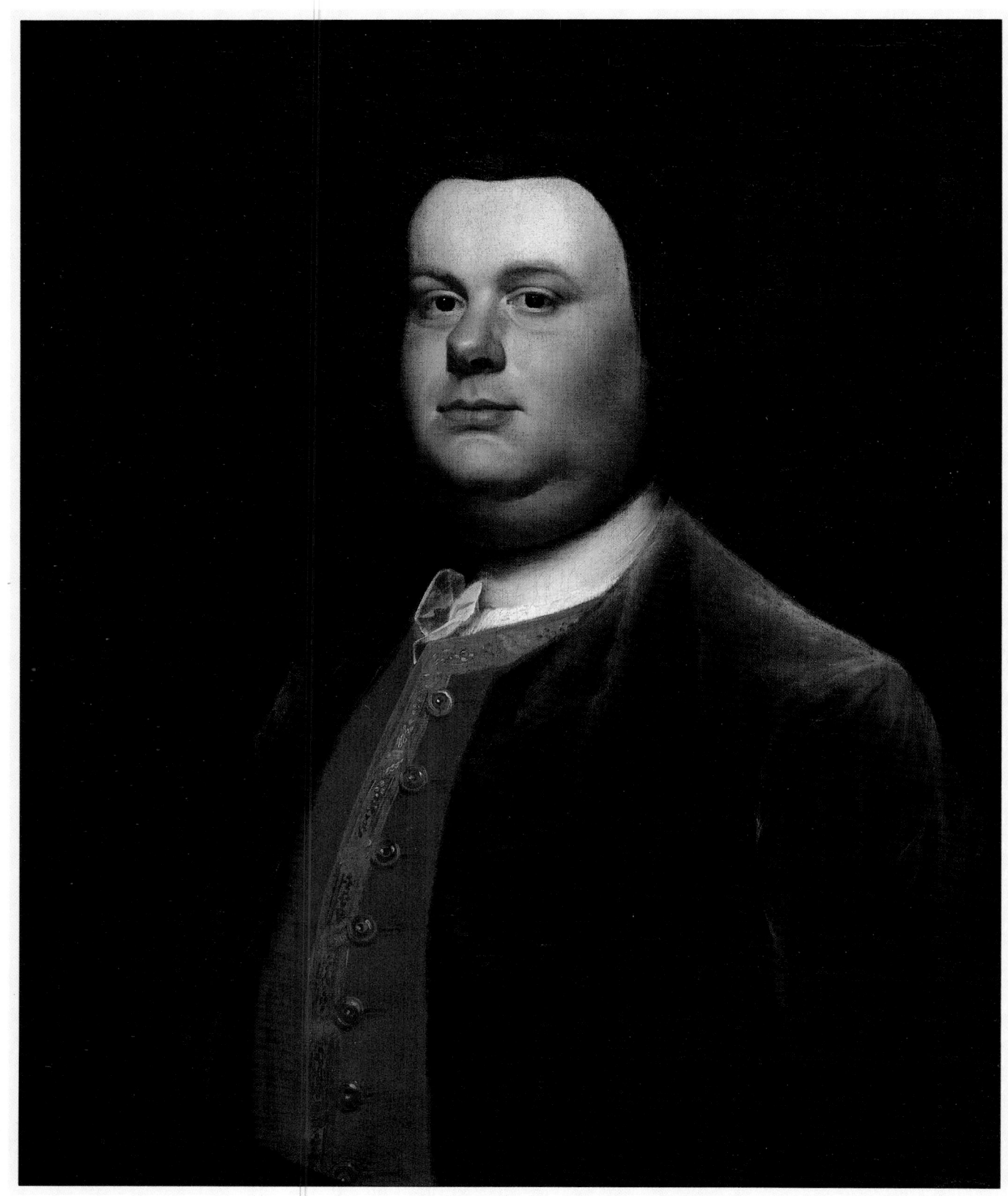

JAMES STANLEY, 1755.
*The sitter may be the James Stanley recorded as living
in Ormond Street in 1758, in which case he could have
been a boyhood neighbour of Stubbs.*

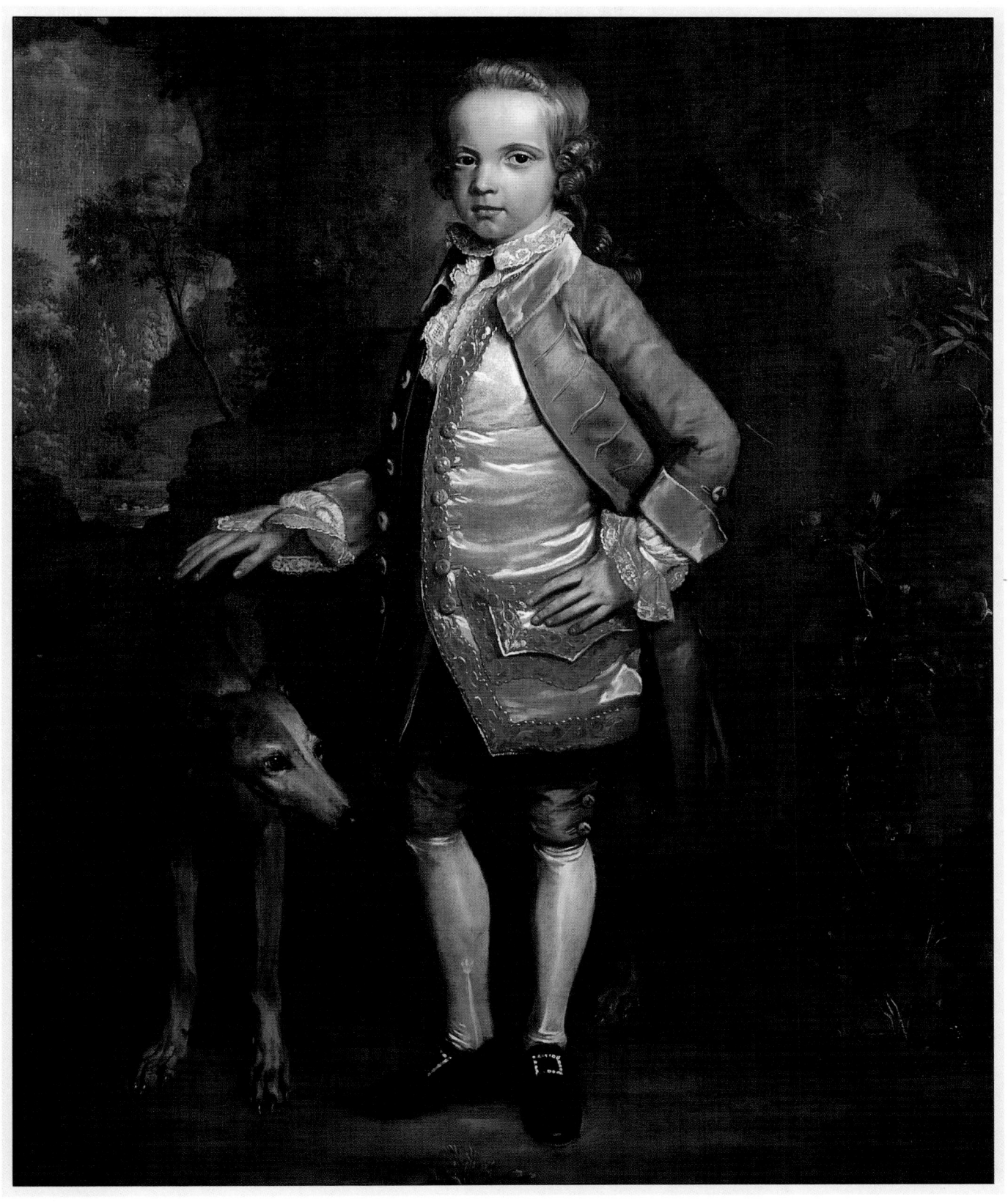

SIR JOHN NELTHORPE, 6TH BARONET, AS A BOY, (?) 1756
*Sir John was to become a loyal patron, continuing the
Nelthorpe family's association with Stubbs. He
commissioned a number of paintings, the last in
1792, and he owned a copy of the* Anatomy of the Horse.

pressed by Stubbs' work and wrote to him from Gronigen, where he was Professor of Medicine, Anatomy and Surgery, in July 1771: 'Sir, if ever I was surprised to see a performance, I was it surely, when I saw yours on the 'Anatomy of the Horse'! The myology, neurology and angiology [study of the muscles, nervous system and blood vessels] of men have not been carried to such perfection in two great ages, as these horses by you. How is it possible a single man can execute such a plan with so much accuracy and industry? You have certainly had before you the scheme of the great Albinus, but even his plates have not that delicacy and fulness, nor the expression of yours. Give me leave to ask you, was you the engraver? for you do not mention the engravers name. I once had a plan to offer to the public, a subscription for the like; but I am sure I could not have obtained the elegancy and exactness of yours'.

He goes on to say that having seen these engravings he has given up his own project, and asks whether Stubbs intends to go further and illustrate the internal organs and their disorders. This makes clear the difference between the approach of the scientist, who wants to know how everything works, and that of the artist who wishes to understand only that which affects the exterior. Stubbs had never intended his book to be a comprehensive study of all aspects of the subject, he stopped when he reached the point when, as an artist, he need look no further.

The experience gained while working on his *Anatomy* was for Stubbs a substitute for the artistic training he never received. There are two known portraits painted before and during the Horkstow period, *James Stanley* of 1755 and *Sir John Nelthorpe* of ?1756. The former must have been executed shortly after Stubbs' return from Italy, but it owes no debt to the fashionable styles then current in Rome. It is a frank and unpretentious study, although the sitter's expression appears a little mask-like. The portrait of the young Sir John is more lively, conveying a combination of boyish charm and stylish dignity. The drawing of the figure is awkward in places, his hands are particularly out of proportion, but the handling of the

'Established in Lyons in 1762

silks and velvets is as accomplished as that of the earlier double portrait of the boy's parents. From these two paintings of the mid-1750s there is a gap in Stubbs' extant work until about 1759, when he produced the first of his animal paintings.

Armed with his knowledge of anatomy, Stubbs was able to bring new standards to horse-painting. In order to view his contribution on a wider stage it is interesting to compare one of his equestrian portraits with one by Van Dyck, since, prior to Stubbs, he was one of the finest of all painters of the horse. Two works of similar pose are Van Dyck's *Equestrian portrait of Charles 1* (late 1630s), and Stubbs' *Lord Pigot of Patshull* (1769). Common to both pictures is a high-spirited warhorse, which serves in each case to enhance the status of the sitters. Both horses are shown in the classical riding movement known as 'piaffe', which is a very slow trot, and both have the look of a horse who cannot be relied upon to behave for very much longer, thus emphasizing the skills of its rider.

At first sight, Van Dyck's horse is convincing, the exquisite head and fine limbs are painted with great skill but the artist has been unable to capture the vitality of the whole animal. The representation of the muscles of the neck, shoulder, chest and hind quarters is soft and flaccid, with no connection established between the exterior and the horse beneath. This effect is so marked that in some areas it looks as though there are pockets of fluid under the skin. The body of the horse has the appearance of a sponge, into which the beautiful head and legs disappear. Owing to the artist's lack of knowledge of anatomy, the horse looks static because no true muscle activity is represented, in spite of the raised foreleg. In contrast, the actions of Stubbs' stallion are expressed throughout the whole animal, giving the impression of a spring about to be released. The muscles ripple with the effort of the movement, which requires considerable impulsion from the horse. The lowered rump and tension of the tail complete an image of great energy, held in check.

Van Dyck's horse-painting was constrained by the limits of his knowledge but he was, nonetheless, an artist of the first rank. Knowledge of anatomy does not necessarily result in great art, but in Stubbs' case it was the key which unlocked the door to his wide-ranging abilities.

EQUESTRIAN PORTRAIT OF CHARLES I, LATE 1630S, *by Anthony van Dyck.*
Van Dyck's lack of understanding of horse anatomy is evident in the soft spongy appearance of the horse's shoulder, chest and hindquarters.

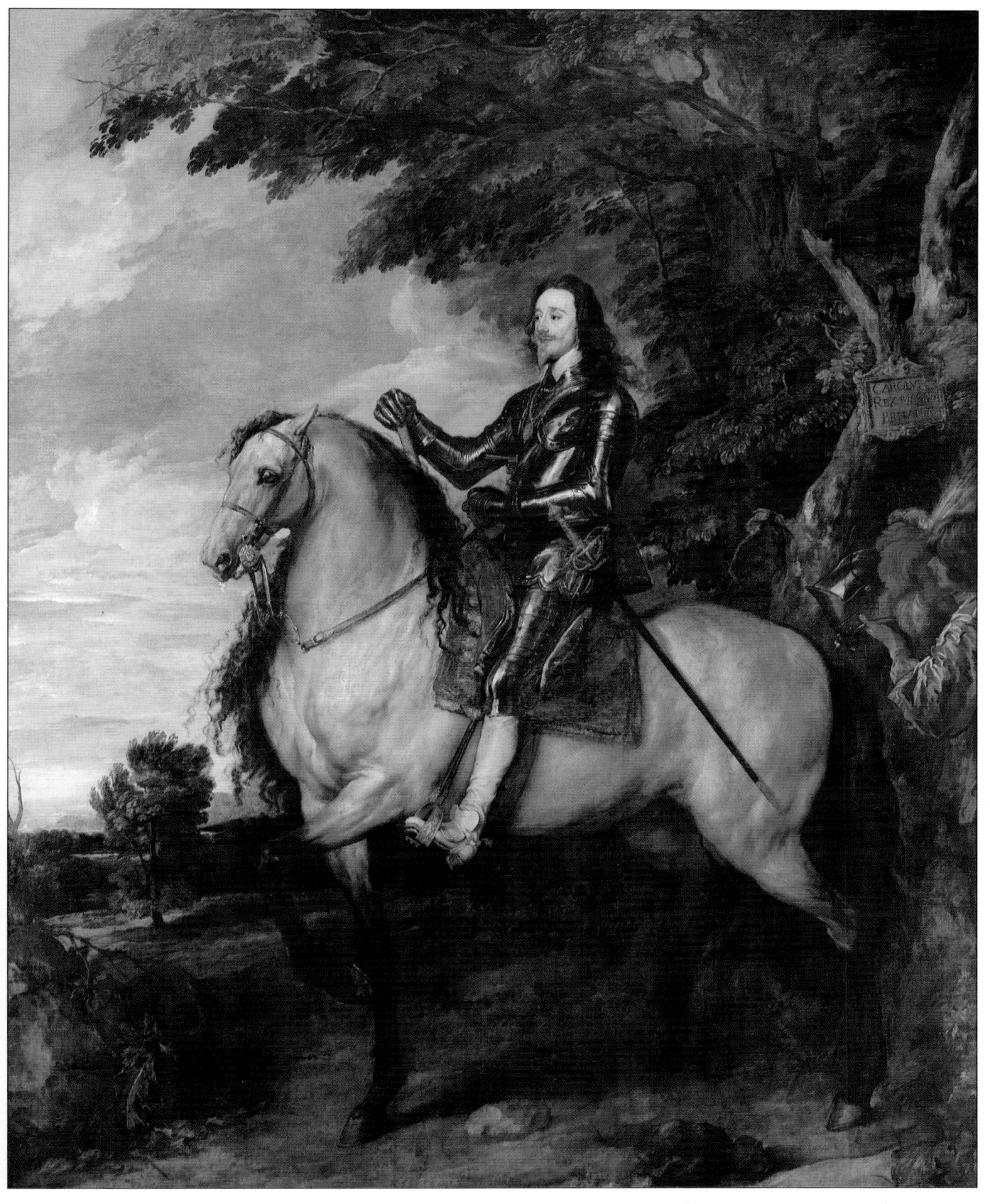

LORD PIGOT OF
PATSHULL, 1769.
*Stubbs relates the
appearance of the
muscles to the horse's
movement. The piaffe
demands considerable
skill from the rider and
great strength from the
horse.*

A BAY STALLION BENEATH A LARGE TREE, (?) C1759
This picture and Mare and Foal *(?) c.1759 (see
following page) are the earliest surviving horse
paintings. They may be related to the Goodwood series
painted for the Duke of Richmond c.1759/60.*

HORSE-PAINTING

For some time it was thought that the earliest surviving horse-painting by Stubbs was one that is now known as *The Death of a Hare*. The attribution was first suggested by Basil Taylor in the 1950s and subsequently reaffirmed in *Stubbs' Dogs* by Robert Fountain and Alfred Gates in 1984. However, Judy Egerton, in her catalogue of the Paul Mellon Collection, published in 1978, argues convincingly that it is not by Stubbs and she suggests that it might be the work of either Benjamin Killingbeck or Robert Healey. It is significant that Basil Taylor did not include the painting in his own book on Stubbs, published in 1971.

Two undated paintings which came to light at Sotheby's in 1984 are probably among the earliest of his horse-paintings. They are a pair showing a stallion under a large tree in one picture and a mare and foal in the other. In comparison with his later works, the drawing of the horses is not entirely satisfactory. The grazing mare is the most convincing but the foal is wooden when it should be tense and alert. The stallion, with its high-stepping trot, rolling eye and snorting nostrils, has a rather melodramatic aspect unusual in Stubbs' work – even the unmanageable *Whistlejacket* is not so wild-eyed. The drawing falls short of his later accuracy, for the neck, shoulder and chest do not quite achieve credibility. The stallion is very light of bone, as are some of the horses in the Goodwood series, particularly the grey on the right of *Racehorses at Exercise*, and Stubbs' later horses do tend to be heavier than the early ones, although this could be something of a sweeping generalization. This point may not be very significant but, curiously, it does not follow the prevailing breeding trends which placed more and more emphasis on speed.

ANGELO AND
EARLY COMMISSIONS

By 1759 it appears that Stubbs had settled in London, where he lived for the rest of his life. He was quick to secure the patronage of a number of rich young aristocrats, including the Duke of Richmond and Lord Grosvenor. However, the Humphry manuscript says that Sir Joshua Reynolds gave him his first commission for a painting of a horse. This would have been of considerable significance to an artist newly arrived from the provinces for, though only one year older than Stubbs, Reynolds was already established as the leading portrait-painter in London.

The painting was called *Portrait of the Managed Horse*, which is the term used to describe a horse being schooled in the movements of classical riding, or dressage in modern terminology. This links the painting, now lost, with Domenico Angelo's riding establishment, where Stubbs was able to study horses being ridden in this way. Angelo, the son of a merchant from Leghorn, came to London in 1755, where he set himself up as a teacher of the noble arts of fencing and riding. His pupils included royal princes, and a number of young aristocrats who were to become patrons of Stubbs'. The memoirs of Angelo's son Henry are very flowery and should not be taken too literally, but he insists that it was to the connection with Angelo that the artist owed his patronage. With Stubbs' insistence on the need to study from nature, Angelo's *manège* would have been an irresistible magnet, and Henry's assertion that Stubbs made studies of Angelo's horses is borne out by the catalogue of Stubbs' posthumous sale, which lists *Nine Studies of Horses in the managed action*. It is easy to envisage contact being established between the artist and future patrons in the sociable environment of Angelo's riding school.

HUNTING PICTURES

The Duke of Richmond and Lord Grosvenor were both pupils of Angelo and it was for these young sporting enthusiasts that Stubbs was to develop and perfect his hunting paintings. For the Duke of Richmond he painted *The Charlton Hunt* as one of a series of three pictures of sporting activities taking place at Goodwood – the other two are *Shooting at Goodwood* and *Watching Racehorses at Exercise*. For Lord Grosvenor, he painted *The Grosvenor*

48

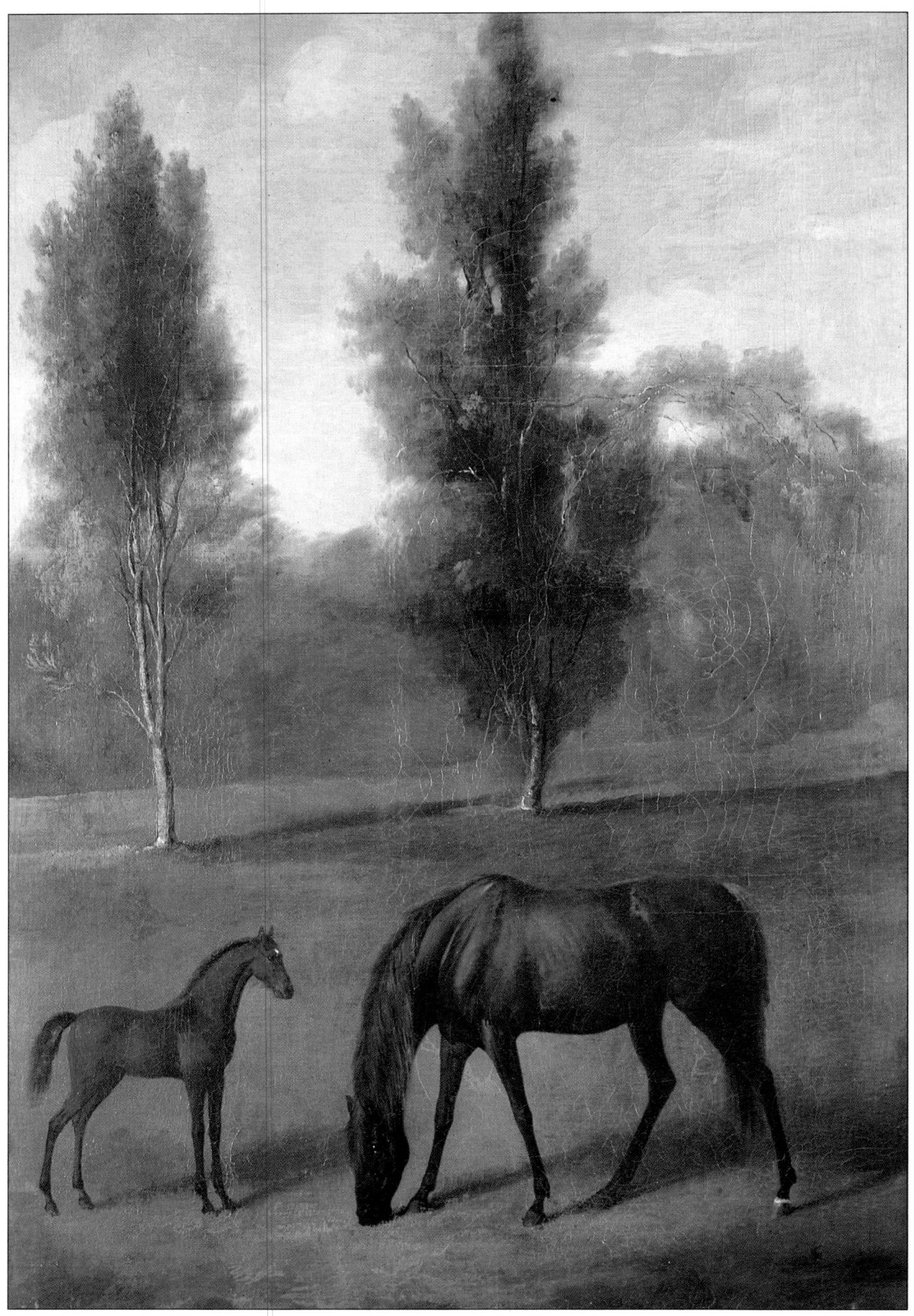

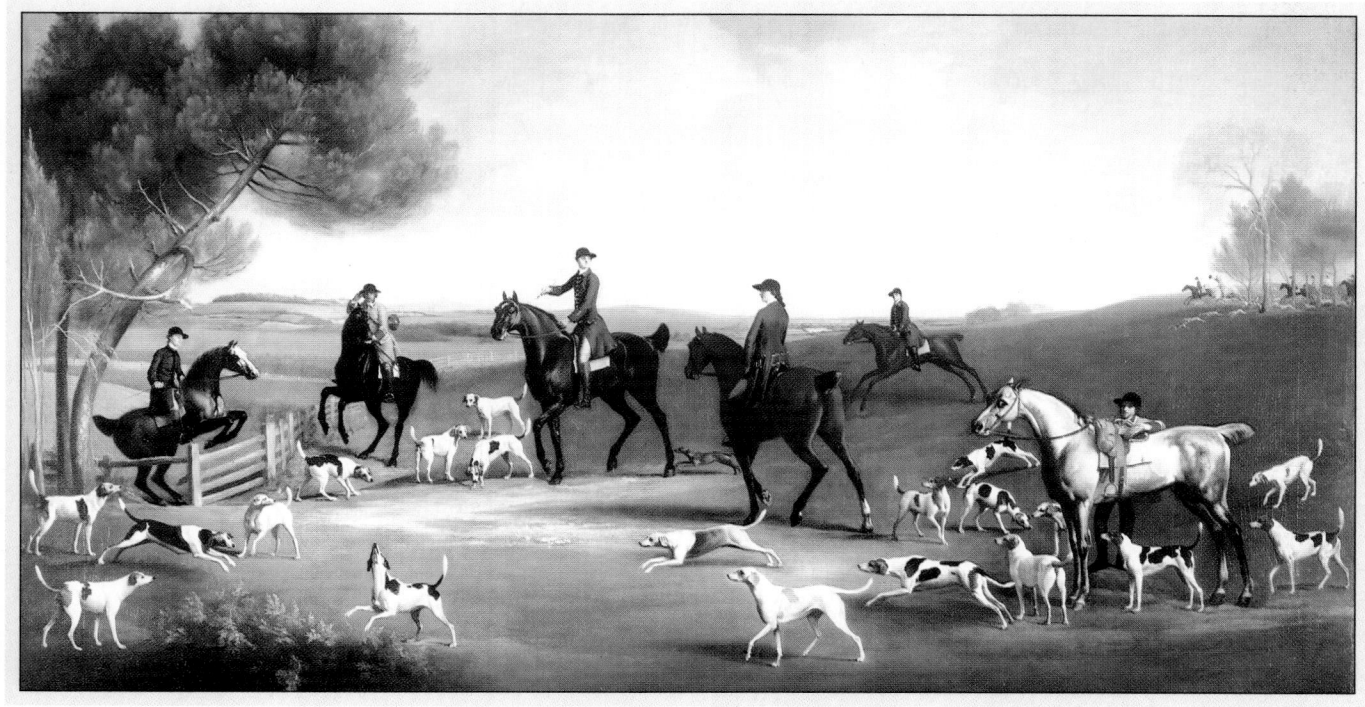

THE THIRD DUKE OF RICHMOND WITH THE CHARLTON
HUNT (?) C.1759.
*The Charlton Hunt was established in the reign of
Charles II. The third Duke of Richmond became master
in about 1756. The three principal figures are the
Duke, his brother Lord George Lennox and General
Jones. It is a complex work in which some of the spatial
problems are not fully resolved.*

Hunt, which, more than a triumph of the sporting genre, merits consideration as a work of art of the highest quality.

Stubbs spent about nine months at Goodwood, c1759/ 60, working on the commissions. *The Charlton Hunt* owes little to traditional hunting scenes such as those painted by John Wootton and James Seymour. Firstly, the subject is unusual in that it represents not a moment of triumph in the hunting field, as was customary, but a scene of disorder and confusion. The hounds have checked and do not know what to do next and the Duke is equally at a loss. No doubt the patron was involved in the choice of subject yet he did not use the opportunity to glorify himself but rather to point out the problems that can arise when foxhunting. The treatment of the landscape also owes little to precedent, being in neither the Continental manner of Wootton, nor the more native but naïve style of Seymour. The view of the Sussex landscape is appropriate to an English hunting scene and does not distract from the main theme.

The composition is easy to read, as Stubbs has given himself plenty of space in which to set his figures; and he unites them through a series of visual links to form a loose semicircle. The carefully considered construction of the design is characteristic of all his work, and is partic-

THE GROSVENOR HUNT, 1762.
*This hunting scene (over) has none of the immaturity
of the earlier* Charlton Hunt. *The bold lines of the
composition successfully unite the large number of
figures into a cohesive design of great vigour.*

ularly noticeable in the earlier examples. Through close proximity he links elements that are not necessarily in the same plane of the picture. Typical of this use of what Basil Taylor called 'false attachments' is the placing of the figure in the middle distance. It is slotted between two horses in the foreground, so that the approaching rider is related to the others, and is included in the elliptical sweep of the rest of the figures. Following this curve from the lefthand side of the canvas, the eye is led into the picture via the embrace of the overhanging tree and through the foxhound at its foot whose tail is almost parallel to the edge of the painting. The angle of the head and neck of the hound are echoed by the lines of the leaping horse, whose head leads, in turn, to the line of the tail and leg of the hound beneath it, upon which it appears to be about to land. This hound almost touches the shadow of the Duke's horse, which is in turn linked to that of his brother, Lord George Lennox, through the brown hunt terrier which does not quite touch either horse. The hind leg of Lennox' horse is outstretched and is almost touched by the shadow of the nearest hound, thus joining it to the group surrounding the grey; and

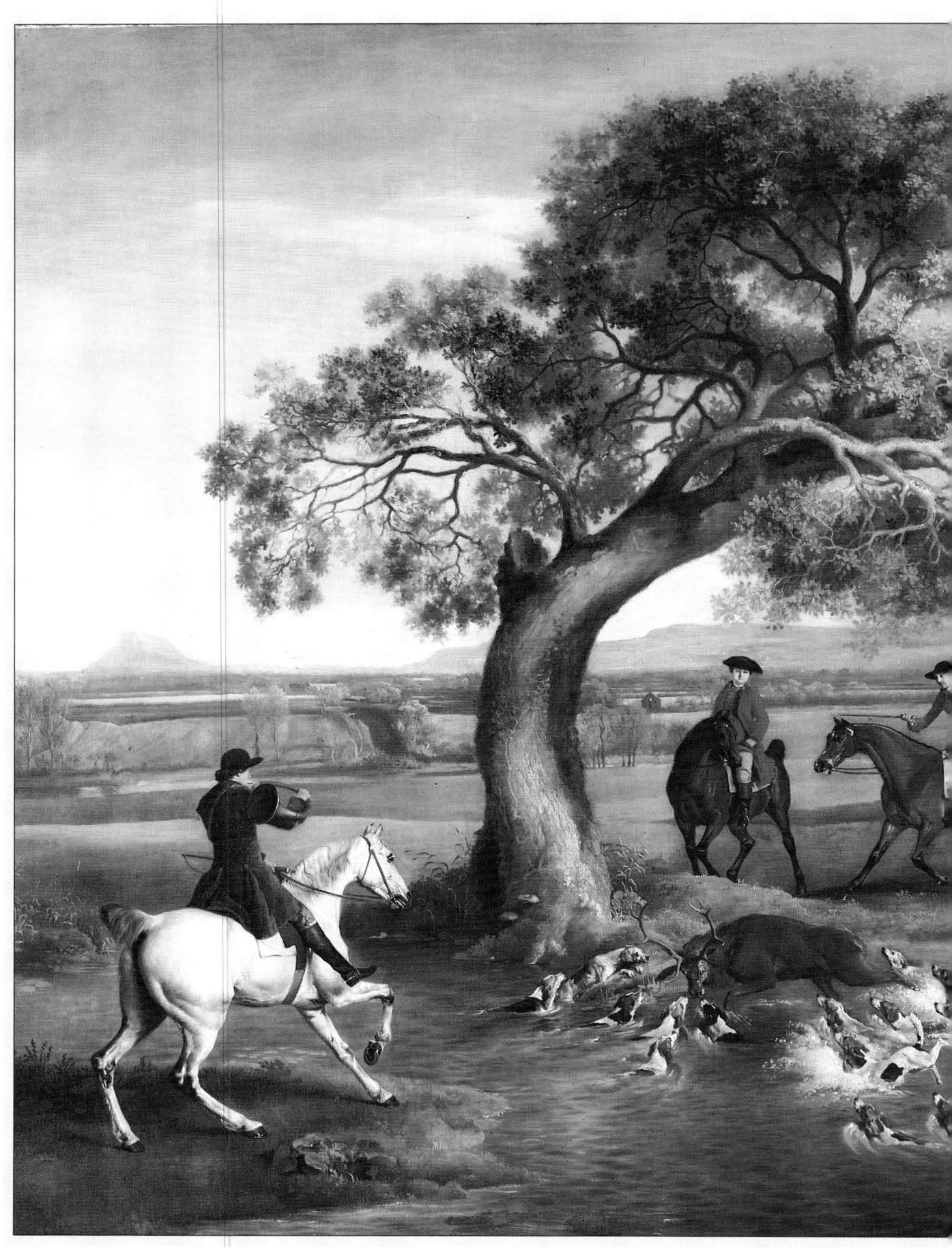

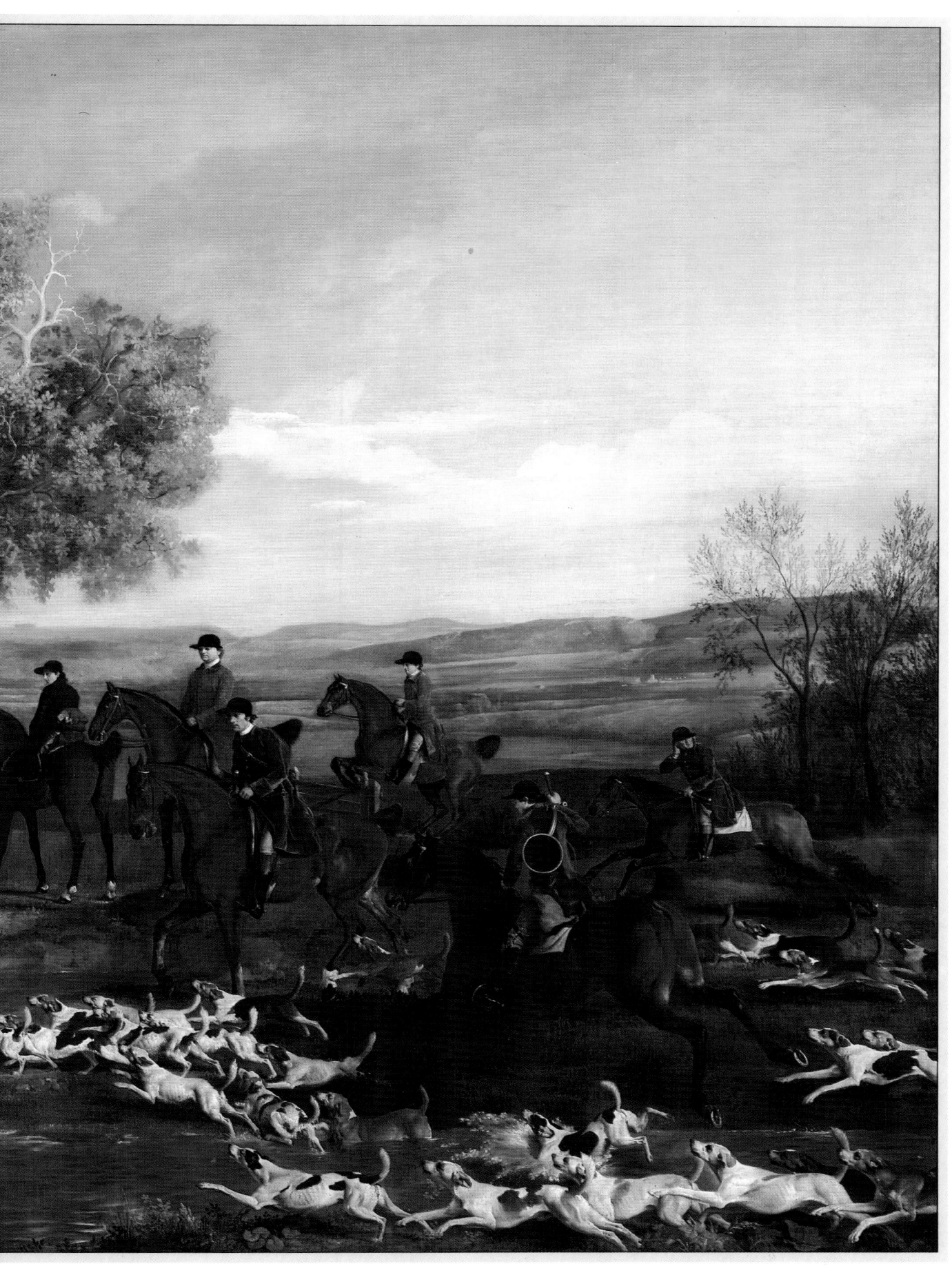

finally to the last hound on the right whose tail lies at the same angle to the edge of the picture as that of his counterpart on the left.

The distant group on the horizon in the *Charlton Hunt* are on the line of the fox and appear rather too close. One cannot help feeling that if they were as near as they seem the Duke would have heard the holloa. Stubbs has not quite given us all the information we need to place them within a realistic spatial context. Other inconsistencies can be found, such as the placing of the two hounds to the left of the Duke, where one appears to be standing on the back of the other. In this painting, Stubbs has illustrated his ability to portray horses in a variety of positions, and the foreshortening is generally convincing though the two horses viewed from the side are handled with greater confidence than those seen from an angle. Taken as a whole, it is an impressive early work, but Stubbs was to achieve his mature style using the full range of his powers in the hunting scene painted for Lord Grosvenor two years later.

The Grosvenor Hunt of 1762 depicts the last moments of a stag hunt, a subject which had been developed on the Continent during the 17th century. However, Stubbs' treatment of it transfers the chase from the realm of the imagination to the real world. Once again, he eschews the contrivance of the picturesque style in favour of a realistic English setting, in this case the view from Eaton Hall looking out over the River Dee. Stubbs sets the tone in a low key which places the artist, and thus the spectator, in the position of an unemotional witness of events. The broad open landscape is unobtrusive – the golden tones to the left of the oak tree are exquisite but do not demand attention – and easily encompasses the mass of figures which are so beautifully balanced in this masterly composition.

There are similarities between this work and a painting by Oudry of 1730 called *Louis XV Hunting the Stag*. Whatever debt Stubbs owed to the French painter, his version is so unique in design that any resemblance to Oudry's work is merely superficial. Instead of the carefully established linking elements of the Goodwood hunting scene, Stubbs used a much bolder method of construction for *The Grosvenor Hunt*. The balance of the picture is established by counteracting the vigorous thrust of the hounds and riders sweeping in from the right with the opposing movement of the huntsman on the grey horse on the left and the sweep of the oak tree. The composition pivots on the figure of Lord Grosvenor to the right of the tree, whose horse absorbs some of the movement flooding towards it. The curve of its body helps to steady the

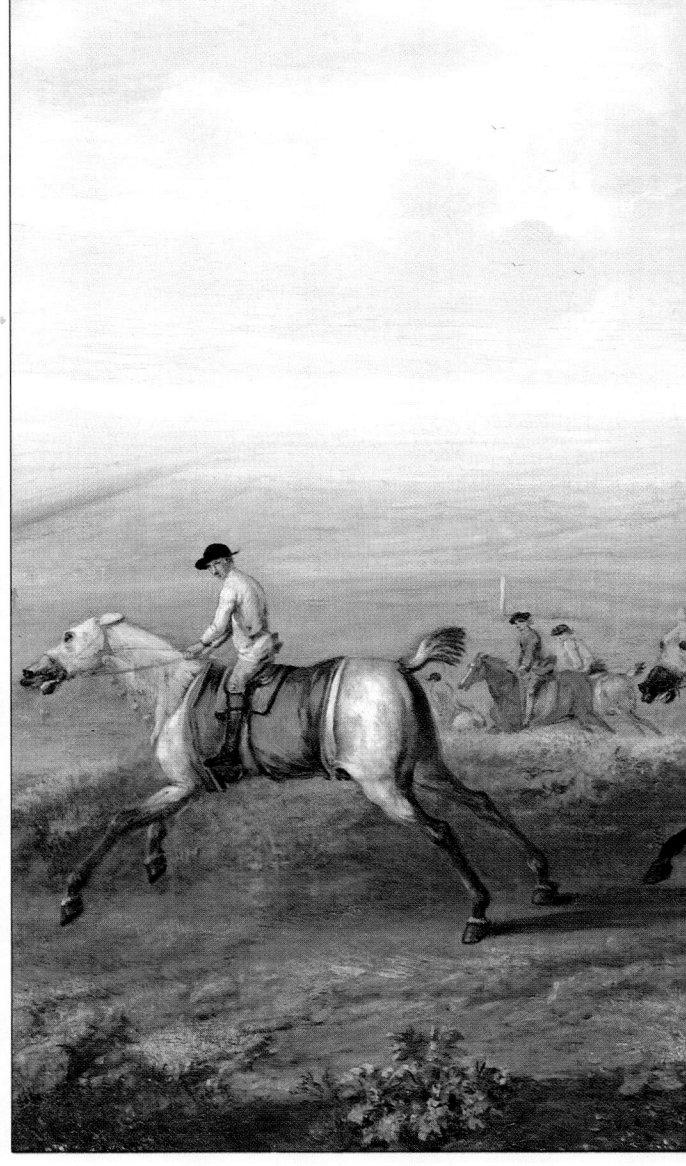

momentum, leading the eye towards the stag below.

The illusion of space is carefully controlled and is particularly successful in the left half of the painting. The grey pushes so forcefully into the picture, leaving no doubt as to the distance between the horse and the turmoil in the river beneath. The taut energy of the design is so impressive, every detail contributing to the whole with a result that is monumental in its authority. Colour plays a part in the achievement of this effect. The contrast between the huntsman's grey and the other horses is vital, and the strong red of Lord Grosvenor's coat helps to give emphasis to his central position. The quality of Stubbs' handling of the paint is superb, especially in the depiction of hounds bounding through water where his acute powers of observation are especially evident. His anatomical knowledge is displayed in the convincing realism

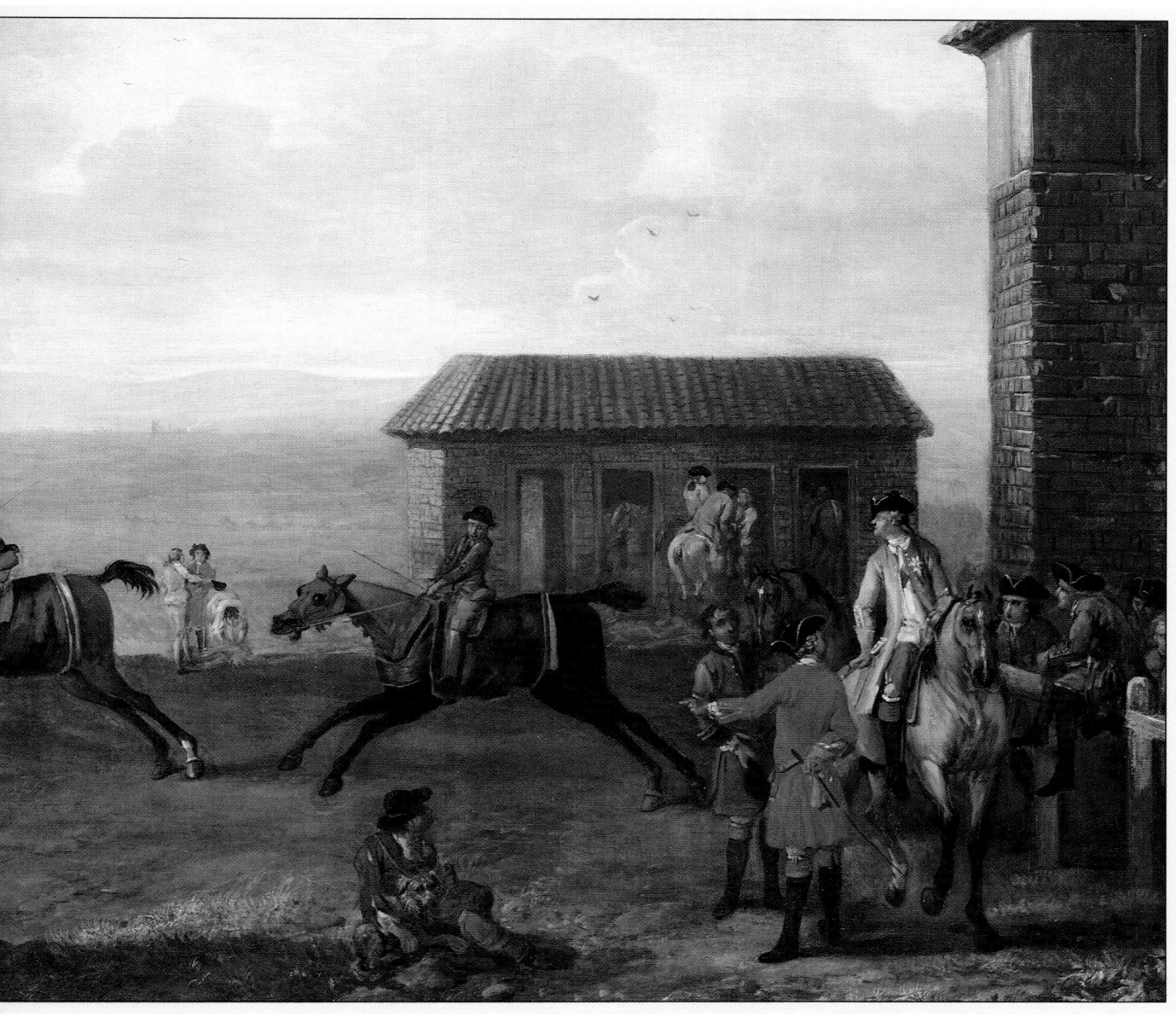

of the grey, which is so sculpturally solid yet so alive and full of energy. An impression of speed brought abruptly to a halt is expressed through the horse's bent hocks and straight foreleg, and also through the outthrust leg of its rider, who has had to brace himself against the change of pace.

It is difficult to comprehend that this painting would, until relatively recently, have been disallowed consideration as a great work of art on the grounds that it is of insufficiently elevated subject-matter.

Having achieved such high standards in the painting of scenes of the chase, it is surprising that Stubbs was to abandon this type of painting so early in his career, for there are no more works of this type following *The Grosvenor Hunt*. Changing fashion may have been the reason, but with such successful results for both the Duke of

Richmond and Lord Grosvenor, one might have expected some of the other young noblemen who frequented Angelo's academy to have commissioned something similar. The second half of the 18th century saw a marked increase in the criticism of sport and sportsmen from outsiders. Hunting and racing were seen, particularly by townspeople, as socially irresponsible, encouraging moral laxity, excessive drinking and gambling. Many spent more than they could afford in the pursuit of their interest in horses; the history of the period is littered with

THE 2ND LORD PORTMORE WATCHING RACEHORSES AT EXERCISE, C.1735 *by John Wootton. In the stiff-legged action of his horses Wootton followed the artistic convention depicting the gallop, a pace too fast for accurate observation by the human eye.*

accounts of noble families being brought to ruin in this way. Both the Duke of Richmond and Lord Grosvenor ran into debt; the latter started out as one of the richest land-owners in the country but he died in 1802 with debts of over £100,000.

The earlier association of sport with nobility, chivalry and the courtly side of life was weakened during the 18th century until it reached the point when the general view of sportsmen echoed that seen in Rowlandson's cartoons of drunken and riotous disorder. However, concern with regard to cruelty towards animals in sport is not evident until about 1790.[5] From the 1740s the trade in prints had brought sporting art to a wider public, and these influenced the layman's perception of a country lifestyle of which he may never have had any direct experience. Why was Stubbs not commissioned to paint any more hunting scenes if the sporting fraternity needed favourable publicity? The answer may be that the need was not recognized by patrons in the early part of his career, and by the end of the century fashions had changed in favour of scenes of galloping and jumping of the type painted by, among others, the Sartorius family. Stubbs' restrained and disciplined style would have seeemed out of date in comparison.

STUBBS AND MOVEMENT

Stubbs made few attempts to portray horses in action, his work is centred on images of stillness, of repose. Even in his portraits of the fastest horses in the country he was rarely tempted to refer to their speed, preferring to show them in impressive tranquillity against the silent open spaces of Newmarket Heath. The most likely reason for the small number of more active subjects is the fact that Stubbs was unable to observe for himself the true action of a galloping horse. Until the development of photography, and more specifically Eadweard Muybridge's experiments of 1872, it was thought that at speed horses bounded along in a similar way to dogs. In fact, the galloping movement of a horse is really quite flat and smooth. By taking sequential photographs of galloping horses, Muybridge proved that, at the fullest reach of its stride, a horse never has all four feet off the ground; one foreleg carries all the horse's weight while the other three legs are fully extended.

The rocking-horse action with front and hind legs outstretched, so familiar from pre-photography racing scenes, was the pictorial convention for an action that

[5]In Sporting Art in Eighteenth-century England, Stephen Deuchar examines these issues in detail.

cannot be accurately observed by the human eye. An early 18th-century artist who used it was John Wootton in The 2nd Lord Portmore Watching Racehorses at Exercise of c1735; Wootton was never too precise with regard to anatomy, but the straddled legs of these horses are particularly wooden. However, even Stubbs, the great observer, accepted the formula, which is surprising, for if he had thought through the supposed movement to its next stage he would have realized that it could not be accurate. With the rocking-horse action the horse's front and back legs are placed very far apart, and the only way for them to come together to take the next stride would be through an explosive leap of the hind-quarters. This would have rounded the back of the horse to the extent that the jockey would be catapulted from the saddle at each stride. In reality, the stride of a galloping racehorse gives a comfortable ride. However, it is unlikely that Stubbs, who weighed almost 200lb in 1782, would ever have been offered a ride on a top class racehorse and it is evident from his few representations of horses in action that he never questioned the rocking-horse pose.

The most famous of his paintings of this theme is also his earliest, one of the series of three sporting subjects commissioned by the Duke of Richmond, mentioned above. The full title of the work is The Duchess of Richmond and Lady Louisa Lennox watching the Duke's Racehorses at Exercise. It is a curious picture with an element of the surreal which arises through the incompatibility of its two halves. The righthand half is an image of intense and convincing realism, whereas on the left the three horses look like stiff wooden toys. The contrast between the grey horse and the galloping trio is so telling. The grey is painted with great assurance, every muscle, vein and sinew understood and playing its part in this remarkable evocation of life. It takes very little imagination to fill in the missing ingredients, such as the smell of the sweating horse as the grooms rub it down after its gallop.

In comparison with this tour de force, the three horses on the left seem to have arrived from another world, a world where Stubbs' knowledge of anatomy cannot help him, leaving him to fall back on convention in a way that must have been unsatisfactory to an artist who depended so much on the direct observation of nature. In spite of, or perhaps because of, the strangeness of the group on the left, it is a picture to which one can return time and again. The Duchess, her sister-in-law and the steward are grouped together in the centre and set slightly deeper into the composition than the groups to left and right. These figures are drawn together by the narrative element, as the steward explains what is going on, and also by their

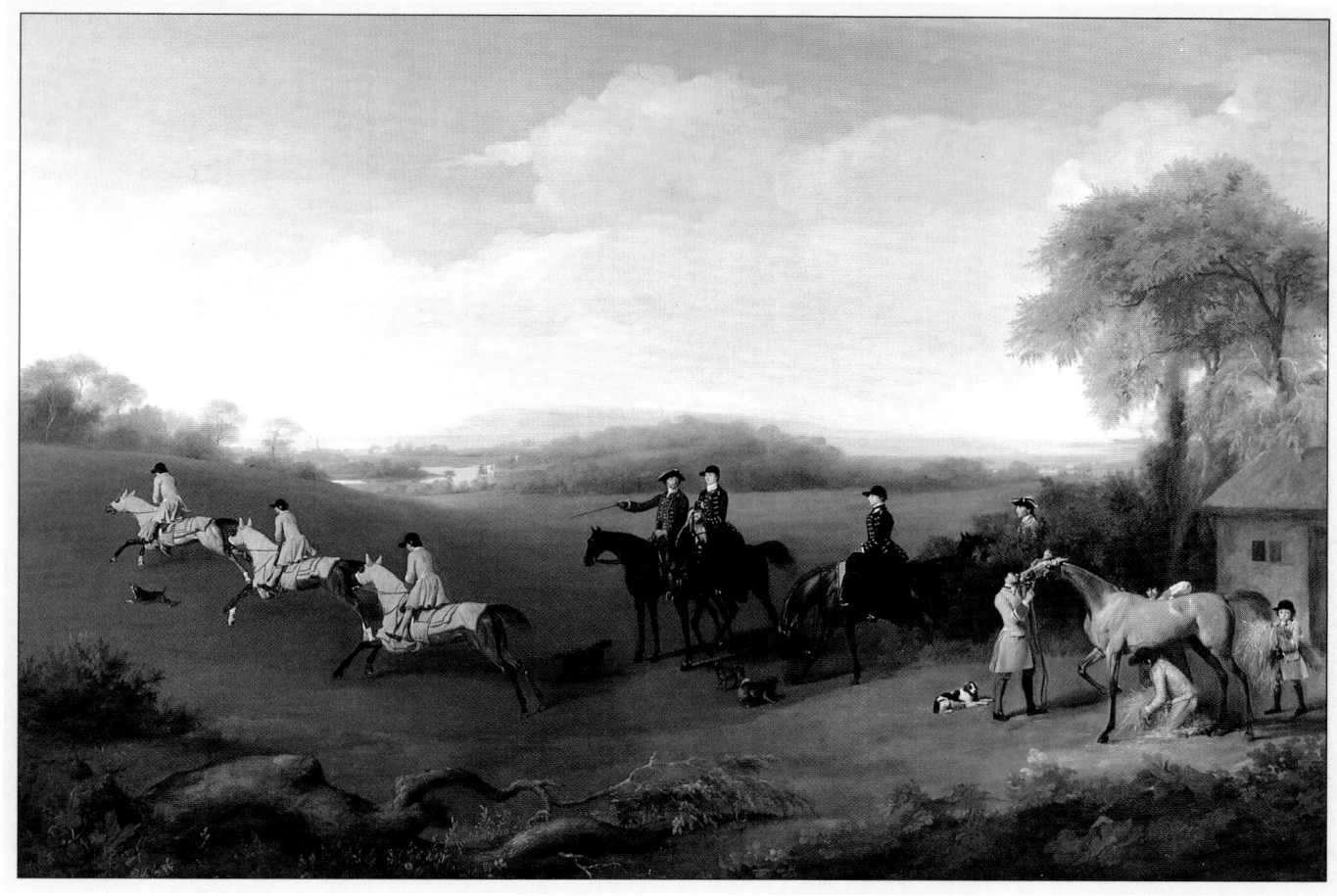

THE DUCHESS OF RICHMOND AND LADY LOUISA LENNOX
WATCHING THE DUKE'S RACEHORSES AT EXERCISE,
(?) 1760.
*The three galloping horses demonstrate Stubbs' version
of the rocking-horse pose. They appear stilted and
wooden in contrast to the lively representation of the
grey horse and his attendants.*

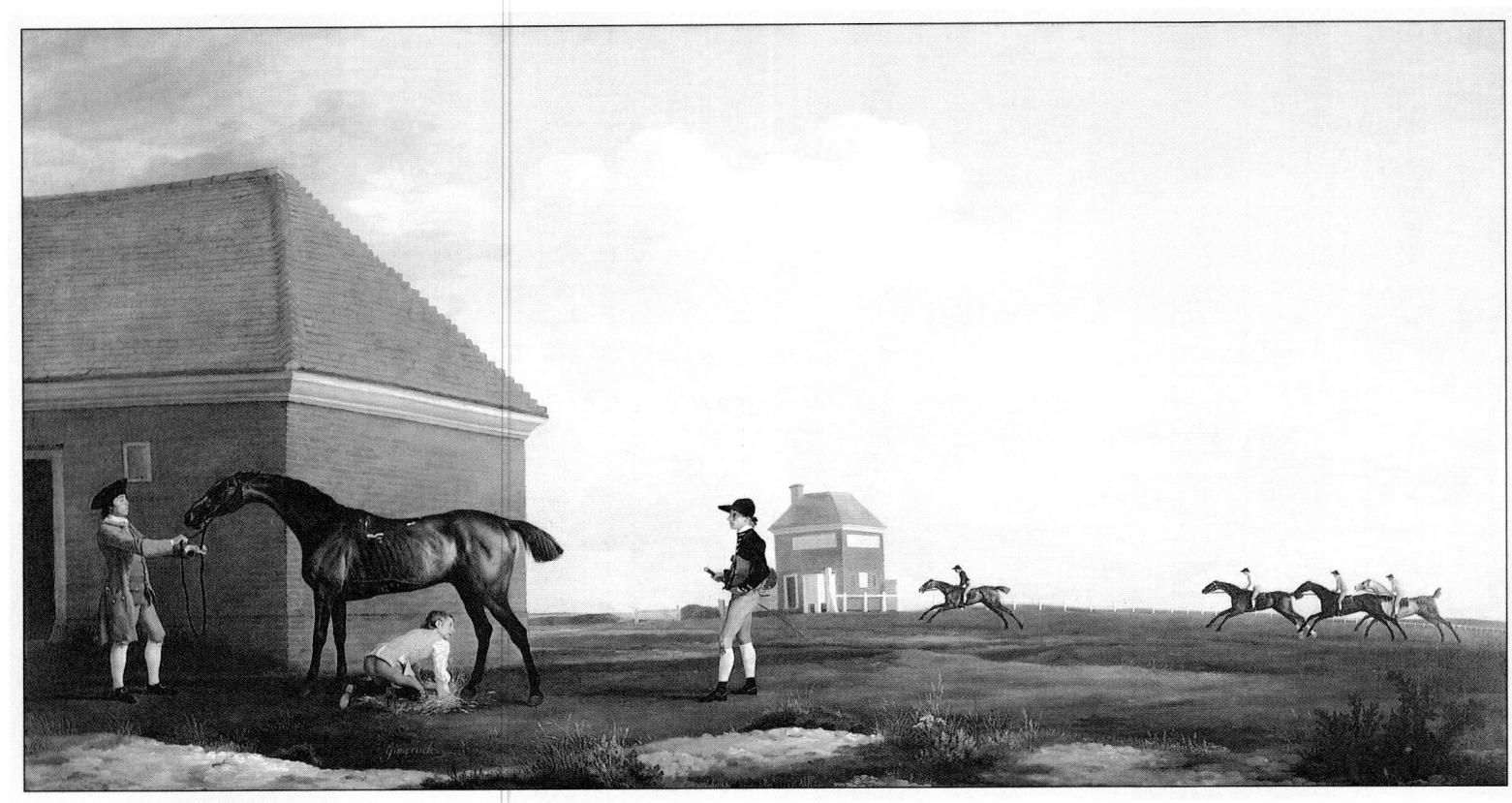

GIMCRACK ON NEWMARKET HEATH, WITH A TRAINER, A
JOCKEY AND A STABLE-LAD, 1765.
*Two different episodes are represented in this picture.
On the left Gimcrack is being dried off, after his
exertions, outside one of the rubbing-down houses. On
the right he is depicted winning a race by several
lengths.*

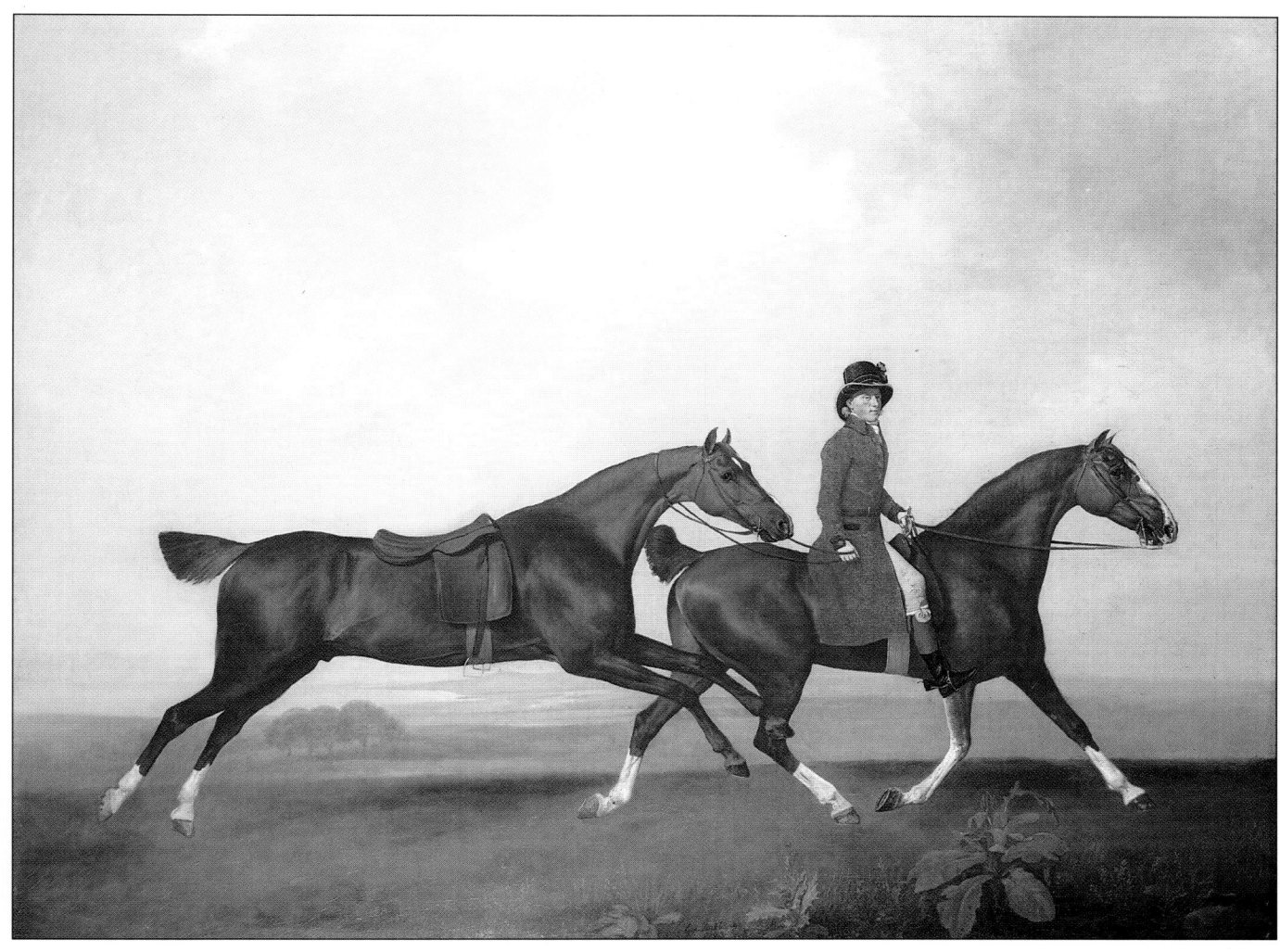

dark dress, which isolates them from the stronger colours to either side. They form the central part of a ribbon-like composition, linked to those on the left by a dog and to the right by the almost hidden figure of another rider behind the hedge. The golden livery of both horses and jockeys on the left is balanced on the other side by the grooms' coats of the same colour and the armfuls of straw of a similar colour. But the final effect is not one of stability for the eye is inevitably led deeper into the picture through the line of receding racehorses. The landscape into which they lead is painted with great delicacy, the thin almost transparent greens and misty blues do full justice to the wide sweeping view from Goodwood looking out towards the sea.

Another painting which illustrates the horse in movement is *Gimcrack on Newmarket Heath, with a Trainer, a Jockey and a Stable-Lad* of 1765. It is the only portrait of a racehorse in which he uses the old-fashioned device of a distant view of racing horses in the background. Once again the contrast between the observed and the imagined creates a strange effect, not least because the race appears to be taking place in a vacuum. There are no crowds to

cheer the horses on and the small building used as a spectator's stand is shuttered, emphasizing the emptiness and silence of the scene.

Stubbs was much more comfortable portraying horses moving at a slower pace. The painting entitled *William Anderson with two Saddle Horses* of 1793 shows that the trot presented no problems but the canter is less than convincing. He makes the best of the rocking-horse pose, but the horse looks as though it should be flying on a merry-go-round. The swinging extended trot of the ridden horse is so perfectly described that it leads one to speculate as to what Stubbs might have achieved with the benefit of Muybridge's knowledge.

WILLIAM ANDERSON WITH TWO SADDLE-HORSES, 1793.
The Prince of Wales' two chestnuts illustrate the shortcomings of the rocking-horse pose. The description of the extended trot of the ridden horse is the result of the artist's observation, and carries conviction. In contrast the cantering horse appears to float above the ground in a very unnatural manner. Despite Stubbs' best efforts, the artistic convention cannot produce a realistic result.

THE VARIETY OF THE
——————— HORSE PORTRAITS ———————

The conventional mid-18th-century horse-portrait as practised by Wootton, Seymour and their contempories was often one of two basic types; the horse was set either against a classical background of the sort associated with human portraiture, or against a background that showed some aspect of racing in the distance. Of course, there were exceptions but in almost all the horse was shown in the obvious lateral position, held by an insipid and characterless groom.

Stubbs did not ignore the conventional approach to portraits, and no doubt some of his patrons requested the familiar formula. However, at the same time he devised a new range of alternative methods with which to represent the horse. His endless reinterpretation of the theme calls to mind Gainsborough's famous remark with regard to Reynolds' portraits, 'Damn him, how various he is'. The key factor in Stubbs' horse-portraits is the greatly increased realism he was able to achieve through his understanding of their structure. However, almost as essential to the creation of this vitality was his understanding of the character of the horse, or rather of the different horses, for they are all portrayed as individuals. This makes it difficult to comprehend the viewpoint of some early 19th-century critics, who said that he made all his horses look the same.

A splendid example of Stubbs' realism is the great *Whistlejacket* of 1762. This life-size portrait is a synthesis of all that the artist had learned since his decision to concentrate his energies on the horse. The pose was almost certainly dictated by the nature of the original commission, for it is of the conventional half-rearing type based on the levade of classical riding so often associated with portraits of royalty. It was almost certainly intended to have been part of a painting of George III commissioned by the Marquess of Rockingham, who planned to have both the figure of the King and the background painted by other artists. However, the project was probably halted at this early stage for political reasons, for the Marquess fell out with the King at the end of 1762. Of course, he may have decided not to proceed owing to the excellence of Stubbs' contribution.

The Humphry manuscript version of the story favours the second reason and at the same time gives a vivid insight into Stubbs at work; Whistlejacket 'was so remarkably unmanageable that it was dangerous for any one but the person accustomed to feed him, to lead him from the stable, and to this man only that task was entrusted. The picture was advanced to such a state that Mr Stubbs ex-

pected to have finished the last sitting or rather standing, at a given hour: when his feeder was desired to attend and take the horse back to his Stall: but it so happened that it was completed before the appointed time, and the boy who held the horse for Mr Stubbs to paint from was leading it up & down a long range of stables. In the mean while, Stubbs had placed the picture advantageously against the wall to view the effect of it, and was scumbling and glazing it here and there, when the Boy cried out, "Look, Look, sir look at the horse". He immediately turned round, and saw Whistlejacket stare and look wildly at the picture, endeavouring to get at it, in order to attack it. – The boy pulling him back and checking him, till at length the horse reared up his head and lifted the boy quite off the ground upon which he began beating him over the face with a switch stick, and Stubbs likewise got up and frightened him with his pallette and Mahl stick: 'till the animal, whose tail was by this time turned towards the picture, with an intent to kick at it, but being thus baffled and his attention taken off, became composed, and suffered himself to be led quietly away.

'The Marquis came shortly after to see what progress had been made, and learning this circumstance, was so pleased with such proof of excellence of the performance, that he determined nothing more should be done to it, tho' it was on the bare canvas without a background, but resolved to have another horse painted for the purpose of introducing the king'.

Stubbs omitted backgrounds from his engravings of *The Anatomy of the Horse,* the plates of which he would have been working on at the same time as he was carrying out this commission; so he would have been aware of the advantages of such a solution but it seems unlikely that he suggested it. Whatever the circumstances, we can only be grateful that the painting was stopped before George III and a landscape were added, for it is an image of considerable power.

The stallion's volatile temperament is beautifully conveyed through the sensitive muzzle and nose and the slightly rolling eye, but the artist resists the temptation to go over the top. Some of his successors were to topple into sentimental anthropomorphism in their animal paintings, but he always stops short of giving his horses human attributes. One of the most attractive aspects of Stubbs' work is that he states the facts as he understands them without exaggeration. This applies to his treatment of the structure of the horse too, for he describes Whistlejacket's confirmation with subtlety, through the variation of his rich golden colours, without undue emphasis on individual anatomical details. The correct structure of the

WHISTLEJACKET, 1762.
*This monumental portrait is one of Stubbs' most
memorable works. As with the illustrations to the*
Anatomy of the Horse, *the plain background
accentuates the power of the image.*

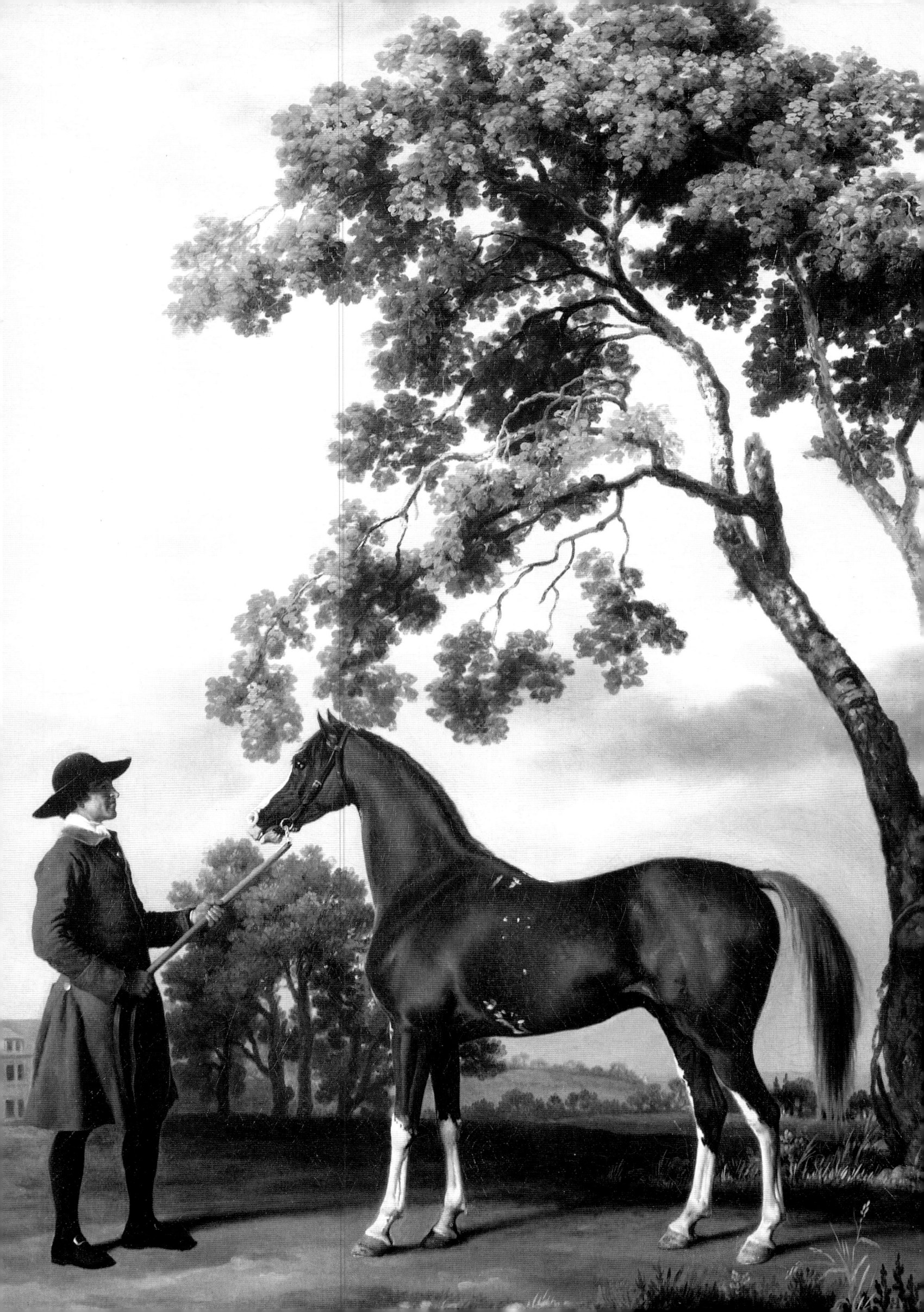

PHAETON WITH A PAIR OF CREAM PONIES IN CHARGE OF
A STABLE-LAD, C.1780—85.
*The relaxed pose of the patient stable-lad provides the
keynote of this painting. His easy elegance is matched
by that of the grey ponies and all three wait calmly for
the arrival of their master. Only the dog is impatient to
be off, but in spite of its readiness to pounce the
painting has a gentle lyrical mood.*

horse gives the work its authority but only as a hidden presence; it never overwhelms the essence of the painting. From the sharply pointed ears to the tail raised for balance, Stubbs' *Whistlejacket* portrait breathes life in a way that no other horse-painter has ever quite achieved. It is a quality which demands more than the art of the facsimilist, as the artist has had to recreate the spirit of a living creature and this requires more than the mere copying of its appearance. A comparison of this work with that of any other horse-painter illustrates the extent to which Stubbs surpasses them all.

THE IMPORTANCE OF
———— SUBSIDIARY FIGURES ————

As well as the increased realism of his portraits, Stubbs refined the genre in a number of other ways, one of which was to give the handler of the subject a more meaningful role. In *Lord Grosvenor's Arabian with a Groom* of c1765, Stubbs has used the groom as an anchor in the composition. He appears to act as stabilizer to the young horse through his firmly planted position and the dark sombre colours of his clothes, which contrast with

LORD GROSVENOR'S ARABIAN WITH A GROOM, 1765.
*Stubbs succeeds in conveying the highly-strung
character of this little stallion through its alert pose with
high head carriage. The taut muscles beneath the
polished coat add to the impression of an animal full
of nervous energy. The groom watches it carefully,
though without apprehension.*

the bright liver chestnut and flashy white stockings of the colt. Though the groom appears to have control of his charge the horse retains its superiority; its lofty gaze into the distance ignores the man at its side who watches his expression attentively. He is relaxed yet alert to the possibility of the horse swinging round suddenly; it seems poised for action and could lose its composure at any moment. This Arab has that metallic sheen to its coat which is characteristic of stallions, but it is badly marked with unsightly white spots. These spots show that, in the past, the horse has had severe saddle sores. Several of Stubbs' portraits show similar patches and it seems extraordinary that these valuable animals should have been exposed to such poor management. However, their inclusion serves as a reminder that Stubbs did not idealize his portraits but painted from the evidence before him.

Another painting in which the attendant has an important role is *Phaeton with a Pair of Cream Ponies in charge of a Stable-Lad* of c1780-85. This boy is vital to the design of the picture, where he and the dog form a counterbalance to the matched cream ponies. He also sets the mood of the image. In spite of his youth he regards his

charges with calm confidence, and they seem to defer to him with their bowing heads. Here it is the phaeton which takes the subsidiary role; in other paintings he gives this smart type of carriage more emphasis. Stubbs' grooms, stable-lads, coachmen and other attendants introduce a new dimension to a type of picture which in the hands of most artists is rarely other than a more or less accurate likeness of the horse concerned. In doing so he turned the form of his horse-paintings into something close to the conversation piece, the type of group portrait which was so popular in England in the middle of the 18th century.

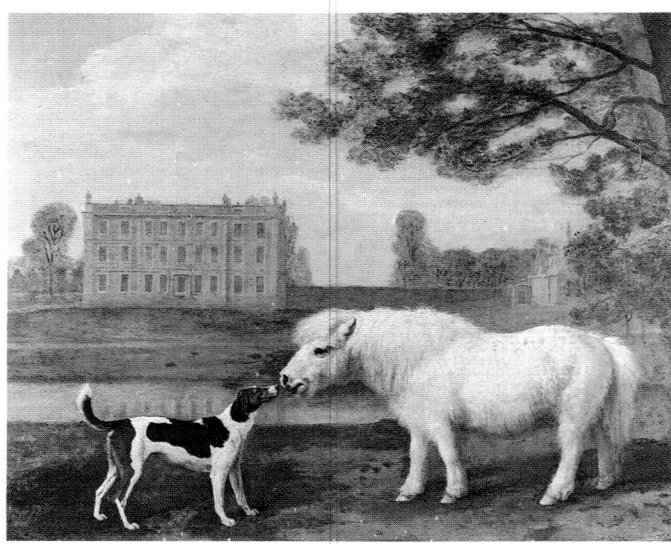

Dogs play a similar role in the horse-portraits, and are also frequently important to their design. In *Two Hunters with a groom and a Dog* of 1779 the success of the construction is dependent on the dog, though its impact on the painting as a whole is not great. In this very inventive composition, the small terrier joins the two halves together by preventing the eye from dropping to the ground between the horse on the left and the groom; instead, the line of rhythm follows the direction of its gaze to the gesturing groom and thus to the other side of the canvas. In *An Old Pony and a Hound* of c1777 the hound is again a vital part of the arrangement of the painting; with Brocklesby Hall in the background, the animal forms the counterbalance to the pony and the overhanging tree. The sociable sniffing of the hound has enabled the artist to show the pony looking grumpy with its ears back, an attitude all too frequently expressed by Shetlands, who are not noted for their good nature. The pony is refreshingly scruffy, in contrast to all the beautifully groomed and glossy-coated hunters. The Pelham children had learned to ride on it and Lord Yarborough had commis-

TWO HUNTERS WITH A GROOM AND A DOG, 1779.
The figures are related to the background by means of the overhanging tree. Its lowest branches overlap with the bay horse's head and neck creating a 'false attachment' (above).

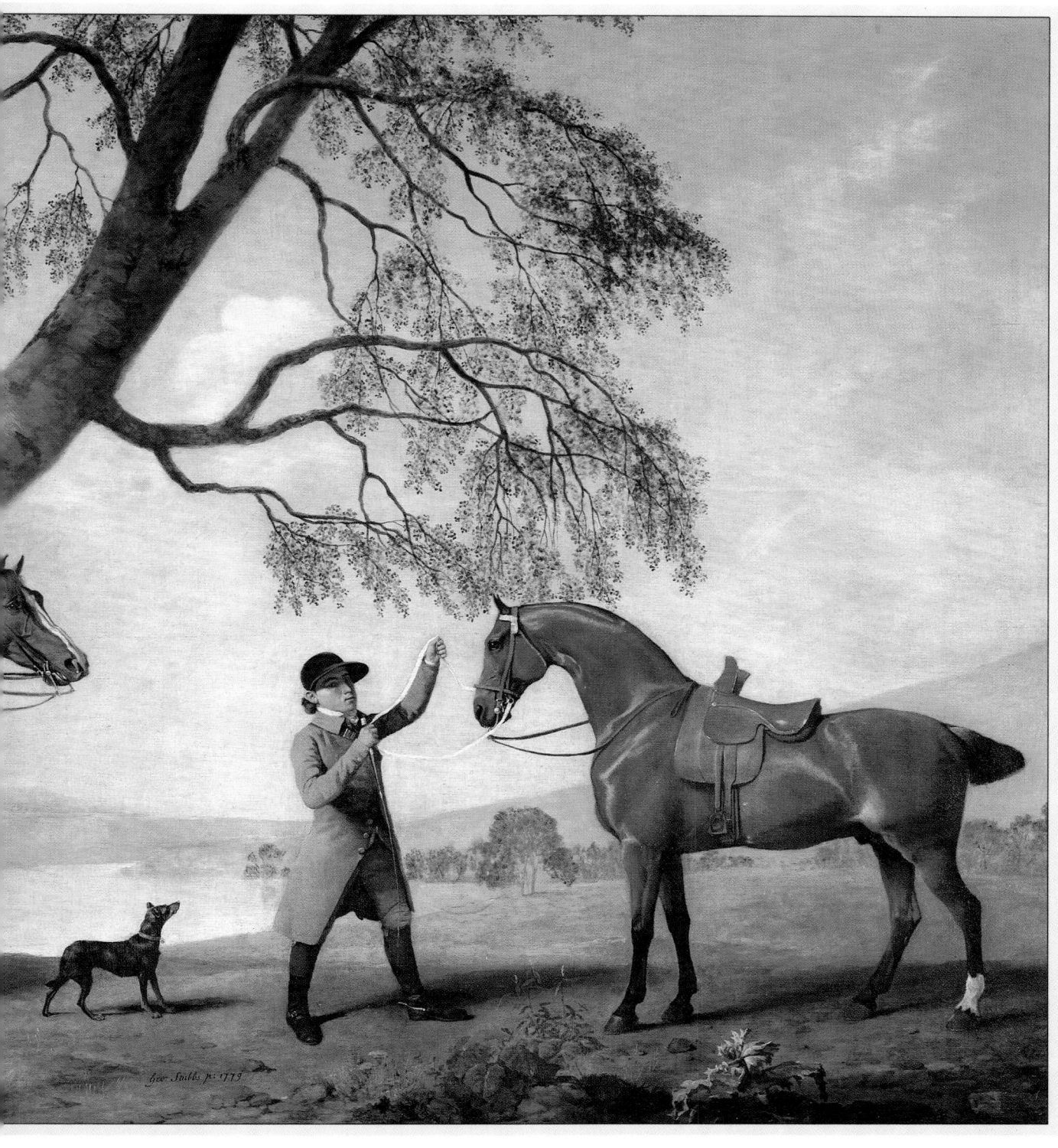

sioned the painting, who 'in gratitude for past services had his picture drawn in the 28th year of his life' (from an inscription on the back).

Another painting in which a dog plays a key part is *The Prince of Wales' Phaeton* of 1793, but it would be stretching the term to describe this as a horse-portrait, for it is just as much a study of the coachman or the carriage as it is of the horses. It is one of Stubbs' most unusual works, in which the various elements are unified not only through linking linear rhythms but also through colour. Dark browns or blacks together with a strongly contrasting red are used to create interesting associations, within which the bold red of the state coachman Samuel Thomas' coat forms the focal point. The dog, Fino, links the tiger-boy and the phaeton on the right to the rest of the composition, startling both horses in the process. As well as joining the

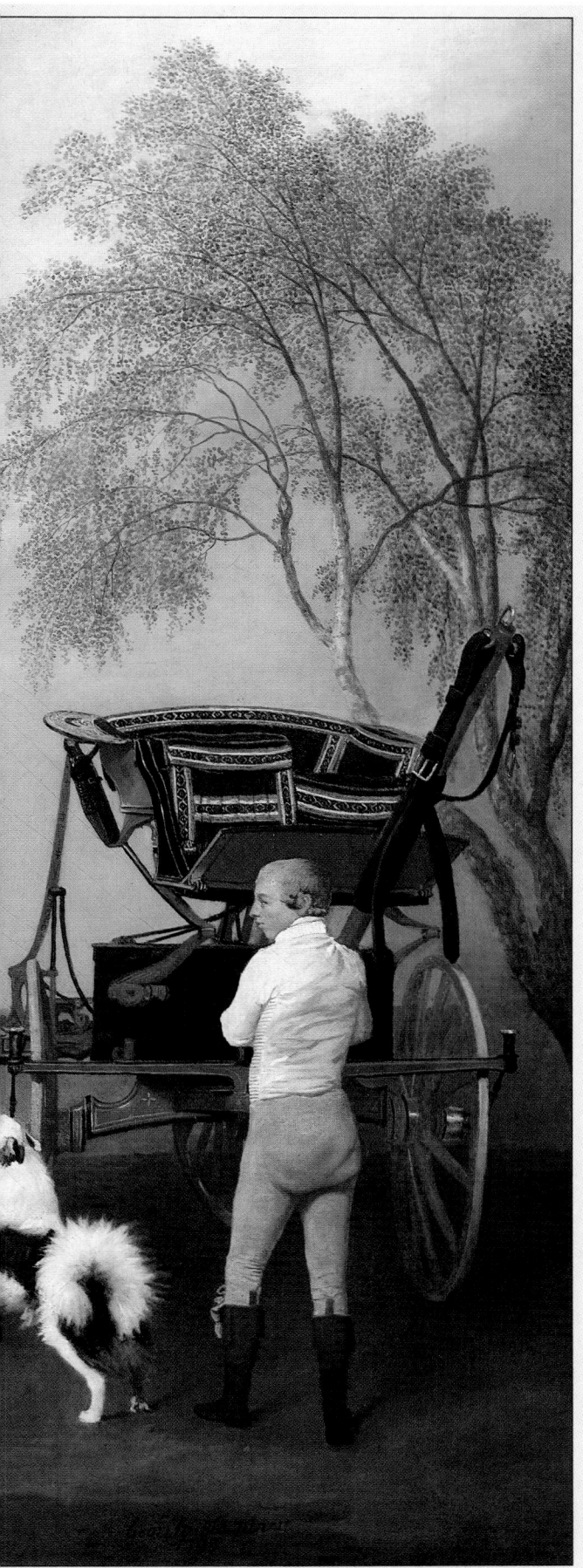

two sides of the composition through his leaping body, Fino's outburst has drawn the tiger-boy into the painting by attracting his attention towards the centre, where one horse is standing free, ready to whip round and disappear at any moment. Thus, once again, the artist has introduced a psychological link involving one of the horses' attendants. The handsome Pomeranian Fino can be seen below (Chapter 5) in full fluffy-coated glory in *Fino and Tiny* of (?)1791.

——— LANDSCAPE SETTINGS ———

A further means of introducing variety into his horse-portraits was through different types of landscape. A number of Stubbs' works are set in a specific English location called Creswell Crags. Some of his lion and horse paintings are situated there, as is the first and last of his shooting series and several horse-portraits. It is a rocky area near the Nottinghamshire-Derbyshire border where high limestone cliffs overhang a small river. The setting probably attracted the artist because of the strong contrast between its wildness and the usual parkland settings he painted. It is possible that he used it for the first time in his early lion- and horse-paintings, for which it would have been particularly appropriate.

The *Grey Hunter with a Groom and a Greyhound at Creswell Crags* c1762–4, may have been the first portrait to make use of this location. Mrs Egerton points out that this picture appears to have been painted from life since later versions do not have the same feeling of real creatures observed in a real place. The natural features allow Stubbs to devise an interesting and original composition which is wholly convincing because it has been studied at first hand. The craggy bluff forms a strong dark backdrop for the body of the pale grey horse, leaving the heads of both horse and groom to stand out clearly against the weaker surround of sky. The heads of all three figures on the left create a strong emphasis on one side which is countered by the cliff and overhanging tree at its foot on the other; the body of the grey acts as a pivot of this see-saw. By these complex means Stubbs achieves an image of great stability, which is so characteristic of his best work.

Another painting, the *Self-portrait on a Grey Horse* dated 1782, appears to be set at Creswell Crags, or at least in an imaginary landscape composed of elements drawn from the area. The rocky outcrop and twisted tree are

THE PRINCE OF WALES' PHAETON, 1793.
*Bold colours play an important part in the design of
this painting. The sharp reds punctuate the linear
rhythms of the composition, with interesting results.*

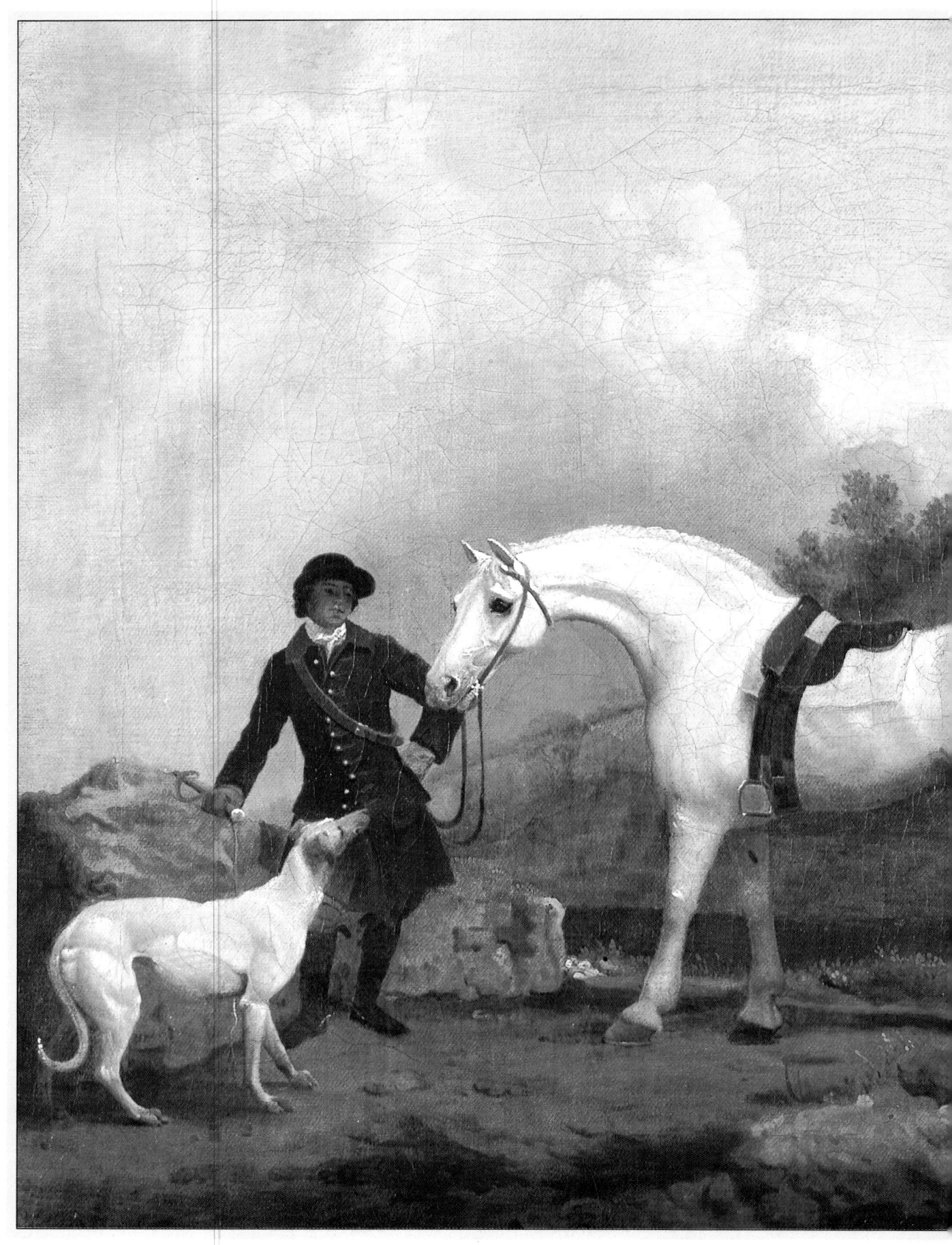

similar to others associated with this location, but lack the sharp first-hand quality of the previous example. Painted in enamel colours on a ceramic plaque, the pale grey horse stands out boldly against the deeply shadowed background.

It is interesting to note that both these Creswell Crags studies are of grey horses. Is it possible that Stubbs developed the use of the dark shadows of the cliff in his portraits because of the contrast they provided to these light-coloured horses? A painting which may pre-date the first of the Creswell Crags portraits is *A Son of Old Sterling* c1762. Here Stubbs has used imaginery rocky outcrops to form the background to a particularly handsome dappled grey. The scenery cannot have been painted from nature for the treatment is too vague and the result is very insubstantial. The area behind the horse's head is particularly poor and looks as though the artist has simply filled the space between the tree and the hedge with a wash of dark grey, with little attempt to describe the rock formation. Perhaps Stubbs, dissatisfied with this result, looked to Creswell Crags to provide him with a real landscape setting which would enhance the delicate tones of these light-grey horses.

RACEHORSE PORTRAITS

Stubbs' portraits of racehorses can be divided into two categories. Firstly, there are those showing horse and handler in open parkland, among which are some of the least interesting of his works; secondly, there are those set on Newmarket Heath, which are highly original paintings of a very different type. A fine example of the former is *Bandy* c1763, commissioned by Lord Grosvenor at about the same time as *The Grosvenor Hunt*. The portrait departs a little from tradition in showing the horse at a slight angle to the plane of the picture and in the use of the dog as a compositional device, but otherwise it is of the conventional formula of racehorse with attendant of which there are several examples in his work.

The Newmarket Heath series are much more innovatory in conception, and to Stubbs' contemporaries must have

GREY HUNTER WITH A GROOM AND A GREYHOUND AT CRESWELL CRAGS, C.1762–4.
This work has the crisp realism of first hand observation. The landscape in later portraits in this setting is rather more generalized (previous page).

BANDY, EXH. 1763.
The lateral position of the horse was preferred by owners and breeders as it gave the best view of its good points. In this case it also shows up Bandy's crooked leg, from which he was given his name. In spite of what appears to be a serious defect, he was a successful racehorse and sire.

seemed daring in their originality. The key constituent of all these paintings is the rubbing-down house, a small brick building used by the grooms for drying off their charges following a race. Stubbs was clearly intrigued by the pictorial potential of this house – his only surviving pure landscapes are both of this subject – and he uses it to achieve a variety of effects in these portraits. In *Eclipse at Newmarket, with a Groom and a Jockey* c1770, it provides a frame for the jockey, the groom and the head of

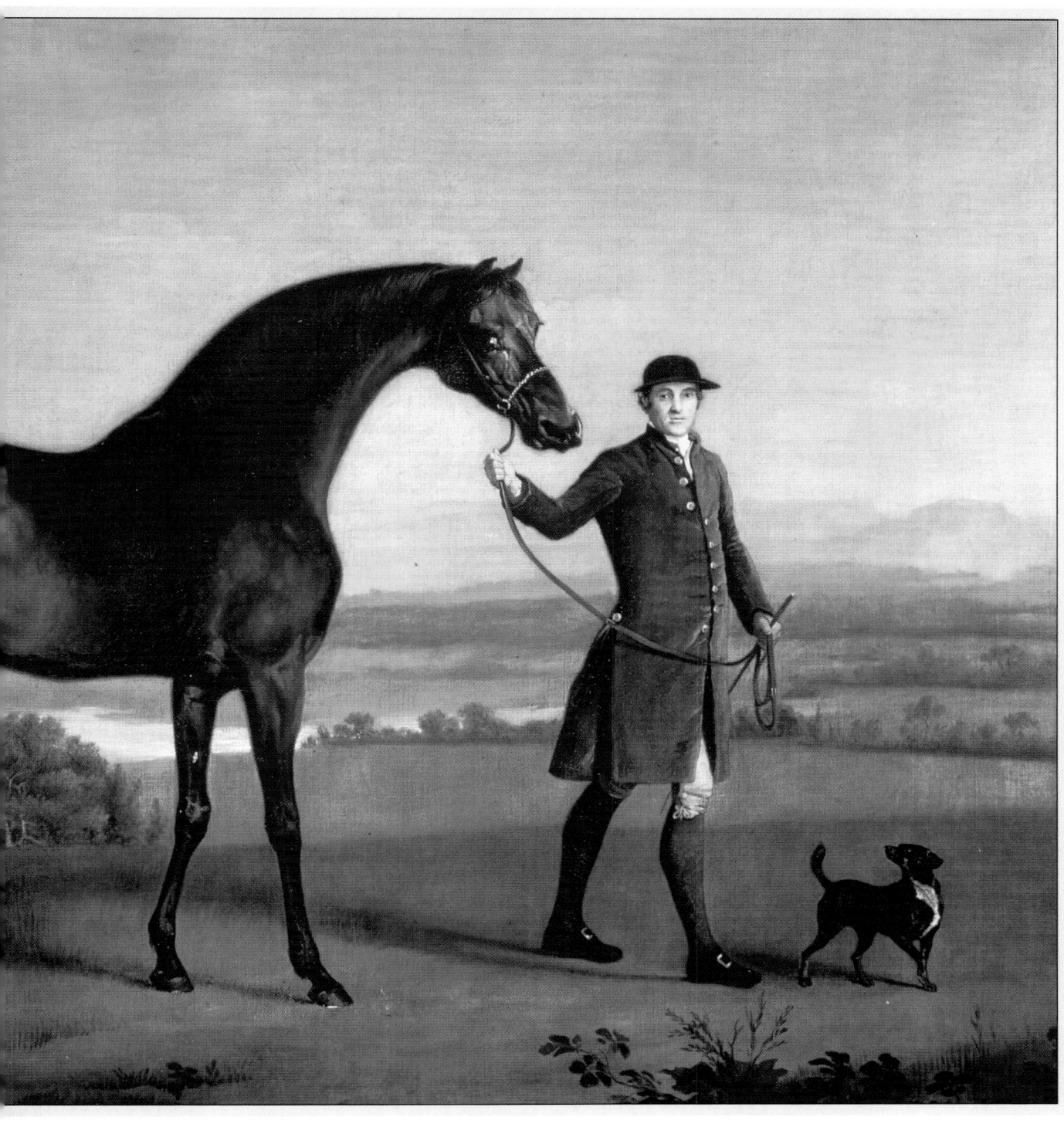

Eclipse, but it also adds a clear, crisp three-dimensional element which defines the space in which these figures are set and extends it to that which encompasses the building. The rubbing-down house is an exercise in perspective, and we know from Josiah Wedgwood's letters that Stubbs believed that an understanding of perspective drawing was fundamental to an artist.

However, having painted the figures with his customary realism and set them in a convincing space, Stubbs gives the whole painting a totally unrealistic emptiness and silence. He never portrays, or even hints at, the hurly-burly of the day at the races; the noisy, excitable and frequently drunken crowd are exluded from his racing scenes. A partial explanation for this omission may lie in Stubbs' method of painting, for it seems likely that the finished Newmarket pictures were built up in the studio from sketches and drawings of his direct observations of both figures and landscape. The preliminary studies were

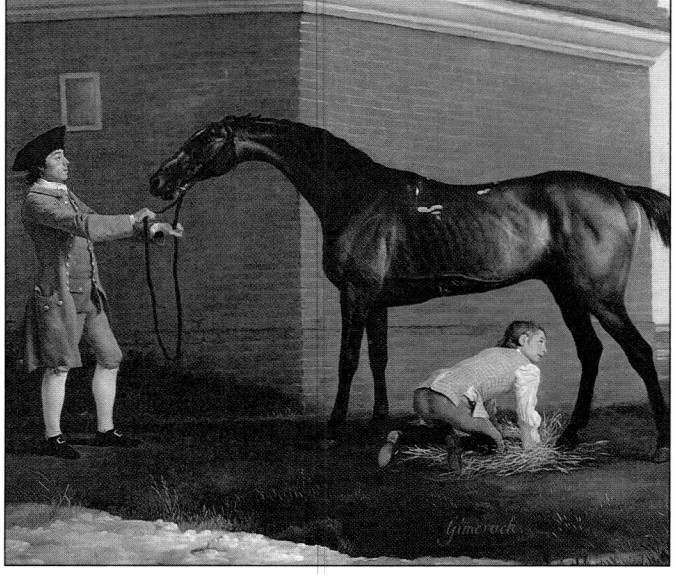

One of only two pure landscape studies to have survived. The other is a companion to this one and shows the same rubbing-down house from a different angle.

GIMCRACK ON NEWMARKET HEATH, WITH A TRAINER, A
JOCKEY AND A STABLE-LAD, C.1765, DETAIL.
In the aftermath of the race, the figures appear united by their relationship to the horse, and by their shared memories of its recent success.

presumably made on days when there was no racing, so the absence of a crowd would not have appeared to the artist as contrary to nature; he was not eliminating it for it had never been present. Stubbs was a solitary man who might not have enjoyed the hustle of the racecourse, and his avoidance of it in his art leads to some memorable paintings, made all the more exceptional by this suspension of reality.

The *Gimcrack on Newmarket Heath, with a Trainer, a Jockey and a Stable-Lad* c1765 is the most remarkable of the racecourse pictures, ostensibly a portrait of the celebrated Gimcrack but in reality a much more complex work. It divides into three distinct sections with Gimcrack, his trainer and groom on the left, the jockey in front of the spectators' stand and the racing Gimcrack in the centre,

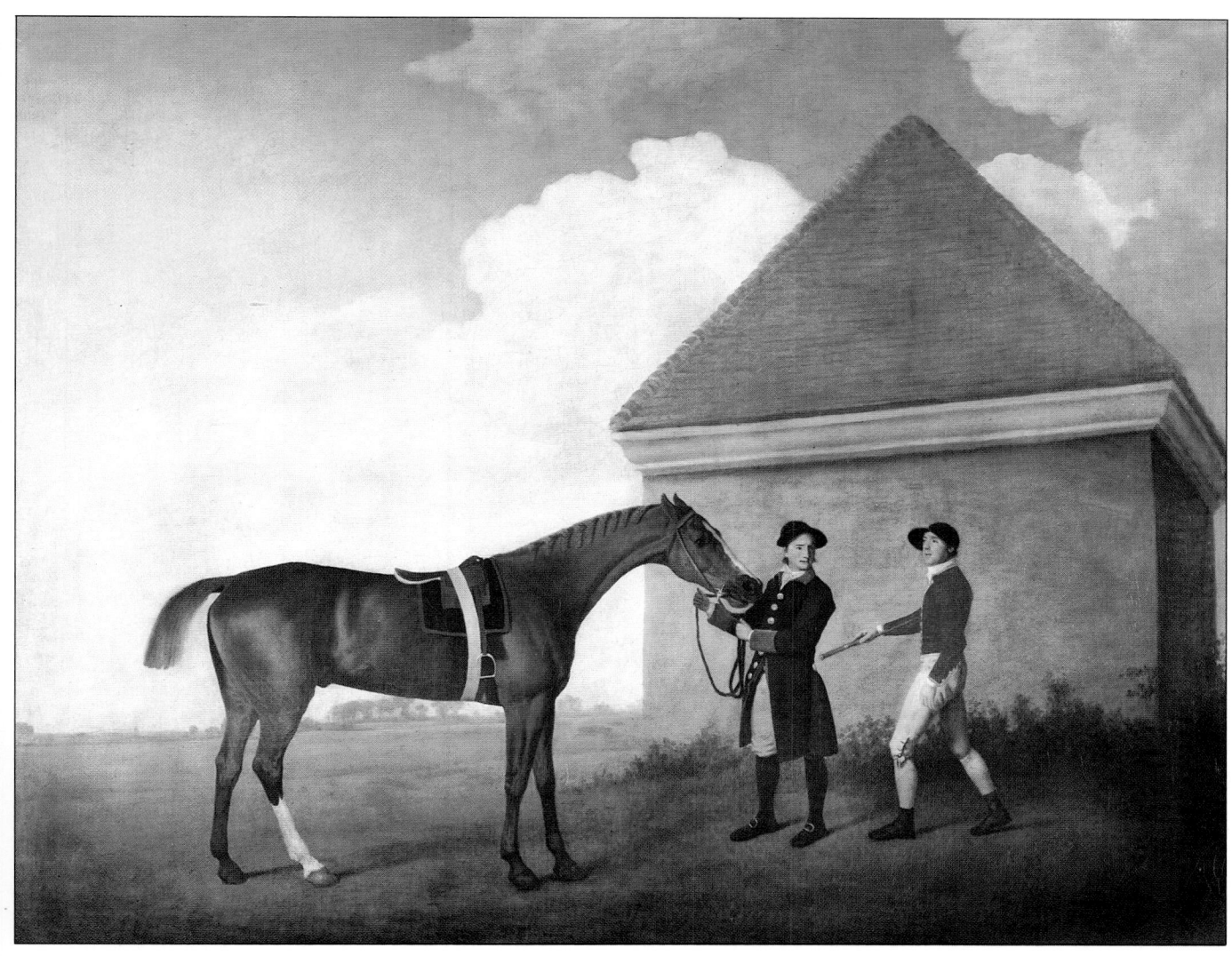

and the three pursuing horses on the right. The central group is interesting because it represents a connection in time as well as space. In the race which takes place in the background the horses would have passed the spectators' stand, and at the time of the rubbing-down the same building would have been visible in the background, so it provide a common factor between two separate episodes. The jockey's saddle just overlaps the side of the stand, providing a visual link in that direction, whilst his gaze is directed towards Gimcrack, focusing attention on the left-hand group.

Alternatively, the composition can be divided into two rather than three sections. By dividing it in half through the spectators' stand, the present is shown on the left and the past on the right, joined by the memory of the race which presumably occupies the thoughts of all three figures. The rubbing-down house is painted here with great authority, and its crisp realism gives credibility to this side of the composition. Assuming that Viscount Bolingbroke asked Stubbs for a painting of Gimcrack, it

seems surprising that the hero of the story should be shown with his head in shadow. In contrast, the human faces are strongly lit, all three are detailed portraits on a small scale. The horse and his entourage are powerfully lifelike, and the wide view of the deserted Heath with its low horizon and vast sweep of sky are all painted in the most convincing terms.

Stubbs almost persuades us that his version of events is true, that racing days were quiet, orderly affairs. For the other side of the story the artist George Morland (1763 – 1804) left an account of his experiences on the racecourse at Margate. 'I rode for a gentleman, and won the heat so completely, that, when I came in to the starting-post, the other horses were near half a mile behind me, upon which near 400 sailors, smugglers, fishermen &c. set

ECLIPSE AT NEWMARKET, WITH A GROOM AND A JOCKEY,
C1770.
This is one of a series of racehorse portraits set in the empty silence of Newmarket Heath. The rather unprepossessing horse was one of the most successful racehorses of the 18th century.

72

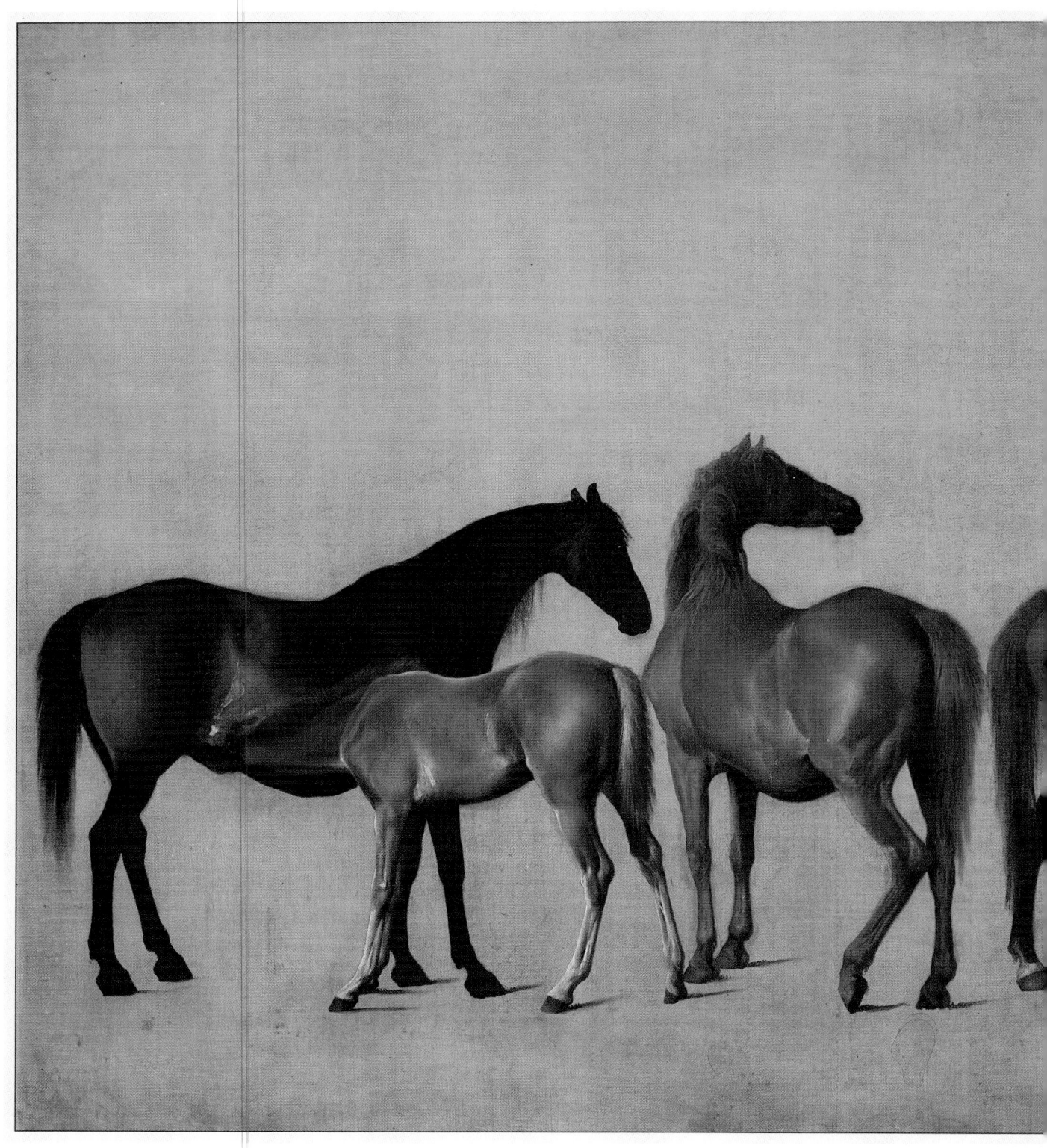

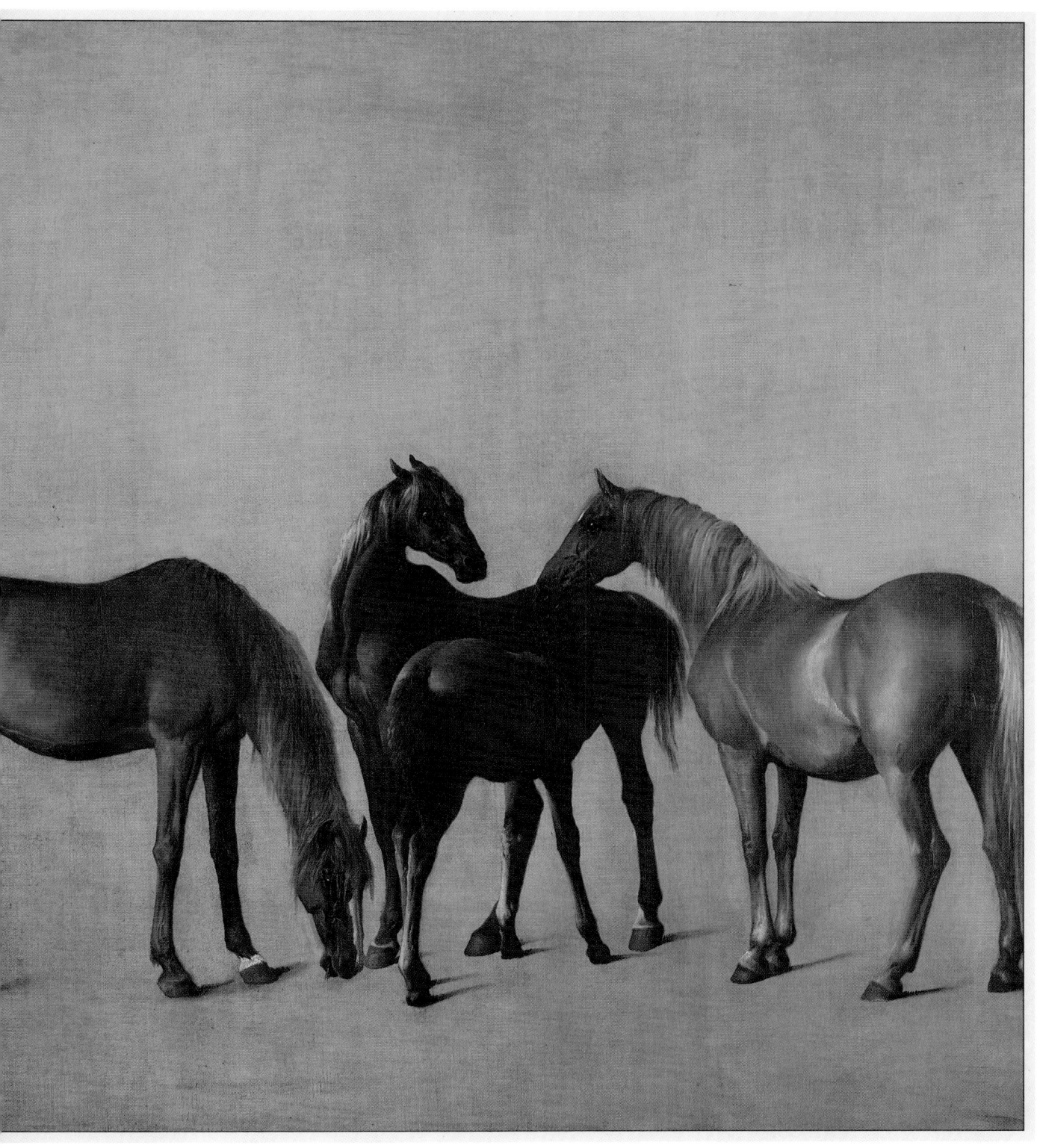

MARES AND FOALS WITHOUT A BACKGROUND, C.1762.
*Stubbs is recorded as saying that he studied from
nature alone, but this work owes as much to the
classical art of Italy as to nature.*

THE LAST SUPPER, 1497
*by Leonardo da Vinci. Parallels can be drawn
between the design and rhythms of Stubbs'* Mares and
Foals without a Background *and those of the masters of
the High Renaissance.*

DISPUTA, 1509
by Raphael. It is very likely that Stubbs saw this fresco during his visit to Rome.

about me with sticks, stones, waggoners' whips, fists, &c... the sounds I heard all were, kill him! strip him! throw him in the sea! cut off his large tail! and a hundred other sentences rather worse than the first'.[6] It is sometimes hard to keep in mind that Stubbs' paintings are creations of an artistic imagination and not direct transcriptions of 18th-century life.

———————— MARES AND FOALS ————————
Another kind of horse-portrait in which Stubbs develops his art far beyond the mere recording of likeness is his group of studies of mares and foals. Together they form a testimony to the 18th-century English gentleman's passionate interest in improved stock breeding. In this case the paintings refer to developments in the thoroughbred racehorse, but this was only one aspect of the vogue; dogs, cattle, pigs and sheep were all intensively 'improved' in the late 18th and early 19th centuries. Most of the *Mares and Foals* were painted during the 1760s, that most fertile period of Stubbs' career.

The first of this series was probably commissioned by the Marquess of Rockingham, the *Mares and Foals without a Background*, paid for in 1762. This painting reveals the artist's debt, whether he was conscious of it or not, to the classical art of Italy. First, there are the overtly frieze-like qualities of its design. The horses are placed in profile, each silhouette linked to the next and set in shallow space in the manner of an antique bas-relief sculpture, of which Stubbs must have seen numerous examples during his visit to Rome. Second, the composition contains

[6]From *The Life of George Morland* by George Dawe, quoted in *Sporting Art in Eighteenth-century England* by Stephen Deuchar

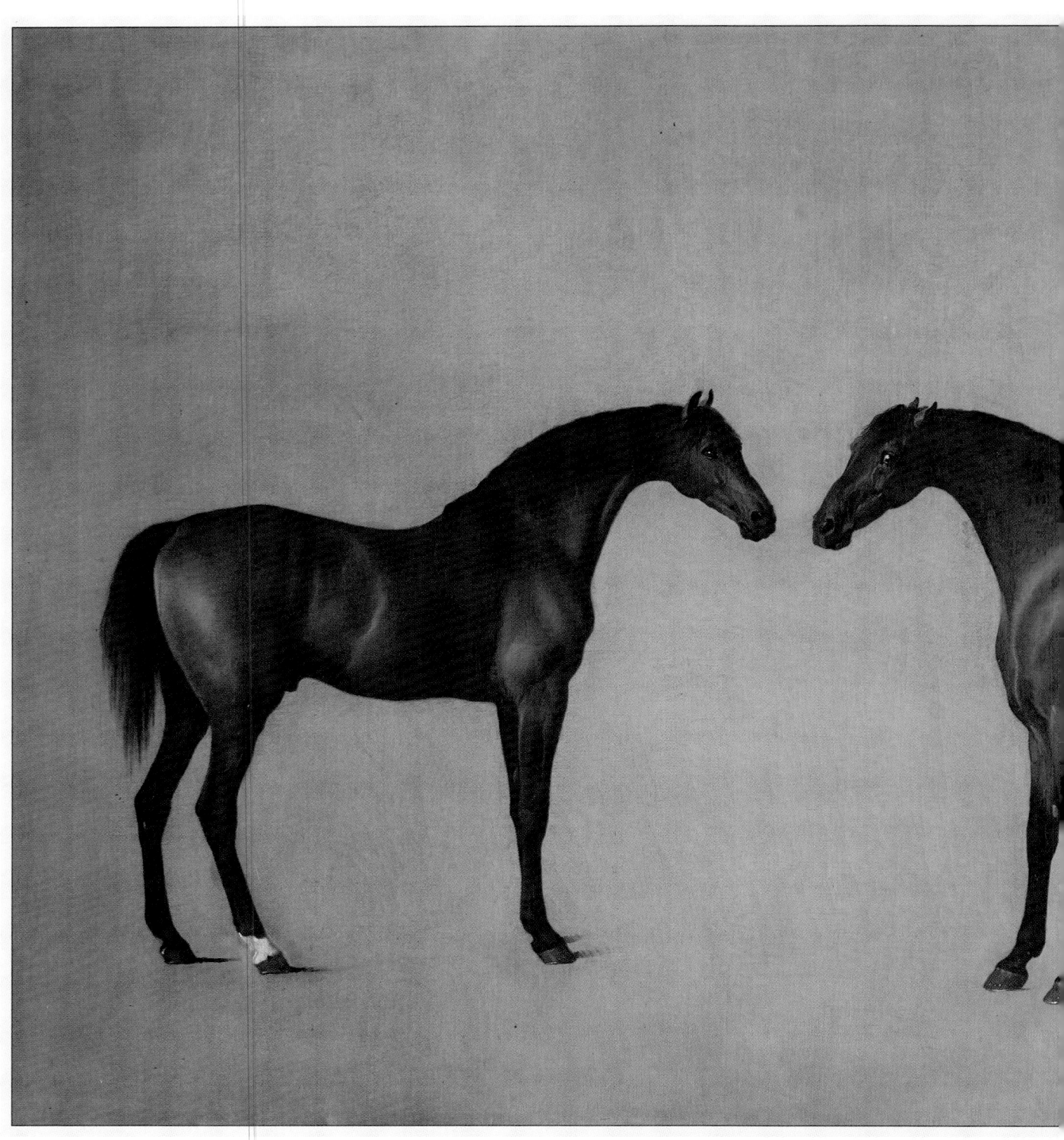

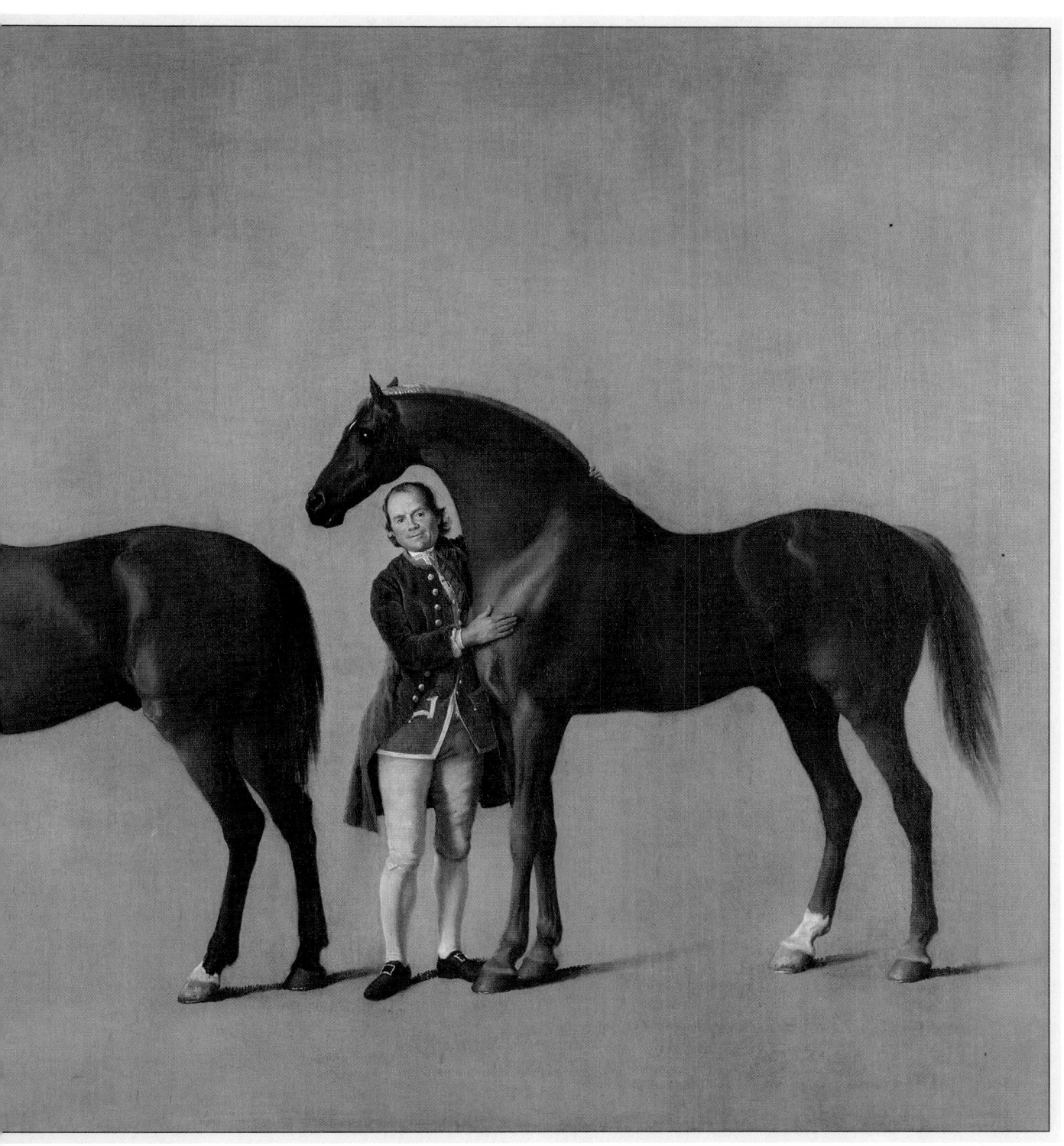

WHISTLEJACKET AND TWO OTHER STALLIONS WITH SIMON
COBB, THE GROOM, C.1762.
*The close proximity of Whistlejacket to the bay in the
centre gives rise to the latter's angrily laid back ears.
Cobb is placed in a potentially dangerous position
between the two stallions, which this experienced groom
would have avoided in reality.*

rhythmic patterns which echo those of the masters of the Italian Renaissance. One of the canons of the High Renaissance style demands that a painting be composed of lines of movement which build up from the sides of the image towards the centre, and that in the centre of the composition there should be an area of stillness, or repose.

Two paintings which illustrate this principle are Leonardo's *Last Supper*, of 1497, in Milan, and Raphael's *Disputa* of 1509, in the Vatican, Rome. The lines of movement in Leonardo's work build up the momentum from the apostles at either end of the table towards Christ in the centre of the table; the two groups of apostles, each of six figures linked together by gesture, point towards but do not actually touch Jesus, who sits alone in quiet isolation.

Stubbs' painting of mares and foals is in every way a less complex work, but the design follows similar rhythms. From the tails and the rounded hindquarters of the mares to left and right, the eye is drawn towards the middle via the curved head-and-neck lines of the next two horses. The horse at the centre of the composition is isolated from the groups to left and right, giving a stillness to the heart of the painting.

There is no record of Stubbs having been to Milan during his travels, but Humphry reports that he did visit the Vatican while he was staying in Rome and it can be fairly safely assumed that he saw Raphael's great frescos which decorate a series of rooms in that palace. Among the treasures of the Vatican they are second only to Michaelangelo's work in the Sistine Chapel. The *Disputa* is painted on the upper part of one wall of the Stanza della Segnatura. Here the pattern of movement described above occurs three times in the same work. At the lowest level are the arguing philosophers, above them is Heaven with Christ and the saints on their cloud, and hovering above them is God and the angels. Although all three layers are composed of lines which sweep towards a static centre, in the grouping of the philosophers this is particularly clear as all their gestures are directed towards the altar in the middle. It seems unlikely that, once an image of this sort had entered an artist's visual memory, it could later be forgotten. Stubbs may have decided that he had learned nothing from the art of Rome, but his paintings would seem to contradict him.

The Rockingham *Mares and Foals* is unique in the series in that it is without a background, but another work for the same patron is treated in this manner. *Whistlejacket and two other stallions with Simon Cobb, the Groom,* may have been painted as a pendant to the *Mares and Foals,* as it is the same size, and was paid for at the same time in August 1762.

The omission of a landscape setting in the *Mares and Foals* was an inspired decision, as it allows the abstract qualities of the painting to come to the fore. The fluid top lines are graceful and poetic, contrasting with the more staccato rhythms of the lower part of the pattern. When it is read simply as an arrangement of shapes the image is satisfying and complete. This does not apply to the painting of the stallions, because Stubbs has been unable to set up the close physical relationships between the horses that is fundamental to the success of the *Mares and Foals.* Mature stallions are almost invariably hostile to one another and to place them close together would run contrary to nature. Stubbs has treated each horse separately and they remain a group of individual studies on one canvas rather than a unified composition.

The relationship between the tempestuous Whistlejacket and his groom, Simon Cobb, is beautifully expressed. Cobb was the only man who could handle the stallion and their mutual respect and affection for each other is manifest in his trusting embrace and the horse's attentive and questioning expression.

The later groups of mares and foals are all set in landscapes but otherwise do not develop the theme any further. Indeed, the version in the Tate Gallery reuses some of the elements of the Rockingham painting, though Stubbs partly disguises this borrowing by changing the colour of one of the mares. Called *Mares and Foals in a River Landscape* c1763–8, it takes five of the seven horses of the earlier work and groups them under a tree on a riverbank. The horse on the right has been changed from chestnut to grey and the angle of its near-hind hock has been altered, but otherwise the composition is directly transposed. Once again the pale colour of a grey has had to be defined by a dark background; here it is supplied in the form of some stormy clouds which look a little improbable among the patches of blue sky.

The later examples of the mares and foals theme tend to be less flattering to their subjects. In the *Two Shafto Mares and a Foal* of 1774, the burdens of motherhood show in the bearing of these aristocratic but tired broodmares. Their demeanour is subdued, and the whole painting is more muted and less crisply finished than the earlier versions. This soft effect is characteristic of Stubbs' works on panel; the earlier ones mentioned are all painted on canvas. The majority of the *Mares and Foals* were painted in the 1760s, and the last was exhibited in 1776, by which time Stubbs had reached and passed the peak of his horse-painting career in terms of his popularity with sporting patrons.

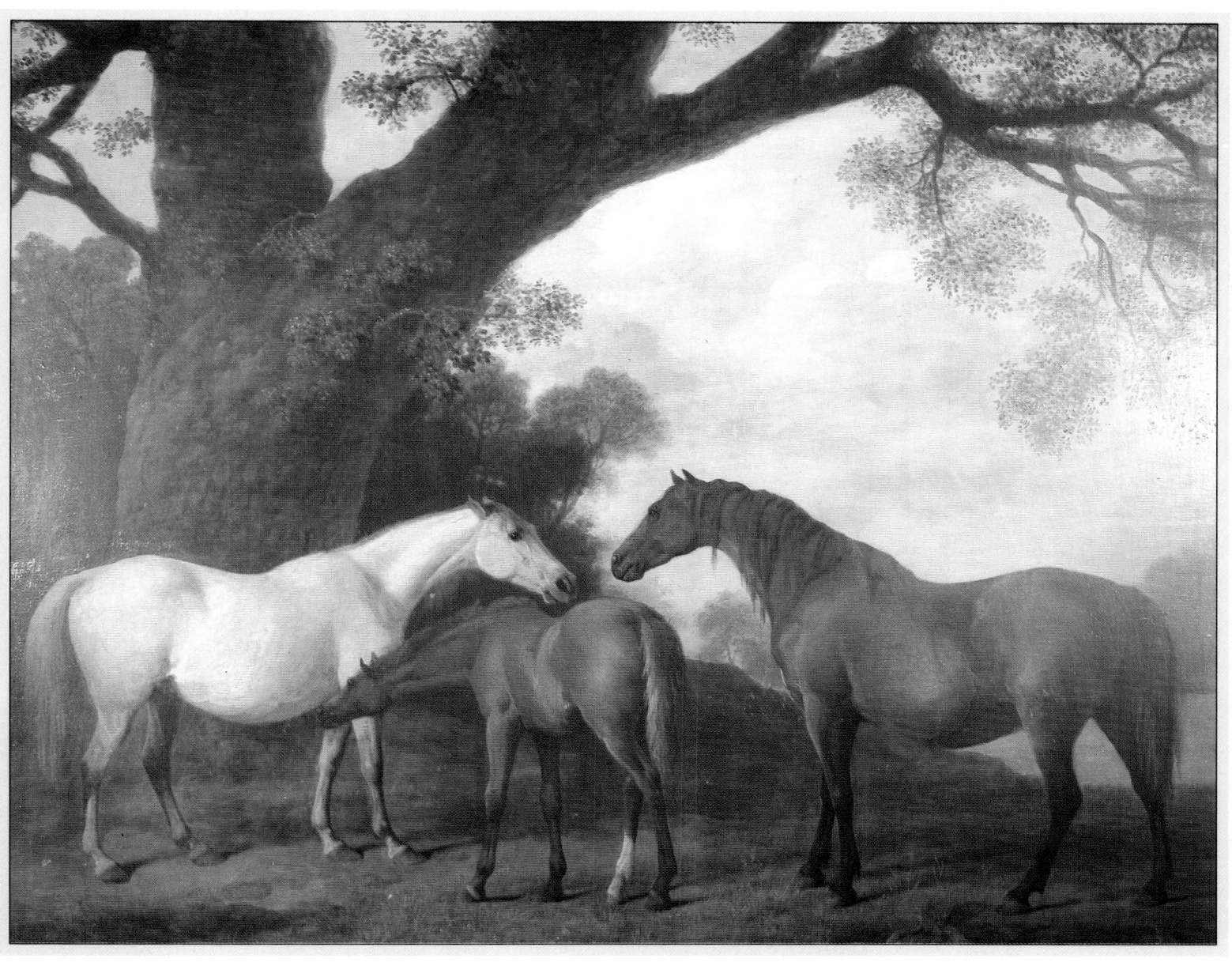

TWO SHAFTO MARES AND A FOAL, 1774.
*This late version of the mares and foals theme is
painted on panel. The softness of the image is
characteristic of Stubbs' works on this surface. For
these he adapted his technique to a thinner more
delicate application of the paint than that employed on
canvas.*

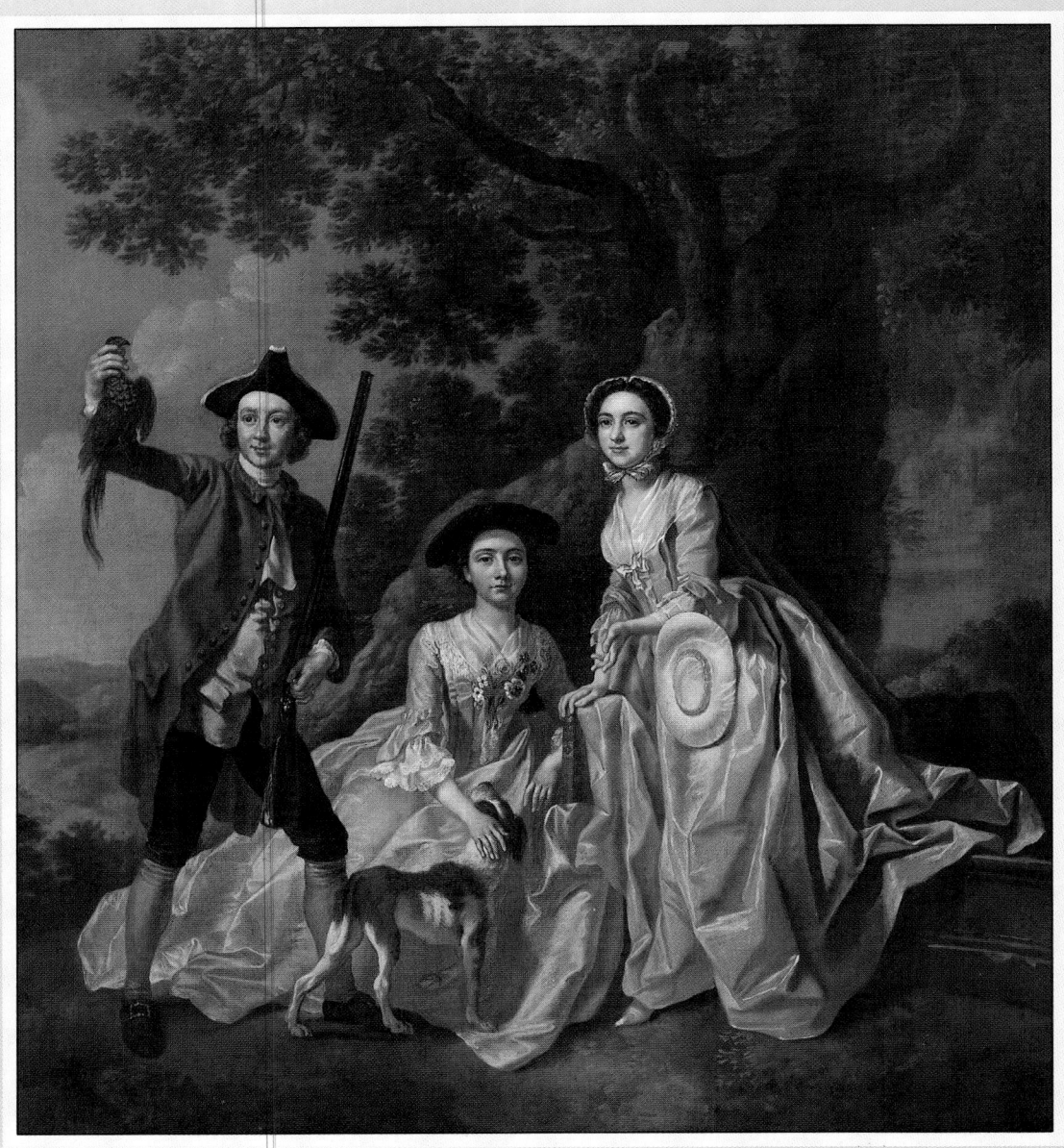

GEORGE ROGERS WITH HIS WIFE AND SISTER, C.1750
by Francis Hayman. In the middle of the 18th century
artists' references to shooting tended to be indirect.
Rather than describing the action taking place,
Hayman has included the accessories of an earlier
sporting episode in this family group.

MARES AND FOALS IN A RIVER LANDSCAPE, C.1763—8.
The sunny river setting gives this work a gentle mood,
but it does not quite have the compelling quality of the
earlier Mares and Foals without a Background, *from*
which the horses are adapted (previous page).

THE ENGLISMAN IN HIS ELEMENT

Stubbs received many commissions for subjects which did not include horses, or in which they played only a subsidiary role. These prove him to have been as suited to the portrayal of the Englishman in a country setting as he was to horse-painting. His perceptive yet detached representation of diverse subjects such as shooting, reading in a park or driving a phaeton illustrate the extent to which his art was not limited to the field of animal studies.

——— SHOOTING THEMES ———

Shooting, both as a sport and as a subject for painting, was less popular in the early 18th century than either hunting or racing. Rather than illustrate shooting in progress, artists tended to refer to their patron's sporting interests by including a dead pheasant or two in a formal portrait. Usually, the sitter poses with gun, dog and game assembled under a tree in a park, as in Francis Hayman's *George Rogers with his Wife and Sister* of c1750. Here, the pheasant is thrust towards the spectator, inviting admiration, while one of the ladies gestures approvingly towards the sportsman and the other strokes the ears of the shooting-dog. Clearly, the reference is to an event which had already taken place. In contrast, Stubbs represented various aspects of the day's sport as though witnessed at first hand.

Stubbs' first shooting-painting was commissioned by the Duke of Richmond as part of the series of Goodwood pictures already mentioned. Its usual title is *Henry Fox and the Earl of Albemarle, Shooting at Goodwood.* Throughout the painting there are numerous *pentimenti.* These are areas within a painting which have been altered during the course of the artist's work, and which become visible in a ghostly way through the layers of paint as time passes. This evidence suggests that this early commission presented Stubbs with a difficult task. Of the three Goodwood paintings, it is the least satisfactory when taken as a whole, but it has some fine parts. The main problem lies in Stubbs' handling of the central figure of Fox, for his position in the composition is rather awkward. Firstly, he appears to be much bulkier than his companions which gives the group an unbalanced aspect. Secondly, Stubbs has not set him on the ground as solidly as the others in the group, he seems to float between them in undefined space. Both difficulties stem from the physical size of Fox, for he was a man of large build and, like his son Charles James, of a somewhat larger-than-life personality. According to the rules of perspective he should be the smallest figure in the group because he is furthest away, but owing to his physique he appears to be larger and more substantial than his companions, and therefore nearer than the artist intended.

Another strange inconsistency in the painting lies in the apparent length of Fox's gun, for it is impossibly short; the flintlocks held by the loader behind have the characteristic long barrels of the period and his would have also been of this type. Fox and Albemarle were probably shooting birds on the ground, for the technique of shooting flying was slow to become established in England and was not commonly practised until later in the century. The two dogs in front of Albemarle point towards the game, and the keeper behind the guns is mounted on a horse for a better view of the direction the birds take following the shot. A miss was more than likely owing to the unreliable behaviour of the guns. The two most convincingly represented figures are the yellow liveried servants on either side of the composition; the African and the Arab horse he holds are particularly successful.

Between 1767 and 1770, Stubbs painted four shooting subjects which, when taken together, tell the story of a day's sport in four episodes. It is not known who commissioned them, or whether the initial one was originally conceived as the first of a series. The full title of the earliest, given by Stubbs when he exhibited it at the Society of Artists in 1767, is *Two Gentlemen going a Shooting, with a View of Creswell Crags: taken on the spot.* It is this evidence which identifies the rocky area shown here and in other paintings. The land was owned

by the Duke of Portland, but the two sportsmen are not of the aristocracy, as they are not accompanied by a retinue of keepers, loaders, and other attendants, and their dress is simple. Their identity remains a mystery but they must have obtained the permission of the Duke to shoot on his land, for under the stringent game laws of the period they would have been acting illegally without it. If the artist had devised this painting as a fictitious scene illustrating the pleasures of shooting in general he would have been unlikely to have identified the location so specifically, for by doing so he inevitably associated it with the Duke, an important patron for whom Stubbs was working.

The Crags and the water-mill form a naturally picturesque setting in which preparations are being made for the day's sport. The portraits of the two gentlemen are beautifully observed, their poses are relaxed and informal and they appear to be discussing the prospects of the day ahead. The pointers look on whilst the laborious process of loading the guns is completed. The landscape, with its silvery river and early morning sky, is one of Stubbs' most beautiful – in fact, in all four pictures the quality of the background is good.

The second scene shows the sportsmen setting out, the pointers leading the way. These dogs were invaluable for this type of shooting, since they would find and point towards game, holding their position until the shot had been fired. Until the development of more organized days of shooting with driven game, pointers were almost essential to most types of shooting. Though sharply observed this is the simplest subject of the set of pictures,

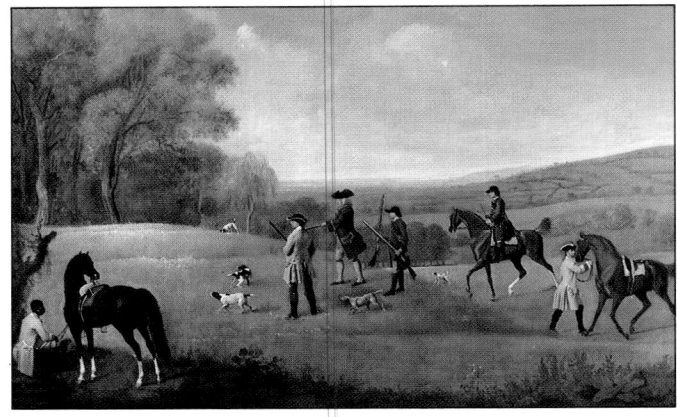

HENRY FOX AND THE EARL OF ALBEMARLE SHOOTING AT
GOODWOOD, C.1759.
*Stubbs' first attempt at a shooting scene was not
altogether successful, but it is an interesting record of
the conduct of the sport in the early 1760s (above).*

TWO GENTLEMEN GOING A SHOOTING, WITH A VIEW OF
CRESWELL CRAGS: TAKEN ON THE SPOT, EXH. 1767.
*The painting is the only
documented reference to Creswell Crags, from which
the site was identified.*

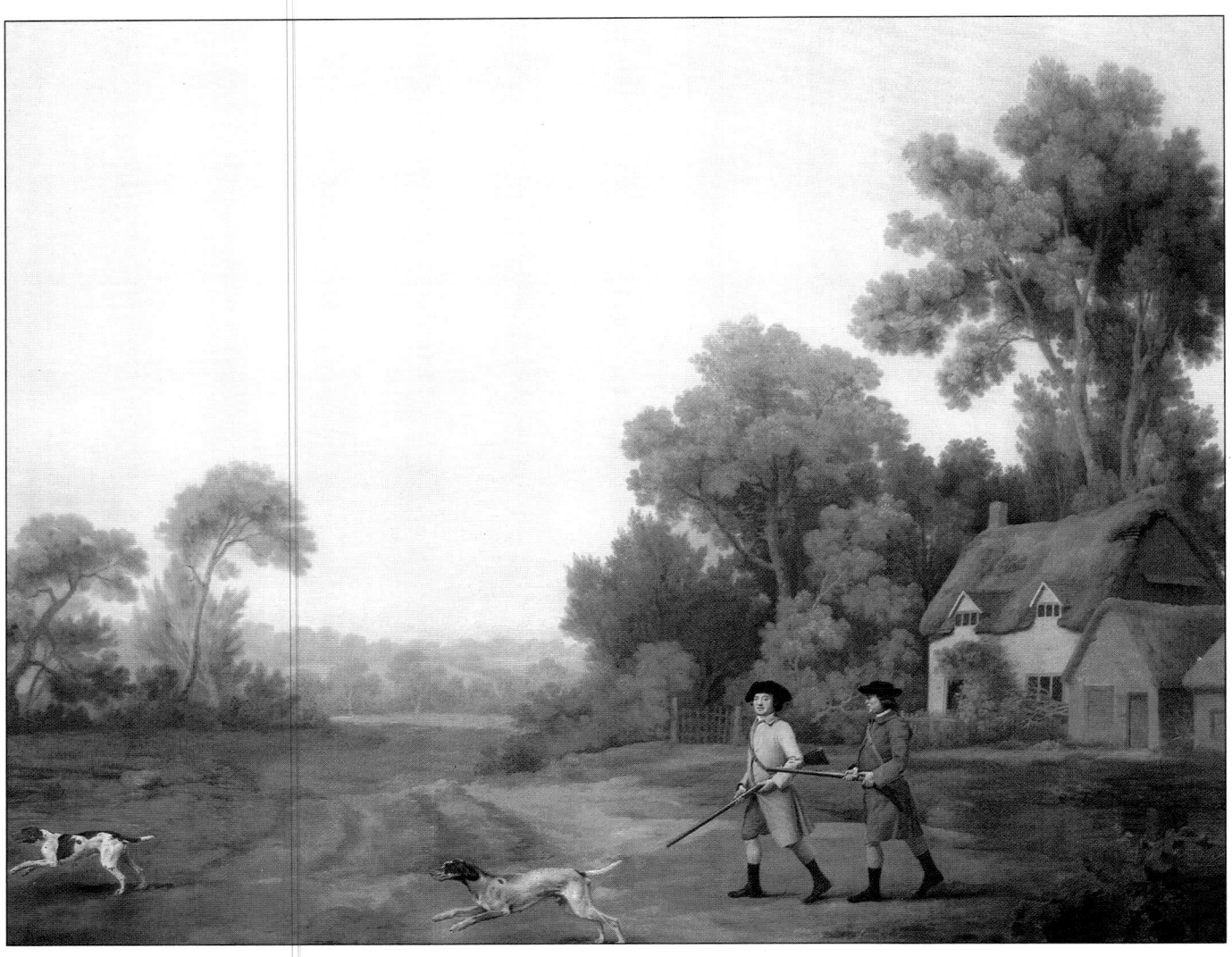

TWO GENTLEMEN GOING A SHOOTING, EXH. 1768.
*The pictures were exhibited one at a time over four
concurrent years from 1767. Although they may not
have been conceived as a set, the order in which they
were shown follows the sequence of the day's sport.*

a necessary link to the third, which illustrates a high point of the day's activities, the successful shot. Stubbs' portrayal of the action of shooting flying would have been of great interest to his contemporaries, since it was still a relatively new technique. It was, however, common practice on the Continent by this time.

The modest character of the day's sport is described in the fourth painting, for the gentlemen appear well pleased with their small bag of just a handful of birds and a hare. The grand shoots of the next century would seem to belong to a different sport, with game driven by armies of beaters and the results counted in thousands. In contrast, Stubbs' sportsmen do not impose themselves on the natural environment which surrounds them; they are dwarfed by the great trees and have but a small part to play in this

wooded scene. Through the trees another glimpse of Creswell Crags can be seen, shining in the evening light through the gloom of the interior of the wood. The day's sport has brought the gentlemen back close to their starting point, giving a satisfactory end to Stubbs' conception of the perfect day's shooting.

The four paintings were engraved by William Woollett and published as individual prints between 1769 and 1771 by Thomas Bradford. It is possible that Bradford commissioned the whole series, or possibly just the last three, having had the opportunity of seeing the first at the exhibition in 1767. Added to the prints are some anonymous verses which describe the gentlemen as having come from the 'Smoaky Town'. Presumably the lines were added by the publisher to make the prints more relevant to the town dweller with sporting aspirations. Though in theory the game laws allowed only owners of land worth £100 a year or more to kill game they were strongly contested. Presumably those who did not qualify could find sympathetic or impoverished landlords who would permit them

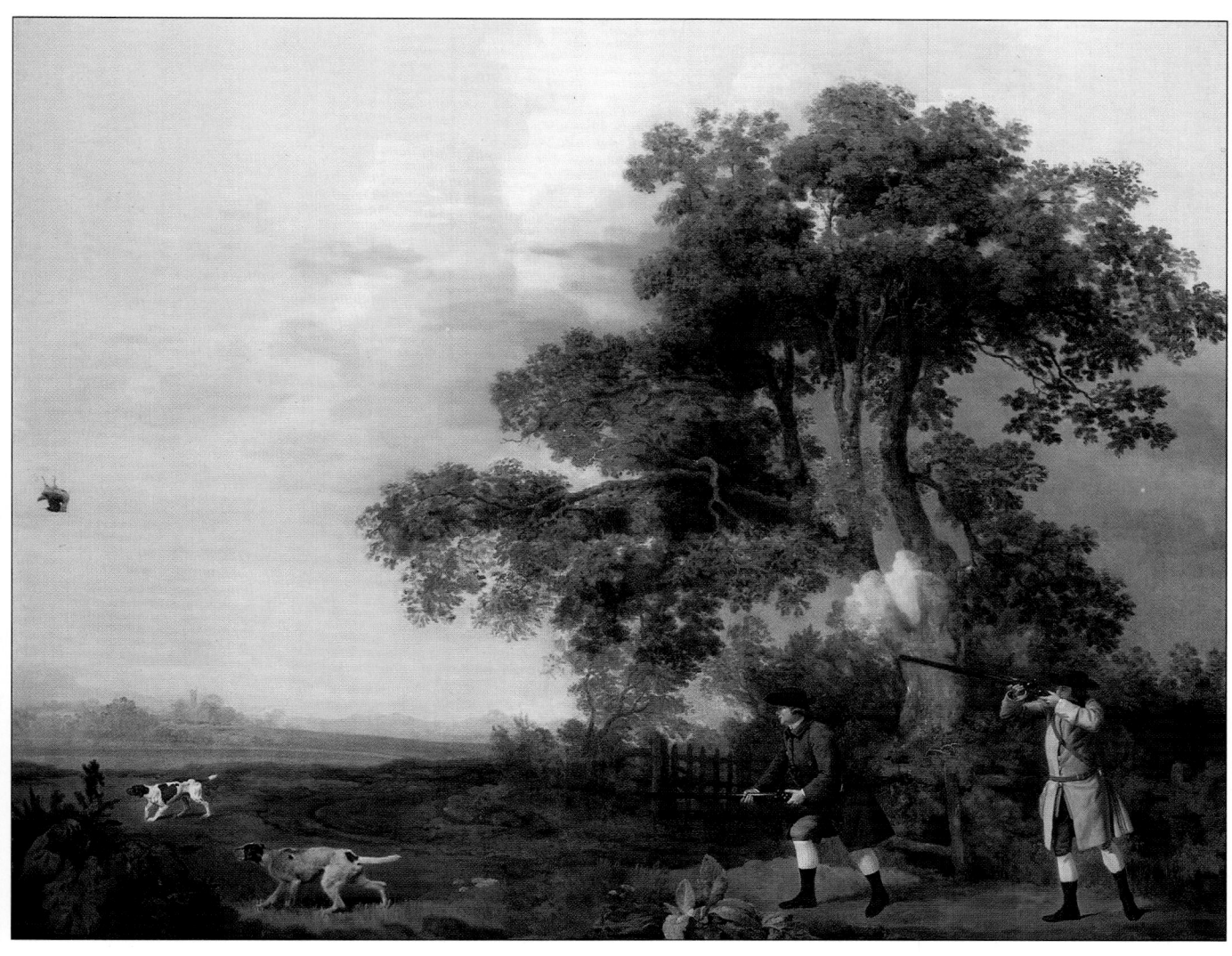

to shoot on their land, but it is not surprising that all reference to Creswell Crags and, therefore, to the Duke of Portland is dropped from the prints.

The finest example of Stubbs' portrayal of the Englishman in the country is *Sir John Nelthorpe out Shooting with his Dogs* of 1776. The artist's characteristic detachment, his low-key approach to this sort of subject is perfectly matched by the calm, level-headed attitude of Sir John to his sport. The support of the Nelthorpe family must have been of great value to Stubbs, especially in his early years as a portraitist. Lady Nelthorpe had been among the first of his patrons and she may have helped him during the time he spent working on his anatomical studies at Horkstow. Lady Nelthorpe's son, Sir John, commissioned a number of paintings throughout his life, the last in 1792; he also owned a copy of *The Anatomy of the Horse* and some of Stubbs' prints. His commitment to the artist was well rewarded in this splendid shooting portrait, which so vividly sums up the relationship between the English country squire and his land. The

design of the painting helps to suggest his close identification with the landscape by making him seem an integral part of it. The dog in the foreground serves to push Sir John into the composition, and the strong dark triangle of the field to the left anchors his position. This is further strengthened by the angle of his gun, as it almost touches the sloping diagonal in the middle distance. The picture is a symphony of greys and browns with the silver highlights of both the frosty field behind and the River Humber in the far distance. These sober colours pick up the general mood of the painting, which is one of calmness and quiet in the chilly Lincolnshire landscape. Here, the impression of silence is probably closer to reality than the atmosphere in Stubbs' racing paintings; the simple pleasure of walking up a field on his own estate in

TWO GENTLEMEN SHOOTING, EXH. 1769.
Stubbs' accurate description of shooting flying suggests that he had had the opportunity to observe the new technique in practice. The dead bird is particularly well observed as it tumbles head first to the ground.

the company of his dogs is vividly described. The fact that Sir John is carrying a gun is rather under-played; the painting concentrates on the gentleman at ease in his own environment with congenial companions rather than on the sporting potential of the occasion.

A shooting-painting which is much more concerned with the killing of animals, though not necessarily for sport, is *Freeman, the Earl of Clarendon's Gamekeeper, with a Dying Doe and a Hound* of 1800. It was painted when Stubbs was 76 years old and is one of his most exceptional works. The wooded setting with its deep shadows contrasts with Stubbs' more customary open landscapes with their wide clear skies. The composition is also unusual in its pyramidal grouping of the figures, though the legs of the hound and the doe form a rhyth-

mic pattern similar to the legs of the horses in the compositions of mares and foals. From this very tightly knit and solid design the gamekeeper Freeman, stares out at us with equally solid self-assurance, confident in the execution of his task.

This work can be interpreted in various different ways, for Stubbs' intended meaning remains unclear. It can be taken as a straightforward appreciation of the skill of Lord Clarendon's gamekeeper, who is obliged to cull a certain number of beasts from the herd in the park every year to maintain the health of the rest. Having taken a single clean shot to kill the doe, he pulls back its head prior to gralloching (disembowelling) it. A more emotive reading of the situation would suggest that the doe is wounded but alive, and that the hound is looking up to the man in supplication for the life of its fellow creature; meanwhile, Freeman stares out at the spectator, defiant of disapproval. Given the impartiality of so much of Stubbs' work the simpler version appears initially as the more likely, but against this must be put his lion- and horse-paintings,

A REPOSE AFTER SHOOTING, EXH. 1770.
The series follows the sportsmen from dawn to dusk.
The first two have the pale silvery colours of early
morning. In the third this is replaced by a clearer light
in which the distant landscape is more defined. In the
last the evening shadows are long and the sun low.

SIR JOHN NELTHORPE, 6TH BARONET, OUT SHOOTING
WITH HIS DOGS IN BARTON FIELD, LINCOLNSHIRE, 1776.
*Stubbs' portrait of this quintessential English
gentleman succeeds through subtle and understated
means. It is the antithesis of the Grand Manner
advocated by Sir Joshua Reynolds and other leading
18th century art theorists.*

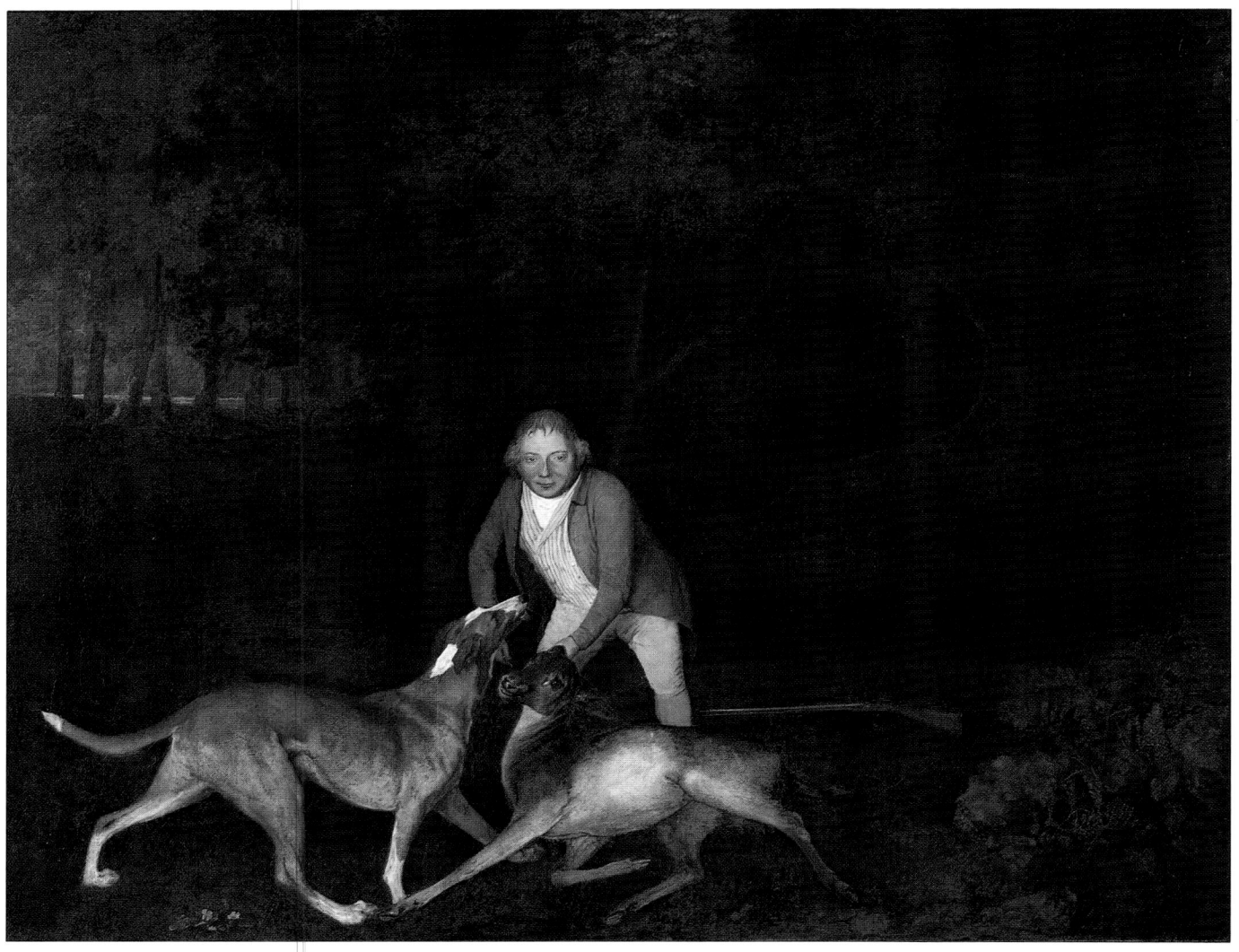

FREEMAN, THE EARL OF CLARENDON'S GAMEKEEPER,
WITH A DYING DOE AND A HOUND, 1800.
*In contrast to the bulk of his work, it is difficult to
establish just how Stubbs wished this enigmatic
painting to be read. It is certainly a portrayal of a
servant carrying out his job, rather than a gentleman
killing for sport.*

which are dramatic expressions of animal pain and which examine closely the plight of a wounded creature in the moments before death.

────── AT HOME IN THE COUNTRY ──────

Some of Stubbs' subjects defy tidy categorization. These include the views of people enjoying doing nothing very much in the country, such as *William, 3rd Duke of Portland, and Lord Edward Bentinck, with a Groom and Horses* of 1766–7. This painting illustrates the leisurely pace of aristocratic country life, with the two young grandees watching the groom at his work. Much of the appeal of this picture is created by the relaxed positions of both gentlemen, implying that they have all the time in the world. Lord Edward rests his elbow on the rail whilst the Duke leans an arm on

his brother's shoulder in a pose which suggests an easy friendship. The Duke stands with all his weight on one foot, copied by the horse behind him.

It appears that Lord Edward has handed his horse to the groom so that it can be introduced to a schooling jump; but if it is to have a jumping lesson, why has it been unsaddled? It is clearly not going to be loose-schooled since the jump is not fully enclosed, and owing to the height of the uprights it would not be possible to use a lunging rein. This railed construction has a major drawback as a schooling fence, in as much as an unwilling horse would be perfectly capable of ducking under the side rails in order to avoid jumping the bar, with uncomfortable consequences for its rider. The bar also appears to be adjustable to a height that even a modern show-jumper would find challenging. However, this is the most likely function of the structure as the picture was described in a catalogue of 1812 as a *Landscape with Leaping-Barr and Figures*. The railings provide Stubbs with a useful compositional device, for it establishes the necessary spatial relationships

WILLIAM, 3RD DUKE OF PORTLAND, AND LORD EDWARD
BENTINCK, WITH A GROOM AND HORSES, 1766—67.
*Though the atmosphere of this picture is informal and
relaxed the composition is as carefully thought out as
any other. The schooling fence provides a three-
dimensional grid which binds all the figures into a
unified and harmonious group.*

and links between the figures. As a result, the design is
uncontrived and natural. It is a painting without preten-
sions, which simply and effectively conveys the pleasure
the brothers take in each other's company and in a morn-
ing's horse activities.

A very different subject, which is nonetheless concerned
with enjoyment of the countryside is the *Lady Reading in
a Park* of c1768—70. This open-air portrait of a lady is
unique among Stubbs' work, and one can only regret that
more paintings of this sort were not commissioned from
him. Indeed, it stands comparison with the work of any of
the contemporary portrait specialists.

The identity of the sitter is not known, but Mrs Egerton
suggests that it might be Charlotte Nelthorpe, Sir John's
sister, who, as Mrs Carter-Thelwell, is also included in a

LADY READING IN A PARK, C.1768—70.
*This painting underlines the injustice of the criticism of
Stubbs' attempts to become acknowledged as more
than a horse-painter. It is a very attractive portrait in
which it seems possible to detect a suggestion of the
artist's affection for the sitter.*

conversation piece. It is an informal portrait which gives rather more weight to the landscape than was customary; 18th-century portraitists tended to use nature as a backdrop dominated by the sitter. Here the lady is integrated into the wooded scene, as absorbed by its deep shadows as she is absorbed in her book. In the middle-ground, sunlight shines through the trees, rather as it does in both the last of the shooting series and in the portrait of the gamekeeper Freeman. Although the trees in the foreground do have a forbidding aspect, Stubbs does not overplay the gloominess of the landscape. It is held in check by the sunlight and blue sky beyond, by the light summery tones of the cream silk dress with its frothy lace neckline and cuffs, and by such delicate details as the convolvulus winding round the seat or the clump of cow-parsley and primula at her feet. With work of this quality it is not surprising that Stubbs sought to escape the horse-painter tag. Unfortunately, this painting was not exhibited in Stubbs' lifetime; had it been, it might have helped to dispel the increasingly irksome association with horses.

THE CONVERSATION PIECE

The conversation piece was a popular type of portrait in mid-18th-century England. It had the advantage of reducing the cost of the representation of a family by containing many likenesses in one picture; also it usually contained some reference to the family home, the library perhaps, or the terrace with a view over the lake to the park beyond. Stubbs injected variety into this form of painting by moving the setting further out into the countryside and by introducing horses to the family group.

One of his most sympathetic portraits of this type is *Captain Samuel Sharpe Pocklington with his wife Pleasance and (?) his sister Frances* of 1769. Mrs Egerton discovered the true identity of the family (it was previously called *Colonel Pocklington and his Sisters*), and she points out that it commemorates the Pocklington's marriage since Pleasance, the seated central figure, wears her wedding clothes. The setting beneath a towering oak-tree is used elsewhere for this type of picture, and the landscape beyond is unspecific and presumably imaginery. The pinkish sky and long shadows suggest early morning, and the tranquility of the background reflects the quiet contentment of the family group.

CAPTAIN SAMUEL SHARPE POCKLINGTON WITH HIS WIFE PLEASANCE AND (?) HIS SISTER FRANCES, 1769.
The three members of the Pocklington family, though charming, do not appear particularly distinguished. However, the painting is enhanced by the misty riverscape beyond, which is presumably an imaginary setting. By including a poetic background Stubbs has made his rather ordinary sitters look more interesting.

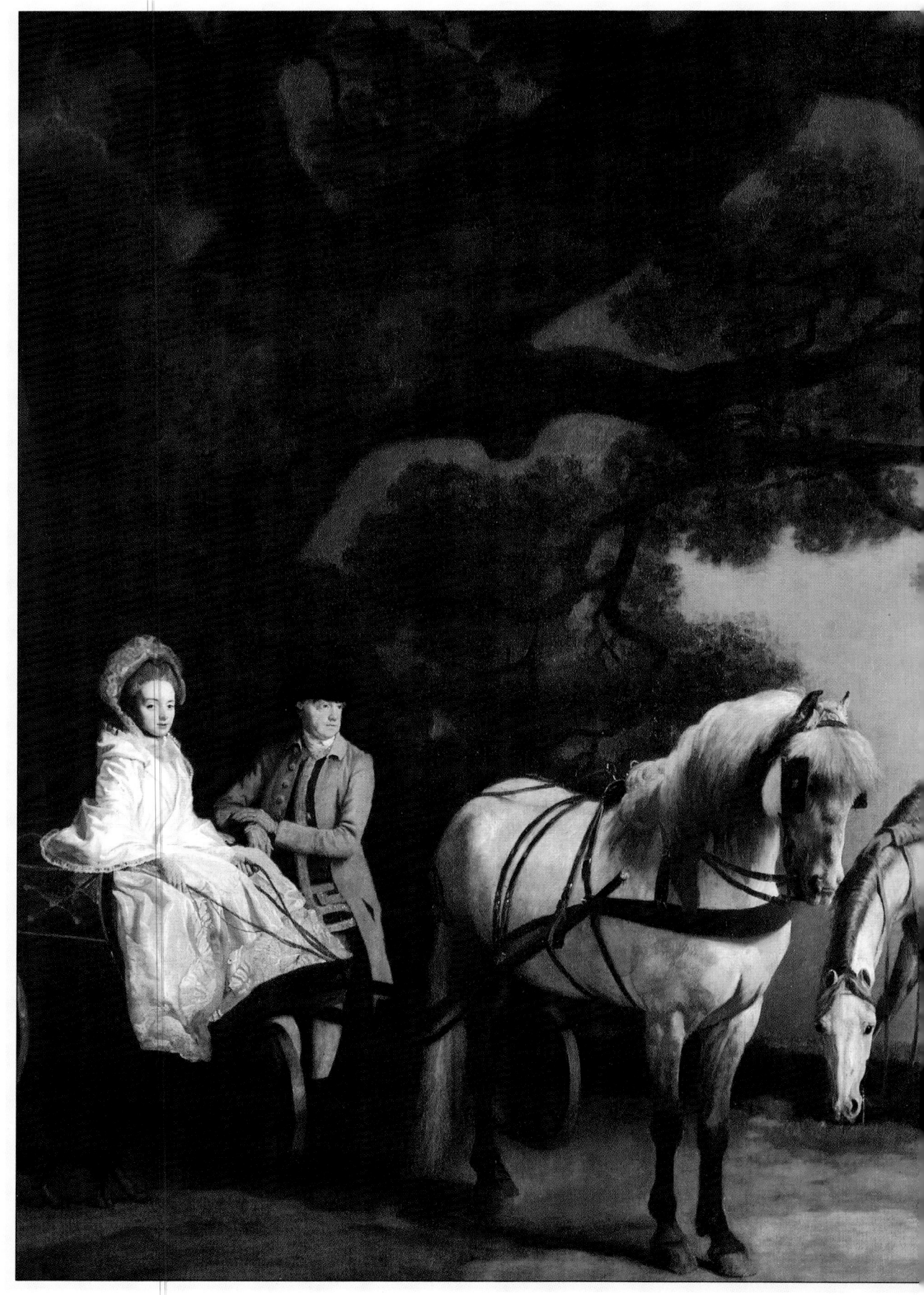

The ladies' silk dresses bring a rare shimmer to the colour scheme; Stubbs was usually restricted to the matt finish of the materials of riding clothes and had few opportunities to make use of his ability to describe the more interesting effects of silks and satins. The women gaze admiringly at Captain Pocklington, who looks out of the picture with calm self-confidence; nobody notices the little brown horse, who nibbles at a bunch of flowers. Once again, the relaxed stance of the man is echoed by the resting leg of the horse, completing the comfortable, easy atmosphere of this group.

In another conversation piece, the *Melbourne and Milbanke Family* of c1770, Stubbs uses some of the features of the Pocklington picture; the figures are grouped under a very similar oak-tree and the background is an even more generalized version of the rocky bluff and water formula. The landscape, however, is less important to this work, for little of it is visible behind the screen of horses and the overhanging tree. The greatest difference lies in the change of mood. Instead of an atmosphere of cosy harmony there is a sense of cool isolation. Each figure appears to be unrelated to the next, and the lack of communication betwen them renders the title of 'conversation piece' ironic.

The characters involved in the scene are Sir Ralph Milbanke and his daughter Elizabeth on the left, with his son John in the centre and Elizabeth's new husband Peniston Lamb (later Viscount Melbourne) on the right. In view of later events it is easy to read too much into Stubbs' characterizations: Elizabeth was to become one of the most ambitious and powerful women of her generation, while her hard-drinking husband was never interested in anything beyond horses and gambling. Stubbs describes the young girl's chilly *hauteur* (she was only 16 years old at the time) with his usual perception. Peniston's position slumped in the saddle is not typical of Stubbs' noblemen and this combined with his vacuous expression suggests that Stubbs had a sharp eye for character, or the lack of it, in his sitters. In a painting comprising so many figures Stubbs maintains the standard of the individual portraits, whether human or equine. John Milbanke and his grey horse in the centre could easily stand alone, such is the quality of the individual elements of this work.

Unlike the two works mentioned above, Stubbs' painting of the Carter-Thelwell family is set in an identifiable location, for in the distance is Redbourne church. In this way, it is like the more usual type of conversation piece in which there is some reference to the home or its surroundings. In contrast to the Milbanke and Melbourne group, the atmosphere of this painting is warm and unpretentious, even homely. Mrs Carter-Thelwell was Sir John Nelthorpe's sister, and may possibly be the unidentified sitter in Stubbs' *Lady Reading in a Park*. A comparison of the two portraits shows that they are sufficiently alike to be the same woman, but the closed inward-looking expression of the lady reading is difficult to compare with the affectionate smiling face of Mrs Carter-Thelwell, so no definite conclusions can be drawn. If they are the same person, Charlotte Nelthorpe before her marriage appears to have been rather smarter than she was as Mrs Carter-Thelwell. The stylish young woman under the tree in the park has become the wife of a portly parson, whose lack of elegance is underlined by his stocky pony, a world apart from the refined thoroughbreds of Stubbs' noblemen. Could it have been said that Charlotte Nelthorpe married beneath her? If so, she appears to have been happy in her choice, for the painting radiates contentment.

STUBBS AND CLASS

Stubbs' keen powers of observation were never more effective than in the description of social standing, and in this matter he was unusually egalitarian in his approach. This is not to say that he shows all men as equals, but that he gives all men equal attention. He never falls back on the convention practised by some of his contemporaries (Gainsborough and Morland amongst them) of showing the working classes as generalized types. In his paintings the different levels are described through dress, bearing, demeanour and expression. By these means he builds up an impression of a stable social strata in which every man knows his place and accepts it.

Stubbs' emphasis on the study of nature may lie behind his unblinkered observation of servants, for he would not have distinguished between them and any other element of the natural world. Artists with a more conventional attitude tended to divide subjects into those that were worthy of an artist's attention and the rest; the working classes usually fell into the latter category. However, while Stubbs' work illustrates the differences between the classes, it also reinforces the status quo. The master-servant relationships appear to have the consent of both sides, in none of his work is there a hint of dissatisfaction, the social order is upheld unquestioned. Such is the realism of his paintings that it is difficult to remember that there might be another side to the story, that he is giving us his version of the situation, which may or may not be objective.

The second half of the 18th century was a period of social turbulence and there are numerous contemporary

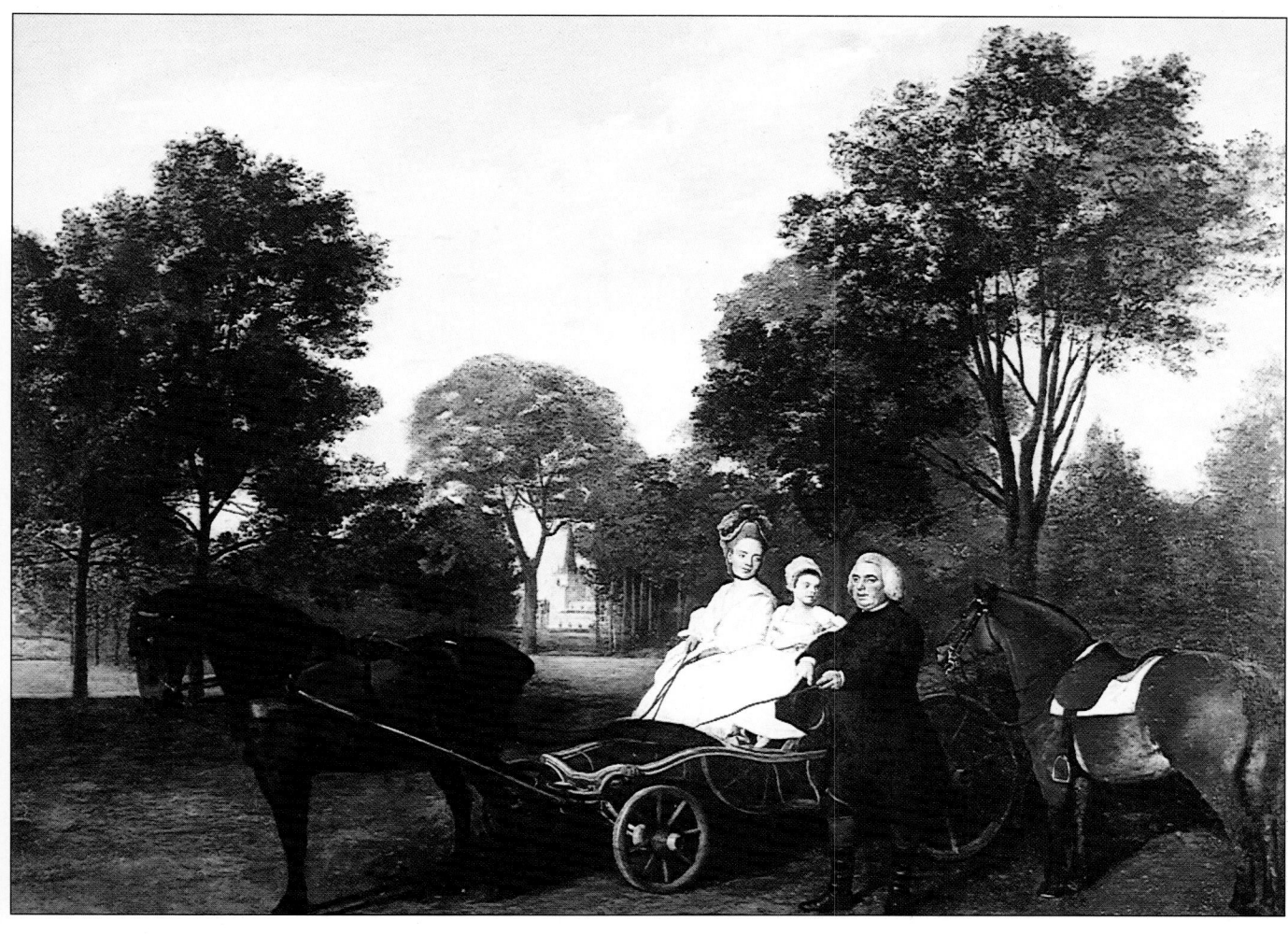

THE MELBOURNE AND MILBANKE FAMILIES, C.1770.
*This chilly conversation piece has none of the amicable mood
normally associated with this type of family group.
(previous page).*

THE REV. CARTER THELWELL AND HIS WIFE AND
DAUGHTER, 1776.
*Less formal than either of the preceding examples, this
conversation piece is homely and unpretentious.
(above).*

accounts of working-class dissatisfaction. Josiah Wedgwood, the Staffordshire potter and patron of Stubbs, had to deal with an uprising among his workers in 1783. The tone of his address to his empolyees is moderate and essentially understanding of their grievances, but he was an exceptional employer; most attempts to deal with such incidents were less sympathetic, especially during the 1790s, following the French Revolution. Perhaps in the individual cases that he represents, Stubbs does tell the truth as he saw it, but can every servant that he portrayed have been satisfied with his position? He would have us believe that all was well in the world, that rural unrest did not exist, and 200 years on it is tempting to believe him.

One of his most halcyon views of English country life

is *Lord Torrington's Hunt Servants Setting out from Southill* of c1765–8. Lord Torrington commissioned two other works from Stubbs, one showing his bricklayers at work and another of his steward and gamekeeper patrolling his woods.

The scene is set just outside Southill Park, with the west end of the church to the left and the village spread out behind the figures. Two grooms are departing just after dawn for a day's hunting and are being seen off by the coachman. The three figures are strongly characterized, each a small-scale portrait in its own right. The older groom on the right looks out at the spectator without curiosity, comfortable on the brown horse which he rides trustingly on a loose rein, an eloquent statement of his confidence in his own ability. His expression implies that this is a routine event for him, whereas the young boy shows some apprehension at taking charge of his master's horse; and his task is not helped by the apparently unwilling horse with its laid-back ears. The complex double bridle of the chestnut indicates that it is to be ridden by a gentleman, in contrast to the simple snaffle bits of the servants' horses.

The coachman seems to be relaxed and at home in his role as the older groom, and it is this sense of rightness, of belonging, which is so striking about the picture. The well-knit composition of the figures combines with the stability of the background, giving a quality of permanence and timelessness to the scene which only serves as a reminder that things have changed. This idyllic painting evokes nostalgia today; it represents a golden age when master, grooms, horses and dogs were content to carry out the roles assigned to them without question. It is not possible to assess the extent to which this world existed outside the artist's imagination, but one wants to believe in this English Arcadia.

Though he observed and illustrated the differences between social levels, Stubbs appears to have been person-ally unaffected by considerations of status. He is neither flattering to those that he would have considered his superiors, nor patronizing to those of less standing than himself. The *Duke of Portland outside Welbeck,* exhibited 1767, does not over-compliment the Duke in its portrayal of his round, moon-like face. Stubbs' portrait of the man who was to become prime minister twice (he began his political life as a Whig of the Rockingham faction) is no more detailed than that of his huntsman, of his stable-lad or of his horses and hounds, all of which merit the artist's meticulous representation.

The scene is set before the old riding school and stables at Welbeck, which were built in 1623 by the Duke of Newcastle, who was a great horseman. He had published, in 1658, an illustrated guide to the art of classical riding, a

sions. Few horses of the type that Stubbs was asked to paint would have been placid enough to have 'stood' for him without a groom being present, though the grooms are not always included in the portrait. The account of the painting of Whistlejacket points out the necessity of the presence of a competent handler. Stubbs would have had endless opportunity to observe the skills of the grooms, coachmen, gamekeepers and huntsmen who attended to the sporting requirements of their masters. His apparent respect for their abilities shines through many of his works, such as his portrayal of Simon Cobb in the group of three stallions mentioned above.

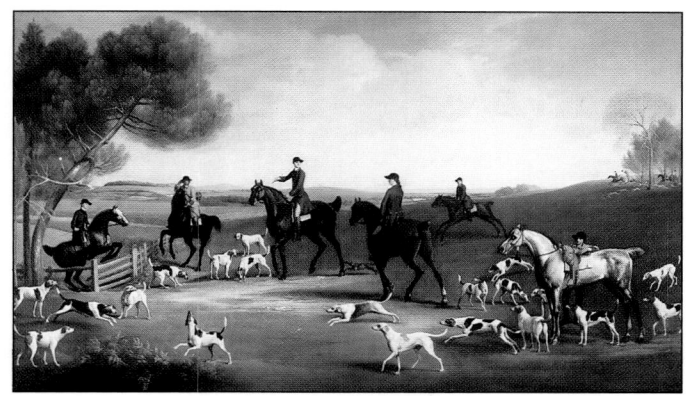

THE THIRD DUKE OF RICHMOND WITH THE CHARLTON
HUNT, C.1759.
A huntservant with a few hounds is on to the line of the fox. He raises his hat to give a 'holloa' to the rest of the field in the foreground.

milestone in equestrian literature. The Duke of Portland may have chosen to be painted in this setting because of its association with the earlier owner, or more probably because the house at Welbeck was renowned for its singular lack of beauty: John Byng in 1789 called it 'mean, ugly and ill-built'.

Stubbs' paintings evince his empathy for the servants that he portrayed. He was in a position to appreciate their skills, for he would have spent many hours in the company of grooms and stable-lads while carrying out his commis-

LORD TORRINGTON'S HUNT SERVANTS SETTING OUT FROM
SOUTHILL, C.1765–8.
Painted in the mid-1760s when Stubbs was at the height of his popularity, this outstanding work is one of his most vivid descriptions of servants at work.

This attitude is also evident, in a more subtle way, in *The Charlton Hunt.* In this hunting scene, Stubbs suggests that the huntsman knows more about hunting than his master, for it is he who has the answer to the problems faced by the Duke and his companions. It is to the Duke's credit that this version of events is depicted, not all patrons would have been so generous. The painting describes class differences in various ways, the most obvious being through their dress. The Duke and his two companions wear the livery of the Charlton Hunt, that is, blue with gold buttons. The figure on the left in the plain dark coat is possibly William Tregoze, described as 'helper to the hunt', neither guest nor servant. The hunt staff wear the brilliant yellow and scarlet of the Goodwood uniform (colours which Stubbs used to great effect in all three of his Goodwood paintings).

The composition of *The Charlton Hunt* defines social boundaries in a more subtle way. The Duke, his brother

THE DUKE OF PORTLAND OUTSIDE WELBECK, EXH. 1767.
*The Duke was a client of Domenico Angelo, and may
have originally met Stubbs through this connection. He
commissioned several works in the second half of the
1760s (above).*

and friend form an inward-facing circle in the centre, while the other ranks are placed like satellites around the edge. The narrative suggests that the young Duke is unsure of the best course of action, whereas the experienced huntsman shows his quicker understanding of events on the hunting field. The hounds have lost the scent of the fox, their heads are up and they seem to have given up all hope of finding it again. The Duke turns to his brother for advice, not yet aware that the huntsman behind him has already heard the 'holloa' of the whipper-in who is hunting the other half of the pack in the background. The professionals have the situation in hand and the painting gives credit to their skills.

The English gentleman as a type covered many nuances of social standing, and Stubbs observed these with his usual acute perception. His ceramic portrait of *Warren Hastings* would appear to portray a man of very refined breeding; his immaculate dress, proud bearing and fine Arab horse all speak of quality. In comparison with the Duke of Portland he looks much grander; however, the Duke's rank was unquestioned, whereas Hastings came from an impoverished middle-class background. He grew up in the rectory at Daylesford, but his grandfather had had to sell the house. Hastings dreamed in his youth of buying back the estate, and, by the time this portrait was painted he had succeeded in doing so.

It was at this time, that Hastings was also involved in his agonizingly long trial. Having gone to India in 1750 in a humble position in the India office, he had risen to the position of Governor-General of Bengal by 1771. In 1787 he was impeached for corruption, amongst other crimes, but was finally acquitted in 1795. His character and behaviour were closely investigated during the trial, and he was found to have behaved rather better than might have

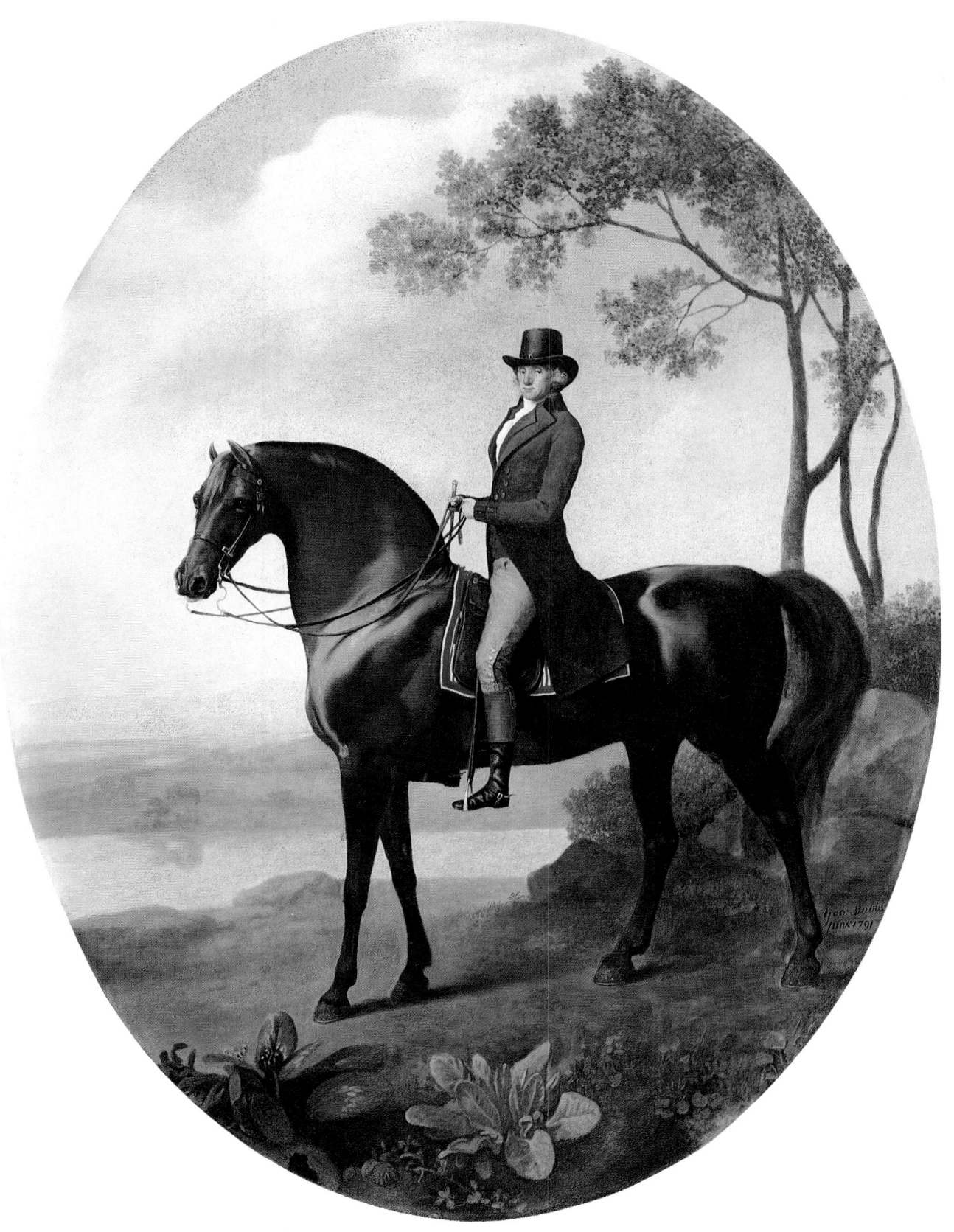

WARREN HASTINGS, 1791.
*The studied elegance of this portrait is diminished
somewhat by the horse's slightly protruding tongue.*
(above).

been expected; at this time many Englishmen were amassing vast fortunes in India, using their position to increase their personal wealth through more or less dubious means. However, Hastings was shown not to have abused his powers, and emerged from his ordeal with honour. Stubbs' portrait suggests a man not unaware of his own importance, a man who takes pride in his immaculate appearance, who tries very hard to present himself as the perfect gentleman. His ramrod bearing is so different to the comfortable stance of the Duke of Portland, but was characteristic of a man of fashion, though rather exaggerated perhaps. His stirrup-leathers are very long, which gives the impression that he is standing on tiptoe. It is not a very sympathetic image, yet one of his biographers said that 'he is not ever known to have lost a friend', which is a generous tribute and suggests a more sympathetic character than that described by Stubbs.

Stubbs' early patrons were drawn from that aristocratic circle of friends who met at Angelo's; the Dukes of Richmond, Portland and Buccleuch, the Marquess of Rockingham, Viscount Torrington and Lord Grosvenor among others. However, later in his career his patrons included the Irish horse-dealer Denis O'Kelly, the Smithfield butcher William Wildman, the Staffordshire potter Josiah Wedgwood and the colourful Colonel Thomas Thornton, whose wild sporting escapades contributed much to the poor reputation of sportsmen in general.

The sitters for Stubbs' *Lady and Gentleman in a Phaeton*, 1787, are no longer identifiable, but there can be little doubt that they are newly prosperous merchants or professionals of some description. The couple's pride in their handsome equipage is evident, though the matched pair of smart horses and the elegant lines of the phaeton accentuate the dumpiness of the figures, especially that of the gentleman, whose coat with its single button is being tested to the limit. They look down on the spectator from their position in the high carriage, well pleased with their elevated situation. Stubbs describes their air of quietly self-satisfied prosperity, but he does not comment on what he perceives; in his work he does not patronize, still less satirize, he simply observes. However, in his one military painting there is a suggestion of humour, though whether it was intentional is hard to assess.

In 1793 the Prince of Wales commissioned a painting of four members of his regiment, called the *Soldiers of*

LADY AND GENTLEMAN IN A PHAETON, 1787.
The phaeton was the carriage driven by those who wished to be considered fashionable, and was usually drawn by a pair of horses. This couple probably considered their smart equipage a statement of an improvement in their status.

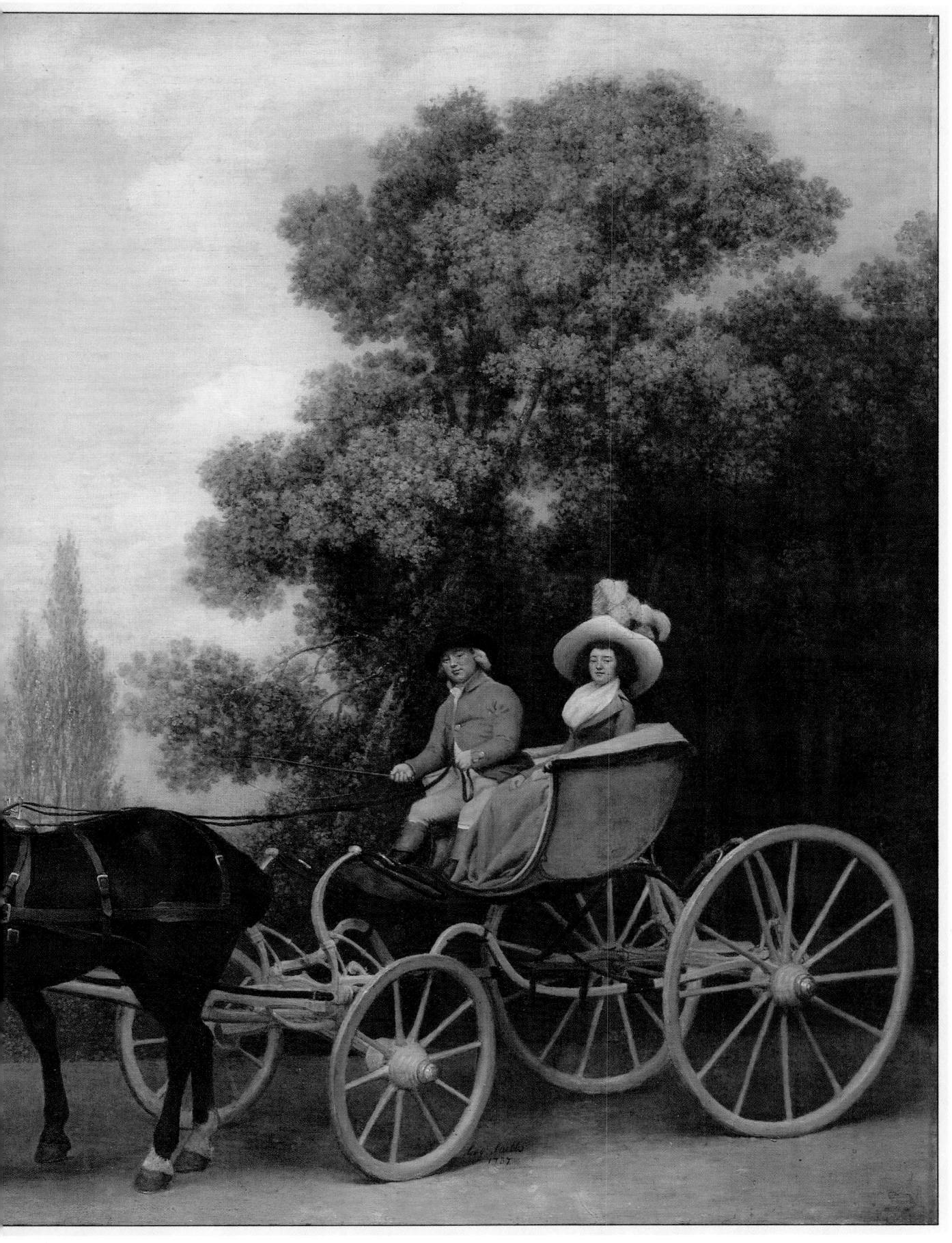

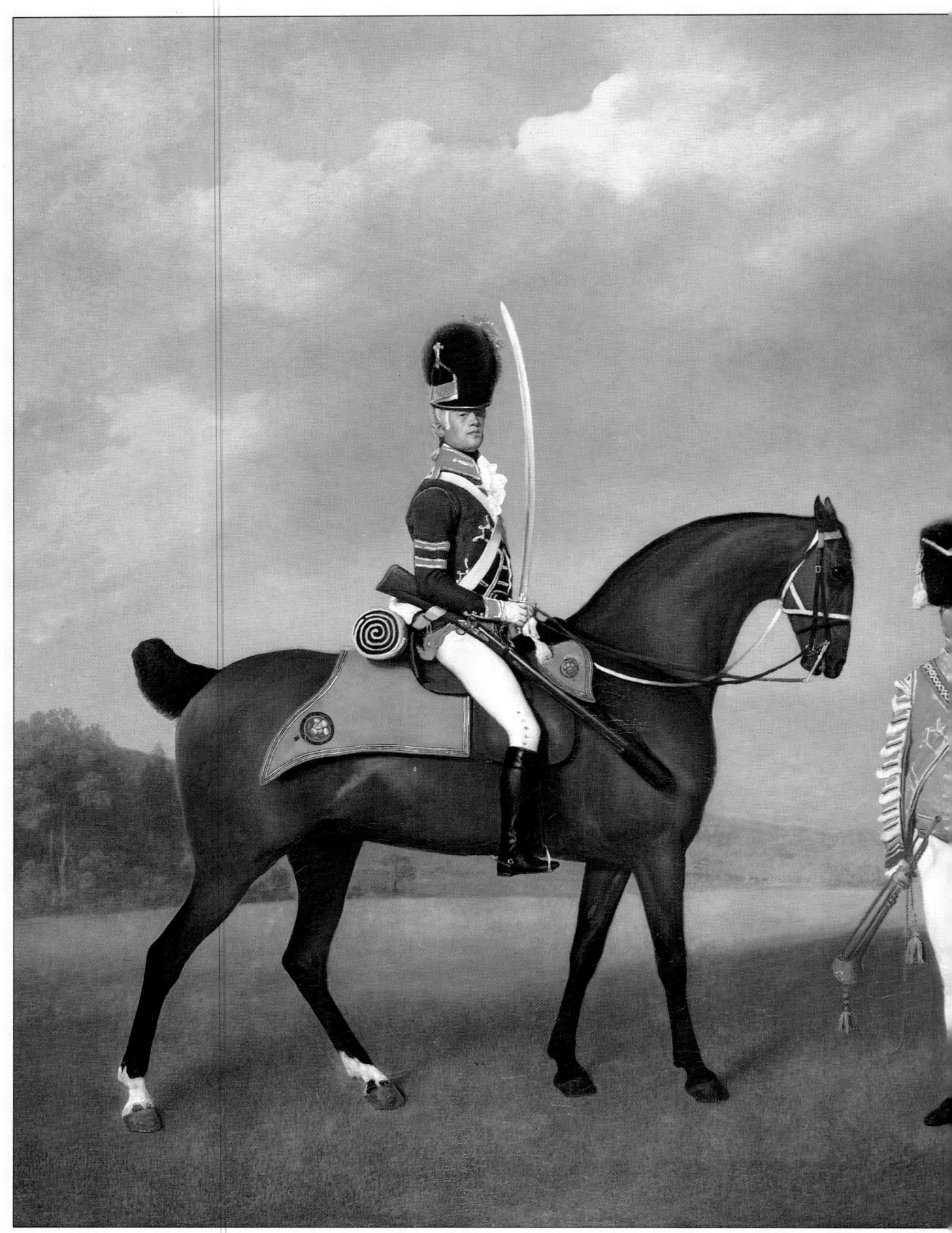

the 10th Light Dragoons. Not precisely a description of a class, but rather a description of a profession, the military aspect of this painting is unmistakable: the stiff, starchy poses of all four figures suggest the disciplined precision of the parade ground. There is something amusing about the juxtaposition of the fat, red-faced, smiling trumpeter and the thin, dour soldiers beside him; their erect bearing with feet in an absurd parody of the balletic first position only adds to the slightly eccentric air of the painting. The crisp realization of every detail of their splendid uniforms would have been important to its patron, who was very fond of dressing up as Colonel Commandant of the regiment. The dress and equipment of the mounted sergeant is particularly fine, and all four wear splendid cravats which have the stiff curls of cream-coloured cabbage leaves.

The figures in this group are all rather two-dimensional; the horse is unusually flat and lacking in substance. This has the effect of emphasizing the patterns within the group, with the curves of the mounted sergeant and his horse contrasting with the staccato rhythms of the foot soldiers. A comparison of the position in the saddle of this soldier with that of Warren Hastings and that of the Duke of Portland shows that Stubbs tells us much about the rider simply from the way that he sits on his horse. Here the soldier sits deep into the saddle, with his weight falling naturally into his heel, just the tip of his toe resting on the stirrup; this suggests the professional horseman who is untroubled by spending long hours in the saddle, whose expertise is reflected in the easy grace of his bearing. Warren Hastings looks tense, strained and self-consciously correct in comparison. The Duke does not appear to care what he looks like with his feet thrust 'home' in the stirrups and his lower leg pushed forward in a position which owes more to considerations of comfort than of elegance.

So much of Stubbs' work stands up to close and repeated scrutiny. One of the reasons that his portraits do not lose their interest lies in the fact that he is never lazy, that is, he never stoops to using a formula in the descriptions of his figures, whatever their rank. His insistence on dependence on nature gives his art a freshness which is reinforced by the fact that he did not employ assistants, and through his own perceptive yet sympathetic understanding he throws light on a variety of aspects of English country life. In effect, he leaves us with such a vivid impression of a golden age that it is easy to forget the darker side of the story.

SOLDIERS OF THE 10TH LIGHT DRAGOONS, 1793.
The Prince of Wales commissioned this picture in the year that he was granted his appointment as Colonel Commandant of the regiment. Its inherent touch of humour must surely have been intentional, although it is not a quality normally associated with Stubbs' work.

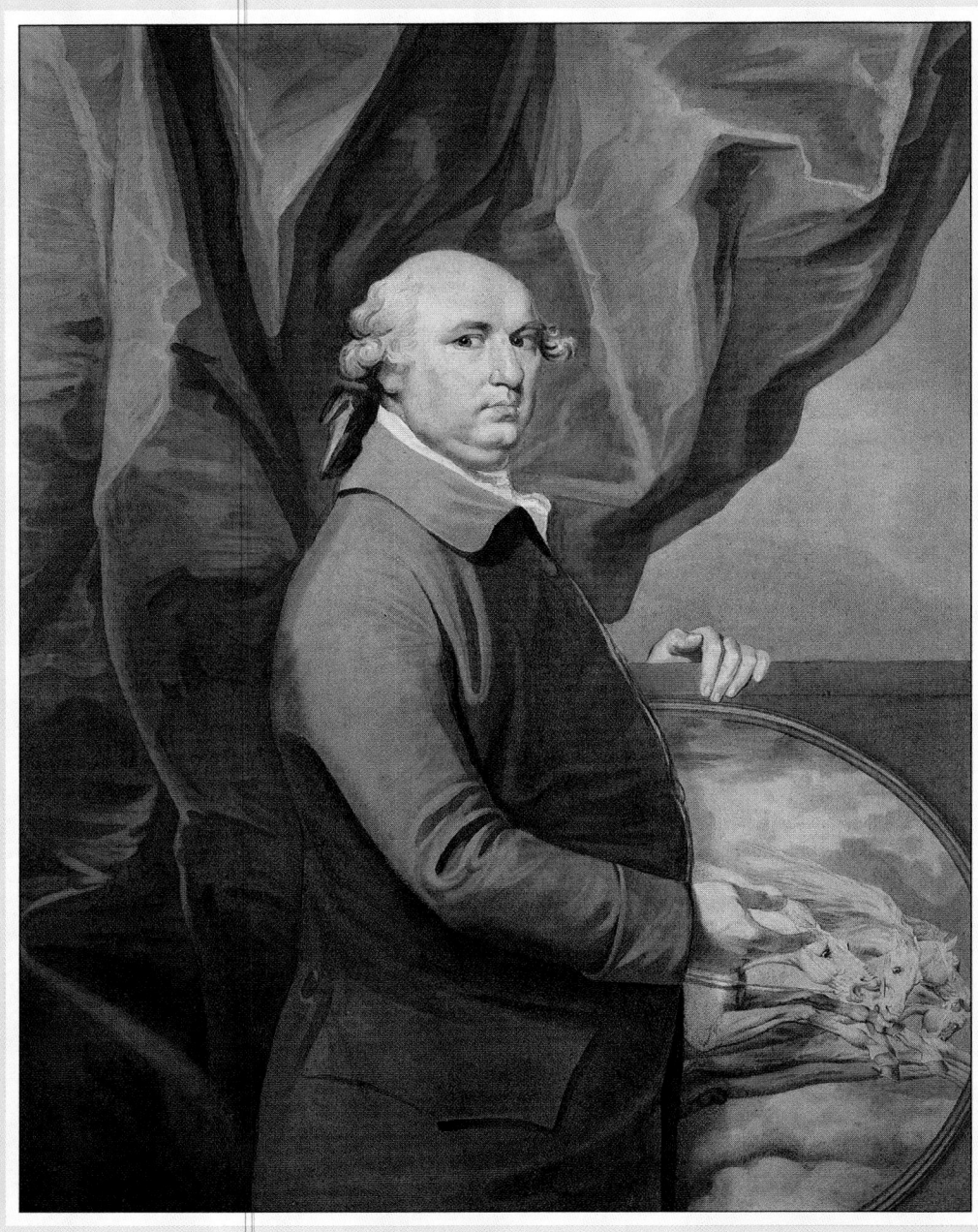

PORTRAIT OF GEORGE STUBBS WITH 'PHAETON',
*by Ozias Humphry, (?) 1777. Humphry's watercolour
portrait shows Stubbs gesturing towards an example of*
Phaeton, *a favourite mythological theme. It is the
version painted in enamels on copper, dated 1775. Its
inclusion in the portrait underlines Stubbs'
commitment to both history painting and to the
enamel medium.*

THE DESIRE TO CHANGE

'Tis said that nought so much the temper rubs
Of that ingenious Mr. Stubbs,
As calling him a horse-painter – how strange
That Stubbs the title should desire to change.'

This rhyme was written by John Wolcot, alias Peter Pindar, the satirical poet who published *Lyric Odes to the Royal Academicians* in 1782. The view that painters who specialized in animal subjects should not attempt other forms of painting was widely held, and did not only apply to Stubbs. Sawrey Gilpin (1733–1807) and George Garrard (1760–1826) were amongst those who were also castigated for attempting to progress beyond the confines of sporting painting.

——— EARLY ASPIRATIONS ———

It would appear that Stubbs, once he had developed his horse-painting technique, aspired to painting subjects that were more prestigious in the established artistic hierarchy than humble sporting themes. As early as 1762 he exhibited a work entitled the *Fall of Phaeton* at the Society of Artists. It included horses, but also illustrated a Greek myth and was, therefore, a type of history painting. The myth tells of Phaeton, the son of the sun-god Helios, who demanded to drive his father's chariot of the sun. He was unable to manage the horses and they careered across the skies out of control, coming perilously close to burning the earth. Consequently, Zeus, the greatest of all the Greek gods, killed him with a flash of lightning. Thus, Phaeton became the symbol of all those who tackle tasks beyond the limits of their abilities.

In the light of subsequent criticism of Stubbs it seems an ironic choice for his first history painting, but perhaps he was unaware of the connotations of the theme. It is probable that he was drawn to the story simply because it was a mythological subject which included horses. Clearly, he remained attached to it as he executed several other versions of it during his career, including one made of Wedgwood Jasperware in 1780. His affection for the theme is also evident in the watercolour portrait of Stubbs (1777) by Ozias Humphry, which shows the artist holding a version of this subject under one arm as he gestures towards it with the other.

The *Fall of Phaeton* exhibited in 1762 was uncommissioned, but caught the attention of Sir Joshua Reynolds, who asked if he might have it in exchange for the early painting of a horse he already owned. A second version, exhibited in 1764, was painted for Colonel Thornton. Like almost all attempts at history painting by 18th-century English artists, it does not carry conviction. The danger of the situation is not conveyed successfully, largely because Phaeton himself does not appear to be very concerned about his predicament. The horses are more expressive: the front one gives a good impression of speed, although any sense of drama that they create is dissipated through the passivity of their driver. He is supposed to be pulling with all his might on the reins, his legs braced on the chariot for leverage; however, his expression appears relaxed as he leans back with eyes closed as though he was enjoying the breeze. Alterations to the angle of his head and his expression in later versions are more successful dramatically. Since lightning brightens the sky behind him Stubbs may have been attempting to describe the moment when Zeus strikes him dead and this would account for the lack of facial expression. In literary terms this would have been the most dramatic point of the story but visually it does not have the same impact. Stubbs must have felt that the *Fall of Phaeton* was a success: Reynolds' approval would have been sanction enough for him to continue with this type of subject had he wished to do so, but, instead, during the 1760s, he worked on another dramatic theme, developed in the paintings of the lion and horse series. He did not return to painting mythological subjects until later in his career, when he painted a number of history subjects derived from the cycle of Hercules myths.

—— THE LION AND HORSE SERIES ——

There can be little doubt that Stubbs undertook both the history paintings and the lion and horse series as a result of the artistic climate of his age. Great pressure was exerted upon an ambitious artist to paint 'elevated' subjects, if he wished to be taken seriously by the artistic establishment. The various lion and horse themes treated by Stubbs do not have any historical or mythological narrative content and therefore cannot be strictly described as history paintings; but through them Stubbs moves beyond the known world into the realm of his imagination, as he did with the *Fall of Phaeton.*

The first of the lion and horse series was probably painted in 1762, the same year as the first *Fall of Phaeton* was exhibited. He painted 17 versions of the theme between then and the mid-1790s. As a group they were well received by connoisseurs for, unlike almost all the rest of his work, they fulfilled the newly fashionable intellectual requirement for the sublime in painting. In 1757 Edmund Burke (1729–97), philosopher and politician, had published the *Philosophical Enquiry into the Origin of our Ideas of the Sublime and the Beautiful* in which he describes the concept of the sublime and how it should affect a person's emotions: 'the passion called upon by the great and sublime in nature, when those causes operate most powerfully, is astonishment, and astonishment is the state of the soul, in which all its motions are suspended, with some degree of horror.' A painting that could be described as 'sublime' had to surprise and frighten the spectator to the point where reason was overpowered. Painters of landscape evoked it through the use of towering cliffs, deep chasms and awesome ravines. Stubbs used the wild rocky scenery of Creswell Crags as a background to some of his lion and horse paintings to achieve similar results.

In choosing the conflict between the two noble animals Stubbs took a middle path between the animal world he knew so well and the less familiar world of the imagination. His choice may have been inspired by a classical marble sculpture of a lion attacking a horse which he was very likely to have seen during his visit to Rome; it was well-known and accessible to travellers in the 18th century. Possibly dating from the 3rd century BC, it depicts a horse lying on the ground having been brought down by a lion who sinks its teeth into the ribs of its struggling victim.

PHAETON, EXH. 1764.
One of the few surviving history paintings, it exists in many different versions, including a jasperware relief (see p122).

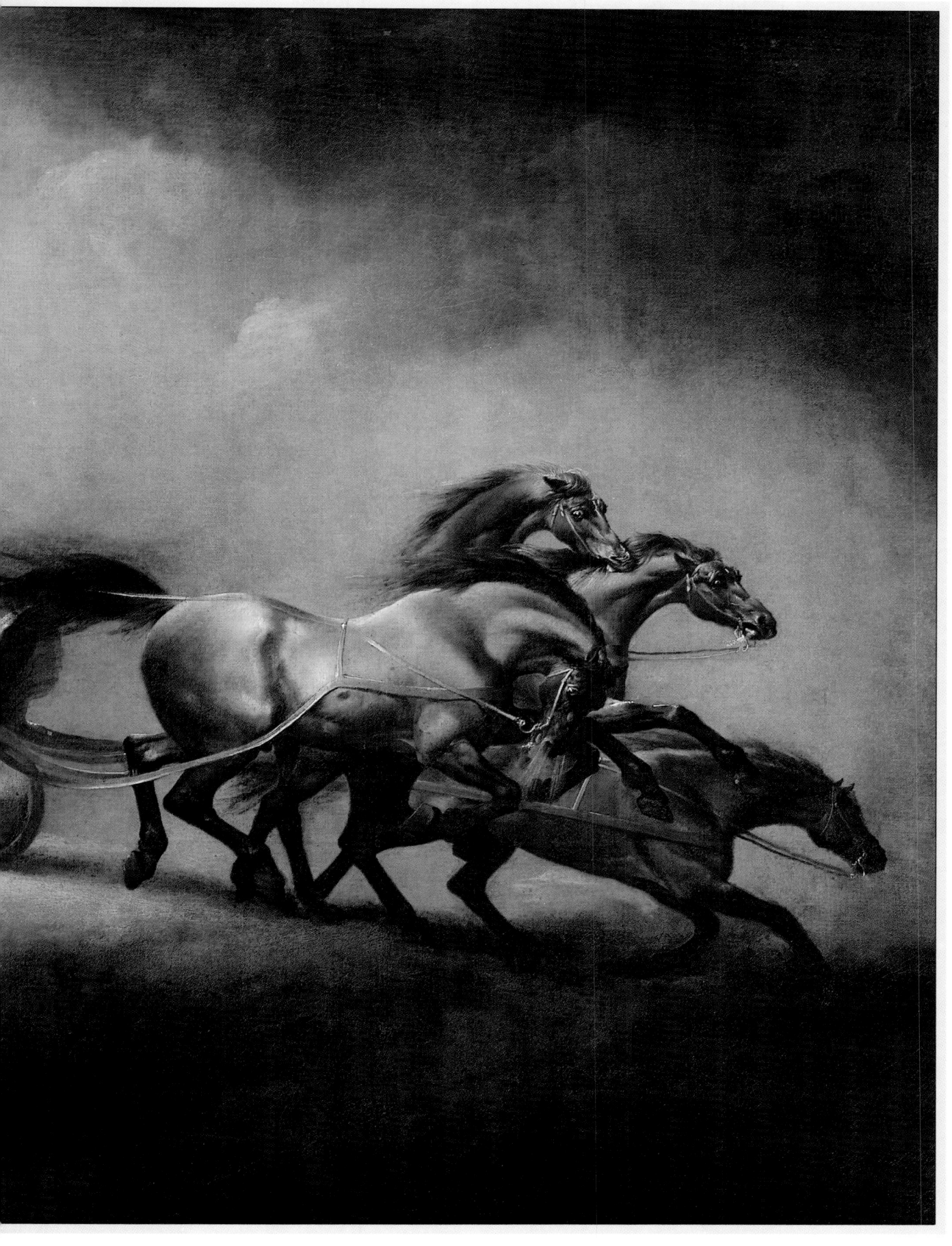

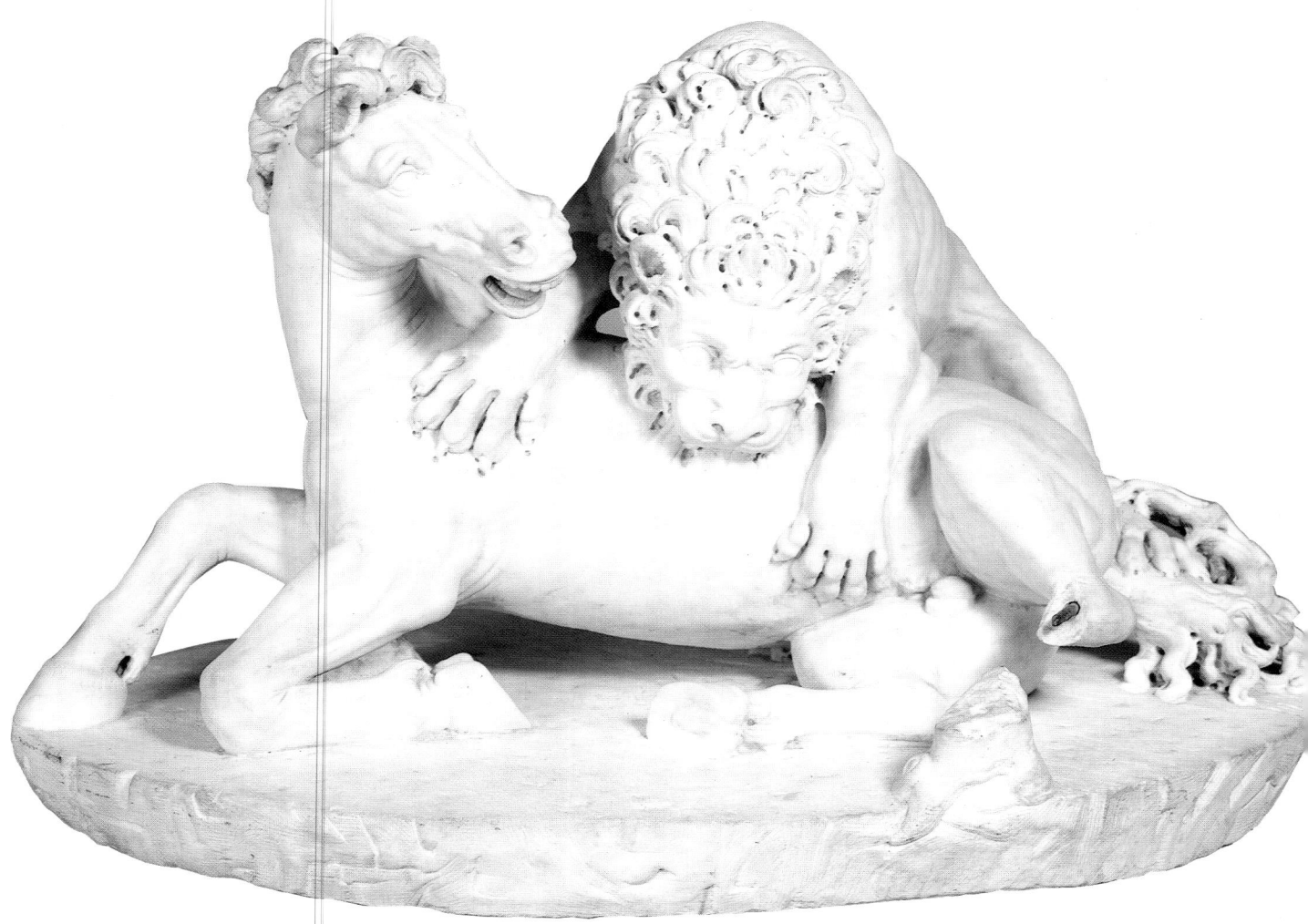

The horse is shod, a hind shoe and clenches are clearly visible; in contrast, Stubbs avoids this reference to domestication in his paintings. If he did not see the original in Rome, which must be unlikely given his interest in horses, he could have seen one of the copies, such as the damaged example now in the Walker Art Gallery, Liverpool. This statue is an 18th-century Italian version called *Horse attacked by a Lion.*

The story quoted in Chapter 1, taken from the *Sporting Magazine* of 1808, refers to Stubbs having witnessed a lion attacking a horse on his journey home from Rome: this must be considered improbable on the present evidence, for it has no earlier authentication than this posthumous article. If Stubbs had witnessed such a scene would he not have publicized the fact? After all, it would have reinforced his claim that he looked to nature alone

for inspiration. There is, however, no reference to it in Humphry's memoir nor in any of the exhibition catalogues. The matter must be left open, for if there were no truth to the story at all, why would someone take the trouble to invent it after Stubbs' death?

The *Horse attacked by a Lion* commissioned by the Marquess of Rockingham was probably painted in 1762 and was, therefore, the first of the series. It measures 2.4 x 3.3m (8 × 10½ft) and is the largest of all the lion and horse paintings. In many ways it is also the most successful, for the design of the picture is bold and vigorous, giving it greater power than any of the subsequent versions. It was painted at approximately the same time as the *Grosvenor Hunt,* another work of masterly design.

It is the abstract qualities of the *Horse attacked by a Lion,* its design, its use of colour to reinforce the composition, its sense of sculptural form in space, which make it interesting to a spectator today. The design of this painting is driven by powerful thrusts along straight lines checked by strong curves moving in the opposite direction; this illustrates Stubbs' interest in the potential of counter-

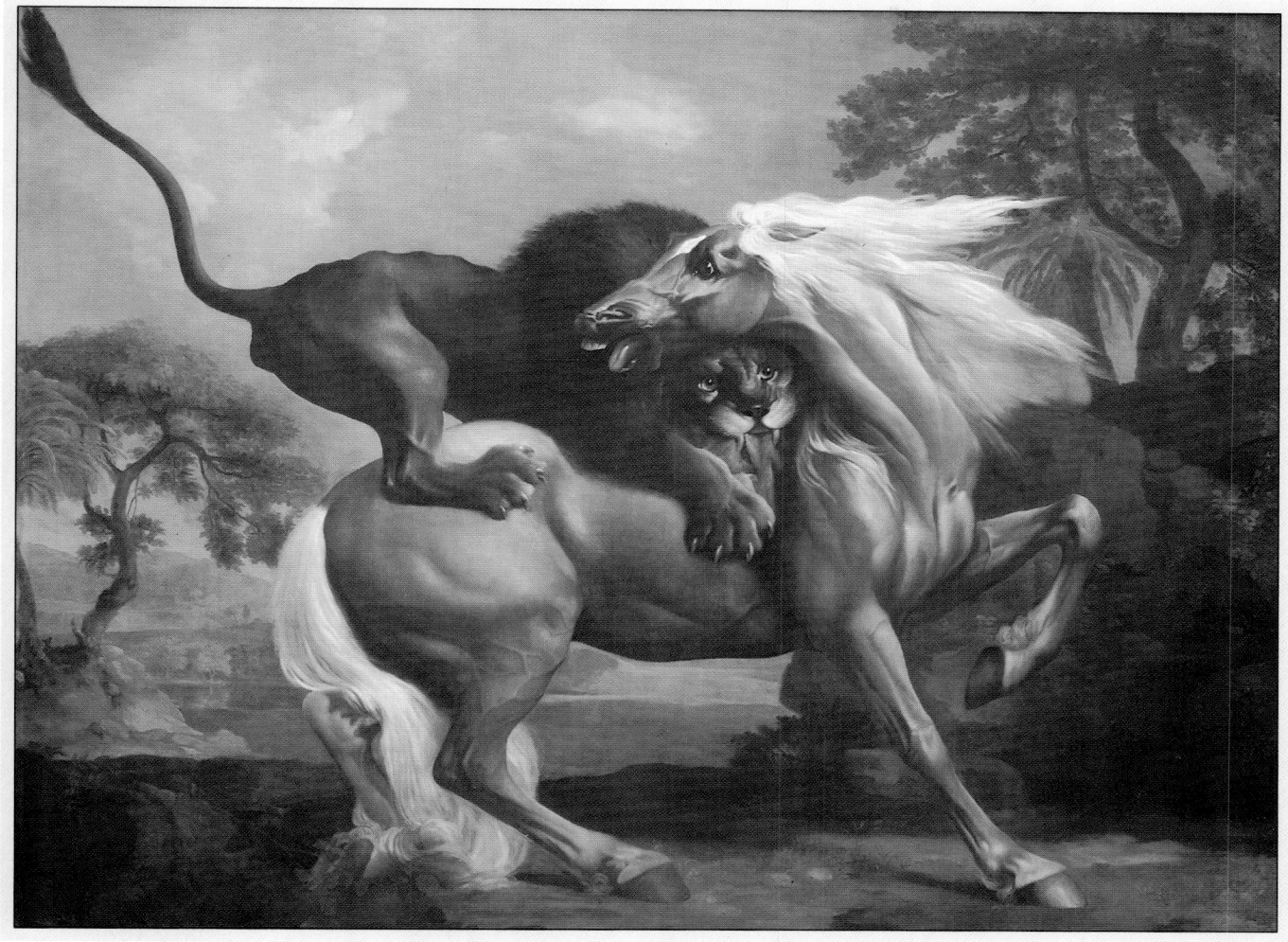

balanced movement in his compositions in the early 1760s. From the lion's outstretched tail, through its legs and gripping claws, the movement is transferred to the horse's legs. Its bent hind leg acts as a shock-absorber for one line of thrust, while the foreleg, similar to that of the grey in the *Grosvenor Hunt,* takes the full weight of abruptly halted action. The horse's sharply curved neck and raised knee contain the movement, directing the balance back towards the centre of the image. The creamy white of the palomino's mane and tail strengthens the curved sections of the composition, and also helps to define the animals against the landscape. The pronounced contrasts between light and shade of both horse and lion give them substance and help to describe their shape in space. By these means Stubbs creates a composition in which line, contour and three-dimensional depth are successful.

To Stubbs' contemporaries, such considerations of composition and form would have been secondary to the 'effect' of the painting. Was it astonishing, was it awesome, did it engender horror? Certainly, in these terms it was deemed satisfying, though today these aspects of the work

seems too staged, too hollow, for most tastes. One of Stubbs' most valuable assets was his ability to persuade the spectator to believe in his representation of 'real life'. In this painting he does not ask us to believe (the landscape with its odd combination of trees does not invite credibility), he asks us to be overcome with awe and terror. We are meant to put ourselves in the position of the stricken horse and to feel the fear and pain that it demonstrates; but the power of the sublime does not extend across the centuries and is no longer effective.

In comparison with Stubbs' less imaginative work, the lion and horse paintings do not carry the same power to convince. Part of the reason for this may be that he could not easily obtain direct experience of his subject. Opportunities to observe a horse in mortal fear must have been infrequent, if available at all, and Stubbs' appears to have

HORSE ATTACKED BY A LION, (?) 1762.
In this early version Stubbs has given the setting an exotic quality through the introduction of palm trees. Nevertheless, the landscape appears to have been imagined rather than observed, making the story of his visit to North Africa even more improbable.

had to look to sources other than nature to observe the force of expression he required. The similarity between some of the illustrations to the French court painter Charles Le Brun's *Characters of the Passions* published in English in 1701 and Stubbs' frightened horses has been pointed out by Stephen Deuchar in *Sporting Art* (1988). Le Brun's book is listed in the catalogue of Stubbs posthumous sale, and the affinity between the small octagonal *Horse attacked by a Lion* of c1768–9 and plate number 10 of Le Brun's work is too close to be coincidental. Common to both are the springy hair pulled back to suggest movement, the wide open mouth with bared teeth, and most of all the heavy brow bone and over-large eye. The semicircular projection of the horse's eye would appear grotesque in a normal context, but here, Stubbs has abandoned his cust-

omary realism in order to exaggerate for the sake of expression. As a result the image lacks the power to persuade us that this event ever really took place, and, therefore, the power to move us.

In the small-scale paintings, Stubbs focuses on the horse and lion very closely so that they fill the image, but in other versions he gives more emphasis to the background to increase the sublime effect. *Horse devoured by a Lion,* possibly exhibited in 1763, is set in a detailed representation of Creswell Crags, already mentioned as a background for various horse-portraits and shooting subjects. With its rocky cliffs, fast-flowing river, dark overhanging trees and deep shadows it is a restrained version of a sublime landscape, observed by Stubbs from nature and, as a result, it is convincing.

The positions of the animals in this work are closest to those of the antique marble sculpture, with the horse on the ground struggling to rise and the lion about to tear the flesh from its ribs. Stubbs has cast the lion in the role of an evil destroyer; it glares out of the picture with

CHARACTERS OF THE PASSIONS,
by Charles Le Brun. Terror.
CHARACTERS OF THE PASSIONS,
by Charles Le Brun. Fear.

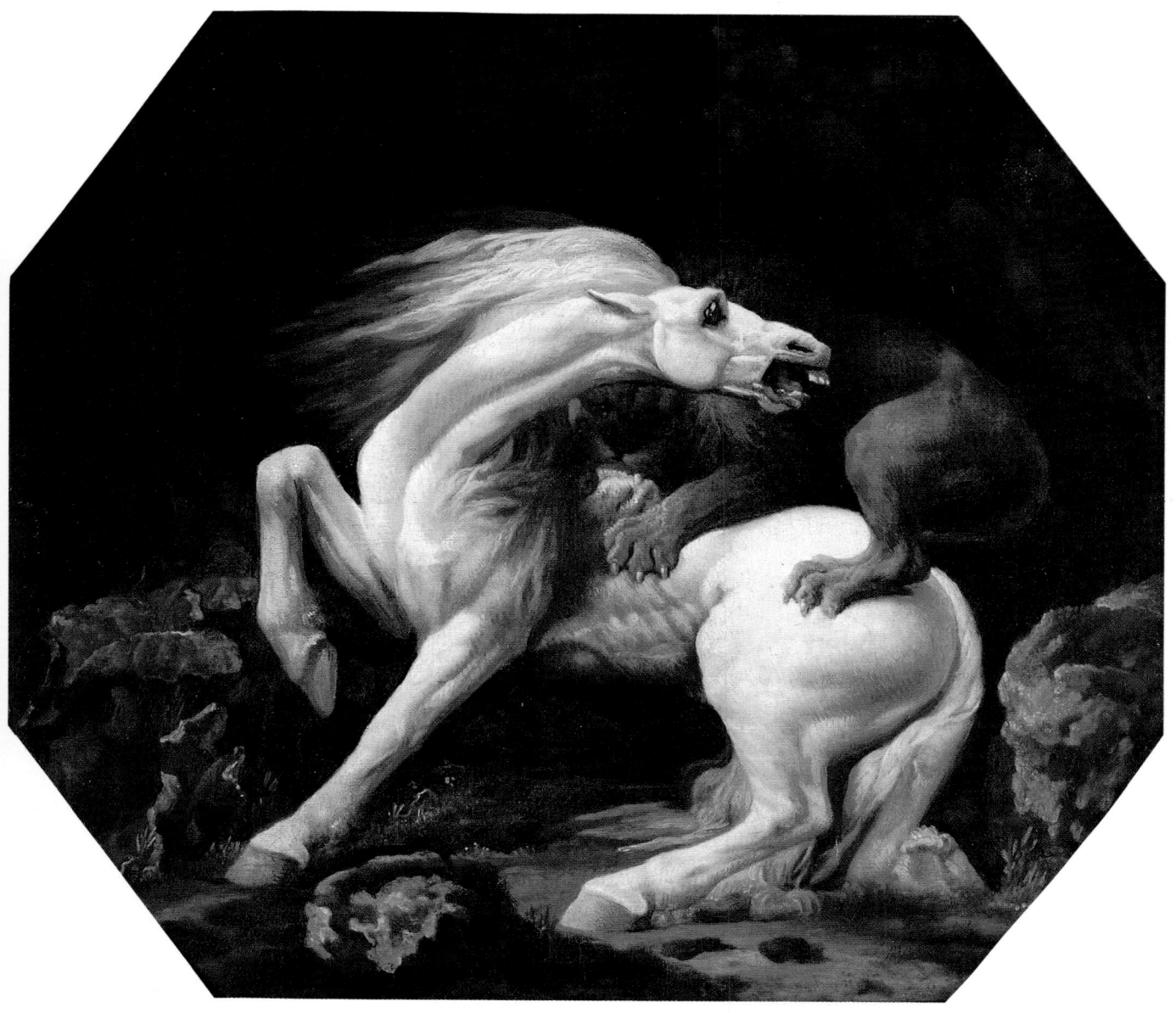

malevolent eyes. His customary detachment is abandoned and he invites the spectator to side with the horse in this battle. Had he treated the subject with the objectivity of his horse-paintings the emotional bias in favour of the horse would have been less pronounced. In nature the lion's actions would be caused by its instinct for survival rather than any evil intention.

The landscapes of the later versions of the lion and horse theme follow the same trend as the backgrounds of his other works; the precision of the early 1760s gives way to a more generalized treatment. In the *White Horse frightened by a Lion* of 1770 he takes Creswell Crags as a starting point, but adds to the height of the rocks and the depth of the gorge. The mysteriousness of the overhanging rocks with their deep gloomy shadows are given more emphasis. Against this dark background the white horse shines as though under a spotlight, creating a contrast

which is absent from earlier examples, such as the Rockingham painting. The less specific and more imaginary landscape increases the romanticism of the work, giving it a dream-like quality in which realistic detail is less important than the overall impression.

All of the paintings in Stubbs' lion and horse series balance between neo-classicism and romanticism. The formal discipline of Stubbs' compositions is neo-classical in spirit whereas the implied or described violence of his theme is romantic in its appeal to the emotions. These elements are rarely combined elsewhere in his work, and

HORSE ATTACKED BY A LION, C.1768–9.
Stubbs appears to have drawn on Le Brun's representations of extreme human emotion for his descriptions of animal pain and fear. In this work the association is particularly evident, but other works in the lion and horse series were probably influenced by Le Brun's publication.

with hindsight, his talents appear best suited to the less dramatic subjects such as *Mares and Foals without a Background* or *Sir John Nelthorpe*.

EXPERIMENT

In the late 1760s, at the height of his career, Stubbs embarked on a new venture which combined both artistic and scientific interests. Up to this point his paintings had been executed in oil on a canvas support, but in 1769 he painted a version of the lion and horse theme in enamel colours on an octagonal sheet of copper.

Working with this medium would have been seen by his contemporaries as an extraordinary departure, for a number of reasons. Enamel colours were usually employed either to embellish small decorative objects, such as snuff-boxes and scent bottles, or they were used to paint miniature portraits. Stubbs' reputation as a serious artist would not have been improved through these associations. The smooth polished finish of enamel did not suit the prevailing fashion for thick impasto and visible brushstrokes; the clear bright colours which result from the use of this technique would have appeared very vivid, even garish, to spectators used to oil-paintings which were usually finished with layers of brown varnish.

Why Stubbs should have devoted so much energy to the technique of painting in enamels is difficult to understand, although it did have the attraction of permanence; once they have been fired, enamel colours are almost indestructible. Oil-painting technology in the 18th century was imperfectly understood. Some of Sir Joshua Reynolds' paintings have deteriorated very badly; it is said that, in one case, a sitter returned home from a long journey abroad and declared that his portrait had aged faster than he had. Problems of this kind would have made the effort of painting in enamels more attractive to Stubbs. Also, no other artist had attempted to use the technique on a large scale. To a man of his enquiring mind the challenge might have been reason enough. It is also possible, however, that Stubbs saw the enamel paintings as a means to break away from the horse-painter image, as though by painting in this extraordinary new manner his association with horses would be overlooked. The majority of the subjects

WHITE HORSE FRIGHTENED BY A LION, 1770.
*The atmosphere of the later versions of the series is
more romantic and mysterious. A comparison
between this work and that on pp110–11 clearly
illustrates the change.*

HORSE DEVOURED BY A LION, (?) EXH.1763.
*Taken as a group, the lion and horse paintings
describe various stages in the encounter.
(previous page).*

116

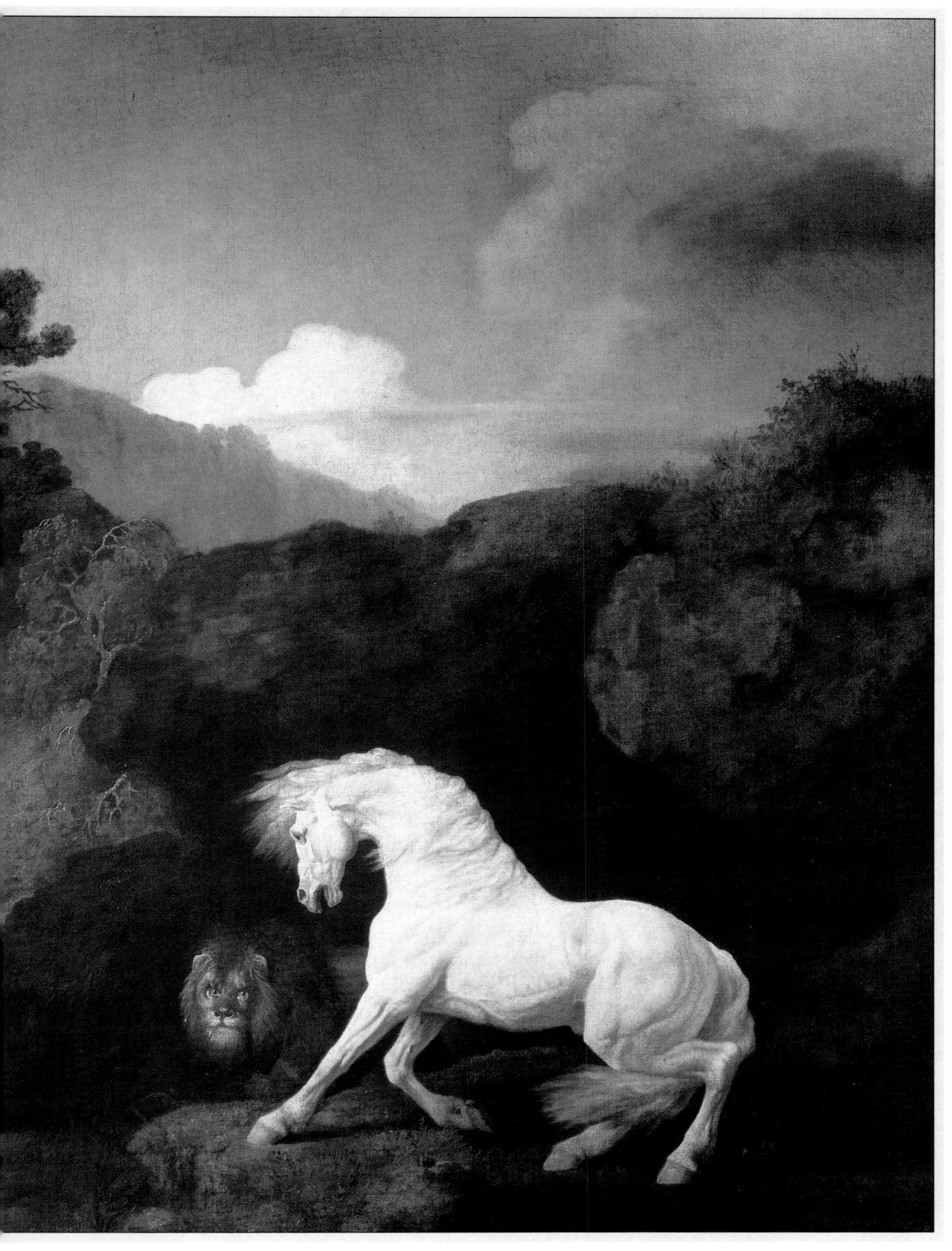

that he executed in enamels did not include horses, and he appears to have seen them as a vehicle with which to promote himself as a serious artist. Humphry records that the person who suggested that Stubbs should try enamel painting was an artist called Richard Cosway (1742–1821). It is possible that Cosway helped him to master the technical difficulties of the medium; on the other hand, he might have gone to one of the commercial producers of enamel objects to learn the method.

Stubbs' paintings in enamel colours fell into two categories; a small number of early ones were painted on copper, but the majority were painted on earthenware plaques. In both cases the 'paint' was a type of glass made of silicates with additions of lead and potash or borax. To this, various metal oxides were added to produce different colours. The support, whether metal or ceramic, was covered in a layer of white enamel before any other

colours were applied, and this together with the glassy quality of the paint medium, gives enamel painting its characteristic bright finish.

The paintings were fired in a kiln to fix the colours to the support. Firing was the most hazardous part of the process and disasters not infrequent, the most common being the blistering of the paint surface. One of the drawbacks of the technique was that an artist could spend hours on a work that was then wrecked whilst under the control of the kiln manager. A further difficulty was that the colours were altered by the firing process. They only took on their final look in the kiln. Enamel painters,

LION AND LIONESS, 1770.
Stubbs' enamel paintings on copper were bigger than any previous examples, but he wanted to be able to paint on the same scale as his oil paintings, so he looked to other materials to provide a support that could withstand the heat of the kiln (above).

whether miniaturists, or those employed by factories producing enamelled metal objects, such as Battersea, or in the ceramics industry, had to become accustomed as apprentices to seeing their work undergo a radical change in the firing process. To an artist like Stubbs (now in his forties) it must have been very hard to adapt his painting method to take this change into account. Indeed, he spent some time experimenting with the development of colours which did not alter when fired; with some degree of success, according to Humphry.

The *Lion and Lioness* of 1770 is one of the early enamel paintings on a copper support. It is octagonal and measures 24 x 30cm (9½ × 11in). The subject falls half-way between the lion- and horse-paintings and the straightforward animal-portraits. The dark, rocky setting is similar to that of some of the former, but the overt violence of those scenes is absent, though the potential for it is illustrated in the angry snarl of the lioness. The treatment is less evocative of the sublime but is, nevertheless, in a higher key than the cool objectivity of his horse-paintings. The works painted in enamel on copper have a soft, almost stippled look which is the result of the use of small precise brushstrokes to build up the image. By this means subtle graduations of tone are possible, as can be seen here in the lioness's coat. The paintings on copper were limited in terms of size, partly due to considerations of weight but more importantly because the larger the plate the more likely it was to buckle in the firing process.

It may have been the limitations in size which initially prompted Stubbs to look into other forms of support for his enamel paintings. He approached both the potteries and the makers of artificial stone. He may have become interested in the latter when one of the manufacturers, Daniel Pincot, provided some specimens for an exhibition by the Free Society of Artists in 1767. Used for making statues, vases and architectural details from moulds, it was probably made of clay mixed with flint, sand and glass. The most famous and successful of the early makers was Mrs Eleanor Coade, who was in business by 1769. None of the firms registered patents and no records survive with the exact ingredients of the material. None of the makers of artificial stone were willing to undertake Stubbs commission, which is perhaps not surprising as they were geared to mass production, so he began his association with Josiah Wedgwood, who led the world with his developments in ceramics during the second half of the 18th century.

The largest of Stubbs' paintings on copper is about 38 x 45cm (15 × 18in), whereas the largest of his paintings on a ceramic support is about 75 x 100cm (30 × 41in).

This was very large in terms of all previous work in enamels, and similar in size to many of his oil-paintings on canvas – *Horse Devoured by a Lion,* for example. The development of a suitable surface was a very slow process, and successful results were not achieved until the end of the 1770s. No correspondence between Stubbs and Wedgwood survives and they appear to have communicated via the latter's partner, Thomas Bentley, who ran the London end of the company from Greek Street in Soho. Wedgwood's letters to Bentley contain some references to the project, and mention the inevitability of the slow pace of experiment as though Stubbs was impatient for results. In a letter of November 1777 Wedgwood writes, 'My comp.ᵗˢ to Mr. Stubbs. He shall be gratified but large Tablets are not the work of a day'. In a postscript of December 1777 Wedgwood writes, 'We have fired 3 tablets at different times for Mr. Stubs, one of which is perfect, the other two are crack'd & broke all to pieces. We shall send the whole one (22 inches by 17) on Saturday & are preparing some larger.'

Nearly a year later Wedgwood was still having difficulties, and indicates that a further reason for the slow progress was that his work for Stubbs had to take second place to the commercial production of the factory, reasonably enough, 'When you see Mr. Stubs pray tell him how hard I have been labouring to furnish him with the means of adding immortality to his very exellent pencil. I mean only to arrogate to myself the honor of being his *canvas maker.* But alass this honor is at present denied to my endeavours, though you may assure him that I will succeed if I live a while longer undisturbed by the french as I only want an inclin'd plane that will stand our fire. My first attempt has failed, & I cannot well proceed in my experiments 'till we lay by work for xmas when our kilns will be at liberty for my trials.'

The plaques are made of a refined form of cream-coloured earthenware, called creamware, of the type that Wedgwood had improved, though not invented. The same material was used for making wares for the table, which Wedgwood called Queen's Ware, and for making decorative vases and urns. Stubbs painted onto the fired but unglazed creamware, and when the picture was finished it was refired to fix the colours. The ceramic surface gave different results to the earlier works on copper, for it was both a more textured and more absorbent support, producing an effect closer to painting on canvas than on metal. His half-length *Self-portrait* of 1781 has the luminous quality of all the paintings in enamel colours but it does not have the glossy finish of those on copper. It appears that the paint could be worked in a similar man-

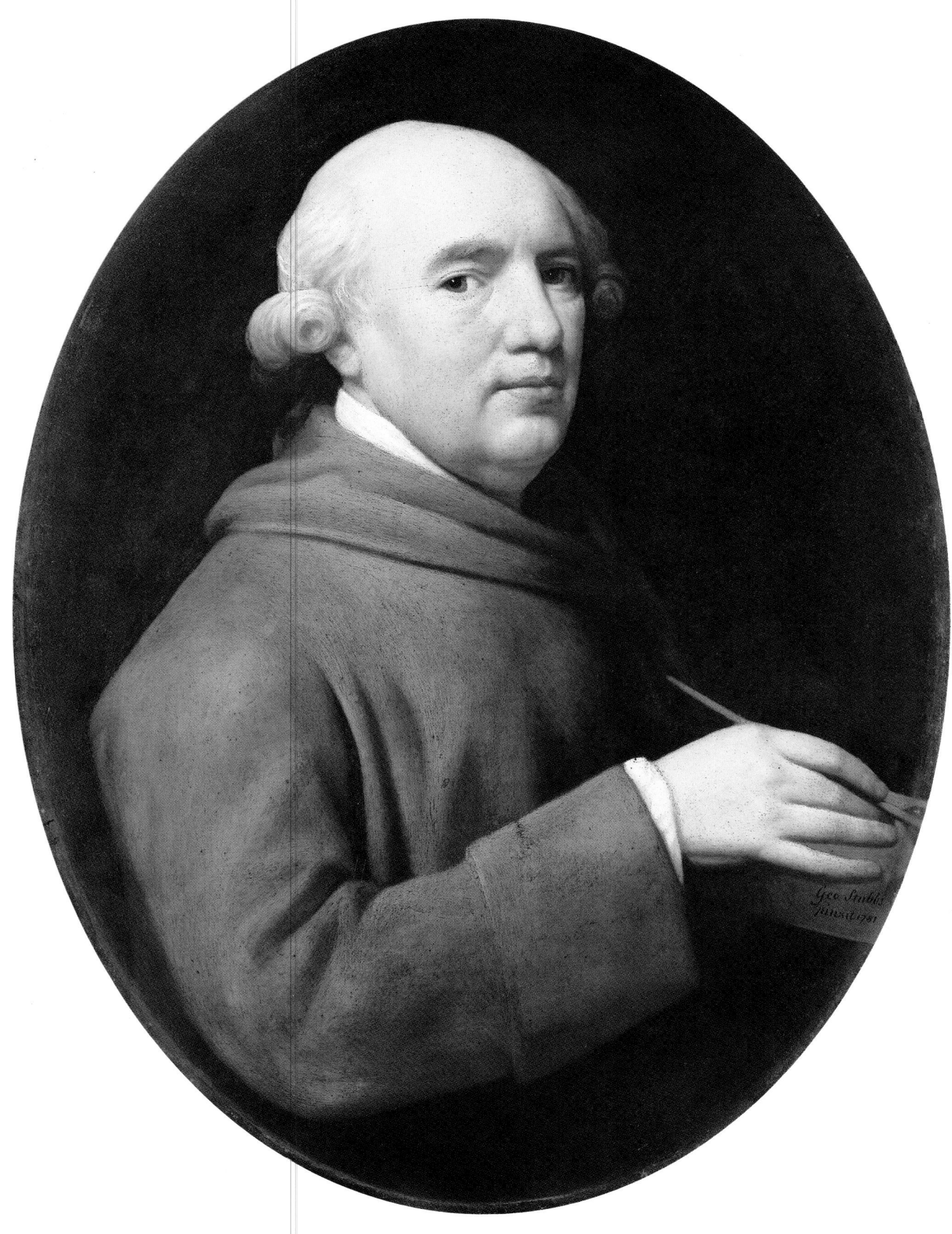

SELF-PORTRAIT, 1781.
*This superb work was painted for a friend, Richard
Thorold and is one of the most successful of his
paintings on creamware.*

THE WEDGWOOD FAMILY, 1780.
This painting falls very far short of the high standards of the conversation pieces mentioned above. Wedgwood expressed his dissatisfaction with it to his partner in London 'my wife I think very deficient – Mary Ann more so, & Susan not hit off well at all'.

ner to oils; the softness of image, as in the earlier works on copper, is absent. The white ground applied to the creamware gives the flesh tints an especially attractive quality, though it was these colours that were particularly troublesome in the kiln.

The cost of Wedgwood's experiments were high, but he aimed to recoup them, at least in part, when the technique became accepted and practised by other artists, as both he and Stubbs hoped it would. Wedgwood was an astute businessman who was familiar with the concept (though not the term) of the loss-leader; for instance, in the 1770s he made a service of Queens Ware for Empress Catherine the Great, which was more valuable in prestige than profit, and in the 1780s and early 1790s he spent many years of painstaking experiment in the production of a copy of the Portland Vase in Jasper Ware (the original is made of Roman cameo glass). However, while he hoped Stubbs would set a profitable trend for work on creamware, he did demand payment for his efforts, either in cash or in portraits of his family.

In 1780 Stubbs went to stay with the Wedgwoods at Etruria in Staffordshire in order to paint a family group and a number of individual studies. The *Wedgwood Family* was less than a success, and Wedgwood's letters record his dissatisfaction with the result. It is painted in oil on panel, a combination which Stubbs used frequently, following his experience of painting in enamels, presumably because the firm surface is closer to metal or earthenware than canvas. The best part of the picture is the portrait of Josiah, who leans on a table on which a black basalt vase is displayed. The horses, especially the two in the centre, are not well drawn, and the children with the cart are wooden and characterless.

The circumstances in which the artist was working may have contributed to the failure of the painting, as there were many other projects in hand during his stay with the family. Wedgwood had prepared some 'large jarrs' for Stubbs to decorate in enamels, and was also encouraging him to do some modelling in clay. With various commissions for individual portraits also in hand, and with teaching the Wedgwood boys to draw, it is hardly surprising that Stubbs was distracted from finishing the family group, and that it fell short of his usual standard. The 'large jarrs', if completed, are not known, but the results of the artist's first venture in modelling do survive.

These are low relief plaques made by Wedgwood from Stubbs' clay prototypes. These original models were used to make reverse moulds, from which the copies were made in both jasper ware and black basalt (both types of stoneware) for factory production.

The first subject was the *Frightened Horse,* a much simplified version of the lion and horse theme. Wedgwood objected to Stubbs' choice of the *Fall of Phaeton* for the companion piece, giving his reasons and some insight into Stubbs' personality in his letter to Bentley written in October 1780: 'I have objected to this subject as a companion to the frightened horse as that is a piece of natural history, this is a piece of un-natural fiction, & indeed I should prefer something less hackney'd & shall still endeavour to convert him, but would nevertheless wish to have the [print of] the Phaeton sent lest he should be obstinate in which case I think it will be better to have that than nothing.' Stubbs obviously won this argument but did no more of this sort of work, although he may have provided drawings of horses for some reliefs made by Wedgwood in the late 1780s.

PORTRAITS

Since Stubbs' decision, in the 1750s, to concentrate on the painting of horses he had received no important commissions for formal portraits, or what he would probably have called face paintings. The success of his horse-paintings and the *Anatomy of the Horse* had ensured him a reputation with which he was becoming increasingly impatient. A letter from Wedgwood to Bentley written in September 1780 throws some light on Stubbs' standing and his aspirations, 'Mr. Stubbs came to us again last night after finishing a portrait of Mr. Swinnerton which is much admired, & I think deservedly so by all who have seen it, & I hope this, with our family picture & some others which he will probably paint before he leaves us will give him a character which will be entirely new to him here, for nobody suspects Mr. Stubs of painting anything but horses & lions, or dogs & tigers, & I can scarcely make anybody believe that he ever attempted a human figure.

I find Mr. S. repents much his having established this character for himself. I mean that of horse painter, & wishes to be considered as an history, & portrait painter. How far he will succeed in bringing about the change at his time of life I do not know.'

The majority of Stubbs' portraits after the 1750s were painted for Wedgwood and his family, or for their connections, in the 1780s. The oval head and shoulders study of Josiah, of 1780, is painted in enamels on creamware, and is a fine study of the great potter, in spite of the fact that

PHAETON, 1780.
The invention of jasper ware was Wedgwood's greatest contribution to the history of pottery.

THE FRIGHTENED HORSE, 1780.
A version in black basalt.

the flesh tints have blistered in the kiln and the plaque has been broken and imperfectly mended. Wedgwood was a superb potter and one of the great early industrialists, with an excellent understanding of the importance of good public relations and marketing. As well as being a very capable businessman he was a man of generosity with a sense of humour. The attractive character portrayed in the painting is reflected in his letters to Bentley. In one of these he is concerned with the reroofing of the kitchen, 'We are still open to the sky in our kitchen, which, though the weather is as fine as could be wished for, is nevertheless an uncomfortable situation for animals whose nature urges them to go through the drudgery of eating three or four times a day – Oh! for the sleep of a Dormouse, or the life of a Toad in a stone for a few weeks till our troubles

are past & we are safely cover'd in from the wind, & open air again.' This domestic upheaval took place while Stubbs was painting the family portrait, and cannot have improved Etruria as a working environment.

A further portrait in enamels on creamware is that of *Erasmus Darwin*, dated 1783. Grandfather of the evolutionist, Charles Darwin, Erasmus was a friend of Wedgwood's and also the family doctor. With an interest in ceramics (he was the first to receive a copy of the Portland Vase), he commissioned both this portrait and possibly a version of *Labourers* (see p131) also painted on creamware. This portrait is less successful than that of Josiah, the face is pale and appears to lack shading, especially about the forehead and cheekbones. The hands are not well drawn and the joining of the sitter's right hand to his body is

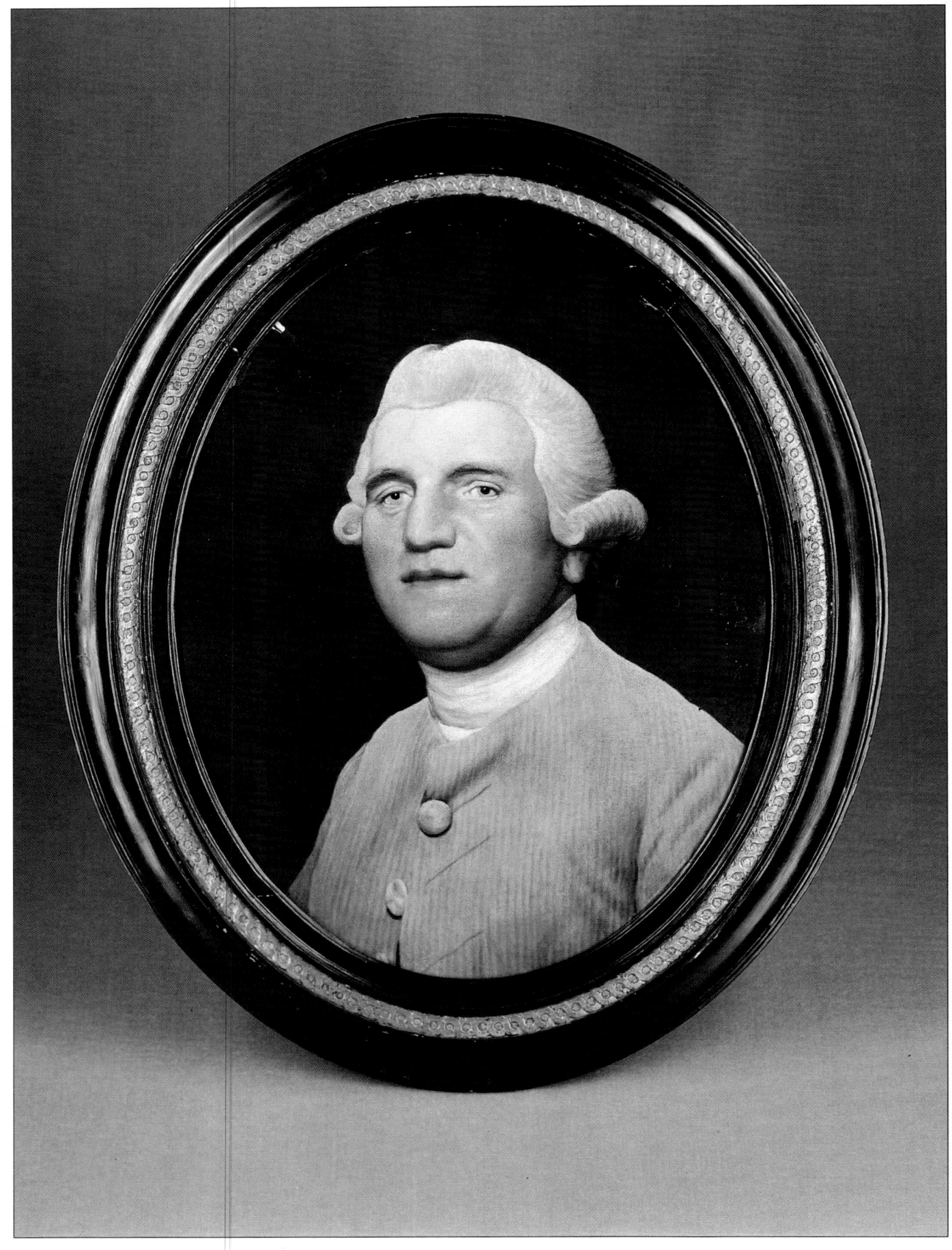

awkward. A better example is the study of *Richard Wedgwood,* Josiah's father-in-law, painted in oil on panel in 1780. This ranks with the *Self-Portrait* mentioned above as among the best of Stubbs' portraits. Painted at the same time as the family piece, Wedgwood wrote to Bentley that he thought it would be a very strong likeness, and it does give a good impression of an elderly man still in possession of all his faculties in his eightieth year. The eyes are intelligent but a little tired, and the set of the rather tight-lipped mouth is particularly descriptive. A work of this quality should have enabled Stubbs to secure other portrait commissions, but the Wedgwood works were not exhibited in London, and his ambitions to become a portraitist remained unfulfilled.

——— CHANGING THE SUBJECT ———

Wedgwood's letters record that Stubbs wished to be considered not only as a portraitist, but also as a history painter. The *Fall of Phaeton* was an early manifestation of this ambition, and the lion and horse theme could be described as a compromise between his animal studies and the more elevated type of subject associated with history painting. Two lost works indicate that in the early 1770s he was painting mythological pictures of a type similar to the *Fall of Phaeton,* in as much as the themes he illustrated involved animals, though not necessarily horses. Both these lost works were exhibited at the Society of Artists and both were derived from the Greek myths of the 12 labours of Hercules.

Hercules and Achelous was exhibited in 1770, and would have described the fight between Hercules, the hero of great physical strength and courage and Achelous, a river-god. They fought for the hand of Dejanira, daughter of another river-god, and during the fight Achelous changed his shape from human into a serpent and then into a bull. It is likely that Stubbs chose the stage of the fight when Hercules wrestles with his rival as a bull for this is the most popular version of the story, and would have best suited his animal painting abilities.

The second history painting was exhibited at the Society of Artists in 1772 and was called *The Centaur Nessus and Dejanira.* Hercules having beaten Achelous, takes Dejanira on a journey during which they have to cross a river. The ferryman is Nessus, who is a centaur. While carrying Dejanira across the river he attempts to ravish her, so Hercules

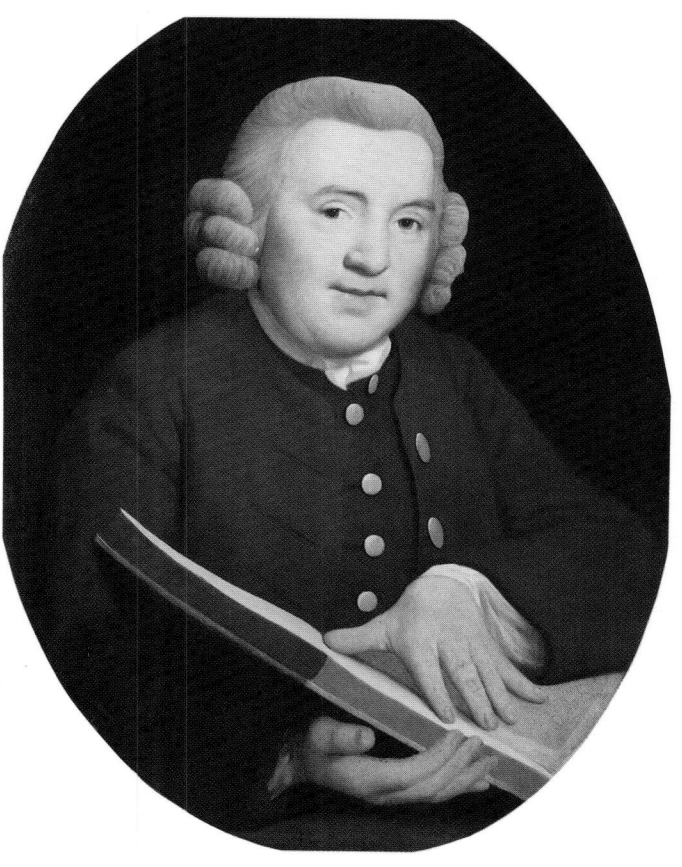

ERASMUS DARWIN, 1783.
The sitter was the Wedgwood's doctor, and a friend of Josiah's. The majority of Stubbs' 'face paintings' of this period are of members of the potter's family and their circle.

draws his bow and, with an arrow from the far bank, kills Nessus. Artists usually show the point when Nessus is about to gallop off with Dejanira on his back, while Hercules, across the river, prepares to shoot.

A further illustration to the Hercules cycle was included in Stubbs' posthumous sale, where it was called the *Judgement of Hercules.* It was never exhibited, but it was later owned by Walter Gilbey and described in his *Life of George Stubbs R.A.,* published in 1898. Gilbey called it *Hercules and the Cretan Bull.* From his description it would seem to illustrate the fight between the hero and King Minos' mad bull, which, though it belched flames, Hercules succeeded in overcoming after a great struggle. These tales from Greek mythology are far removed from the type of work normally associated with Stubbs, and their loss leaves a small but highly significant gap in his known work.

Apart from the *Fall of Phaeton,* the only other history painting to survive is an illustration to a fable called *The Farmer's Wife and the Raven.* The *Fables* of John Gay had been published in 1727, with illustrations engraved after John Wootton. In comparison with the drama of the tales

JOSIAH WEDGWOOD, 1780.
Wedgwood rarely made mistakes in his assessment of a potential market for a new product. However, he was very wide of the mark in his hope that Stubbs' work would set a fashion for painting on ceramics.

RICHARD WEDGWOOD, 1780.
Like the Wedgwood Family *it is painted in oil on panel.*
Stubbs has used a feigned oval within this work, a
device which also occurs in the early portrait of James
Stanley *(see p40).*

THE FARMER'S WIFE AND THE RAVEN, 1786.
This work illustrates one of John Gay's Fables, *in which
a farmer's wife has an accident on her way to market.
'The Raven on yon left hand oak,
(Curse on his ill-betiding croak)
Bodes me no good. No more she said,
When poor blind Ball with stumbling tread
Fell prone.'*

of Greek heroes the subject of Stubbs' painting is less heroic. It illustrates a tale which is a variation on the proverb 'don't count your chickens before they are hatched'. The farmer's wife is riding to market with her basket full of eggs which she hopes to sell, but, while she is dreaming of the money she will shortly make, her horse is startled by the raven's croak and falls, smashing the eggs and her dreams of riches. It is difficult to know quite why the subject should have appealed to Stubbs, but he painted three versions so it must have been a favourite. It gave him an opportunity to portray a horse in an unusual position; the grey struggling to regain its footing would have posed a challenge, but as a whole the subject, however beautifully painted, is not an inspiring one. The example shown here is painted in oils, dated 1786. His first version of the fable was painted in enamel colours on creamware in 1782; Stubbs painted a number of new subjects in this medium.

At about the same time as Stubbs was working on the Hercules subjects he painted two small circular pieces in enamel colours on copper. These are *Mother and Child* of 1772, and *Hope Nursing Love,* of 1774. These are not of a style suited to late 20th-century taste, since plump babies and sentimental mothers are not fashionable to-day. The pictures are a new departure in subject-matter for Stubbs, and it is possible that they were not for public consumption. The suggestion that they portray Mary Spencer (Stubbs' mistress) and George Townley Stubbs appears unlikely. Both pictures were listed in the posthumous sale, but if the sitter were Mary Spencer she would probably have kept these intimate studies as she retained quite a large number of Stubbs' works. Nevertheless, if the sitter is not Mary Spencer, there is insufficient evidence to suggest another candidate.

In 1782 Stubbs stepped up his campaign to change his artistic status. In that year, five of his seven exhibits at the Royal Academy were painted in enamel colours on creamware, and of these only one was a straightforward animal study. However, the enamel paintings were not favourably received, and though the account of events in the Humphry memoir is very confused, it would appear that Stubbs was

disappointed with the manner in which they were hung; he was annoyed also at the ommission of verses he had selected for their entries in the catalogue.

Stubbs' relationship with the Royal Academy was somewhat stormy in the early 1780s. Having exhibited with the Society of Artists since 1761, and been involved in its administration from 1765–1774, he began exhibiting with its more successful rival, the Royal Academy (formed in 1769), in 1775. In February 1781 he had been elected an academician, which involved submitting an example of his work, before he could be confirmed as a full member. When the Academy imposed a time limit of one year for the submission of a work Stubbs appears to have felt insulted and subsequently refused to send anything at all. As a result he never attained the status of Royal Academician. Stubbs seems to have behaved in a very prickly manner over this business, and the reception of his enamel paintings may lie at the root of his dissatisfaction. There is no surviving documentation to show that the Academy introduced a ruling against the showing of works on ceramics, but it is possible that this is what happened, since Stubbs did not exhibit this type of work at the Royal Academy after 1782, though he continued to show oil-paintings. The fact that, in 1879, painting on ceramics was

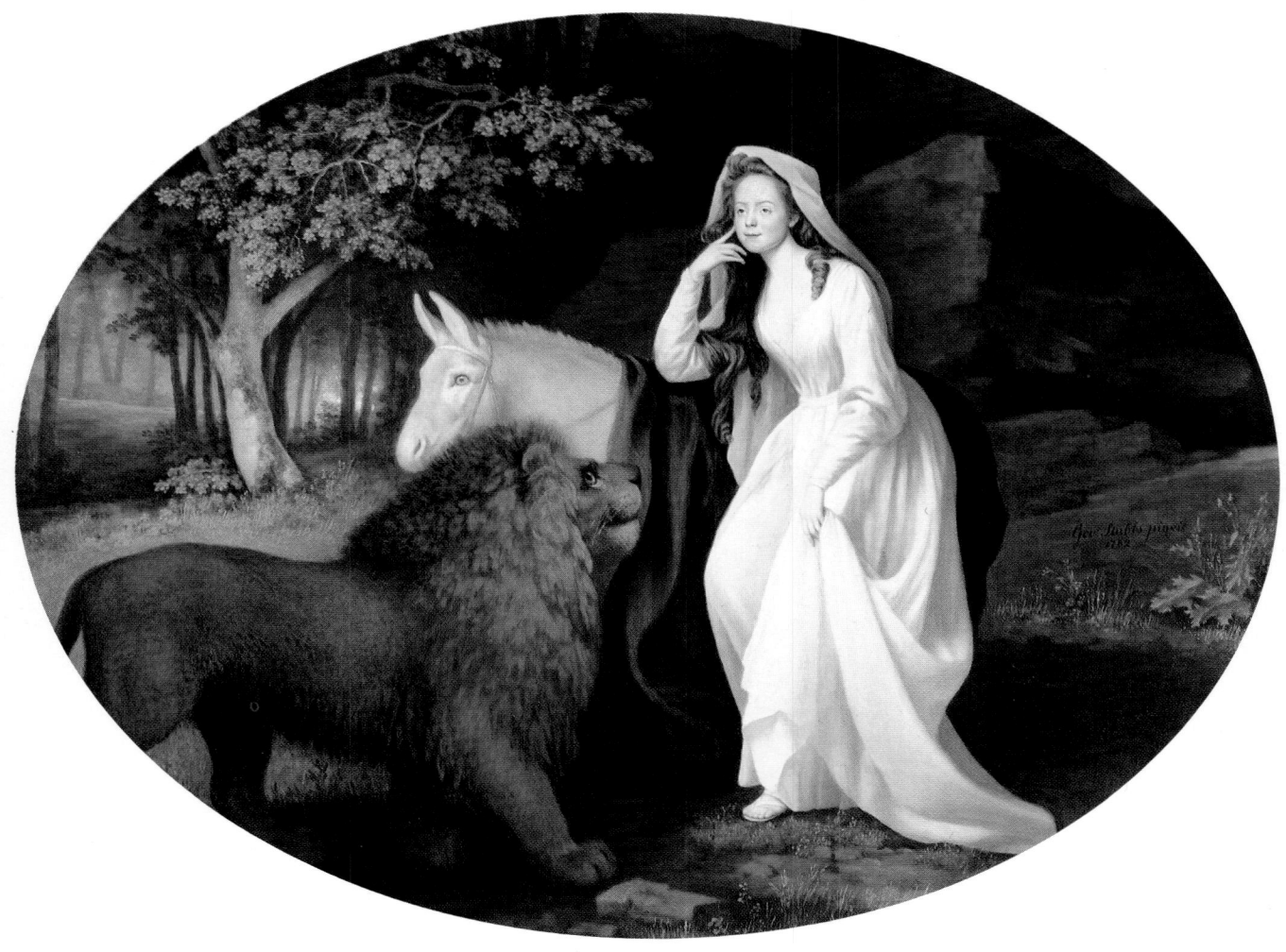

reallowed, reinforces this reading of Stubbs' behaviour.

One of the five enamel paintings exhibited in 1782 is among the most attractive of Stubbs' more ambitious subjects. A mixture of portrait and history painting, it is called *Isabella Saltonstall in the character of Una,* the heroine of Spenser's *Faerie Queene.* The sitter was to play an important part in the last lean years of Stubbs' life, as she lent him considerable amounts of money from about 1791. She was only 16 when this was painted; the subject is well suited to her youthful innocence, for Una was a virgin maiden who personified Truth. The composition is interesting, as it has much in common with the later *Freeman, the Earl of Clarendon's Gamekeeper.* The setting in both pictures is a dark forest interior, with views through to an area of light on the left of the picture. In both pictures the design of the figures is pyramidal; in *Una* the rocks behind her are an integral part of the group, whereas Freeman, the hound and doe are freestanding.

ISABELLA SALTONSTALL IN THE CHARACTER OF UNA, FROM
SPENSER'S FAERIE QUEENE, 1782.
*This work was among the five enamel paintings
exhibited at the Royal Academy in 1782. The others
were* Portrait of a Young Gentleman Shooting, The
Farmer's Wife and Raven, Self-Portrait *and* Portrait of a
Dog.

The use of colour in both pictures is restrained, with browns, greys and beiges dominating the palette. In *Una* the composition has been constructed from a closer viewpoint than in the other work, so that the forest assumes less importance; a lyrical tone is set by the sitter's dreamy expression, which is a world apart from the harsh realities of *Freeman.* The white ass has a rather ghostly aspect, and the lion, who was Una's guardian and devoted servant, is a mild character far removed from the evil creatures of the lion and horse theme. The painting succeeds where other imaginative subjects fail because of the portrait of Isabella/Una, which is as fresh and lifelike as anything in his work. It was obviously painted from direct observation and, as ever, Stubbs' work is at its best when studying his subject at first hand.

MOTHER AND CHILD, 1772.
*This intimate study offers a glimpse into Stubbs' private
life, but the figures have not been identified.*

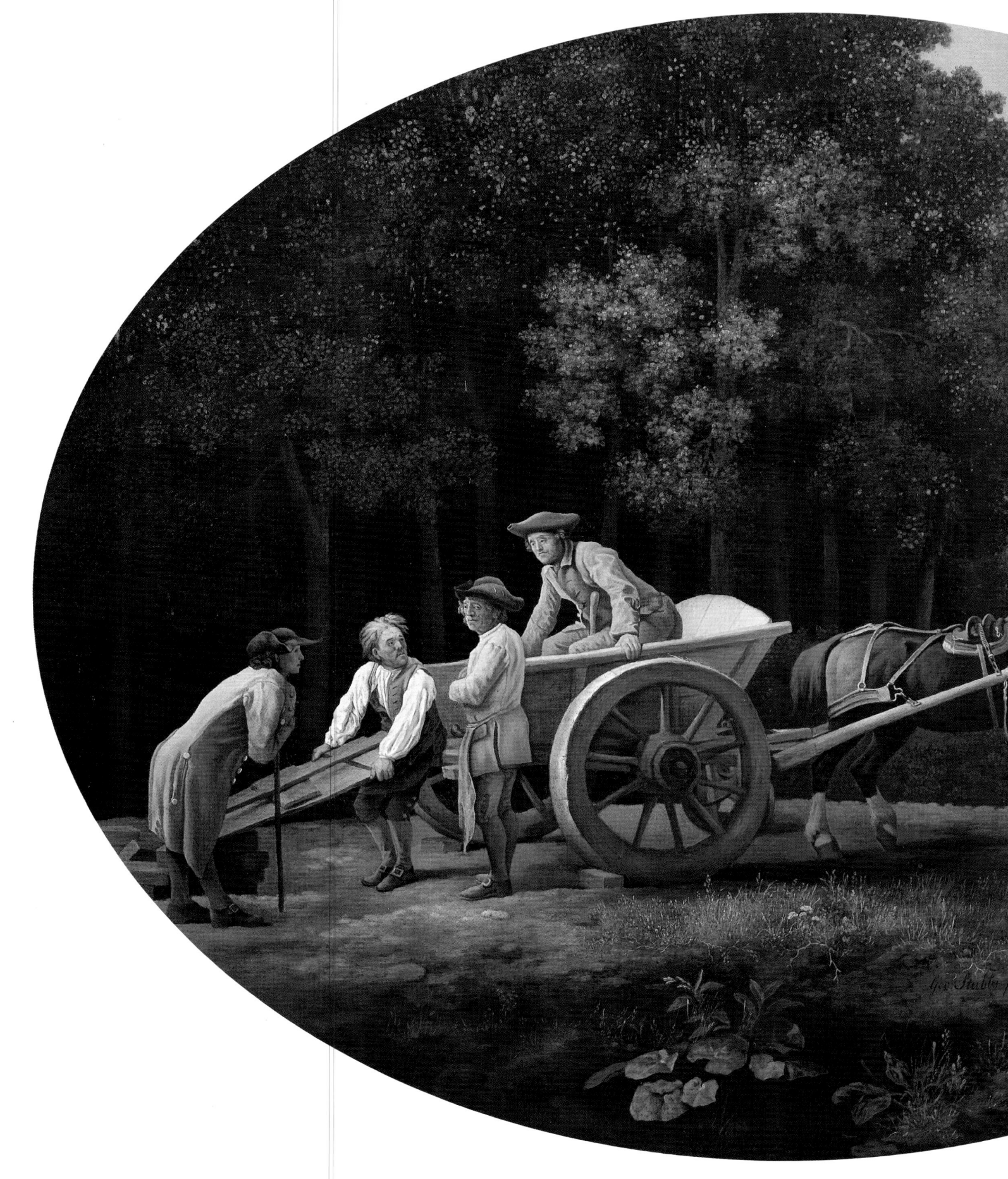

A work such as the *Farmer's Wife and Raven* cannot compete on equal terms with *Una*. This is partly because it depended on another artist's original interpretation, but more importantly because the pose of the stumbling horse could not be observed accurately in nature, just as the gallop was beyond the understanding of artists of the period. It was the experience of his own eyes that was vital to the success of Stubbs' paintings.

——————— RURAL SCENES ———————

Stubbs painted a number of views of labourers at work, the first of which was for Viscount Torrington, who also commissioned two others, *Setting out from Southill* and *Gamekeepers.* Called *Labourers,* the earliest version in oil on canvas was painted in 1767 and was later altered when a landscape painter, Amos Green, was commissioned to repaint the background. The illustrated version of the subject was painted in 1781 in enamel colours on creamware and shows Lord Torrington's bricklayers loading up a cart. The patron had often watched his employees at work and thought that they appeared 'like a Flemish subject'. This observation may have influenced Stubbs' treatment of the work, because the figures are not typical of his sympathetic style. Here, he seems to look at them from afar and to slightly caricature what he sees. The men's eyes are heavy lidded, their faces craggy, with tight-lipped down-turned mouths. Little attempt has been made to describe individual personalities and they all have expressions which are suggestive of limited intelligence. *Gamekeepers* is treated in a similar manner, whereas *Setting out from Southill,* the first of the group, includes some of Stubbs most sensitive portraits.

In the 1780s Stubbs painted a number of rural scenes. He may have been prompted to venture further into this field as a result of the success Thomas Gainsborough and George Morland had had with similar subjects; or, perhaps following the failure of the enamel paintings he may have hoped that the pretty country scenes would enhance his reputation at a time when he was receiving fewer commissions for horse-paintings.

Two of these rural scenes were Stubbs' only exhibits at the Royal Academy in 1786 (this was the first time he had exhibited any works since the unhappy circumstances of the 1782 exhibition). Called *Haymakers* and *Reapers,* both are in oil on panel and dated 1785. Stubbs idealizes life

LABOURERS, 1781.
The earliest painting of this subject is dated 1767.
Painted in oil on canvas, the background was
radically altered before 1790 by another artist. This
version on creamware shows the lodge and trees on the
right as Stubbs intended.

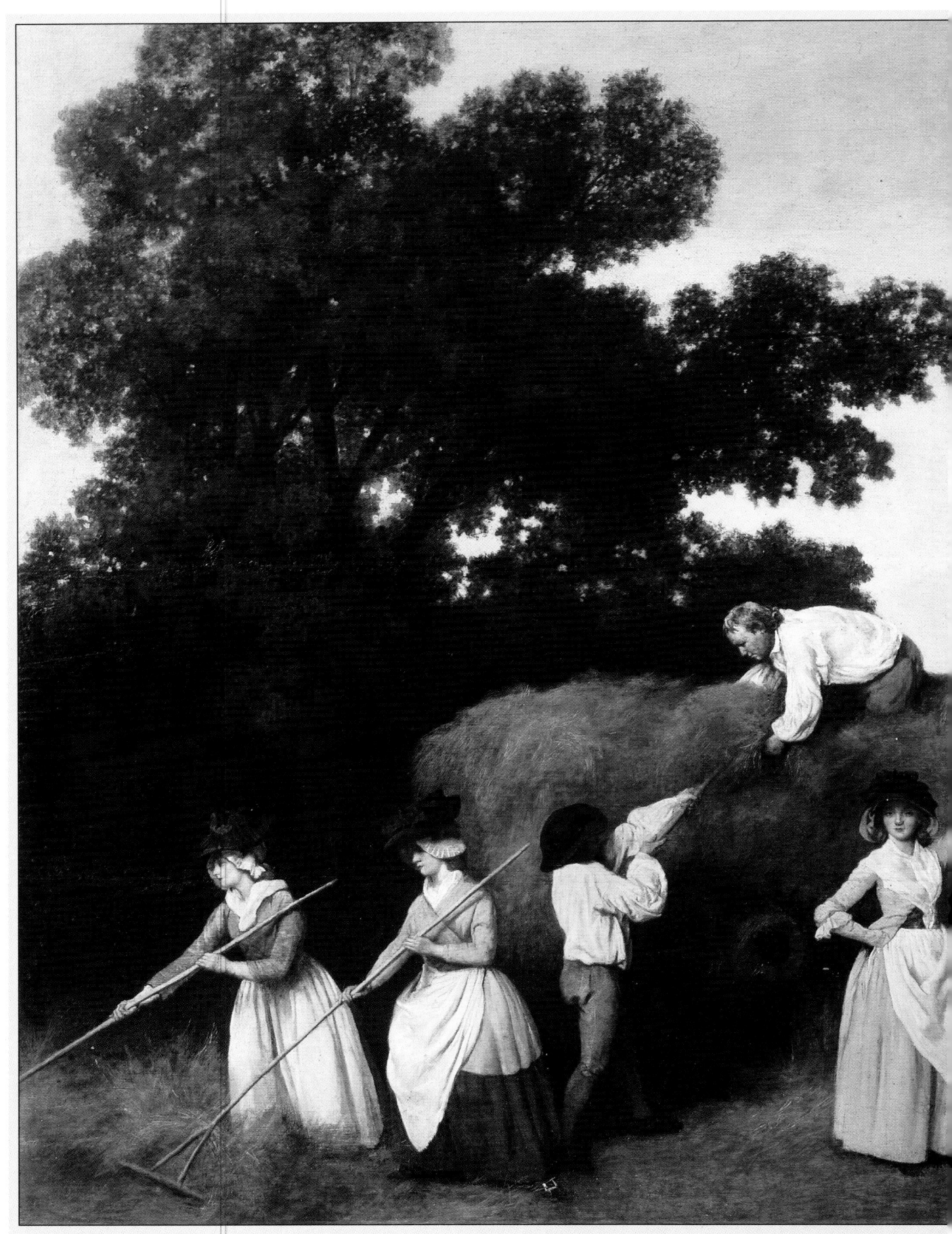

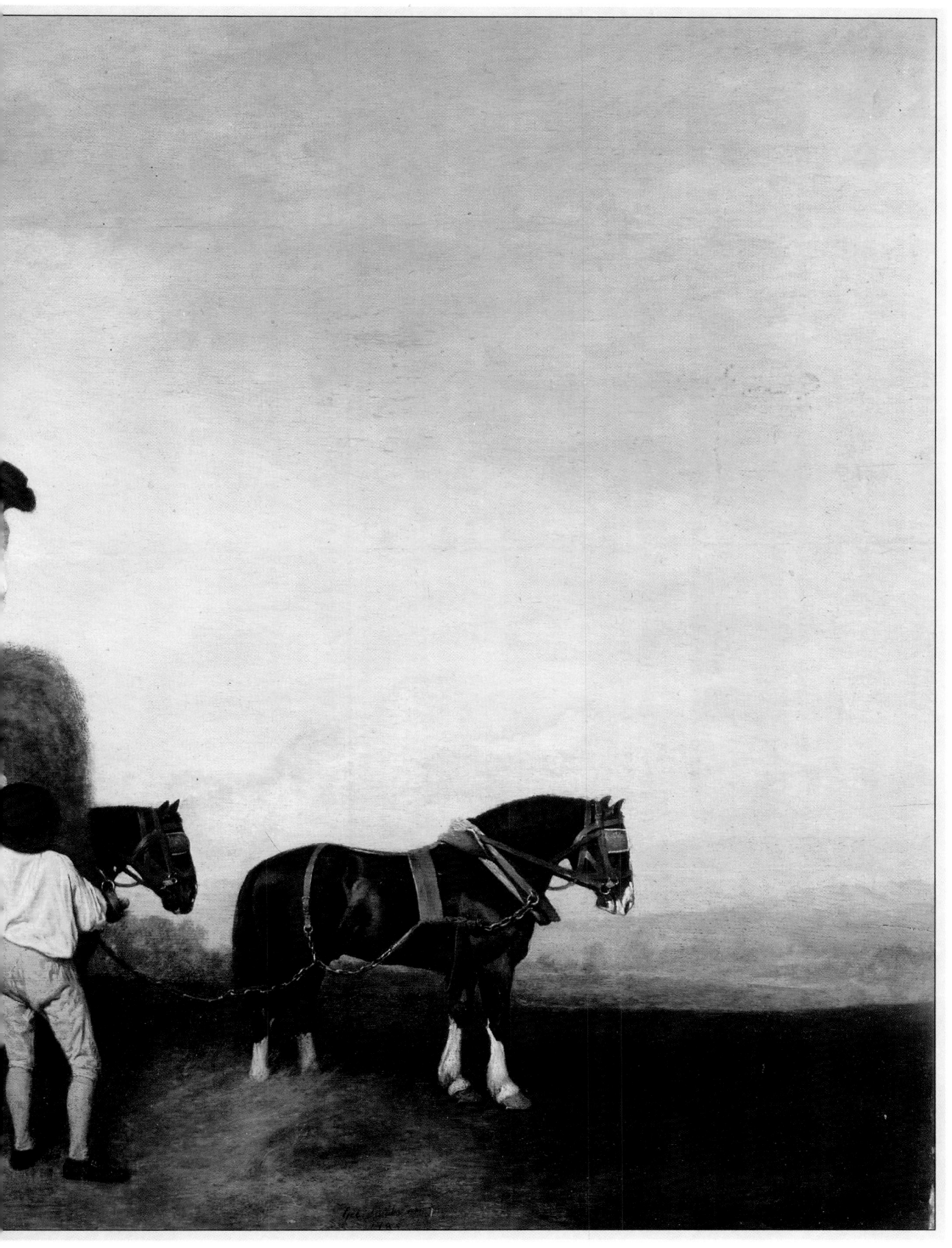

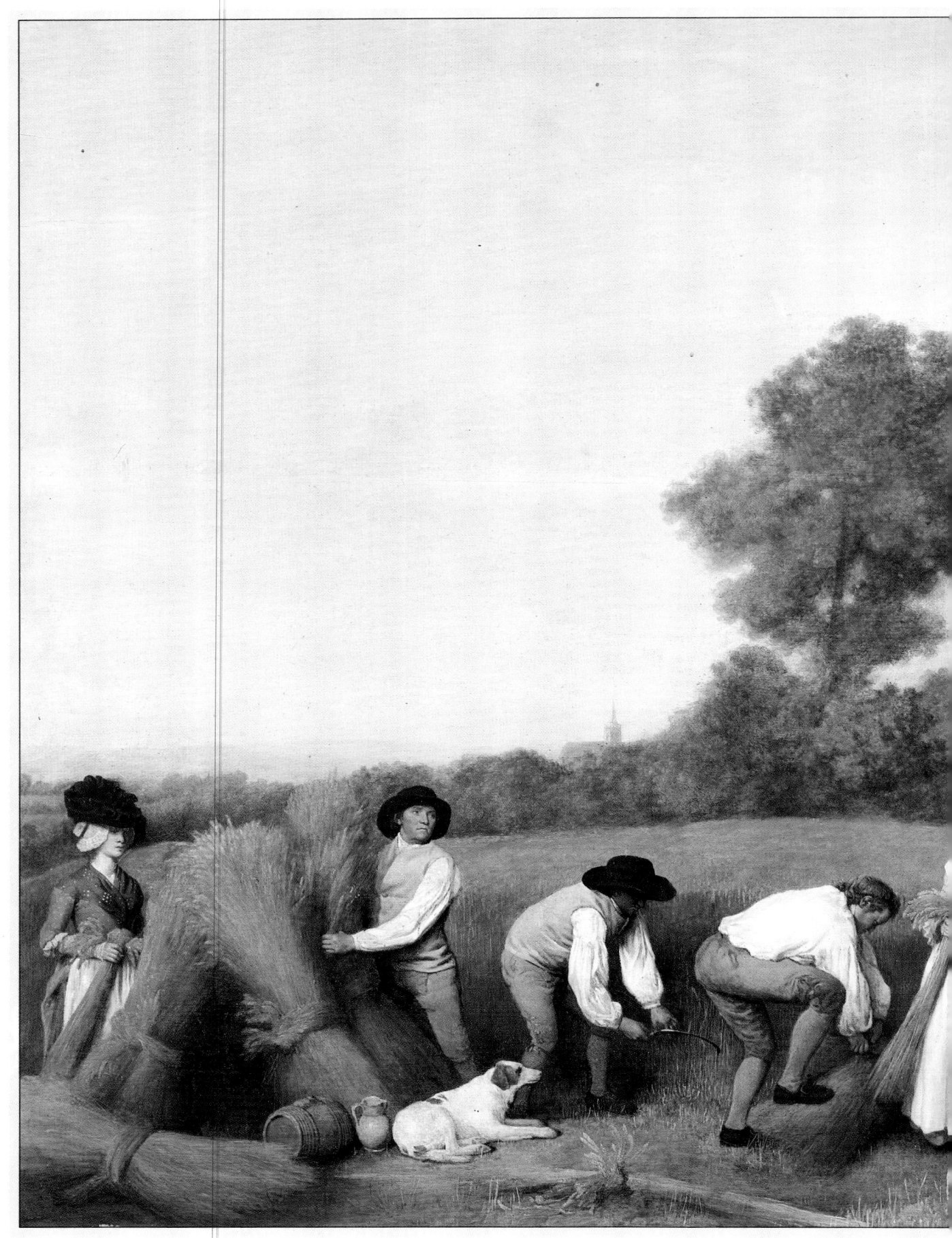

135

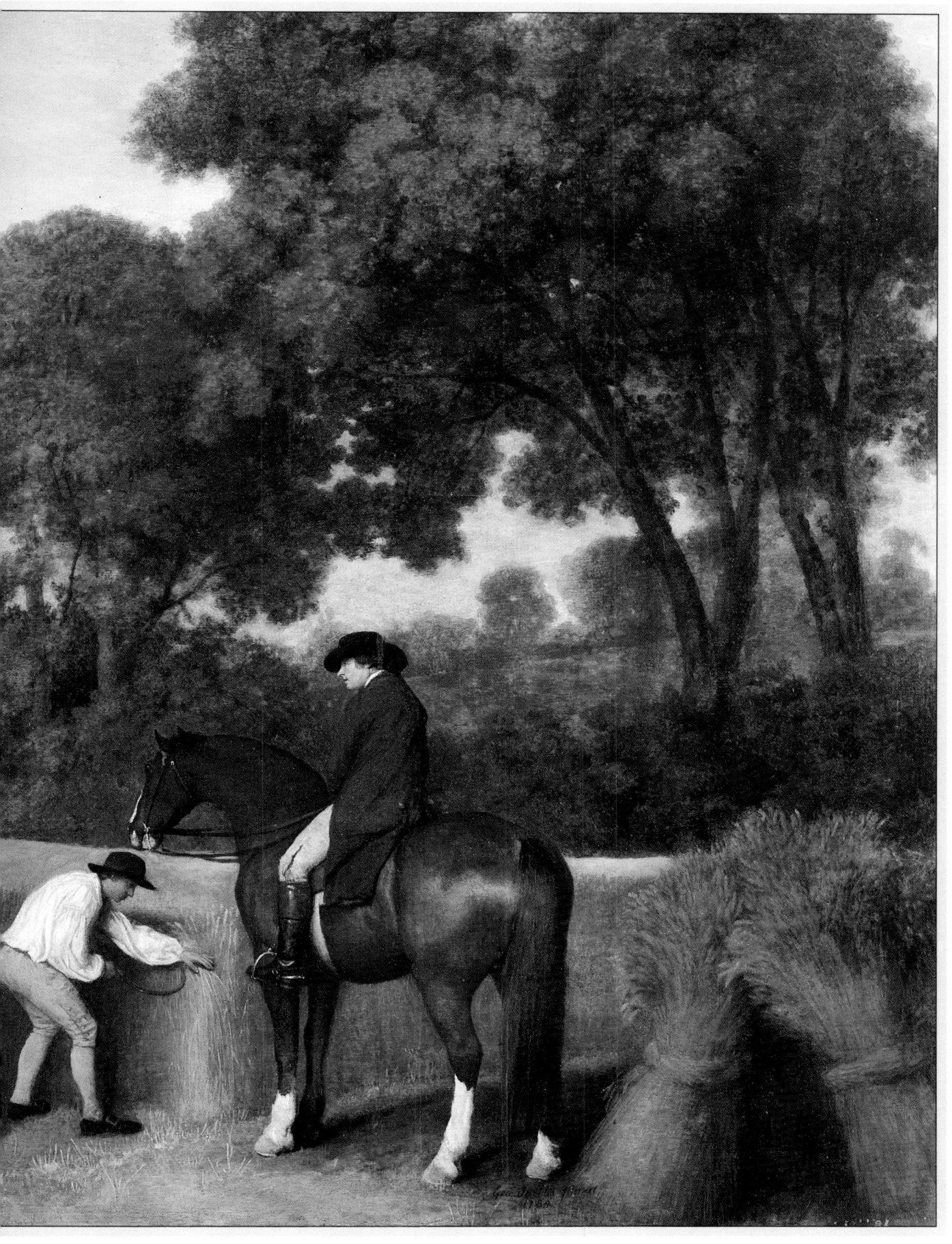

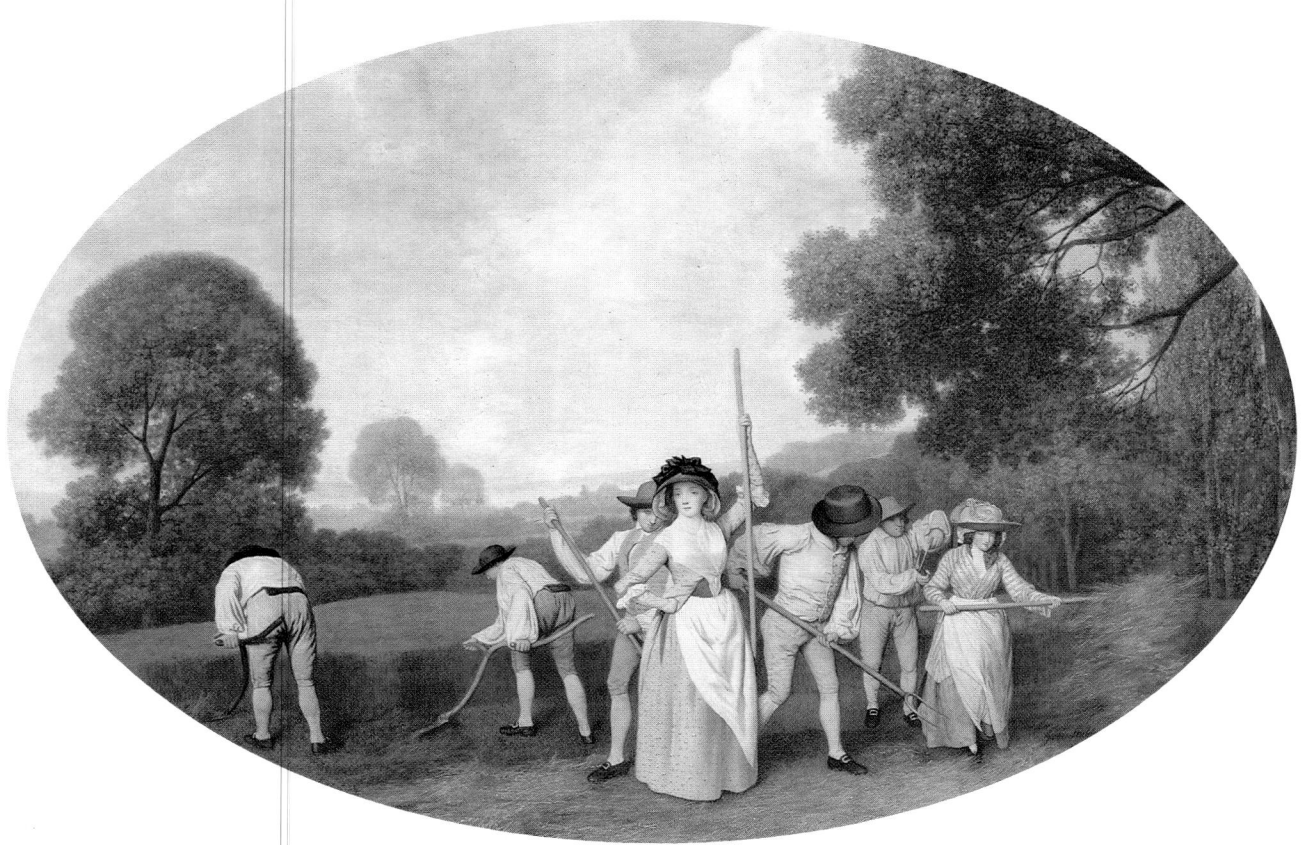

on a farm, showing none of the sweat, dust and pain of the backbreaking work, but by contemporary standards his rural scenes are more down to earth than most. There is none of the wistful sentiment which characterizes the work of his contemporaries in this field. (This may, of course, account for their lack of popularity in Stubbs' lifetime.)

The pictures are assembled with Stubbs' usual precision. Although not built on identical lines, they complement each other beautifully if they are hung side by side. The composition of *Haymakers* is designed as a pyramid, the base of which is formed by the feet of men, women and horses. All the movement converges on the figure on top of the hay wagon. The rakes and pitchforks draw the eye upwards, towards the focal point, and the man on the top throws the movement back down towards the horses by the angle of his body, the curve of his arm and the tilt of his hat. The tapering of the design towards the right side of the painting is intended to balance the companion work, which is similarly arranged, but in reverse.

Reapers builds up from a low horizon on the left to the

HAYMAKERS, 1785 *and* REAPERS, 1785.
The designs of the two paintings complement each other
if shown side by side, but each can successfully stand
alone (previous pages).

tops of the trees on the right. However, the composition is not pyramidal but frieze-like, with a ribbon of figures united by some of Stubbs' familiar 'false attachments'. As there are so many figures in both these paintings Stubbs has reduced the background detail to a bare minimum; the lines of the landscape in both are very softly described. There is little to distract from the complex groups of figures in the foreground.

Since the beginning of his experiments in enamel painting, Stubbs had altered his manner of applying paint, and introduced the use of panel supports, which are used in both *Reapers* and *Haymakers*. The catalogue of the Tate Gallery exhibition of 1984 contains a fascinating account of Stubbs' painting technique by Robert Sheperd. Technical analyses of the paint of four different works on panel revealed that they are not really oil-paintings at all. The paint medium is a varying mixture of pine resin, beeswax and non-drying oils and fats. However, since it is impossible to know this by looking at them, restorers in the past have caused considerable damage. The layers of paint are very thin, without the relatively heavy impasto of his pre-enamel technique, and so any loss of the original surface is costly. Stubbs did not use the same ingredients for every work, and seems to have been continually revising the formula. He began to paint in enamels on cream-

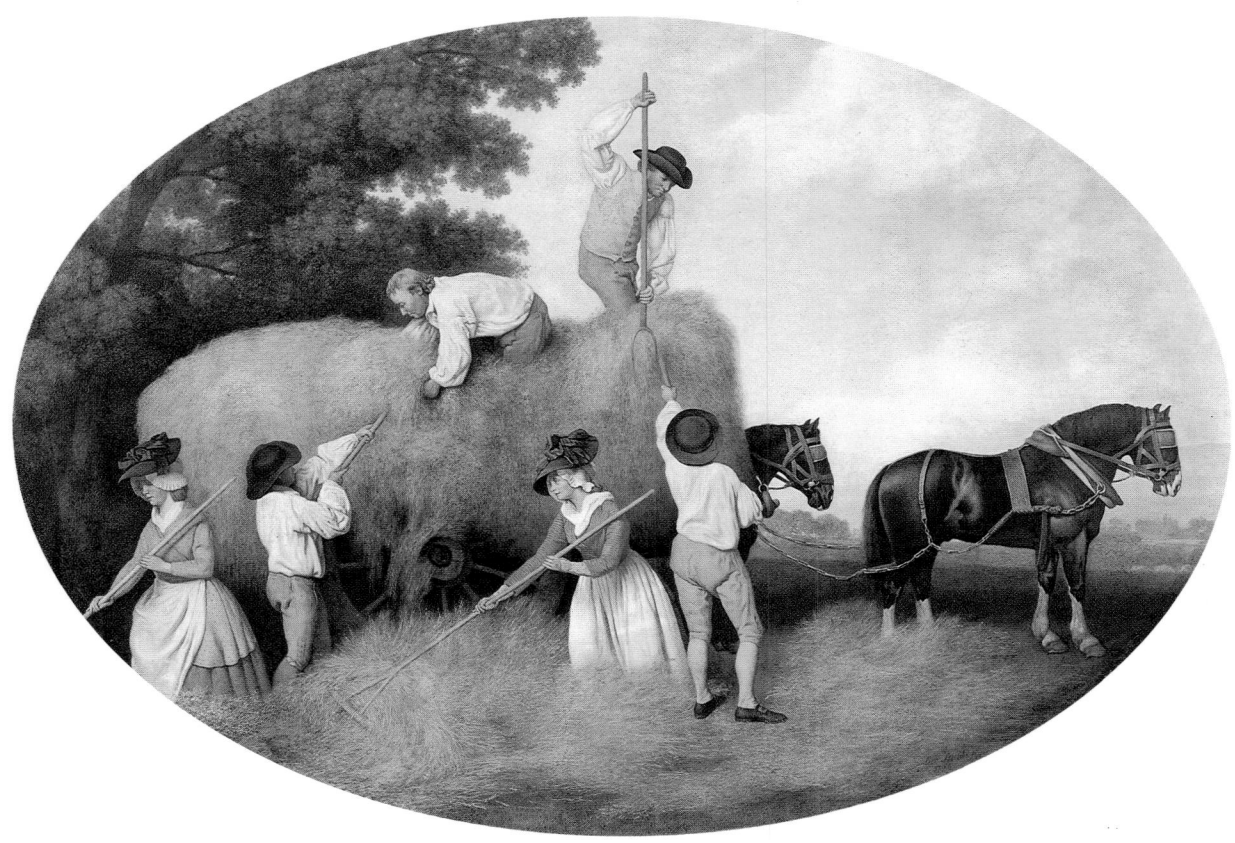

ware again, returning to the medium for the portrait of *Warren Hastings* after a break of several years from 1783 to the 1790s. By this time Stubbs cannot have had much hope of making his enamel paintings popular, but the permanence of the technique would still have been attractive. He turned to it again for three more rural subjects, two of which were reworkings of the two of 1785 mentioned above, and a third new subject which used elements of the earlier works. These pictures are usually called *Reapers, Haymakers* and *Haycarters*.

Haymakers takes the central figure from the earlier version of the same name, and gives her an even more prominent position in this composition. She stands tall and straight with her long rake, gazing out at the spectator with confidence. Behind her the mowers are working with scythes and the newly cut grass is being turned with pitchforks to allow it to dry. *Haycarters* is a simplified version of the earlier *Haymakers,* from which the central figure has been omitted and the girl on the far left has been moved to fill her place. The quality of the colours in these pictures is breathtaking, and, in comparison with the panel paintings, they glow with a clear, pellucid light.

The lack of a market for the uncommissioned rural subjects, whether painted on panel or creamware, is evident from the fact that most of them are listed in Stubbs'

posthumous sale. It appears that all Stubbs' efforts to broaden the range of his art merely served to define his position even more clearly. A critic commenting on his portrait of *Fino and Tiny* exhibited in 1791 said, 'This picture is a convincing specimen of this Artist's superiority as an animal painter; nothing can exceed this just imitation of nature, when engaged in this line of art the painter is mounted on his proper Pegasus; and will never experience the disgrace which must be ever attendant on mounting his hobby-horse of enamel portrait painting'.

Stubbs eventually abandoned his attempts to achieve acceptance as more than an animal-painter. The commissions of the last decade of his life were mostly for the sort of horse and dog studies with which he had made his reputation in the 1760s. The prejudice against animal-painters was so entrenched that once Stubbs had become closely identified with horses it was impossible for him to break free from the straight-jacket implicit in the term 'horse-painter'.

HAYCARTING, 1795.
This reworking of the Haymakers *of 1785 is smaller than the earlier work (right).*

HAYMAKERS, 1794.
The arresting central figure of the panel painting of the same title is used again to great effect (left).

ZEBRA, EXH. 1763.
*The Zebra would have aroused Stubbs' curiosity, for it
is both so like and yet so unlike a horse. It arrived
from the Cape of Good Hope in 1762, when Stubbs was
still completing the* Anatomy of the Horse, *so its
conformation was likely to have been of great interest.*

ANIMAL STUDIES

In the second half of the 18th century, the natural world, including all types of animals both domestic and foreign, increasingly became a subject of interest and study. Interest in domestic animals resulted in the campaign for improved breeding of all kinds of livestock; interest in foreign animals led to a more scholarly approach to zoology. Collections of unusual animals were assembled by both amateurs and scientists, and it was inevitable that the exotic species would have attracted the attention of Stubbs. To the animal-painter they offered fresh subject-matter, and to the anatomist they presented the challenge of unexplored territory.

The practice of keeping exotic animals was not new to England, there had been a menagerie at the Tower of London since the 13th century, which was still maintained in Stubbs' day. The public were allowed to visit on payment of an entrance fee which was waived if the visitor brought a cat or dog to feed to the lions. Wild animals had been exchanged between monarchs as an early form of diplomatic gift (in 1595 the future James I had been given a lion by his father-in-law the king of Denmark), but they were valued more for their strangeness and ferocity than as animals worthy of serious study. In Stubbs' time the two parallel interests in wild animals were concurrent. The Duke of Cumberland (the second son of George II) had a menagerie at Sandpit Gate in Windsor Park where he amused himself by setting different animals against each other in fights to the death. At the same time the two Hunter brothers, William and John, both surgeons, were conducting scholarly experiments, investigating a wide variety of animals in a professional manner. In a country where bull- and bear-baiting were still popular country sports the former approach to the subject was probably more common than the latter.

In addition to the royal menageries at the Tower of London and Sandpit Gate, there were others at Buckingham Gate, at Kew and at Richmond. Some of Stubbs' early patrons also kept collections, including the Duke of Richmond, the Marquess of Rockingham and the Duke of Portland. Travelling animal shows had never been as common in England as they had been on the continent, but Pidock's Menagerie in the Strand was a commercial venture which offered the public the opportunity to see exotic creatures for a fee, and occasionally very unusual animals, such as an elephant or a rhinoceros, were taken on tour.

Stubbs' first wild animal study was a portrait of a *Zebra*, exhibited in 1763. It had been brought from the Cape of Good Hope in 1762 and presented to Queen Charlotte, who kept it at Buckingham Gate, where Stubbs observed it. Though the zebra was a wild animal from a far distant country, Stubbs has avoided any overt reference to its exotic origins. He studied it with the same objectivity that he would apply to an English hunter. As with the best of his horse-paintings, the sense of the animal's existence in space is totally convincing. Its character is also clearly described, giving a good impression of the habitual short-temper of the tamed zebra. The *Zebra* painting illustrates the first of the species to be brought to this country.

The *Cheetah and Stag with two Indians*, which was exhibited in 1765, shows Stubbs' version of a famous 'hunt' which included the first cheetah to be seen in England. The animal had been presented to George III by Sir George Pigot (whose portrait Stubbs painted in 1769), and the King had given it to his brother the Duke of Cumberland for his menagerie at Sandpit Gate. The duke wanted to see how it hunted its prey, so arranged for an enclosure to be made into which the cheetah and a stag were released. As a spectacle it did not go according to plan, as the stag was able to defend itself from the cheetah with its antlers until eventually the latter gave up and escaped to the woods.

The painting was commissioned by Sir George Pigot, and shows the cheetah being made ready for the hunt by its Indian handlers. However, in order to refer to the chase, Stubbs abandoned reality and adopted a device similar to that employed in *Gimcrack on Newmarket Heath* (probably painted in the same year). In the racing picture

he shows two separate episodes within one image, and suggests that the figures in the foreground are thinking about the scene in the distance. In the *Cheetah and Stag with two Indians,* the attendants appear to be discussing the forthcoming chase; the subject of their discussions is shown behind them but it is not of their time, it is in the future. The stag looks as though it was an afterthought added to tie the painting more closely to the hunt – a later owner had it painted out altogether. If the work is read as a portrayal of reality then the stag does not make sense, for it is too close to the cheetah and the scale is wrong. The only way to solve this problem is to see it as two episodes combined in one canvas. Nothing can detract from the beauty of the cheetah and its handlers, for here Stubbs' painterly abilities are seen at their best. The texture of the animal's coat is described with minute

precision and every fibre of the creature's body is electric with the tension of the moment. The sensitivity of his portraits of the Indians matches that of any of his works, and the rare opportunity to describe dark skin would have been interesting to an artist used to modelling the face in pale colours. The group stands very well on its own and one can sympathize with the owner who had the stag painted out in order to focus attention on the quality of the foreground figures.

Some of Stubbs' paintings of unusual animals were commissioned as little more than scientific records, though the results, as always, far exceed the mere description of physical attributes. The Hunter brothers had a deep interest in anatomy, both human and animal. Stubbs painted a total of seven pictures for them, including the *Nylghau*, the *Blackbuck* and the *Duke of Richmond's first Bull Moose* for William, and the *Rhinoceros* for John. William's attitude to Stubbs' work is recorded in a paper he gave to the Royal Society in 1771: 'Good painting of animals give much clearer ideas than descriptions. Whoever looks at the picture, which was done under Dr. H.'s eye by Mr Stubbs, that excellent painter of animals, can never be at a loss to know the nyl-ghau, wherever he may happen to meet with it'. They were used to illustrate talks in the same way that a modern lecturer would use slides.

The *Nylghau* was painted in 1769, and shows an animal which is now called a nilgai. It is a species of large Indian antelope, also sometimes known as a blue bull. Its fine-boned head is delicately described by Stubbs, with a shiny black nose which almost twitches with life. The beautiful head is set onto a comparatively prosaic body, supported on spindly legs and overlong hooves. Hunter praised the

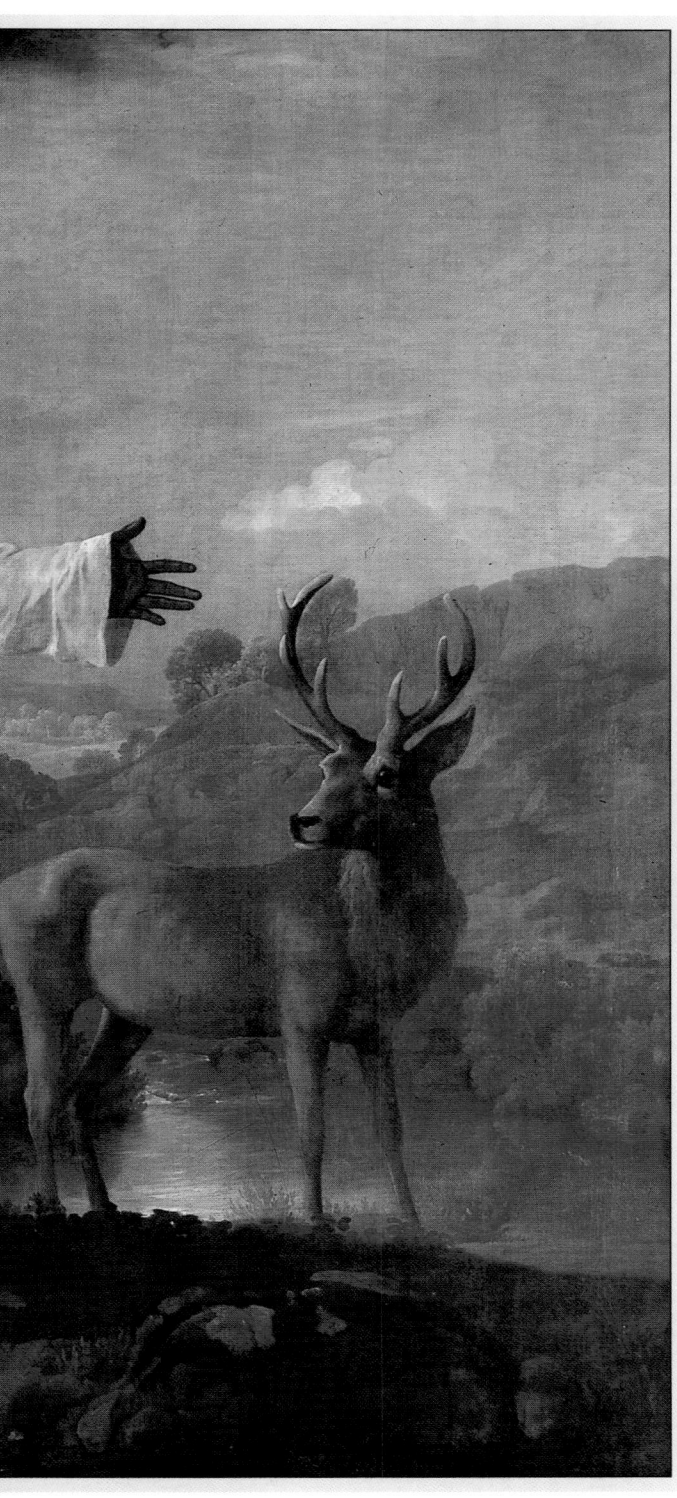

CHEETAH AND STAG WITH TWO INDIANS, EXH. 1765.
Although the 'hunt' took place in Windsor Park, Stubbs has chosen to show them in an imaginary setting which he may have felt was more appropriate to the Cheetah's Indian origins.

NYLGHAU, 1769.
Although the Hunters would probably have been satisfied with an accurate representation of the physical attributes of their subjects, Stubbs gives these works as much attention as a portrait of a favourite hunter.

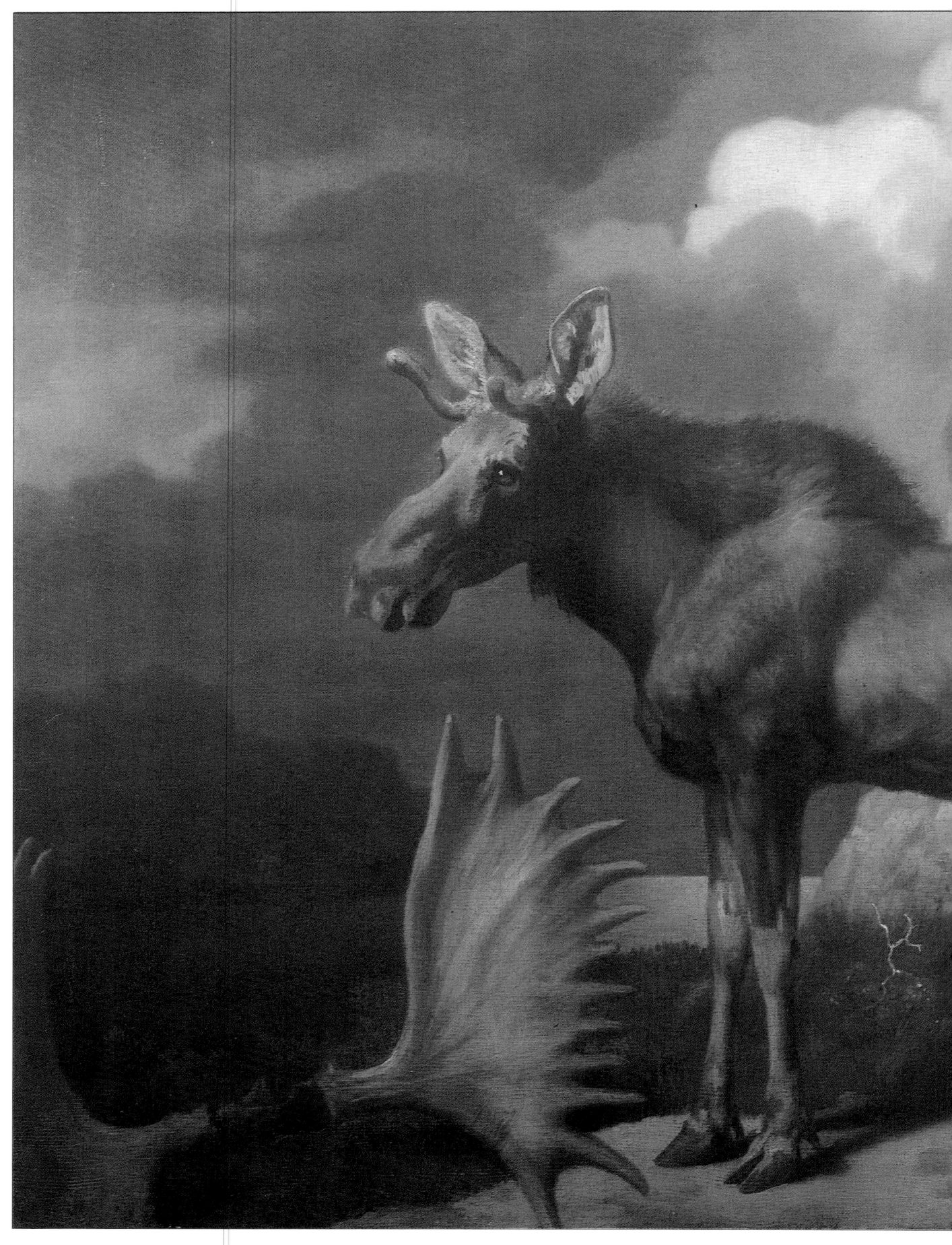

BLACKBUCK, (?) C.1770—8

As a zoological record this representation of a blackbuck is adequate. Its unfinished quality serves to remind us of the extent to which Stubbs' other animal studies describe so much more than a mere physical likeness.

portrait for its accuracy, so it is the animal, rather than Stubbs' illustration of it, which is disproportionate.

The *Duke of Richmond's first Bull Moose* of 1770, is in one way similar to the *Cheetah and Stag with two Indians,* as it contains a reference to the future in the shape of the magnificent horns in the foreground. However, in this case it is purely for the purposes of scientific record, as Hunter specified that the young moose, recently arrived from Canada, should be shown with a pair of horns of a full-grown animal; the horns that it will one day grow. The nature of the moose is well expressed in Stubbs' choice of landscape; the rugged craggy aspect of the animal is echoed in the steep barren hillside behind him, which was, no doubt, intended to represent its native habitat.

The *Blackbuck* of c1770 was not finished to the same degree as the others for William Hunter, and was therefore presumably more of a record for his personal use than for public appreciation. It is clear from comparison with Stubbs' horse-paintings without backgrounds that this fine study of the antelope is incomplete. The animal lacks the fullness of form of the finished works, and the canvas is left in a relatively raw state without the homogenous finish of the earlier paintings.

THE DUKE OF RICHMOND'S FIRST BULL MOOSE, 1770.

The benign expression of this animal corresponds with William Hunters' description of its character. He found it docile and friendly, and records that it would follow anyone for a piece of bread or an apple.

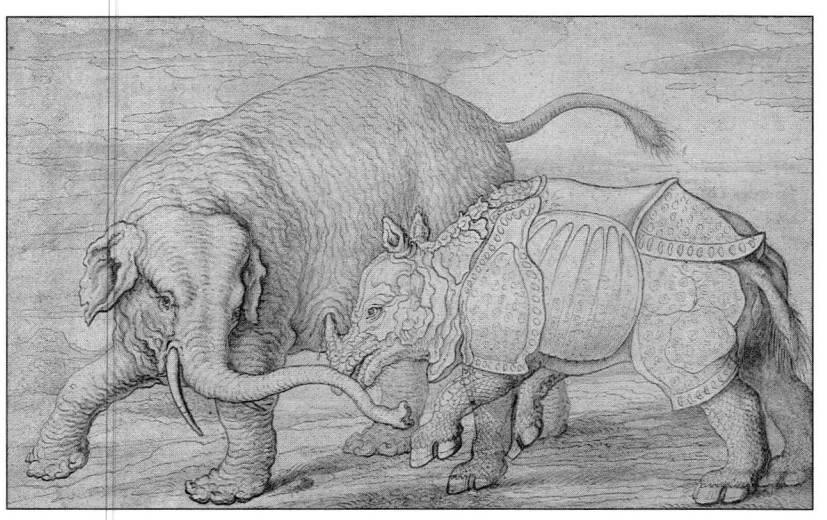

RHINOCEROS, ?1790 OR 1791.
*Stubbs has abandoned the more extreme elements of
earlier representations. Nevertheless, he depicts the
animal's skin as hard and plate-like ·*

ELEPHANT AND RHINOCEROS,
*by Francis Barlow, 1684. In representing the
rhinoceros as a spiny, armour-plated creature Barlow
was following artistic convention .*

144

SLEEPING LEOPARD, 1777.
*For this first experiment in enamels on creamware
Stubbs' choice of an animal study reflects his
enjoyment in painting this kind of subject.*

More than 20 years later Stubbs was commissioned again to record the likeness of an unusual animal, this time by John Hunter. The *Rhinoceros,* probably painted in 1790 or 1791, had arrived in London in 1790 and was displayed at the Lyceum in the Strand, where one report described it as 'a Male Unicorn'. Ever since the 16th century the representation of the rhinoceros in art had been influenced by Dürer's version of the animal, which gave the impression that it was made of plates rather like a suit of armour. Francis Barlow's drawing of the late-17th century follows the convention established by Dürer as did most artists prior to Stubbs. He certainly had the opportunity to study this animal, but his observation appears to have been clouded by the accepted pictorial code for the creature. He clearly describes a folding of its skin which is an exaggeration of the animal's true form. The colours of this painting are interesting, for they do not occur elsewhere in Stubbs' work. The combination of greys, blues and greens used with touches of pink and ochre can be found in the work of William Blake (1757–1827), but the similarity is probably coincidental as Blake's first coloured prints were produced in 1794.

As well as the commissioned animal studies, Stubbs painted a number of pictures which, like the *Zebra,* may have been painted for his own interest. The *Portrait of a Monkey* may come into this category. Unlike the animals mentioned above, this was not a rare species. It was probably to be found in private or commercial menageries, or even kept as a pet. Stubbs painted two versions of the subject, and the date of the second, 1798, coincides with his work on the *Comparative Anatomical Exposition,* which he began in 1795. In this work he compares the structure of man, tiger and chicken. The relationship between the monkey family and man would have been of interest to him in this context and may have led to the painting of the second version.

Another uncommissioned animal study is the *Sleeping Leopard,* dated 1777. This is painted in enamel colours on creamware, but unlike the plaques which resulted from Wedgwood's experiments the surface is glazed. It is also very small, only 10.5 x 16.5 cm, and would appear to have been cut from the base of a dish. It is very likely that the picture was a trial, and that the subject was, therefore, not important, and chosen simply for the pleasure it gave the artist.

PORTRAIT OF A MONKEY, 1798.
*Several of Stubbs' animal portraits include closely
observed botanical details.*

DOMESTIC ANIMALS

The growing interest in the improved breeding of livestock led to a demand for a new type of animal painting. Towards the end of the 18th century a fashion developed for portraits of cattle, sheep and pigs. These were valued as records of their breeders' successful endeavours. A painting which would at first sight appear to be of this type is Stubbs' *Lincolnshire Ox,* dated 1790.

This portrait was commissioned by the animal's owner (not its breeder), John Gibbons of Long Sutton, Lincolnshire, who is included in the painting. Also shown is the cock which won him the ox in a wager on a fight. The ox was 19 hands high (the size of a carthorse), and weighed over a ton. It was brought to London in 1790 and displayed at the Lyceum at the same time as the rhinoceros. The menagerie's advertisements describe the ox as a 'Living Mountain' which has 'apparently acquired these Superiorities by his own Sagacity, his food is hay, which he dips in water that stands within his reach, before he eats it, This act of Rationality in the Brute is pleasing, its

Effects are obvious, and may prove Instruction to the Feeders of Cattle'. However, a reason other than the consumption of damp hay may account for its unnatural dimensions. It appears from Stubbs' portrait of the beast that it was castrated. Rather than illustrating an improvement in breeding, it may be a record of a freak of nature. The fact that the animal was slaughtered in its prime in 1791 would imply that it had no value as breeding stock, and references to its docile nature endorse this suggestion. The background to the portrait refers to the animal's visit to London, for in the far distance are the twin towers of Westminster Abbey.

A further example of Stubbs' paintings of domestic (in

RED DEER, STAG AND HIND, 1792.
The destruction of the natural habitat of the red deer led to the development of deer parks.

LINCOLNSHIRE OX, 1790.
This portrait would at first appear to commemorate the successful results of improved breeding, but it seems unlikely to have sired any progeny (overleaf).

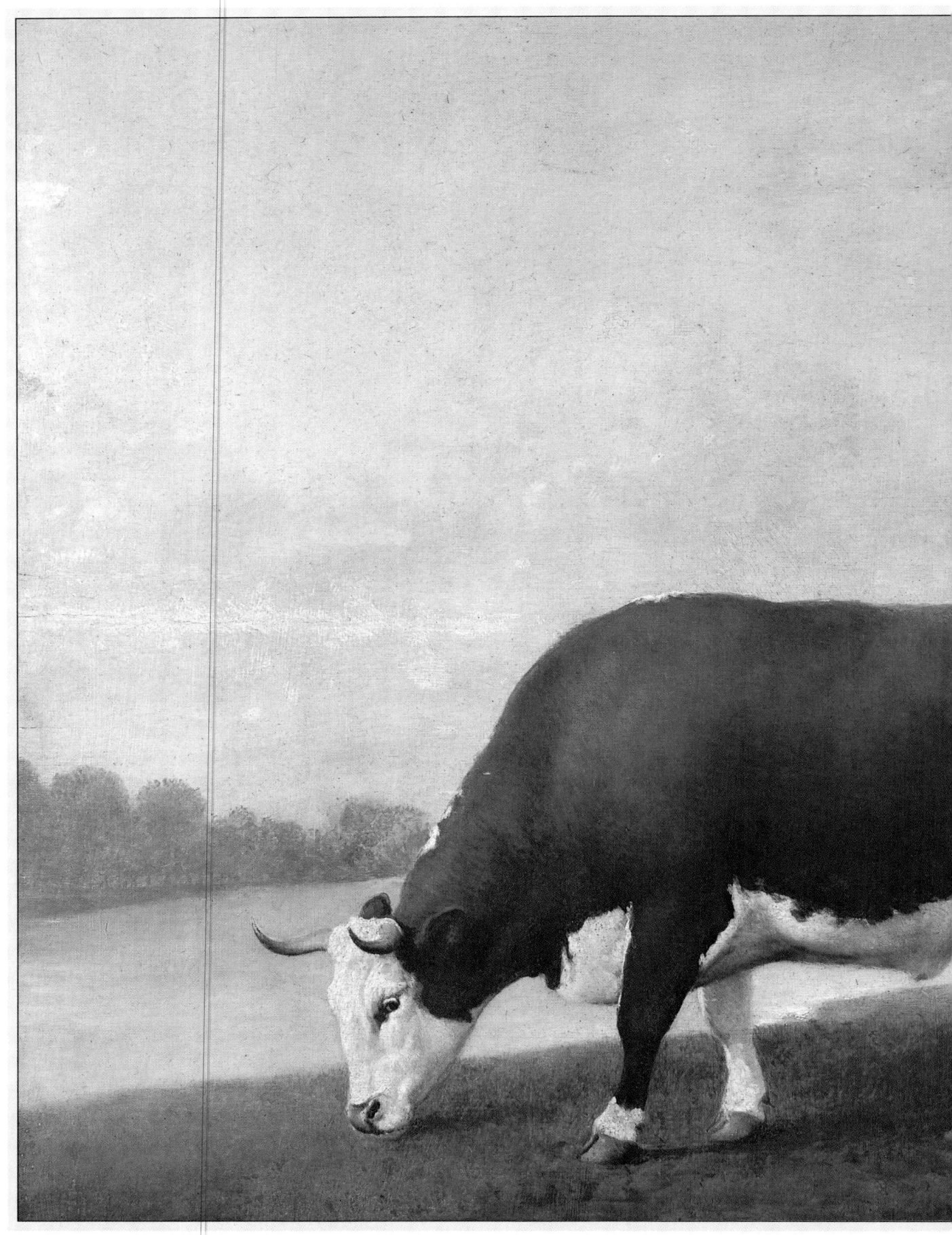

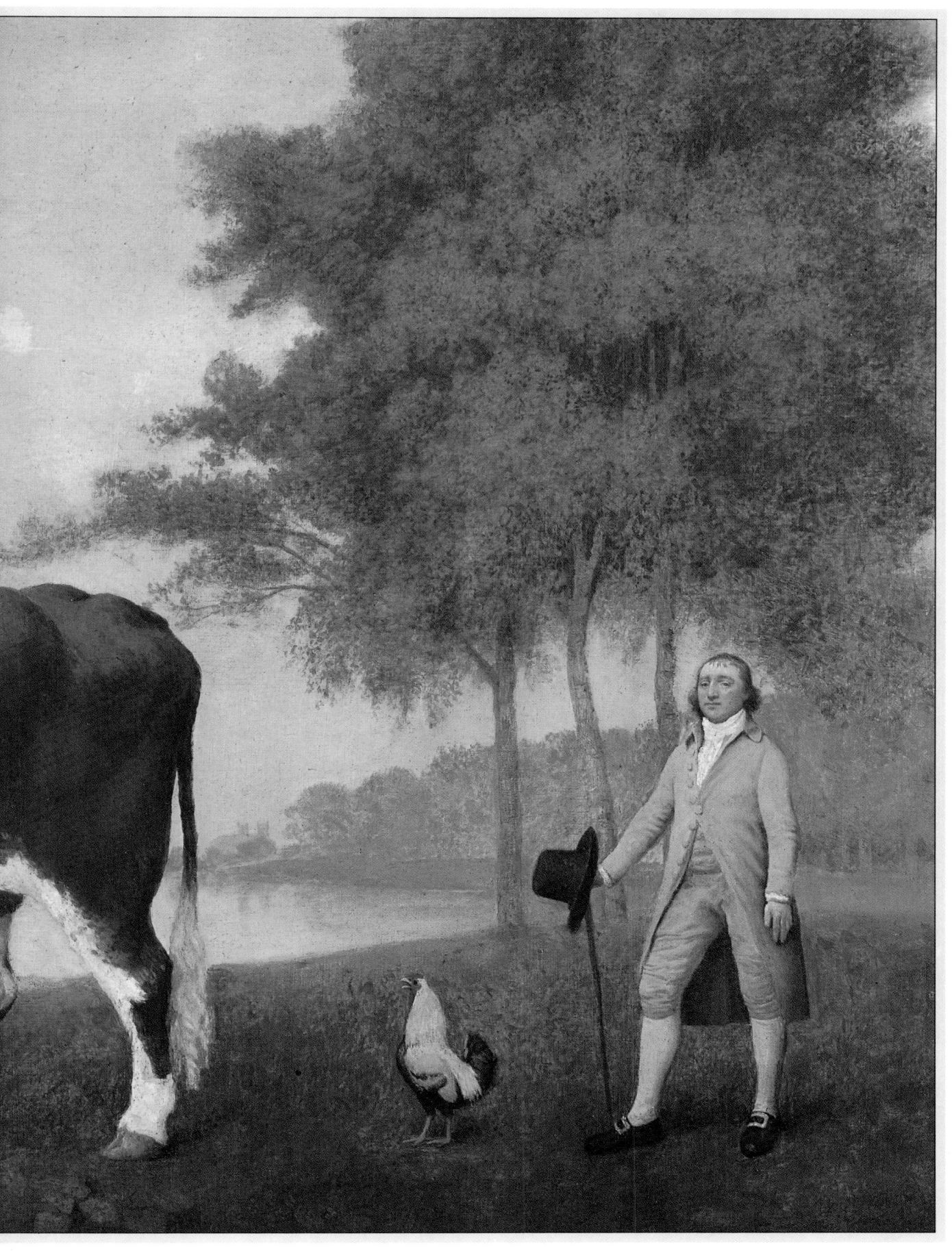

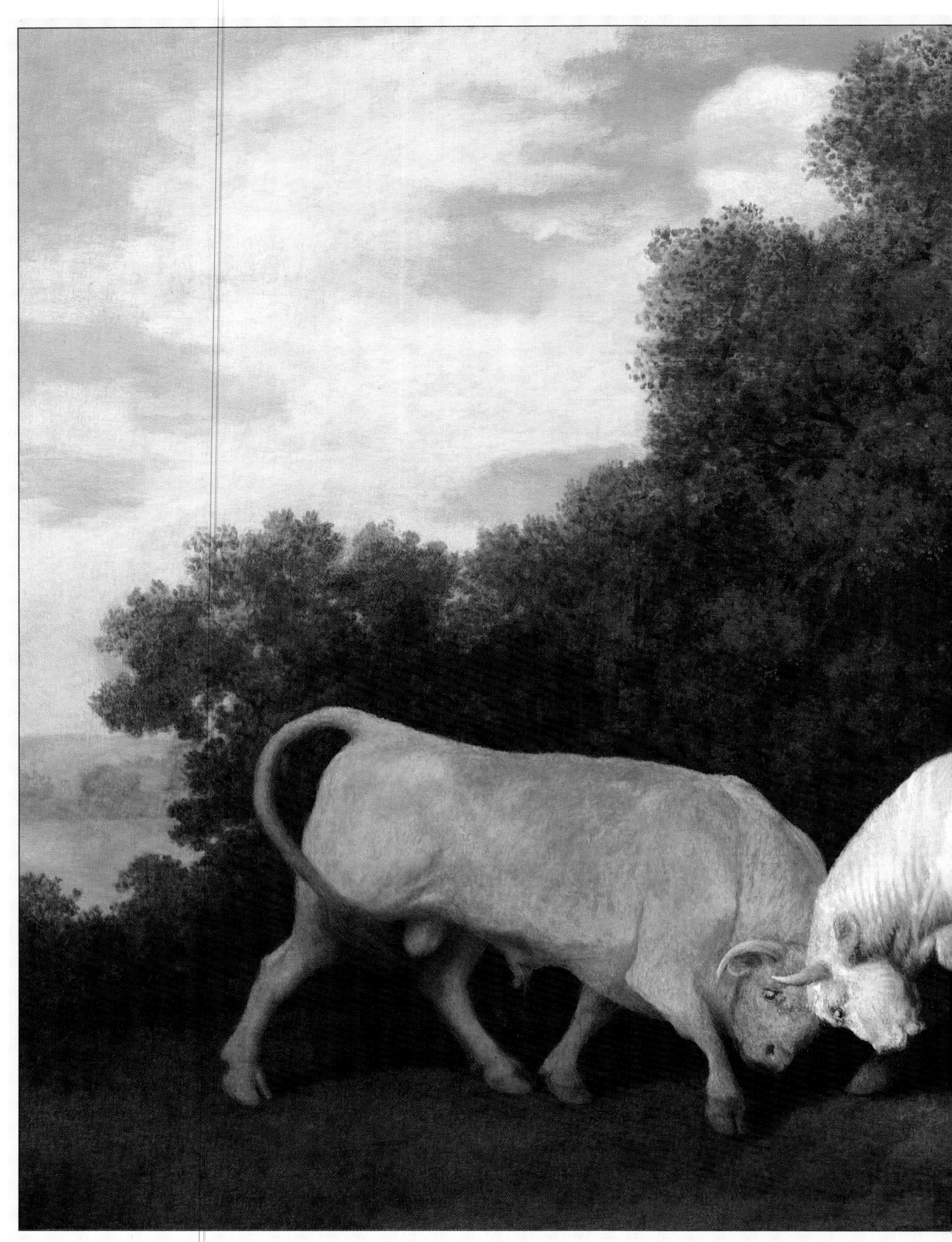

BULLS FIGHTING, 1786.
*Stubbs constantly
sought to attain balance
and stability in his
work. Here these
qualities are very simply
achieved in the perfectly
poised contest between
two evenly matched
bulls.*

151

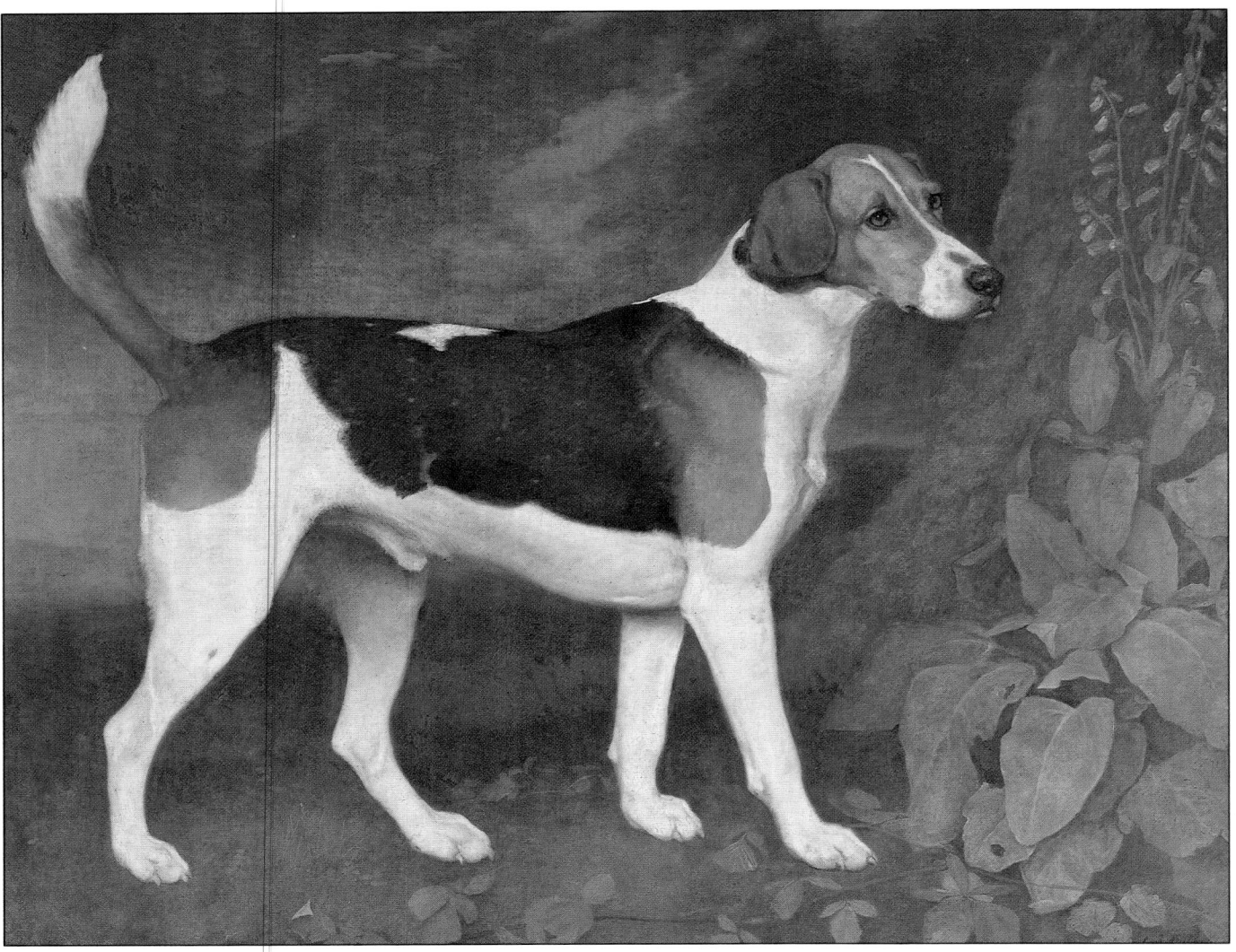

the sense of native) animals is his fine study of two deer painted for the Prince of Wales in 1792. It is known as *Red Deer, Buck and Doe,* but the terminology is innaccurate, as the male and female of the species are more correctly described as a stag and a hind. The pair are set in a fenced area which may have been one of the seven deer enclosures at Richmond. The fine-boned heads of these two animals are beautifully painted, and their expressions are described with great sensitivity. The stag turns back to ensure that the hind is following him out of the cover of the trees into the open park. She appears uncertain, and treads with a tentative stride.

There is one curious aspect of this work, which is the drawing of the stag's pose. The legs are placed impossibly close together, and its right foreleg appears to be in almost the same plane as the left. While deer are of narrow

RINGWOOD, 1792.
The magnificent foxglove plays the same supporting role in this work as the peaches in the Portrait of a Monkey, *(see p146).*

build, Stubbs' draughtsmanship appears to be at fault, for the animal would have found it very difficult to maintain its balance in such a position. The softly mottled colours of the deers' coats are very subtly described, and are particularly suited to the thin fluid paint of Stubbs' works on panel.

A further work which could be described as a painting of domestic animals, *Bulls Fighting* dated 1786, is not a straightforward portrait. It shows two bulls pitting their strength against one another, the match carefully poised between them. Rather than describe the violence of the contest, Stubbs has concentrated on the animals' controlled power. His interpretation of the fight shows it to be as disciplined as a duel, though a better analogy might be to sumo wrestling. The formal quality of the work is enhanced by Stubbs' reduction of the landscape to a minimum of detail, so that all attention is focused on the stately combat. The painting was exhibited in 1787, and reaction varied from praise for its truthfulness to criticism of its lack of ferocity. It leads to speculation about the lost history paint-

152

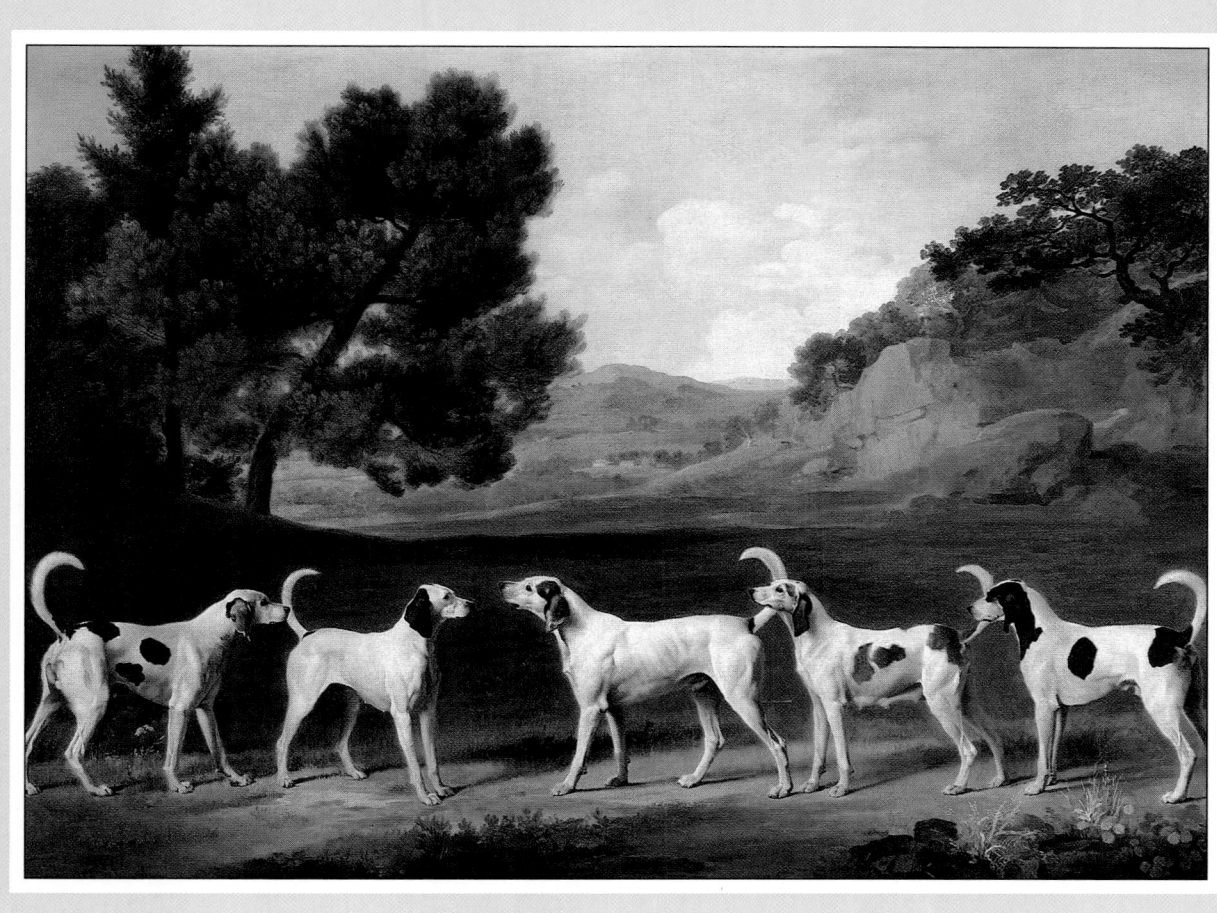

ings which featured bulls, such as *Hercules and Achelous* or *Hercules and the Cretan Bull*.

─────── HOUNDS ───────

Among Stubbs' most universally popular subjects are his hound studies. One of the earliest of these was *Staghounds in a Landscape* painted in 1762 for the Duke of Rockingham. The frieze-like composition is similar to that of the Rockingham mares and foals of the same year, but it is not quite so successful. This is partly because the hounds lack the gravitas of the brood mares; they simply do not have such noble bearing. The design is less interesting, also, for it does not have the depth of the other work, in which the two foals help to create a greater illusion of space. The hounds are arranged in a line across the canvas, linked nose to tail in a loose ribbon.

The Marquess of Rockingham was still hunting stags in 1762, as was Lord Grosvenor, but the trend towards foxhunting was increasing and Stubbs' later hound studies were of animals specially bred for the foxhunting. Through-out the 18th century the Pelham family of Brocklesby had developed and improved the breeding of foxhounds until, by the middle of the century, a relatively standardized breed had emerged. Charles Anderson-Pelham commissioned the portrait of *Ringwood* in 1792 to record the likeness of the leading hound of the period. Stubbs sought to give him the nobility and monumentality befitting his aristocratic blood by portraying him from a low viewpoint and by filling the canvas with his image. Ringwood appears to be fully conscious of his importance. He has a dignified expression which fails to conceal the charming good nature which is characteristic of the breed.

In the same year Stubbs painted a double hound portrait, *Couple of Foxhounds*. In terms of its design this

STAGHOUNDS IN A LANDSCAPE, 1762.
Three other works were painted for the Marquess of Rockingham at the same time as this picture. They are Whistlejacket, Mares and Foals *and* Whistlejacket and two other Stallions. Staghounds *is the exception in that it is set in a landscape. Stubbs may have felt that the hounds were too small and insubstantial to stand on their own.*

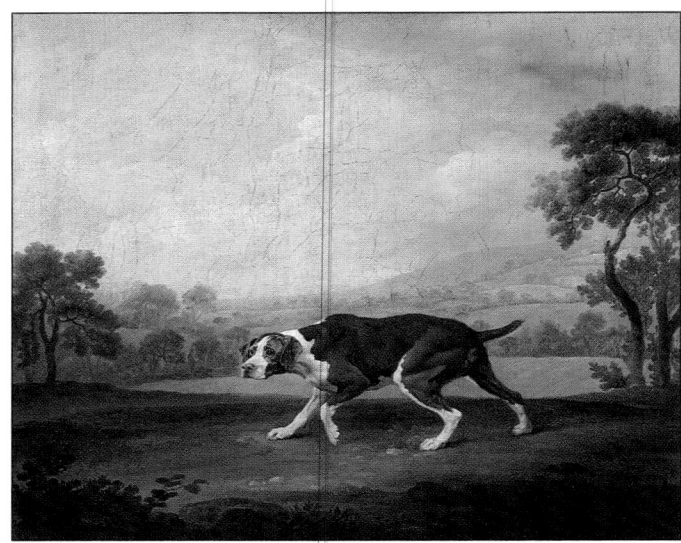

painting works extremely well. It is tightly constructed
and beautifully balanced, in contrast to the loose arrange-
ment of the earlier *Foxhounds in a Landscape*. These
hounds are less grand than the great Ringwood. The natural
ebullience of the breed is more evident especially in the
bitch. She looks very mischievious and liable to bound
away at any moment. The dog's small, narrow head suggests
that one of his ancestors might have been of a terrier
type, and reflects the recent development, and as yet
incomplete standardization, of the foxhound as a breed.

——— WORKING DOGS AND PETS ———

Unlike the foxhound, the pointer was first developed as a
breed on the continent, where it was probably in use as
early as the 15th century. It was introduced to England in
1713, and can be seen in most of Stubbs' shooting paint-
ings. In his portrait of the *Spanish Pointer* of c1768, one is
shown in the stance they adopt when they have caught
sight of and are marking game – slightly crouched with
head low and one foreleg raised. It is not an attractive
position, but it is an accurate portrayal of the dog at work.

One of Stubbs' most sensitve dog portraits is the *White
Poodle in a Punt,* which is undated but probably painted
in about 1780. Not a dog at work, but perhaps a dog going
to work, as in the 18th century poodles were used as
retrievers of water-fowl. The anxiety of the pose, with all
four feet close together, is reflected in the dogs' face; its
unhappy but resigned expression only just stops short of
anthropomorphism.

THE SPANISH POINTER, C.1768.
*Both Spanish and French pointers were introduced to
England in the early 18th century.*

A COUPLE OF FOXHOUNDS, 1792.
*In his later animal studies Stubbs often maximizes the
potential of his subjects by making them fill the canvas.*

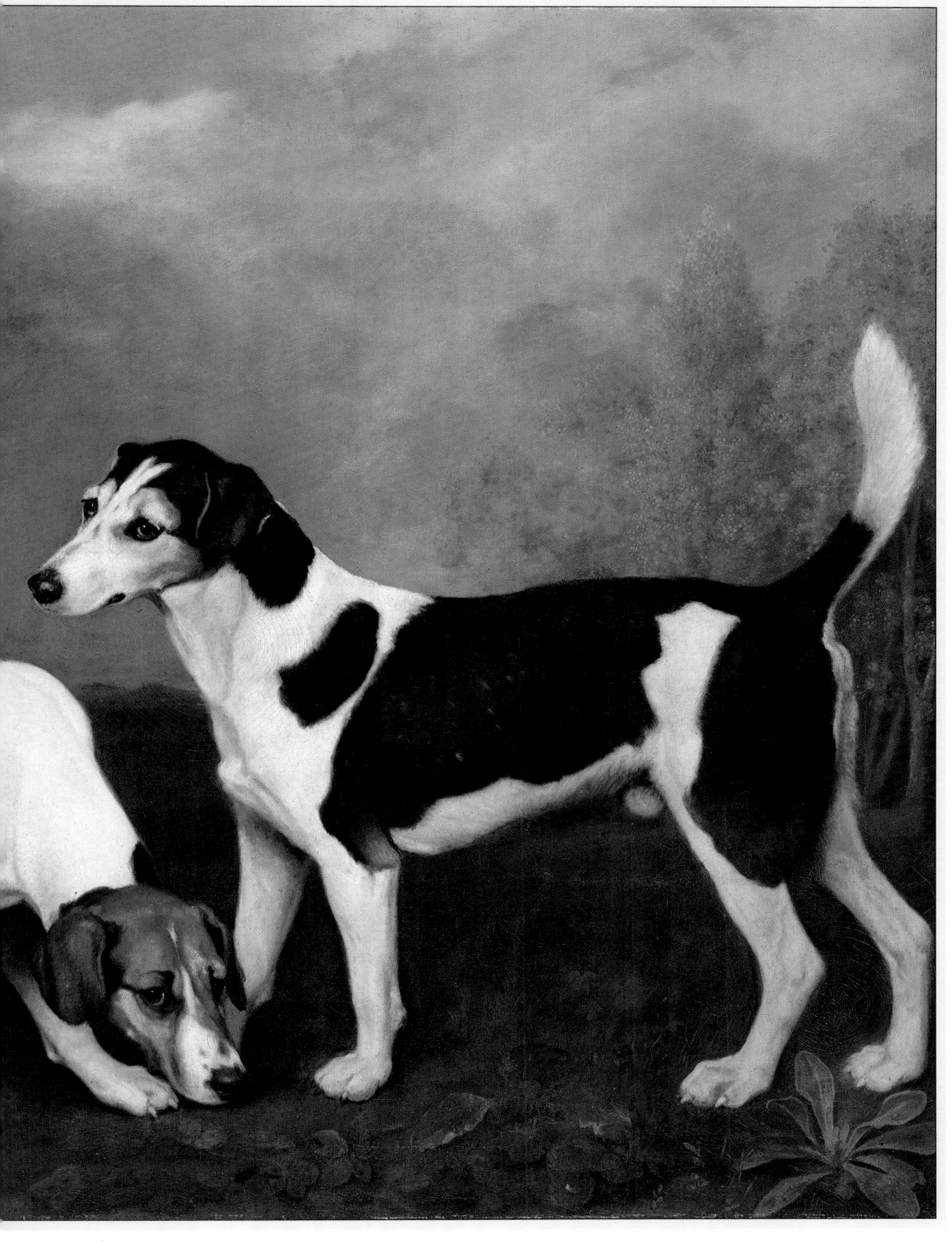

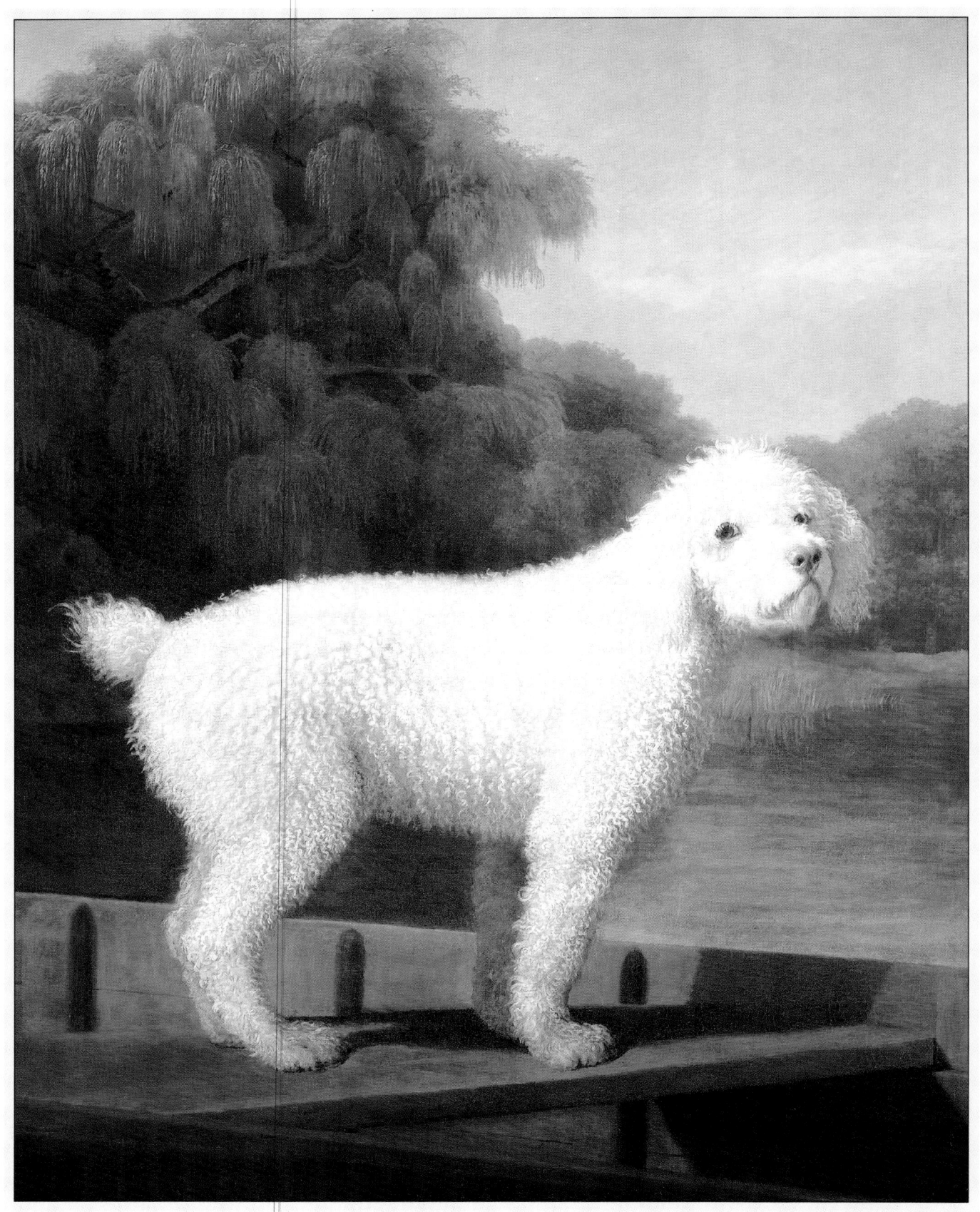

WHITE POODLE IN A PUNT, (?) C.1780.
*The poodle's apprehension is betrayed by its facial
expression and by the slight crouch of its back legs.*

156

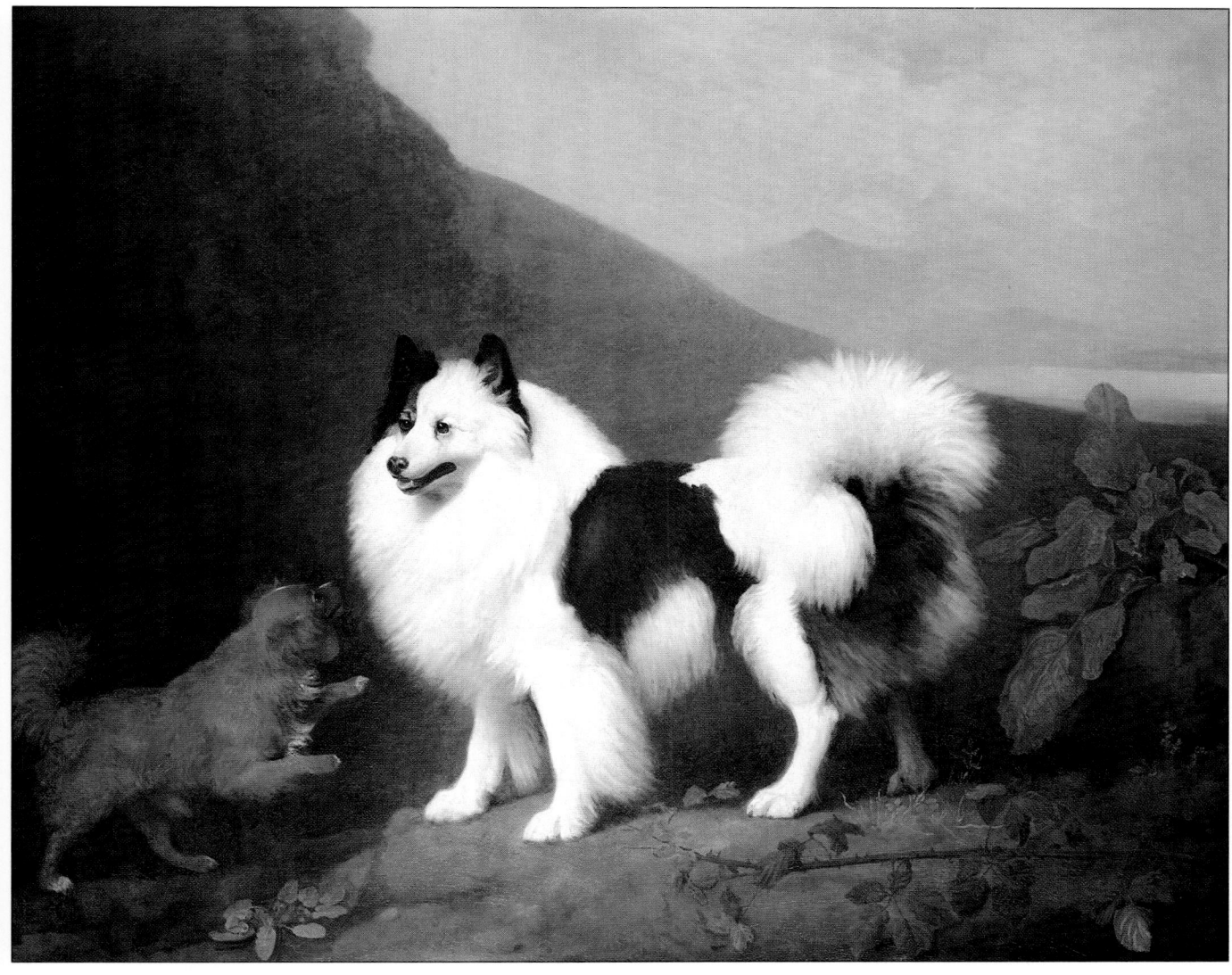

FINO AND TINY (?) 1791.
*Stubbs has used the landscape to refer to the foreign
origin of the Pomeranian in a manner similar to that
of some of his animal studies painted for William
Hunter, such as* The Duke of Richmond's first Bull
Moose *(see p142).*

The *King Charles Spaniel* painted in 1776 may have
been a working dog, but they were also kept as pets. This
one, with its long curly coat, does not look as though it
would be very happy scrambling through brambly thickets.
The portrait is treated in a manner similar to the *Monkey,*
first painted in 1774. Common to both are a shallow dark
setting with tree trunks and rocks and carefully described
botanical detail. Here, the thistle by the dog's front paw
takes the place of the peaches held by the monkey in the
earlier work. The dark background emphasizes very effect-
ively the white and toffee colours of the King Charles, and
concentrates attention on the dog, whose expression is
exceptionally well observed.

Stubbs' ability to suggest texture is ably demonstrated
in these dog portraits; his treatment of the coats of both
this spaniel and the Pomeranian in *Fino and Tiny* is beauti-
fully descriptive. Fino was included in the *Prince of Wales
Phaeton* of 1793, and this portrait was probably commis-
sioned by the Prince in 1791. He is accompanied by Tiny,
a spaniel, to whom much less attention has been paid by
the artist. Tiny's role in the painting, and perhaps in life,
was to act as a foil for Fino, who dominates the picture
and ignores his companion. The Pomeranian is very closely
observed by Stubbs, both his personality and his luxurious
coat are described in detail; in contrast, Tiny is treated
much more generally, and may even have been an after-
thought. The barren hilly landscape appears to refer to
the origins of the Spitz group of breeds, of which the
Pomeranian is just one variety. The Spitz was used in
northern Europe for pulling sledges and herding reindeer.
Further south they were often used as guard dogs, but it
seems unlikely that Fino, with his royal connections, was
ever expected to earn his keep.

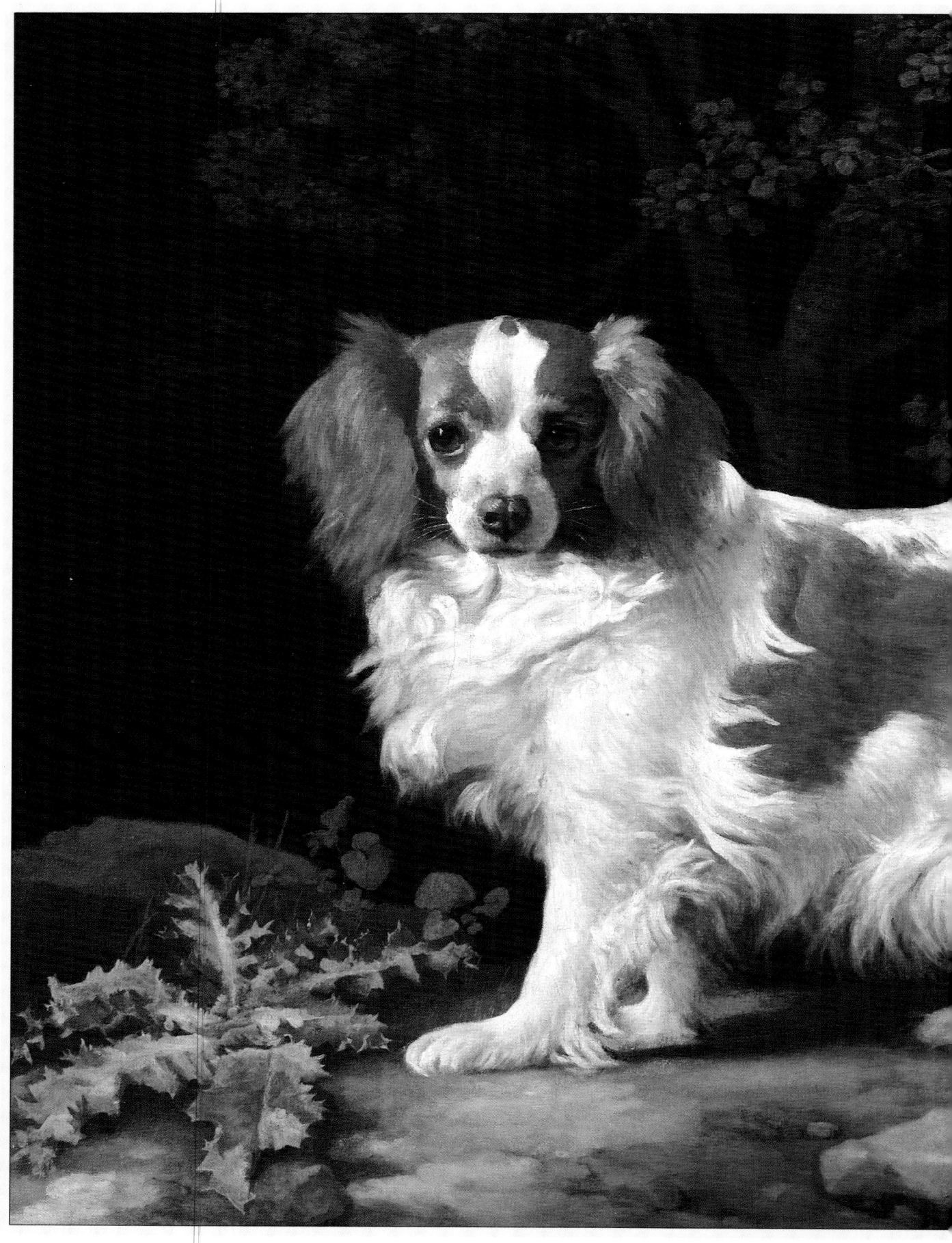

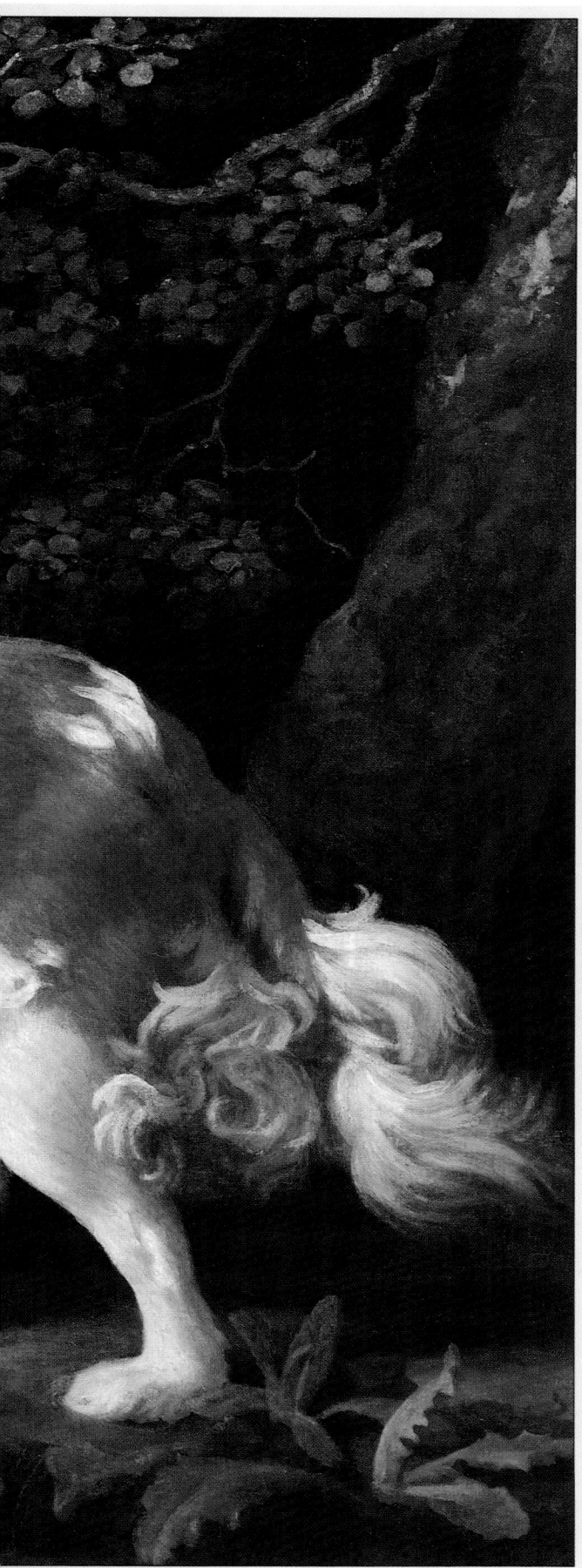

Over 30 dog-portraits survive, not counting the paintings which include dogs as subsidiary figures. Such commissions would have been a useful source of income in Stubbs' later years when the patronage of his horse-paintings diminished, but he never appears to have tired of these bread-and-butter subjects, whether horse or dog. The high quality of his work is remarkably consistent right up until the end of his career.

PRINTMAKING

Stubbs had learnt how to make prints for the midwifery illustrations published in 1751. His second, much improved, venture in this field was the *Anatomy of the Horse,* published in 1766 and then there was a gap of 11 years before he returned to printmaking. This time it was not a book project that prompted him, but instead the publication of one of his own oil-paintings. *Horse frightened by a Lion,* which was published in 1777, was a copy of one of his earliest lion and horse works. (Stubbs worked from this engraving, which reverses the painting, when modelling the same subject for Wedgwood.)

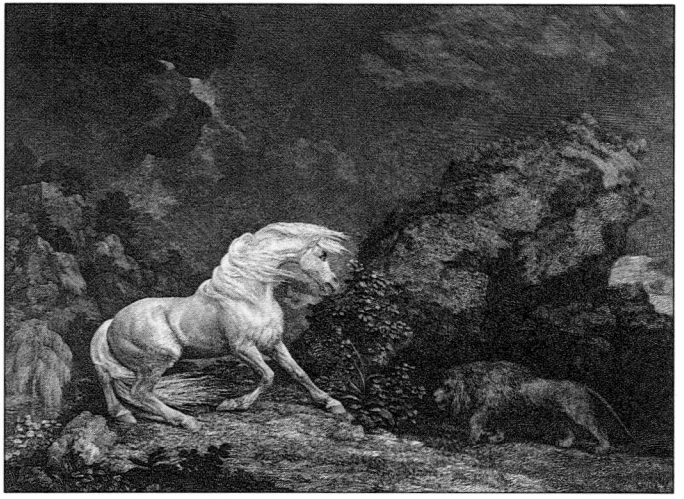

A HORSE FRIGHTENED BY A LION.
Engraving.

KING CHARLES SPANIEL, 1776.
One of Stubbs' most attractive dog portraits, his sympathetic observation of the gentle nature of the spaniel is beautifully described.

This print was made using the same method as the earlier illustrations, that is, a combination of etching and engraving. Stubbs had learnt the rudiments of the former from a house painter in Leeds, but the refined techniques used to execute this work were largely self-taught. In etching the design is scratched through an acid-resistant ground to the copper beneath by means of a needle. The plate is then immersed in a bath of acid, which bites into

the metal areas exposed, giving a blunt-ended line which is usually the same thickness throughout its length. An engraved line usually tapers at each end, as it is the result of a process during which a sharp tool is used to scrape slivers of metal from the plate.

As both techniques are linear, the way in which the printed image is created is easily visible. The fine lines which describe every effect of texture or light and shade cannot be disguised, and are obvious in the depiction of rough surfaces in the work mentioned above. Both the stones in the foreground by the horse's back legs and the rocky outcrop behind the lion are obviously built up out of a network of lines.

In Stubbs' second print, *Leopards at Play,* published in 1780, he used the same methods. His description of the leopards' spotted coats is masterly but once again the landscape shows up the limitations of the technique, which

is particularly deficient in the treatment of large areas. The very close-grained hatching of the sky in both these prints indicate that Stubbs was seeking to work around the shortcomings of these linear methods.

His next two works show a change in working practice which allows him greater range of expression, for he developed a much more subtle printmaking technique. *Horse Frightened by a Lion* and *Horse attacked by a Lion* were both published as part of a series of 12 prints issued together in 1788, and were executed in the manner now known for convenience as 'mixed method'. This rather unhelpful term embraces the wide variety of tools used by Stubbs and the different uses to which he put them. His methods vary from one plate to another, but all the prints dated 1788 show an increase in the tonal range of his work. This is achieved by combining the etching and engraving of the early works with the recently introduced techniques of stipple, aquatint, mezzotint and, occasionally, soft-ground etching. By these means he was able to make much more gradual transitions in the creation of an image, in a manner that is closer to oil-painting. The various textures are more easily described, and in such a

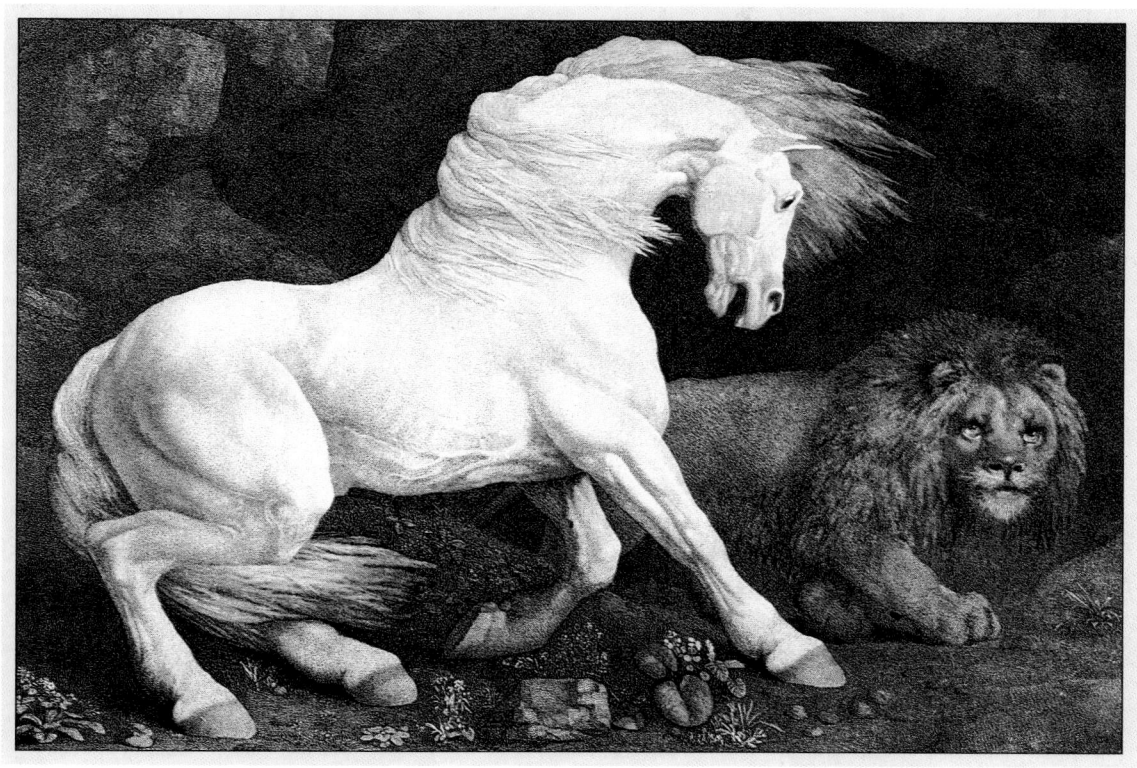

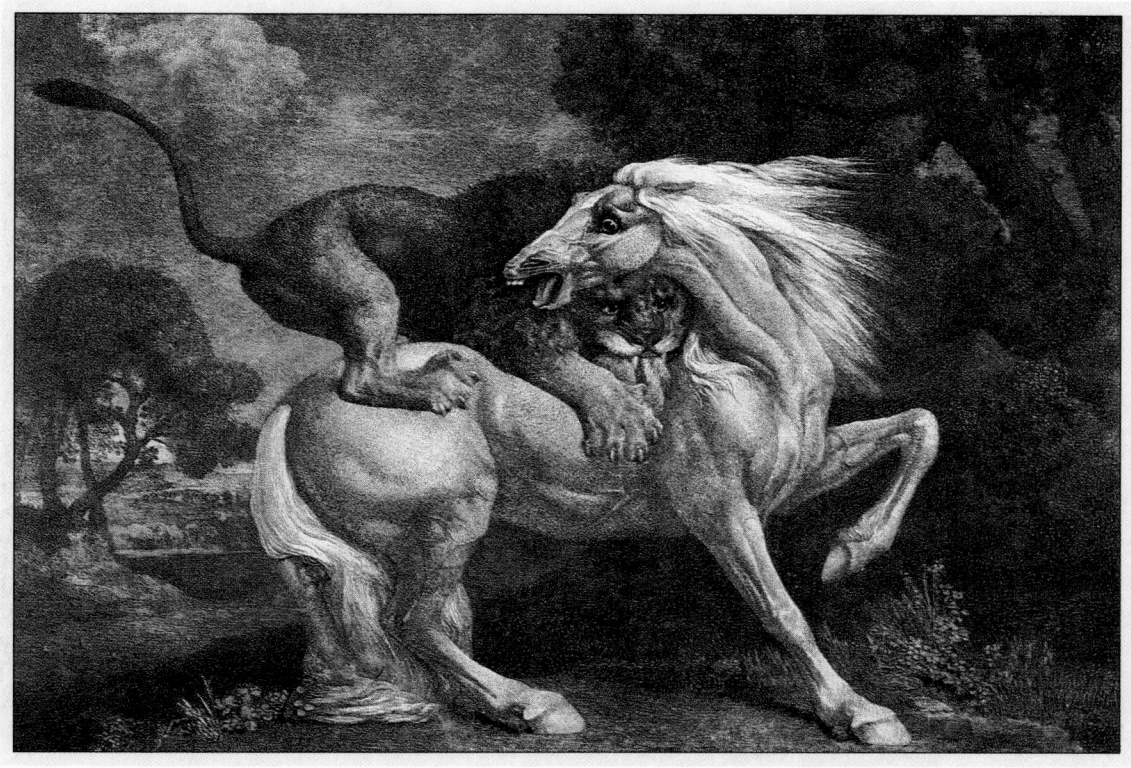

A HORSE FRIGHTENED BY A LION.
Engraving (above).

A HORSE ATTACKED BY A LION.
Engraving (below).

161

A TIGER AND A SLEEPING LEOPARD.
Engraving (above).

A RECUMBENT LEOPARD BY A TREE.
Engraving (below).

A LION RESTING ON A ROCK.
Engraving.

way that the means of achieving the image are not as obvious as before.

This improvement in technique was the result of long hours of experiment, but the reasons behind Stubbs' involvement in printmaking are not clear. Had he wanted to make money from them he would have chosen subjects of broader popular appeal, such as his portraits of race-horses. The fact that a number of his paintings had been reproduced by other printers may have influenced him. However, it appears most probable that his interest in the medium was kindled by the challenge that it posed to his artistic abilities. The time and trouble that he spent on these works was far in excess of that of the professional printmaker, and they fall into the same category as Rembrandt's prints in that they are creative rather than simply reproductive.

Of the 1788 issue, two of the most successful are the *Tiger and Sleeping Leopard* and the *Recumbent Leopard by a Tree*. In both pictures, Stubbs has achieved a masterly handling of light through using his 'mixed method' technique. Sunlight appears to play on the flank of the tiger and its face is beautifully modelled in delicate tonal varia-

tions. In the *Recumbent Leopard* he demonstrates the full potential of the medium. The leopard is very convincingly described in spatial terms, and the broad sweep of the landscape is represented through the most subtle alteration of tone.

Studies of the various members of the cat family form the largest group of subjects amongst Stubbs' prints. Lions, leopards, cheetahs and tigers (not including the lion and horse theme) occur in seven out of a total of 19 surviving published works. Stubbs appears to have used the term 'tygers' in a general way, for this was the original title of *Leopards at Play,* and similarly the *Tiger and Sleeping Leopard* was called 'Two Tygers'. However, though he may not have used precise terminology for these animals, he fully understood the differences between the species and had firsthand knowledge of all of them. The tiger was of special interest to him and when one died at Pidock's

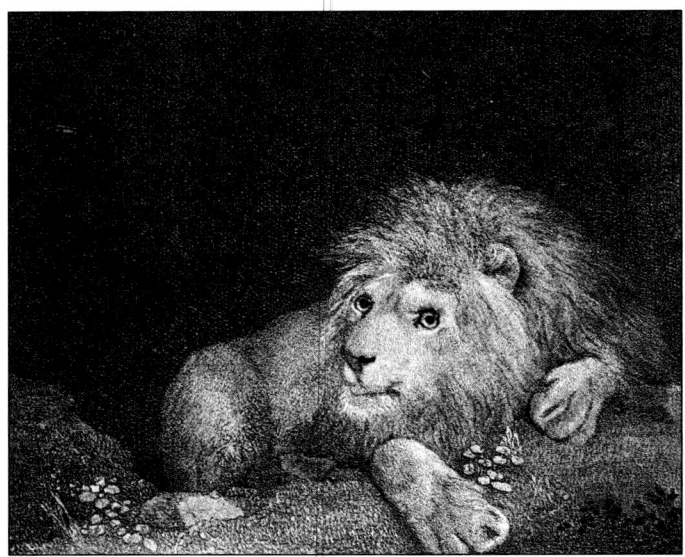

A RECUMBENT LION.
Engraving.

Menagerie, Stubbs sped to the Strand in the middle of the night to obtain the body. Later, he included it in his *Comparative Anatomical Exposition,* and all his illustrations of tigers are very credible.

However, this cannot be said of his lions, whether executed in oil, enamel or print. They never quite succeed in conveying the full character of the species, which is curious, as it appears that he made life drawings of them. Humphry records the fact that Stubbs made studies of Lord Shelbourne's lion, which was kept in a cage at his villa on Hounslow Heath. He would also have been able to see them at the Tower of London, and probably in other private menageries. His two printed representations of them are very weak. Both *Lion resting on a Rock* and *Recumbent Lion* are totally unconvincing portrayals of the animal normally associated with nobiity and majesty. In both works the expressions of the beasts are unaccountably foolish. No matter how skilful these prints may be, they are spoilt by these poor characterizations.

Some of his most successful printed animal studies are those of foxhounds. There are four of these, three of single hounds and one more elaborate work of a pair called *Two Foxhounds in a Landscape.* Like the lion prints, these were all part of the group issued in 1788. In the single studies, Stubbs has placed the hounds in positions which require acute foreshortening. All three are reproductions of hounds in the *Charlton Hunt,* painted nearly 30 years earlier. In these prints he may have enjoyed setting himself the task of representing steep angles in monochrome. In *Two Foxhounds in a Landscape,* the

pair are shown in a setting which is all but dominated by the huge foxglove on the bank behind them. The hounds are described in the softest of tones, and the landscape once again shows the refinement of Stubbs' printmaking methods.

The prints of the late 1790s are mostly versions of the rural subjects such as *Labourers* and *Reapers.* However, in 1791 Stubbs published another animal study, the last of series. Called *Sleeping Leopard,* it is a splendid portrayal of the vulnerability of a wild animal in deep sleep. The position of the leopard, with its paws tucked in and its tail wrapped around its body, makes it a very complete and harmonious image. In this peaceful study there is no hint of the potential power of the animal, it looks as harmless as a cat by the fireside. The way in which different textures of the leopard's coat and the bark of the tree are juxtaposed, suggests that Stubbs took pleasure in achieving such contrasts. Looking at this sort of work there can be little doubt that he involved himself in printmaking primarily for the creative opportunities that it offered to an artist who was always willing to break new ground in the pursuit of his art.

THE COMPARATIVE ANATOMICAL
——————— EXPOSITION ———————

In 1795, at the age of 71, Stubbs began work on the *Comparative Anatomical Exposition of the Human Body with that of a Tiger and a Common Fowl.* It was to be an illustrated publication laid out along similar lines to the *Anatomy of the Horse,* with a total of 30 tables and their diagrams, and an explanatory text. By his death in 1806 he

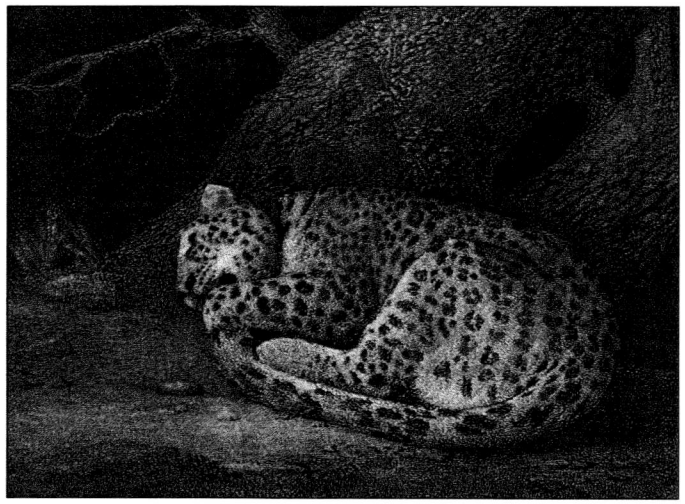

A SLEEPING LEOPARD.
Engraving.

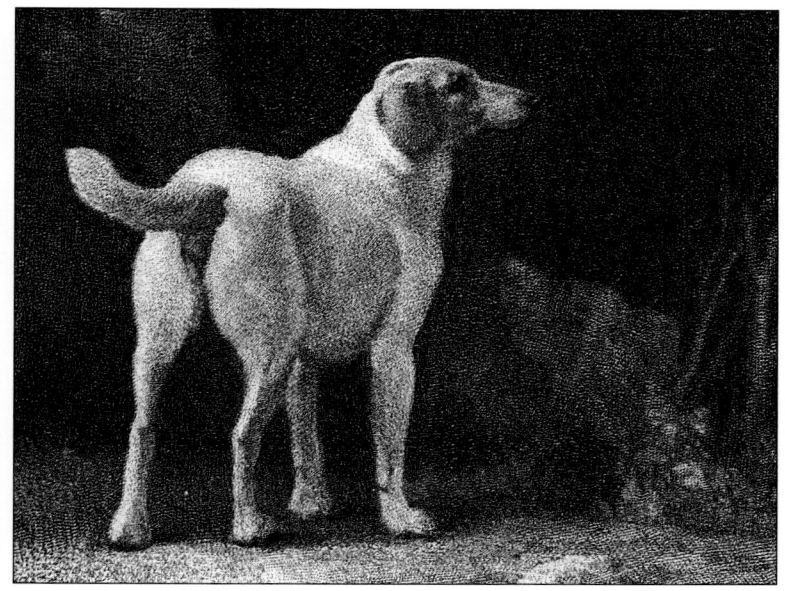

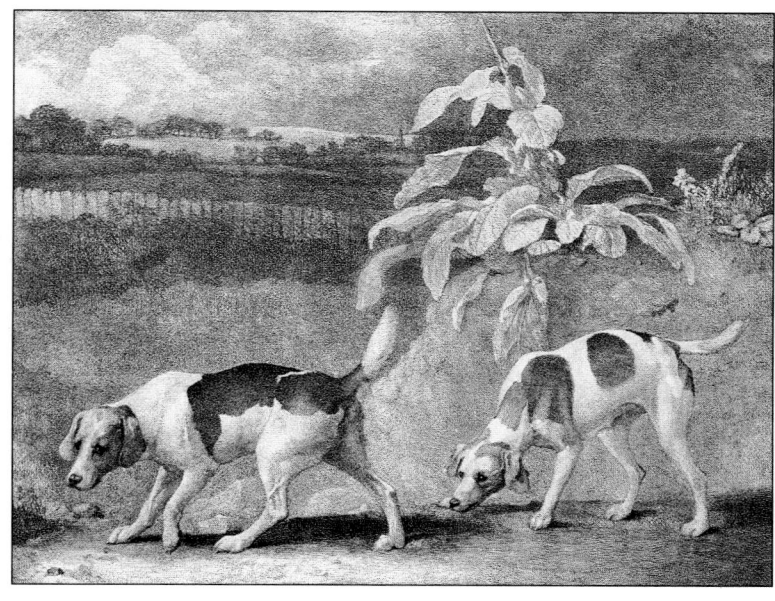

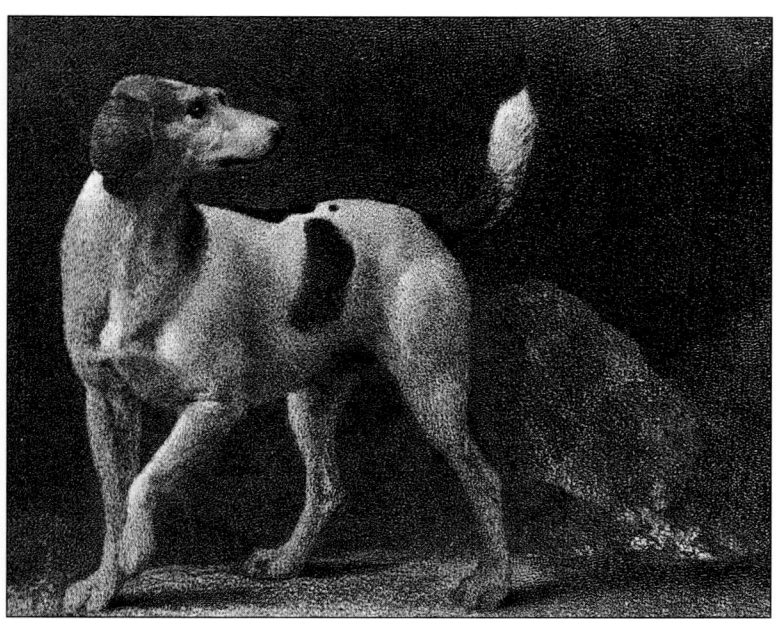

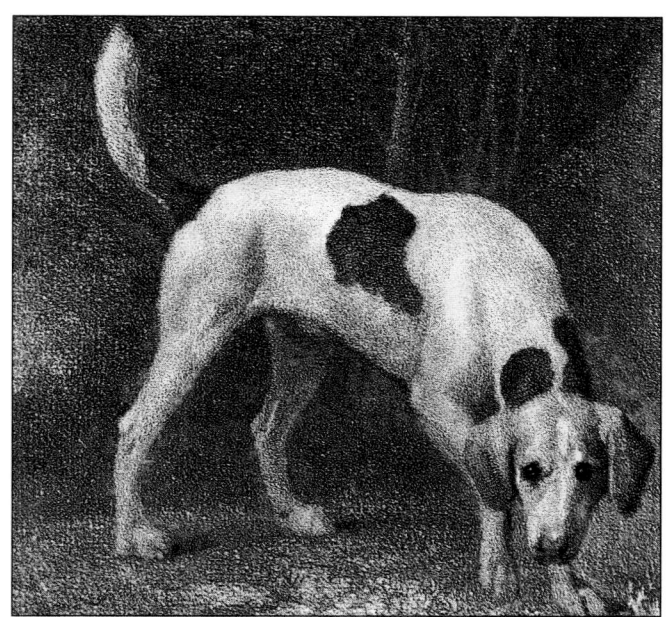

FOXHOUND VIEWED FROM BEHIND.
Engraving (above).

FOXHOUND.
Engraving (below).

TWO FOXHOUNDS IN A LANDSCAPE.
Engraving (above).

FOXHOUND ON THE SCENT.
Engraving (below).

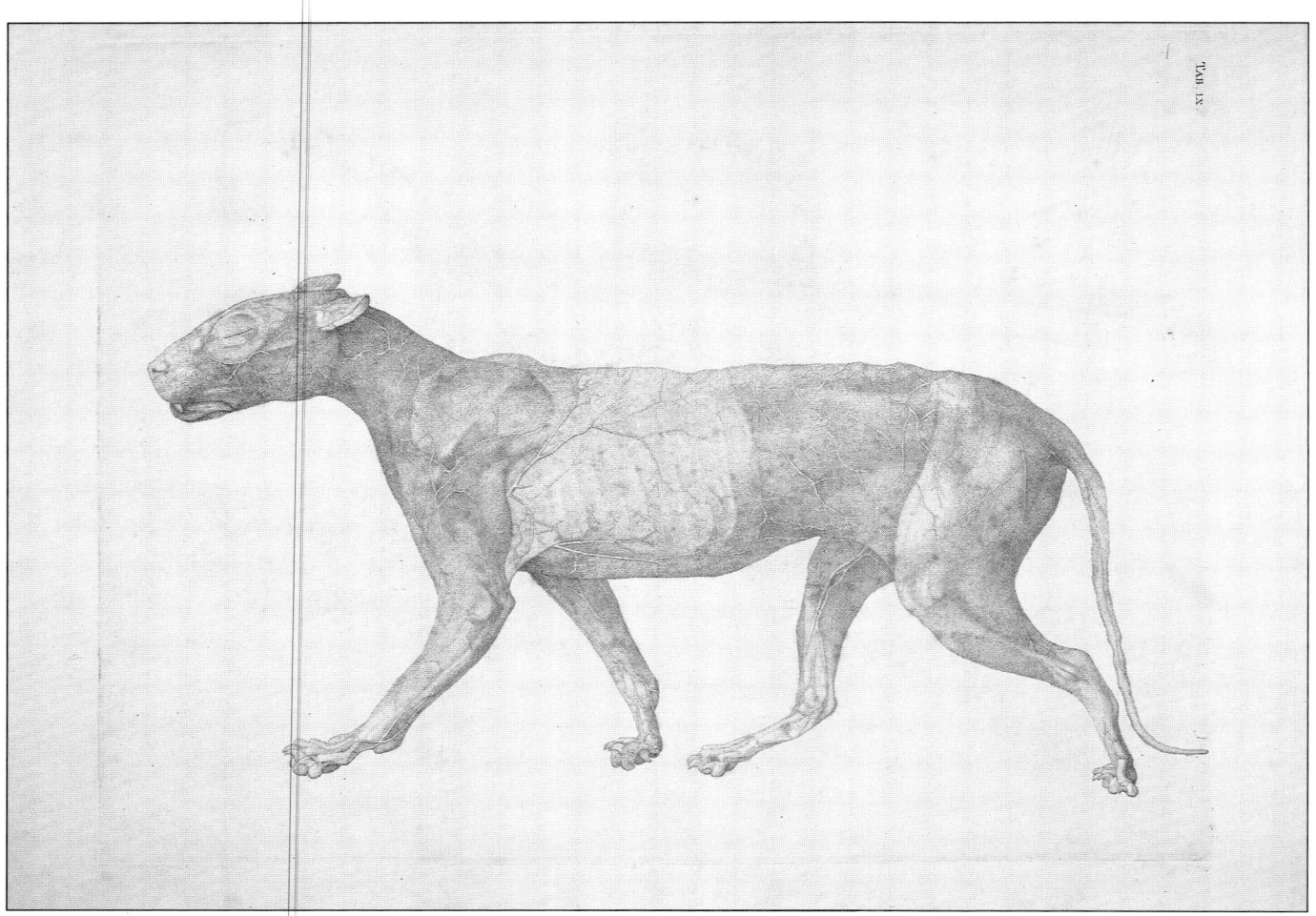

had published 15 of the plates. No text accompanied the illustrations, but he had written a large part of it; the manuscript survives (some of it written in French), together with 124 preparatory drawings. The prints are executed in stipple alone, each being built up from sequences of tiny dots. The clarity which results is well suited to scientific illustration, but it gives a rather soft spongy look to the image which is not as satisfying as the sharp crisp finish of the *Anatomy* engravings.

Mary Spencer, in her additions to the Humphry memoir, says that on the day he died Stubbs said that he had hoped to finish the 'Comparative Anatomy', as he called it, and it undoubtedly formed the main preoccupation of his last years. However, with hindsight this work appears to be of less importance than he had hoped, as in scientific terms it added nothing to existing knowledge. Though the quality of the illustrations is good, the unfinished *Comparative Anatomical Exposition* had none of the impact of his earlier anatomical publication. He may have hoped that it would lead to the sort of acclaim that had been engendered by the *Anatomy of the Horse*, in which case it is fortunate that he did not live to see the project completed.

TAB. X.

A COMPARATIVE ANATOMICAL EXPOSITION OF THE HUMAN
BODY WITH THAT OF A TIGER AND A COMMON FOWL.
*Table VIII: Human Body, lateral view. Engraving (left
below).*
Table IX: Tiger, lateral view. Engraving (left above).
Table X: Fowl, lateral view. Engraving (above).

Feb^y 8th 1794

44

Geo Dance

PORTRAIT OF GEORGE STUBBS
*by George Dance, 1794. Dance's pencil drawing shows
Stubbs in a more mellow light than the earlier
portraits by Ozias Humphry. An architect by
profession, Dance is probably best known for Newgate
Prison (1765–7). He drew portraits as a diversion in
his spare time (above).*

CONCLUSION

Stubbs never succeeded in repeating the success of the 1760s, and some of his artistic ambitions remained unfulfilled. However, in the last years of his life he was not totally neglected, he remained fit, busy and productive at least until 1803, the last year in which he exhibited at the Royal Academy. Nevertheless, his financial situation was not good, and would have been worse but for the generosity of Isabella Saltonstall, who lent him considerable sums against his paintings.

It may have been the need for funds which encouraged him to get involved, in the early 1790s, in a project which aimed to publish an illustrated history of racehorses from 1750 onwards. Called the *Review of the Turf,* it was to include 145 prints taken from Stubbs' specially commissioned paintings. Only 16 of these pictures were completed when the whole scheme was dropped for lack of backing. This probably left Stubbs considerably out of pocket, as it would appear that none of the paintings were sold and all were listed in the catalogue of his studio sale. However, at about the same time he received a number of commissions from the Prince of Wales, which must have been some compensation in terms of prestige. How much difference this connection made to his finances is less certain, as the Prince was permanently in debt himself. Other late patrons included the Duke of York and the Earl of Clarendon, both of whom commissioned works exhibited in the early 1800s.

THE CULMINATION OF A CAREER: HAMBLETONIAN

If a single painting were to be selected to represent the totality of Stubbs' work, *Hambletonian, rubbing down* woud be the one. Dated 1800, it was commissioned by Sir Henry Vane-Tempest to commemorate the epic race between his horse, Hambletonian, and Diamond, run at Newmarket in the spring of 1799. It was a very hard fought contest over almost four miles, and the last half mile was run neck and neck. Though he appeared the more exhausted, Hambletonian won by half a neck.

For this portrait Stubbs refined and tightened his earlier Newmarket studies of horses like *Eclipse* or *Gimcrack.* In this picture the horse dominates the work to a far greater extent, filling the canvas in such a way that the result is imposing and monumental. This, together with its vast lifesize scale, makes it a painting of immense power. The design does not appear elaborate, but nevertheless each constituent part of the work plays a key role, helping to balance the composition and to define the pictorial space.

The massive horse is contained and supported within the picture by his trainer, who acts as a buttress to the animal's movement. The stable-lad is tucked neatly into the void under the animal's neck, his fingers hooked over its withers in a very natural manner, helping to define the horse in space. On the left the rubbing-down house just touches the horse's hind quarters, drawing the eye into the background and linking the figures with the landscape beyond. The spectators' stands punctuate the horizon, their diminishing size indicating the extent of the open sweep of heath behind the figures.

As an equestrian study, Stubbs' painting of *Hambletonian* surpasses even the great *Whistlejacket,* and it marks the summit of English animal portraiture. It is impossible to find fault with his assured treatment of the horse. The knowledge acquired through his anatomy studies and 40 years of artistic experience are here put to the test in this large-scale, close-up view of a horse in movement. The hero of the match stamps in weary irritation, his gaunt frame and lacklustre eye giving some indication of his hard race.

However, Stubbs does not tell the full story, for it is recorded in the *Sporting Magazine* the horses 'were much cut with the whip, and severly goaded with the spur'. Convention demanded that his flanks be shown unblemished. The portraits of his handlers are of equally high quality. Both trainer and lad are perceptively portrayed; the former is a particularly strong characterization. (As with the *Nylghau,* one would know him if one came across him.) These men gaze out at the spectator in a very striking manner, their expressions enigmatic. They both

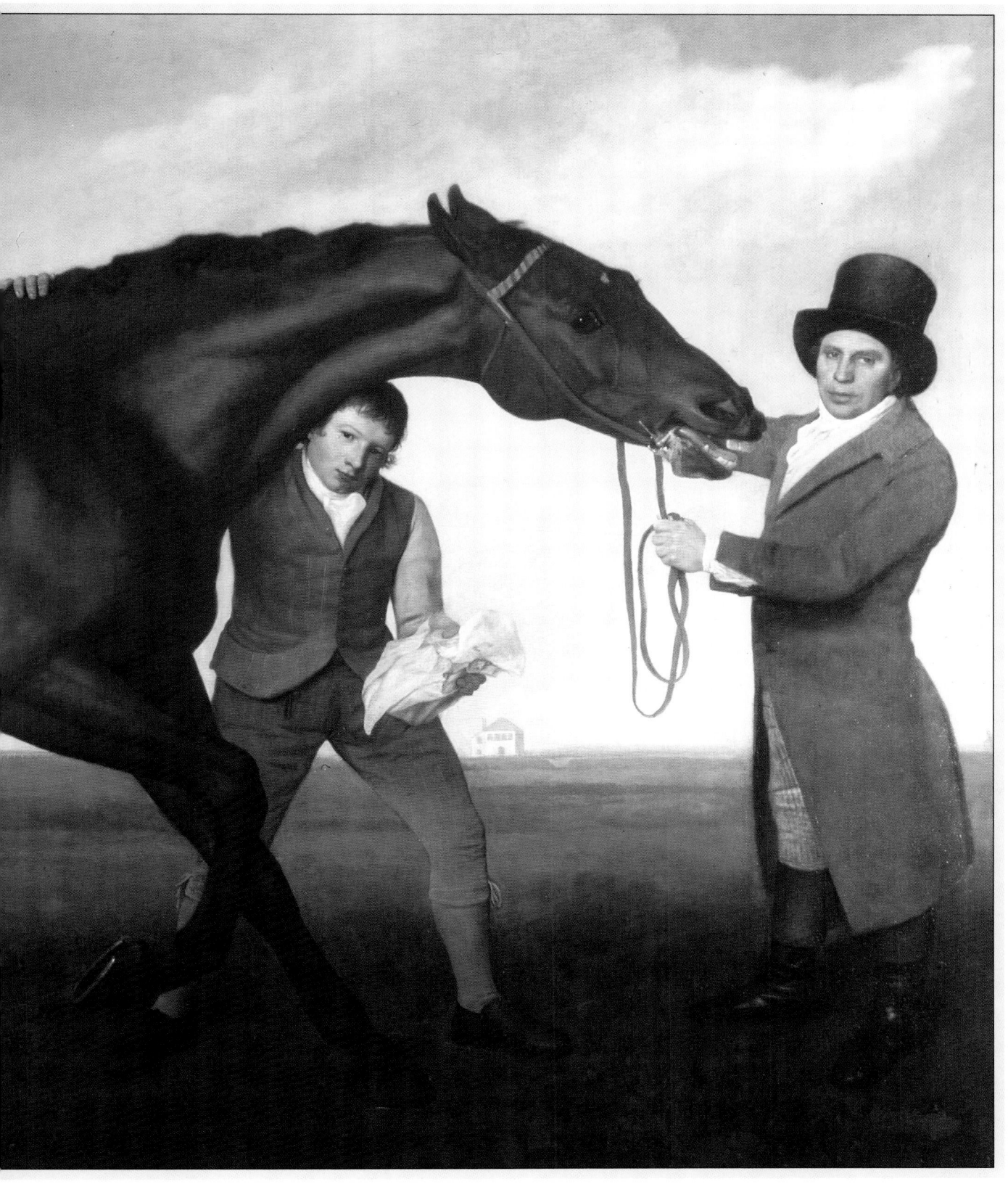

HAMBLETONIAN, RUBBING DOWN.
*While acknowledging the quality of Stubbs' other work,
it cannot be denied that his greatest painting is a horse
portrait. Though he resented the title 'horse painter',
perhaps he would have appreciated Geoffrey Grigson's
assertion that he was a painter who painted horses
(previous page).*

appear to be slightly accusatory, as though blaming the spectator for the horse's ordeal. As with *Freeman,* painted in the same year, it is easy to read too much into these portraits, but the men in both these late works do appear to be, to some extent, in confrontation with the spectator.

With *Hambletonian, rubbing down,* in his 76th year, Stubbs reached the peak of his powers. This great horse-painting shows him to have been a great artist. This was the point that his contemporaries could not appreciate. The humble standing of the subject-matter of his works blinded his critics to their true quality. In his composition and draughtsmanship, in the observation of character and its translation into paint, he stands comparison with English artists of the first rank.

ANIMAL PAINTING AFTER STUBBS, —————— A BRIEF SURVEY ——————

Stubbs' career marks a watershed in animal painting. The standard that he set through his painted work and the knowledge that he made available to artists through the *Anatomy of the Horse* combined to change irreversibly the attitude of artists to animal subjects. He did not have any followers in the sense of pupils or assistants, but Sawrey Gilpin and Thomas Gooch (c1750–1802) both show the direct influence of his work.

Of the next generation the three most interesting animal painters were Ben Marshall (1767–1838), Jacques-Laurent Agasse (1767–1849) and James Ward (1769–1859). The careers of these three artists followed very different paths. Ben Marshall chronicled the world of racing, of which he was very much a part, with great success. His work provides a vivid insight into the sport through his portraits of racehorses and their owners, jockeys and attendants. The Swiss-born, Paris-trained, Agasse painted horse and wild animal subjects mainly to please himself, and sold very few. The closest to Stubbs in spirit (he too had studied horse anatomy), he was even more out of step with his time than his predecessor.

James Ward is the most interesting of the three, as his work bridges the gap between English and French animal painting. He used animals as a vehicle for the expression of his emotions, as did Théodore Géricault and Eugène Delacroix. On his visit to England in 1821, Géricault praised

CYPRON, KING HEROD'S DAM, WITH HER BROOD,
by Sawrey Gilpin, 1764.
Gilpin's debt to the mares and foals series is evident in this work commissioned by the Duke of Cumberland. He appears to have tried to surpass Stubbs in the variety of the positions of his horses, and has set himself some ambitious exercises in foreshortening which are not altogether successful. A contemporary wrote 'Mr. Gilpin is inferior to Mr. Stubbs in anatomical knowledge, but is superior to him in grace and genius'.

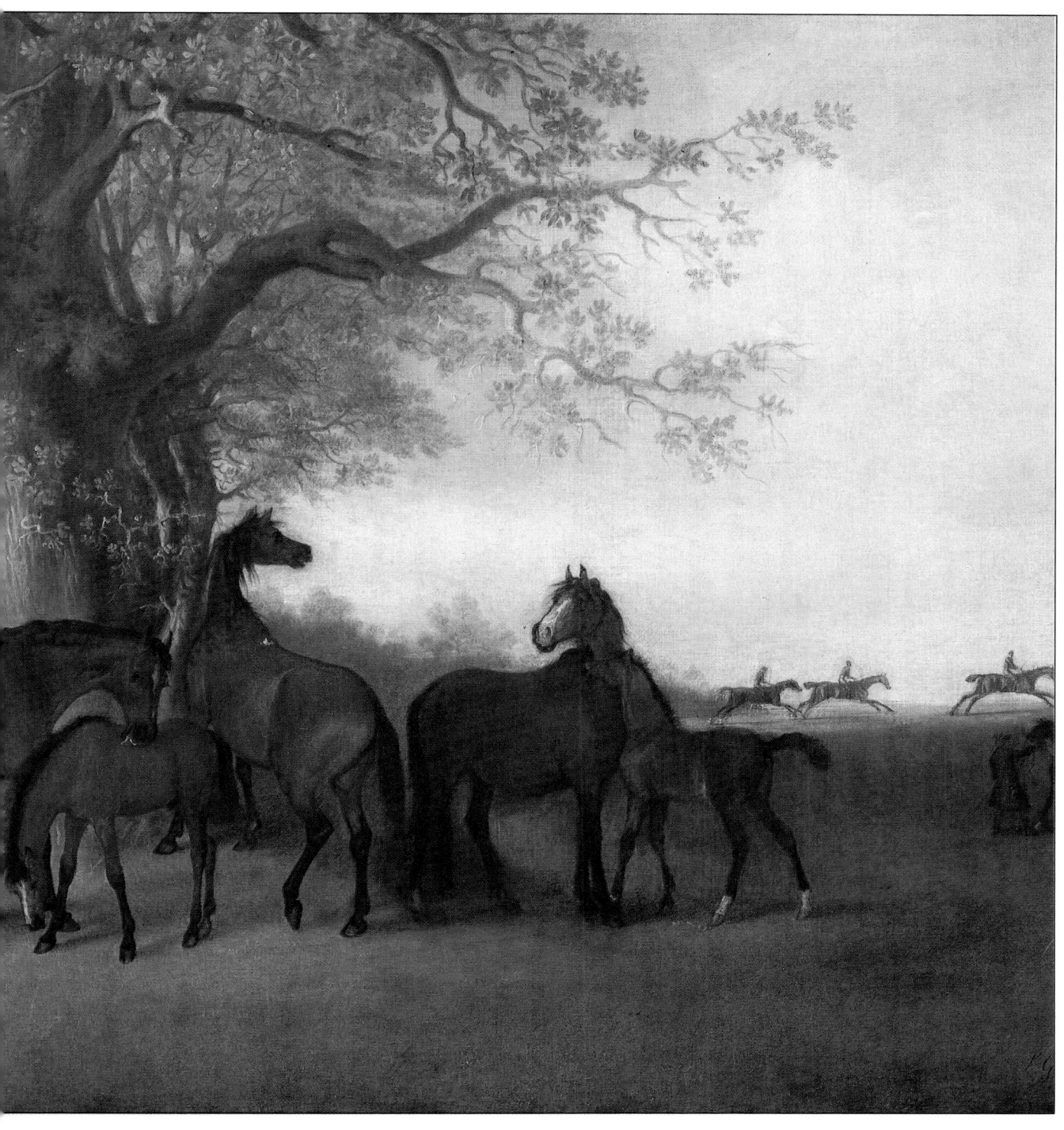

Ward's exhibits at the Royal Academy. (He also copied two of Stubbs' wild animal prints.)

It was in France that the next step forward in animal painting took place. In England the trend was either for artists to produce more or less accurate journalistic work (Aitken, JF Herring, John Fernley etc), or towards the super-idealization of animals in which they were given human attributes such as nobility, pride or dignity. This anthropomorphism is particularly evident in the work of Sir Edwin Landseer, but it was prevalent in the work of many mid-19th-century artists. The developments in France were more fruitful, for there animals became an important part of the expressive language of Romanticism. As an aspect of the work of both Géricault and Delacroix, the painting of animal subjects was freed from the stigma which had cast a long shadow over Stubbs' career.

A GENTLEMAN WITH HIS
HORSE AND DOGS,
*by Thomas Gooch, 1780.
The attractive mood of
this painting is created
by the artist's use of
informal poses for all the
figures. Precedent for the
gentleman's casual
position, with all his
weight on one leg, can
be found in Stubbs'
work. The composition,
however, is
comparatively loose. For
example, the dogs are
not as important to the
success of the overall
design as they would be
in a Stubbs portrait.
Gooch has used flanking
trees to unite the work, a
common device avoided
by his predecessor.*

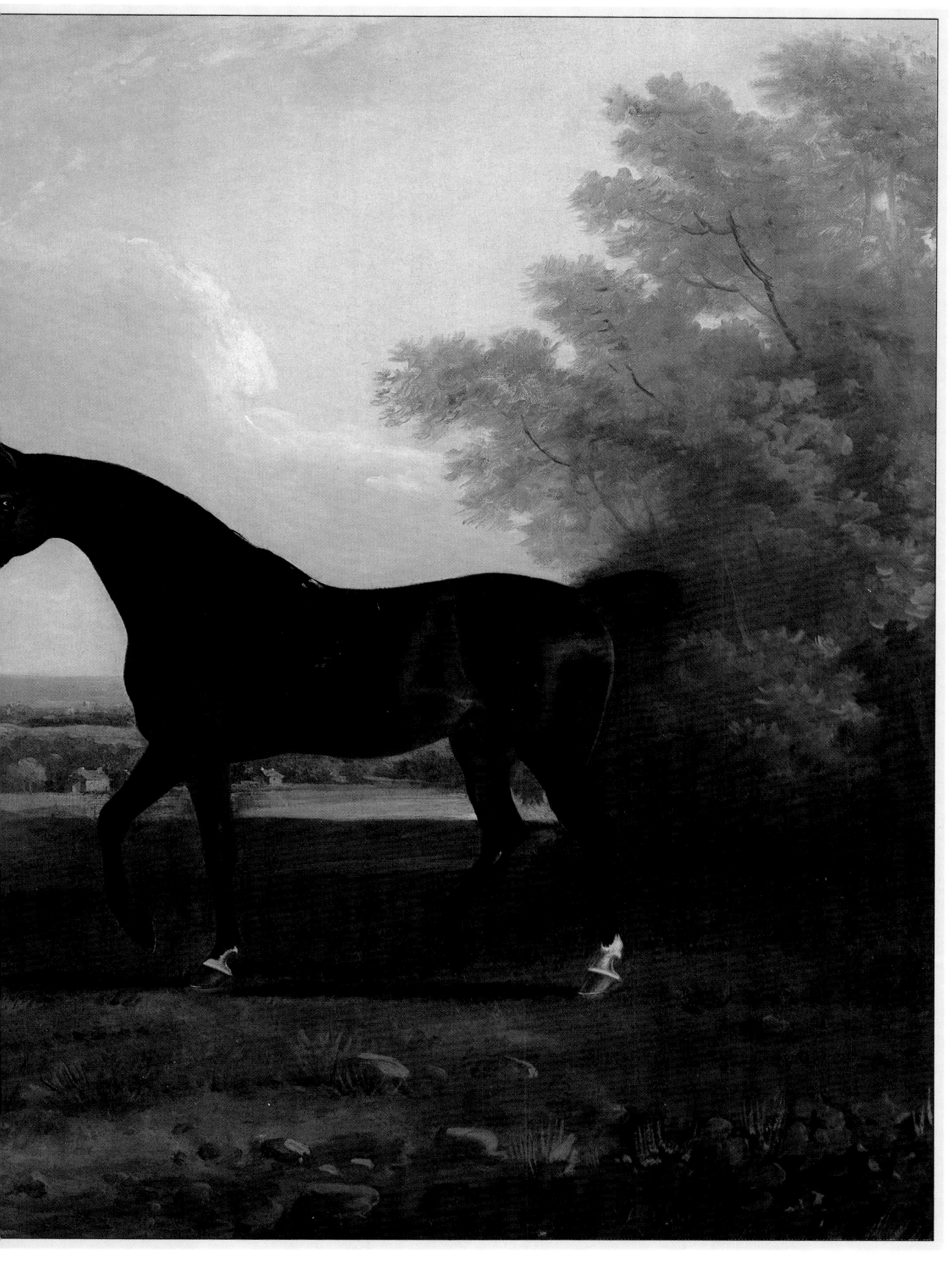

THE ELECTION OF DARIUS, *by Sawrey Gilpin, c.1772. Like Stubbs, Gilpin painted a number of equestrian history subjects. This work illustrates a scene from Herodotus in which Darius is chosen from six other claimants to be king of Persia. The crown was to be given to the man whose horse neighed first after sunrise on a given day. Darius groom weighed the odds in his master's favour by ensuring that a mare previously covered by the stallion was nearby as the sun came up, but Gilpin avoids reference to this aspect of the story.*

HENRY LEGARD WITH HIS
FAVOURITE HUNTERS,
*by Ben Marshall,
c.1825. Racing and
hunting subjects form
the bulk of Marshall's
output, but many
aspects of sporting life
are included in his
work, shooting and
coaching scenes among
them. His compositions
are usually carefully
balanced and his horses
well drawn and
anatomically accurate.
However, while Stubbs'
horse portraits appear to
describe the essence of
the animal, Marshall
tells us only what it looks
like. He is concerned
with the ripple of its coat,
the contours of its
muscles or the liveliness
of its trot, but he does
not convey its
individuality.*

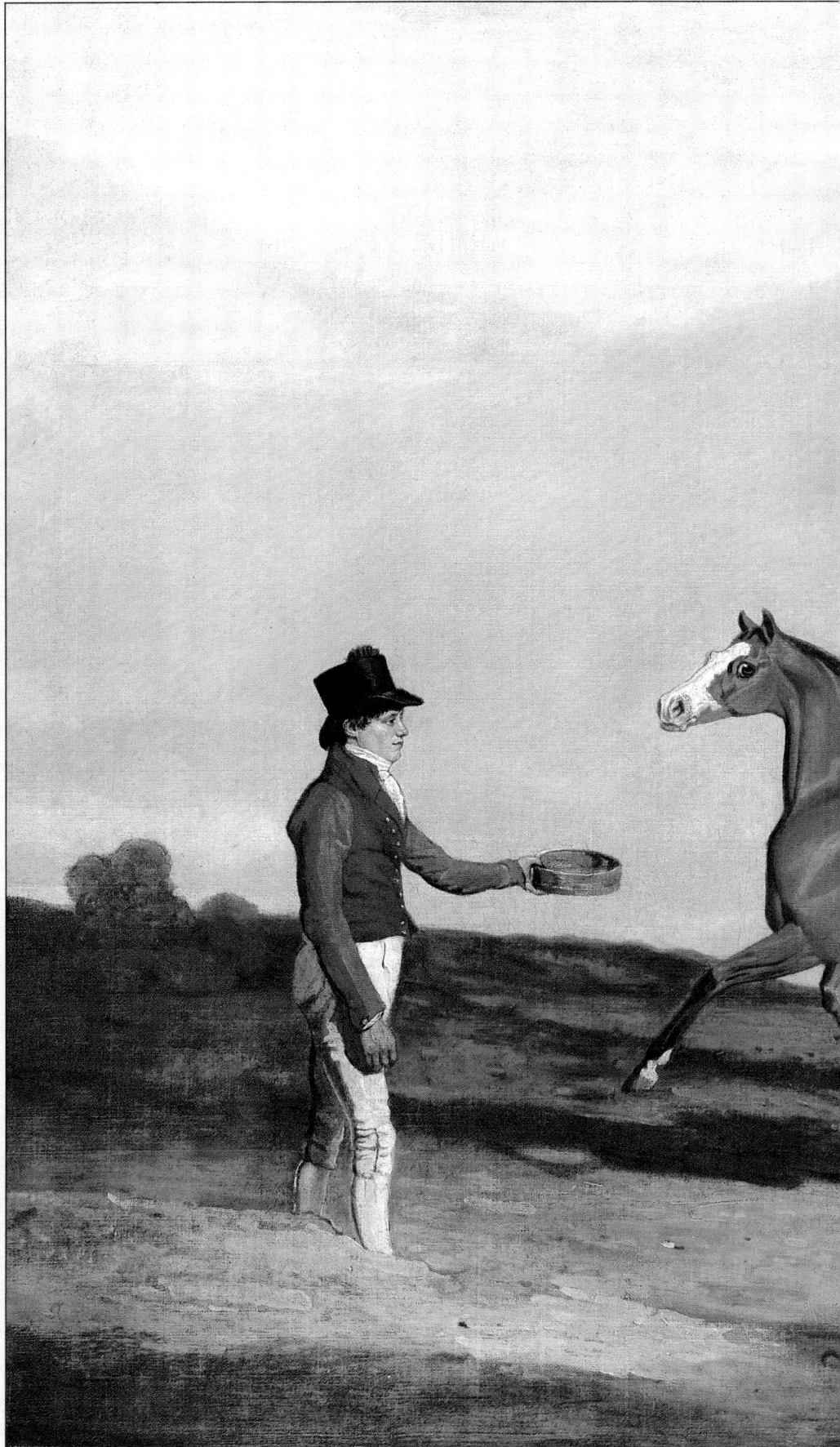

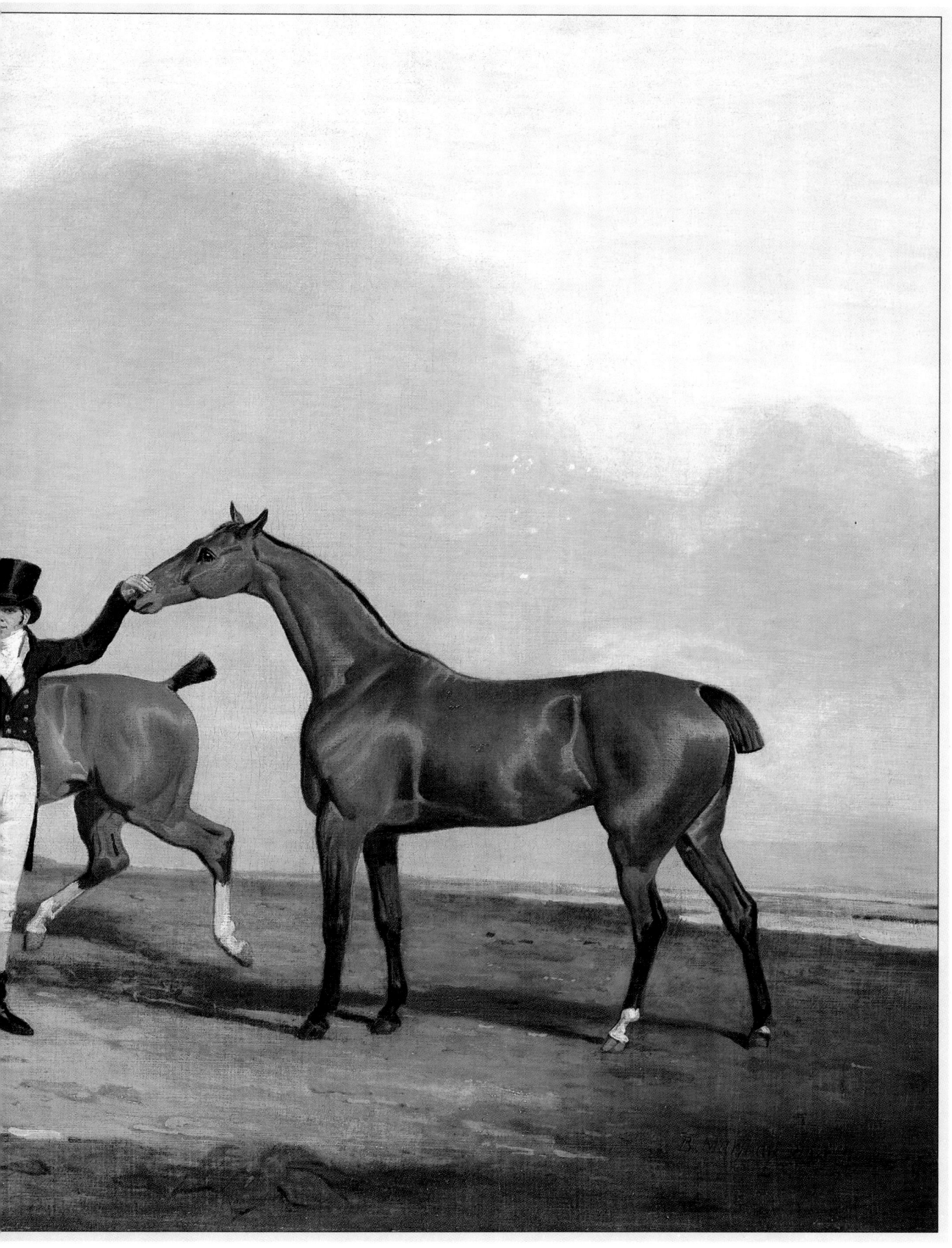

PORTRAIT OF LORD HEATHFIELD,
by Jacques-Laurent Agasse, ?1811.
While Agasse was able to convey something of the
character of the horse, his understanding of anatomy
was not on a level with that of Stubbs.

THE NUBIAN GIRAFFE,
by Jacques Laurent-Agasse, 1827.
This is among the most successful of his paintings.

181

BAY ASCHAM
by Jacques-Laurent Agasse, 1805.
Agasse painted a number of attractive farmyard
scenes which include a horse and a farm labourer
dressed in a smock. The portrayal of the stallion gives a
general impression of vitality, but it lacks the solidity
of Stubbs' horse paintings.

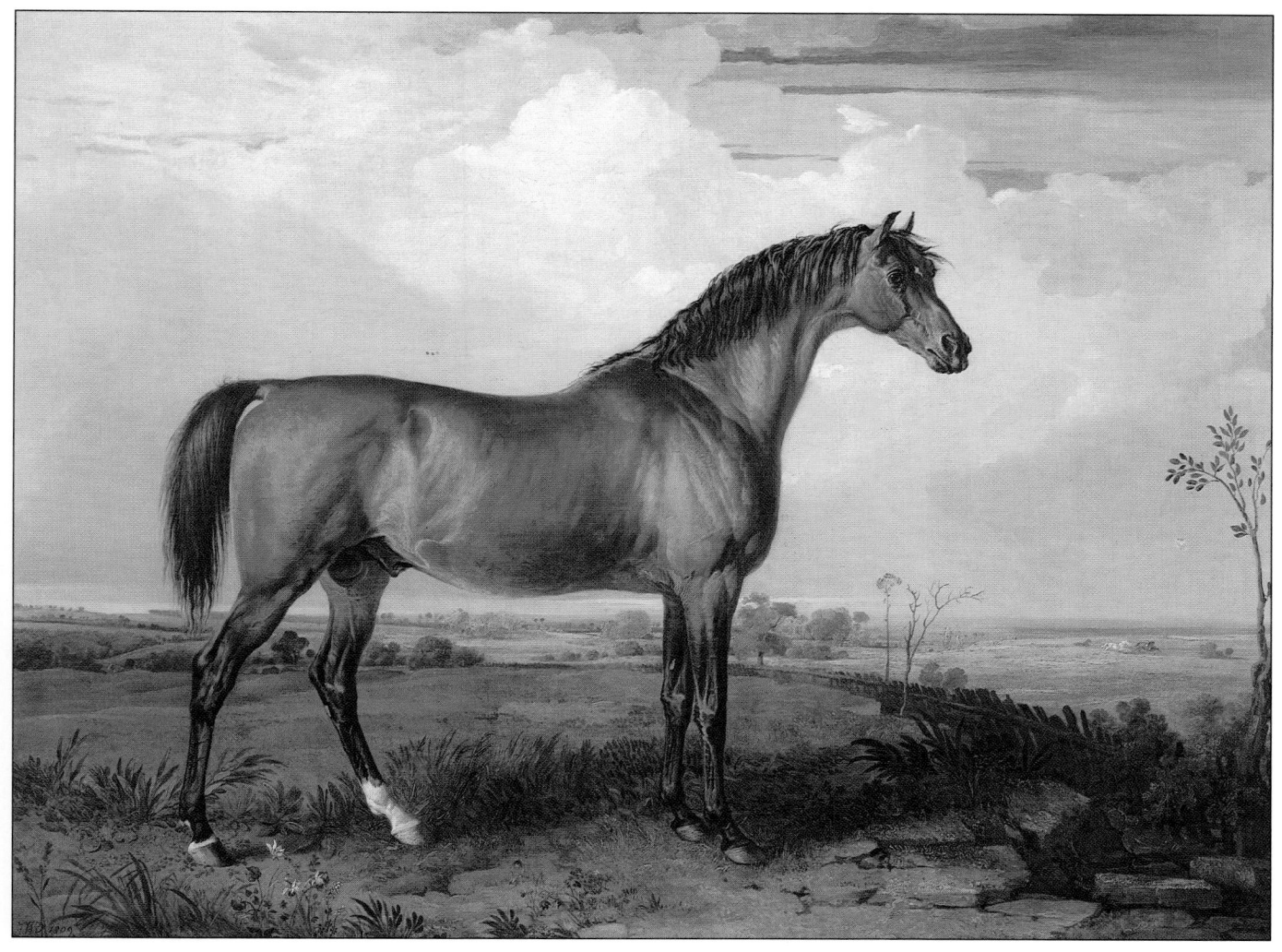

EAGLE,
by James Ward, 1809.
During the first decade of the 19th century James
Ward's horse paintings were much admired. His works
are characterized by their crisp sharp focus in which
every detail is minutely described. From the veins on
the horse's face to the wild flowers in the foreground,
every aspect of the image is sharply defined.

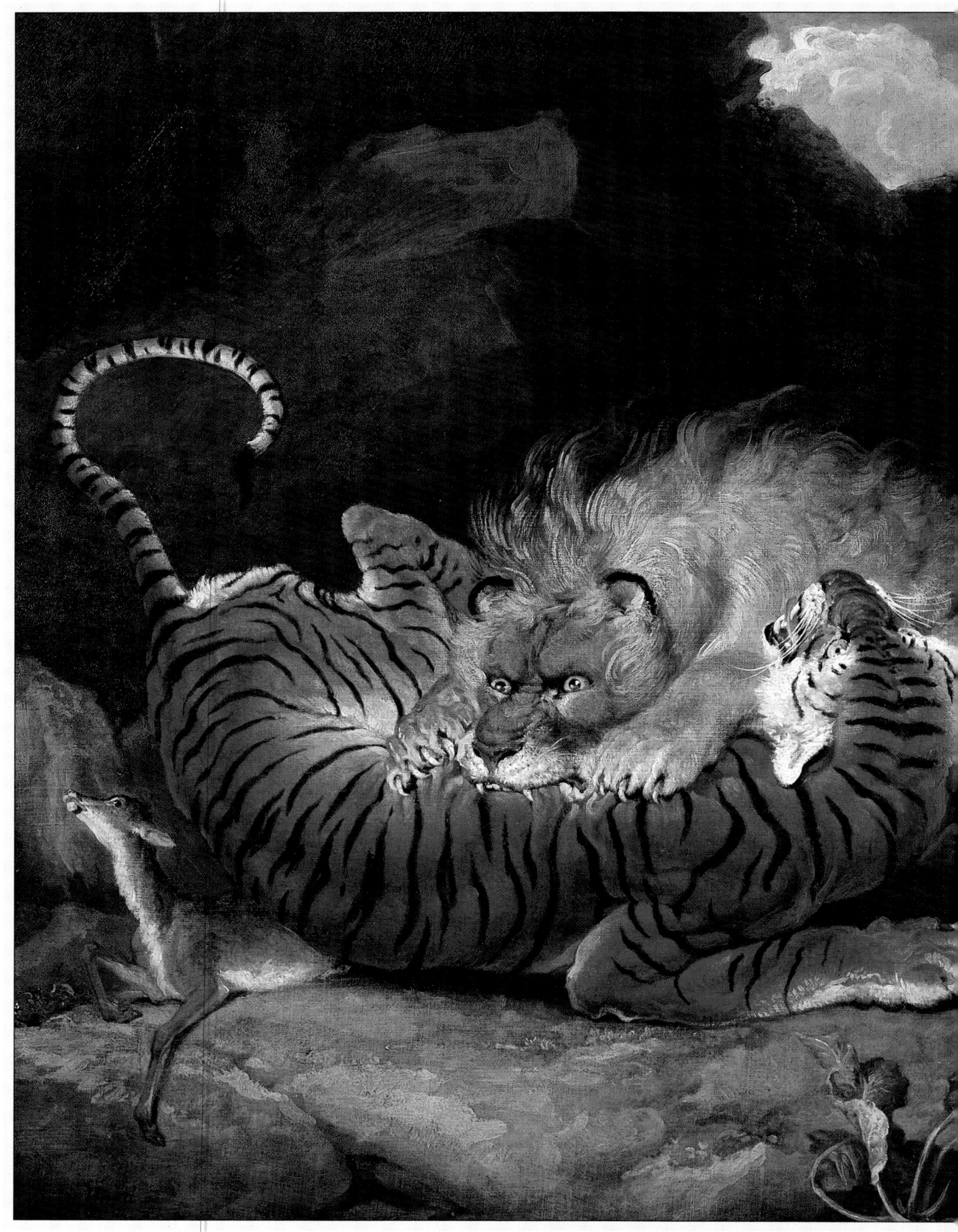

LION ATTACKING A TIGER,
by James Ward, 1797.
Wild animals became
important elements in
the language of
romantic symbolism.
The lion and the tiger
were used as vehicles for
the expression of
powerful emotions, and
it is in these works that
Ward comes closest to the
spirit of French
romanticism.

THE PLASTER-KILN
by Theodore Gericault, c.1822.
Horses played an important role in Gericault's art, as
they did in his life (and even in his death, as he died
following a riding accident). The artist is famous for
his dramatic representations of the animal, but this is
an example of his work in which they play a quieter
role. During his visit to England from 1820–2
Gericault painted many racing subjects and a
number of scenes involving draughthorses, both at
work and resting. This scene was painted after his
return to France, but in its low keyed representation of
a rural scene it draws on the English tradition.

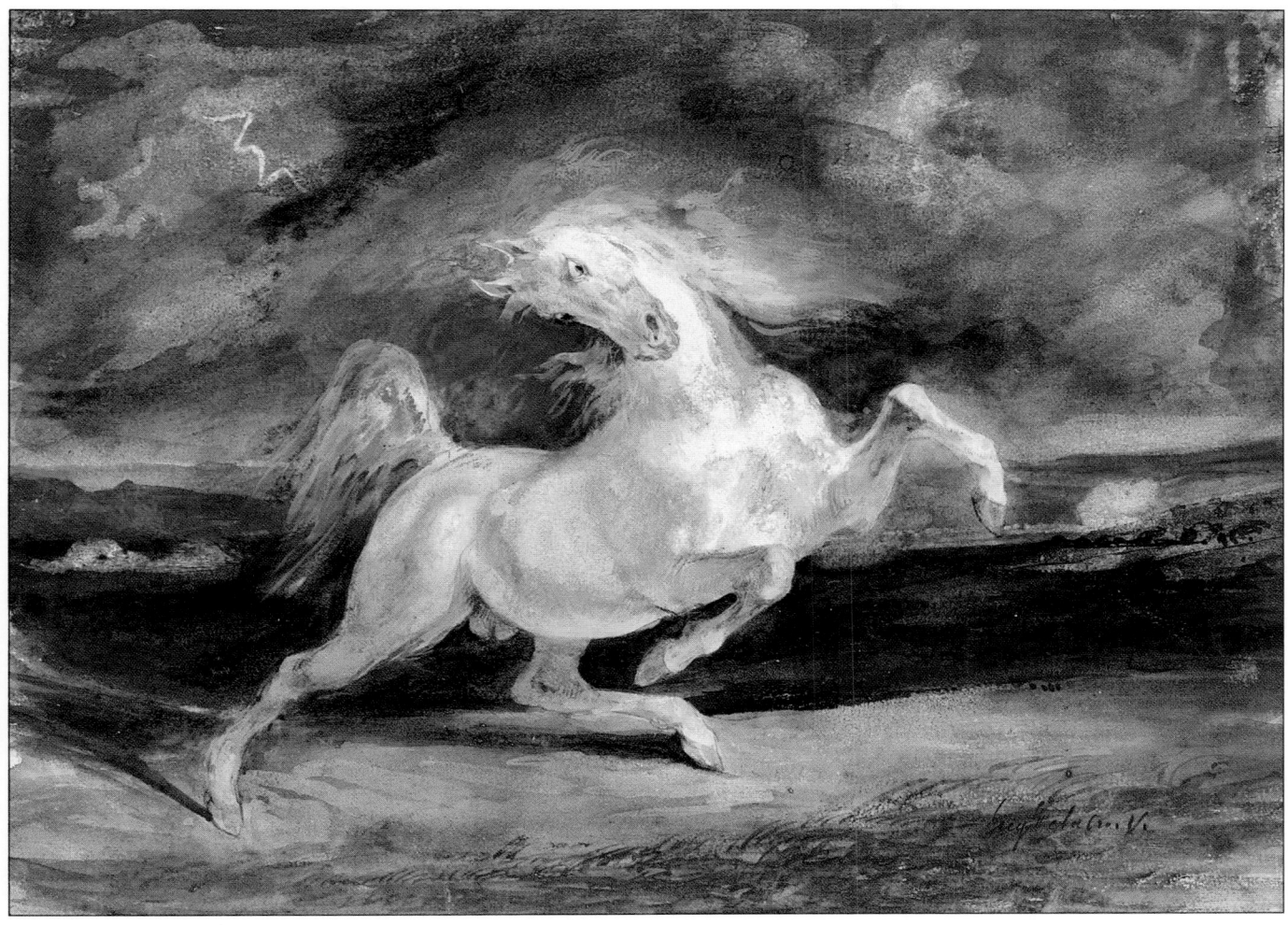

HORSE FRIGHTENED BY A STORM,
by Eugène Delacroix, 1824.
Delacroix's interest in English art and animal
painting may have stemmed from his association with
Gericault. In his revolt against classicism he gives
priority to the expression of passion and energy. The
horse's violent leaping action is the antithesis of the
measured control of Stubbs' paintings.

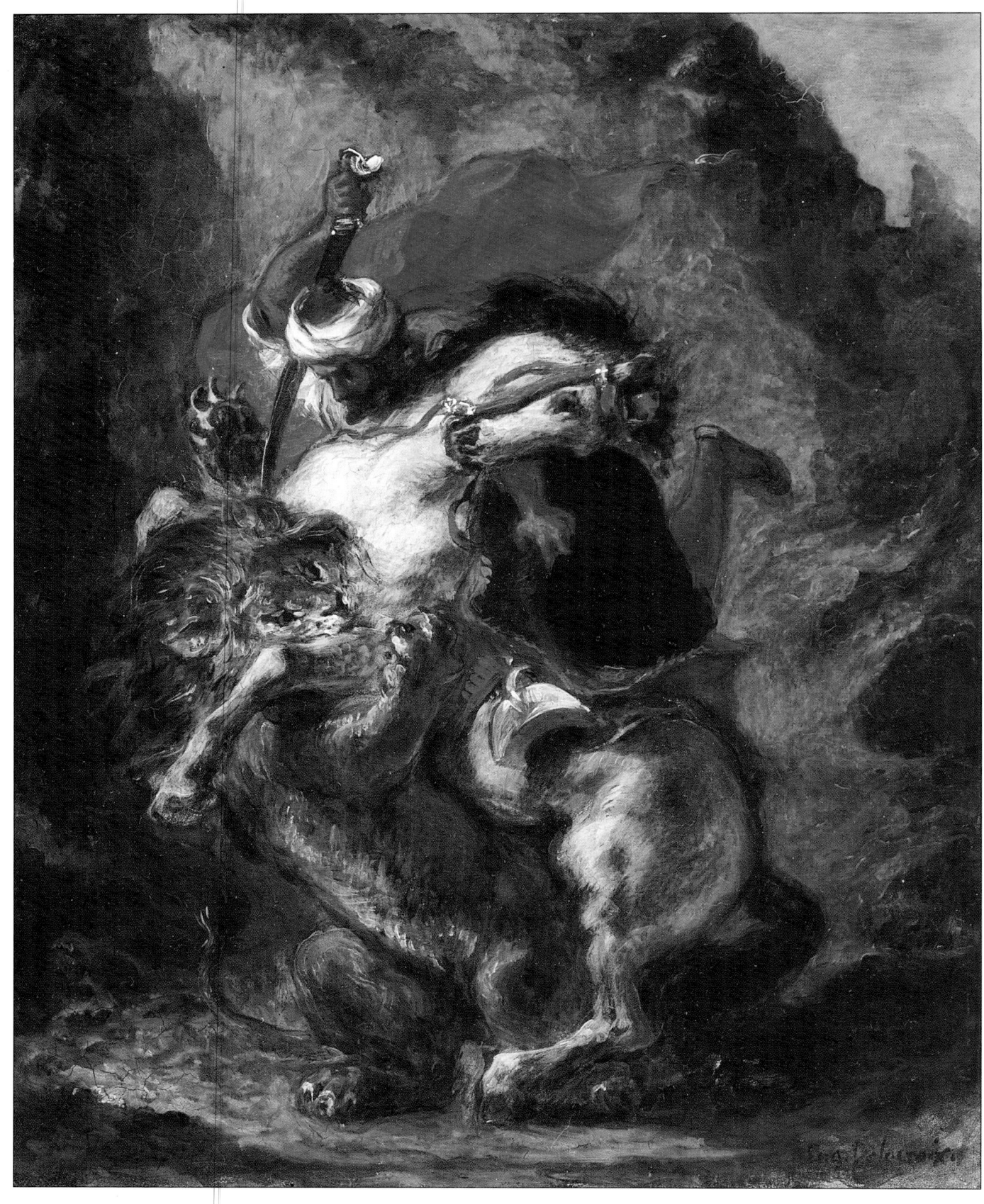

ARAB ON HORSEBACK ATTACKED BY A LION,
by Eugène Delacroix, 1849.

OFFICER OF THE CHASSEURS CHARGING,
by Théodore Gericault, 1812.

INDEX

The entry for George Stubbs is divided into *Life and Career; Works; List of Paintings; List of Engravings*. Works by Stubbs are in SMALL CAPITALS. Works by other artists are in single quotation marks, and titles of publications are in *italics*. Figures in *italic* refer to illustrations.

PICTURE CREDITS

Quarto would like to thank the following for their help with this publication and for permission to reproduce copyright material.

KEY: A = Above B = Below l = left r = right

Artothek: p154

Art Institute of Chicago: p188

The Bridgeman Art Library: pp50/51, 68/69, 74, 75, 79, 91(A), 94/95, 98/99, 110, 130/131, 138, 140, 152, 176/177, 186, 189

By Permission of the British Library: pp13, 14, 16, 17, 18, 19

The British Museum: pp159, 160, 161(A) (B), 162(A) (B), 163, 164(A) (B), 165

Reproduced by courtesy of the Board of Directors of the Budapest Museum of Fine Arts: p187

Lady Juliet de Chair and Trustees of the Olive Countess Fitzwilliam Chattels Settlement: pp6, 59, 72/73, 76/77, 153

Courtauld Institute Galleries, London (Witt collection No 2376): p144(B)

Fitzwilliam Museum, Cambridge: pp129, 184/185

From Goodwood House by courtesy of the Trustees: pp49, 55, 84

Reproduced by Gracious Permission of Her Majesty the Queen: pp57, 64/65, 104/105, 147, 156, 172/173, 181

Holburne Museum and Crafts Study Centre: p97

Hunterian Art Gallery, University of Glasgow: pp141, 142, 143

Jockey Club Estates Limited: p71

Kunstmuseum Luzern: p180

Lady Lever Art Gallery, Port Sunlight: p122/123, 136, 137

Paul Mellon Collection, Upperville Virginia: pp113, 145, 157

The National Gallery, London: pp43, 102/103

The National Gallery of Art, Washington: pp92/93

The National Portrait Gallery, London: pp106, 120

The National Trust Photographic Library: pp170/171

The National Trust Photographic Library/Robert Chapman: pp108/109

Lt. Col. R. S. Nelthorpe: pp10/11, 41, 89

Private Collection: pp44/45, 46, 48, 56, 62/63, 80/81, 91(A), 101, 158

The Royal Academy of Arts, London: pp20, 26, 27, 28, 30(A) (B), 31(A) (B), 32, 33, 34, 35, 36, 37, 38, 39, 166(A) (B), 167, 168

Reproduced by kind Permission of the President and Council of the Royal College of Surgeons of England: p144

The Tate Gallery: pp66/67, 70, 114/115, 128, 132/133, 134/135, 154/155

The Victoria and Albert Museum: pp22(A) (B), 23(A, l) (A, r) (B, l) (B, r), 24(A, l) (A, r) B, l) (B, r), 25, 112, 114/115

Virginia Museum of Fine Arts, Paul Mellon Collection: pp174/175, 178/179

Walker Art Gallery, Liverpool: pp40, 111, 116/117, 146, 148/149

Josiah Wedgwood and Sons Limited: pp121, 122, 124, 125, 126

Yale Center for British Art, Paul Mellon Collection: pp52/53, 61, 62, 82/83, 85, 86, 87, 88, 90, 127, 150/151, 183

Every effort has been made to trace and acknowledge all copyright holders. Quarto would like to apologize if any omissions have been made.

Of the many people who have contributed to the preparation of this book the author would particularly like to thank Judy Egerton, of the Tate Gallery, for reading the manuscript and for her general help, criticism and encouragement. She would also like to thank Richard Charlton-Jones, of Sotheby's, whose assistance with the early stages of the book was invaluable.

SELECT BIBLIOGRAPHY

Humphry, Ozias, *Memoir,* c.1795, manuscript in the Picton Collection, Liverpool City Libraries.

Egerton, Judy, *George Stubbs: Anatomist and Animal Painter* (Tate Gallery Exhibition catalogue), 1976.

Egerton, Judy, *British Sporting and Animal Paintings 1655–1867* (Catalogue of the Paul Mellon Collection), 1978.

Egerton, Judy, *George Stubbs, 1724–1806* (Tate Gallery exhibition catalogue), 1984.

Taylor, Basil, *Animal Painting in England from Barlow to Landseer,* 1955.

Taylor, Basil, *Stubbs,* 1971.

Taylor, Basil, *The Prints of George Stubbs,* 1969.

Parker, Constance-Anne, *Mr. Stubbs the Horse painter,* 1971.

Doherty, Terence, *George Stubbs, Anatomical Works,* 1974.

Fountain, R. and Gates, A., *Stubbs' Dogs,* 1984.

Deuchar, Stephen, *Sporting Art in Eighteenth Century England,* 1988.

Tattersall, Bruce, *Stubbs and Wedgwood* (Tate Gallery exhibition catalogue), 1974.